ISABELLA AND LEONARDO

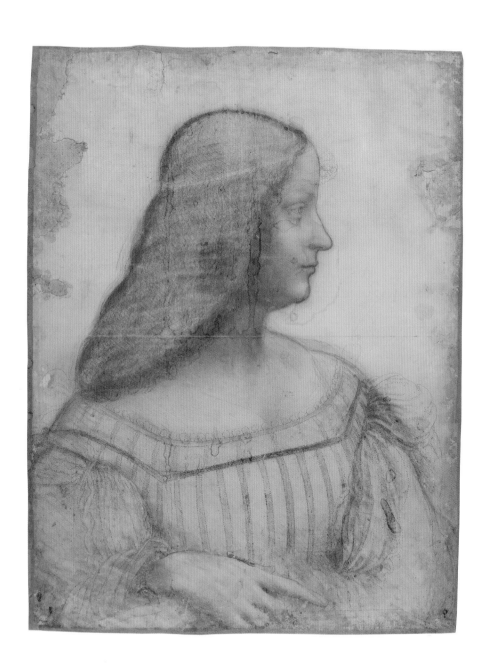

ISABELLA AND LEONARDO

THE ARTISTIC RELATIONSHIP BETWEEN ISABELLA D'ESTE AND LEONARDO DA VINCI, 1500–1506

FRANCIS AMES-LEWIS

YALE UNIVERSITY PRESS

NEW HAVEN AND LONDON

PUBLISHED WITH THE SUPPORT OF THE GETTY FOUNDATION

Designed by Gillian Malpass

Printed in China

LIBRARY OF CONGRESS CATALOGING-IN-PUBLICATION DATA

Ames-Lewis, Francis, 1943–
Isabella and Leonardo : the relationship between Isabella d'Este and
Leonardo da Vinci / Francis Ames-Lewis.
p. cm.
English; correspondence in Italian and English.
Includes bibliographical references and index.
ISBN 978-0-300-12124-7 (cloth : alk. paper)
1. Isabella d'Este, consort of Francesco II Gonzaga, Marquis of Mantua,
1474–1539–Art patronage.
2. Isabella d'Este, consort of Francesco II Gonzaga, Marquis of Mantua,
1474–1539–Correspondence.
3. Leonardo, da Vinci, 1452–1519.
4. Artists and patrons–Italy–Mantua.
I. Title.
II. Title: Relationship between Isabella d'Este and Leonardo da Vinci.
N5273.2.I73A44 2012
709.2'2--DC23
[B]
2011044207

A catalogue record for this book is available from
The British Library

Frontispiece Leonardo da Vinci, *Portrait Drawing of Isabella d'Este*.
Paris, Louvre

Page vi Correggio, *Young Christ*, detail.
Washington, D.C., National Gallery of Art, Samuel H. Kress Collection

FOR

JUSTINIAN, ORLANDO AND JULIET,

THEIR SPOUSES AND THEIR CHILDREN

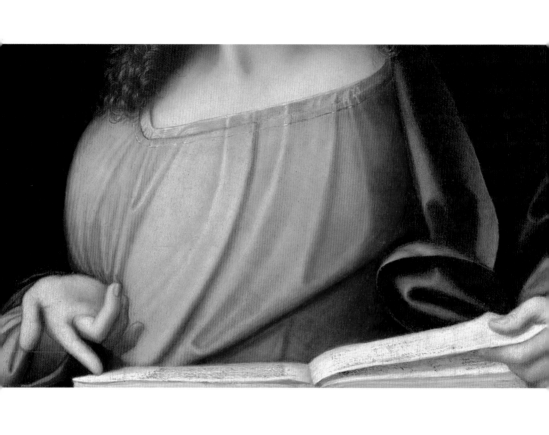

CONTENTS

PREFACE

This book started life as a projected exhibition that was intended as one of the series mounted under the auspices of the 'Universal Leonardo' project in 2006. I am deeply grateful to Martin Kemp for putting his faith in me by inviting me to serve as curator for this exhibition. That it could not in the event be mounted is due to a variety of circumstances outside the control of both me and 'Universal Leonardo'. But when it became clear that the exhibition could not go ahead, I had already done a considerable amount of background research, and it seemed wasteful that this should not be utilised in some other form. Hence my decision to write this book. For various reasons, it has taken considerably longer than it should have done to reach publication.

When I began work on the project, I was well aware of the extraordinary qualities of Leonardo da Vinci as artist and thinker. While writing the book, my respect for him and his qualities (some would say 'genius', but I prefer to eschew this term) has increased by leaps and bounds. But more so has my understanding of – and respect for – Isabella d'Este Gonzaga, not least as a collector and a patron of the major artists of her day. Originally this book would have been called 'Leonardo and Isabella', but it gradually became clear that 'Isabella and Leonardo' is the correct title. As a result of my researches into Isabella and her personality, I have come to wish to correct what seems to me often to be an anachronistic interpretation that emphasises her perceived ungrateful and demanding nature: in fact, her activity as an art patron was subtle and flexible. Like many before me, I have been won over by her

extraordinary determination to perform as an equal in a man's world, and impressed by the many routes along which she travelled in order to succeed in this aspiration.

I am indebted to many scholars past and present who have guided me in my understanding and interpretation of a pivotal moment in Renaissance art patronage, both in Mantua and throughout the peninsula. For anyone studying Renaissance Mantua in general, and Isabella d'Este in particular, the work of Clifford M. Brown is indispensable: I readily acknowledge my great debt to his publications, and I hope that I have not too often misunderstood them or erred in my interpretation of them. The studies of many scholars, from Charles Iriarte, Alessandro Luzio, Julia Cartwright and others up to the present day, have been invaluable. For the present, I am especially grateful for the advice of Francesca Allegri, Carmen C. Bambach, Juliana Barone, Caroline Brooke, John Brooke, Beverly L. Brown, Dorigen Caldwell, Sarah Blanche Cochrane, Paul Davies, Daniela Ferrari, Liz Freeman for her help with the translation of the Isabella–Leonardo correspondence, Paul Joannides, Martin Kemp, Amanda Lillie, Deanna Shemek, Luke Syson, Marina Wallace and Evelyn Welch. I am also deeply grateful to my wife, Christabel, for commenting on the draft typescript from the layperson's point of view, and at Yale University Press to Nancy Edwards, whose eagle-eyed copy-editing ironed out numerous inconsistencies and errors (those that remain, however, are, of course, my responsibility), to Sophie Sheldrake, who dispatchfully and efficiently collected the illustrations, and to Gillian Malpass for her customarily positive and helpful editorial advice.

I

ISABELLA'S INTELLECTUAL PREOCCUPATIONS

In the portrait drawing of Isabella d'Este (Paris, Louvre; pl. 1 and see pl. 62) that Leonardo da Vinci made in early 1500, the sitter is represented in pure profile facing to the right.[1] In this, as in other respects, Leonardo followed the format used by Gian Cristoforo Romano in his portrait medal of Isabella (see pl. 57), cast in 1498.[2] Female portrait medals of the Italian Renaissance that show the right profile are relatively common.[3] On the other hand, although not unknown before 1500, for a painted profile portrait to show the right side of the female sitter's face is very unusual. Two earlier examples, both Central Italian, stand out: Botticelli's *Portrait of a Young Woman* (?Simonetta Vespucci) in Frankfurt, and its derivatives; and Piero della Francesca's *Battista Sforza* (Florence, Uffizi). The first is a poetic, idealised image of femininity, and in no sense a likeness: it occupies an equivocal position in the history of portraiture. As has recently been said of this work, 'the fact that it is much larger than contemporary portrayals and that the woman unconventionally faces right suggests that the painting is not an ordinary portrait. Above all, it is not concerned with likeness.'[4] Probably based on a death mask, the portrait of Battista Sforza is one of a pair of likenesses: in its pendant, the portrait of Federigo da Montefeltro is famously in left profile due to a disfiguring wound to his right eye. Piero's portrait diptych is exceptional in showing the male of the partnership on the sinister panel, and the female on the dexter panel, in the position of greater authority and status.

1 (*facing page*) Leonardo da Vinci, *Portrait Drawing of Isabella d'Este*, detail. Paris, Louvre

Probably because of the strength of the portrait diptych convention, the sitters in Italian early Renaissance female portraits are nearly always shown in left profile. This is almost universally the case, for example, of the group of some forty Florentine female portraits dating from around 1440–70.[5] It is also true of the smaller group of portraits of Milanese noblewomen of the 1490s in which each sitter becomes primarily a framework for the display of fashionable and rich dress and jewellery. One example of this type is the portrait in Christ Church, Oxford (pl. 2), usually identified as Isabella's younger sister, Beatrice, Duchess of Milan; another is the portrait drawing (see pl. 72) recently attributed to Leonardo da Vinci and identified as of Bianca Sforza, an illegitimate daughter of Ludovico Sforza, Duke of Milan.[6] For her portrait, Isabella d'Este broke with convention, but for neither of the reasons that Botticelli's and Piero della Francesca's female sitters face to the right. By appropriating the pose normally taken up by the male sitter of a portrait diptych, she made a statement about her status and authority at the Mantuan court. This is a small example of the strategies adopted by Isabella d'Este to encroach onto male territory, and to be seen as equal in courtly authority and status to her male peers, not least to her husband Marquess Francesco II Gonzaga. Such perceptions were especially important to her image, and to her self-image, when she ruled as regent over the Mantuan state on the not infrequent occasions when Francesco Gonzaga was out of Mantua.

During the last two decades of the fifteenth century, increasing political and diplomatic responsibility settled on courtly ladies such as Eleonora d'Aragona, Duchess of Ferrara, and her daughters, Isabella and Beatrice, during periods of absence of their princely husbands. This may well have stimulated a perceived need in intellectual circles for a theory of gender equality that gave rise to an increase in output in the literary genre of the treatise in praise of women. In 1501 Mario Equicola wrote his *De mulieribus*, a treatise on women that features Isabella as an exemplary woman.[7] It was commissioned by Isabella's close friend Margherita Cantelmo, the daughter of a wealthy Mantuan notary, to whom Agostino Strozzi also dedicated his *Defensione delle donne* in 1501.[8] The production of such treatises may suggest that women established within north Italian court circles at the turn of the century felt the need to find ways to assert their position in a male-controlled political environment, and to claim equality with their male peers in cultural and intellectual life.

Important precedents for these Mantuan treatises were a group of treatises on women composed in Ferrara during the last third of the fifteenth century.[9] All of these Ferrarese treatises list Isabella's mother, Eleonora d'Aragona, amongst their groups of prominent contemporary women. Eleonora was

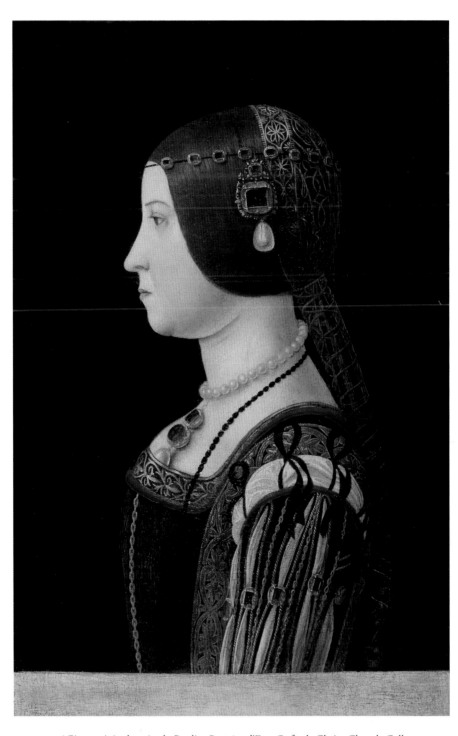

2 ?Giovanni Ambrogio de Predis, *Beatrice d'Este*. Oxford, Christ Church Gallery

generally seen in these texts as an important example of a woman who, faced with the inadequacies of her princely husband as administrator of the state, took power into her own hands and efficiently conducted the affairs of Ferrara. As a daughter of the King of Naples, who, however, married nobility rather than royalty, Eleonora is not likely to have discouraged characterisations of these sorts. As though in response to Eleonora's new seigneurial responsibilities, Antonio Cornazzano wrote for her in around 1479 his *Del modo di regere e di regnare*, a text on how a ruler should conduct himself or – in her unusual case – herself, and the qualities such as strength and wisdom that the ruler requires.[10] In the frontispiece (pl. 3) to the dedication manuscript of this treatise, Eleonora d'Aragona is shown holding a wand of authority and in profile facing right, as in her daughter's portrait drawing. Eleonora provided her daughter with a noteworthy role model when Isabella came to shape for herself her own image as ruler of the Mantuan state, especially when Francesco Gonzaga was absent on military duties.[11] Like her mother, Isabella took close interest in both the political and the cultural developments of her time, and she proved herself more than competent in promoting them and in exercising her political and administrative powers.

In his *De mulieribus* Equicola appears to be persuaded of the essential equality between the sexes, and he strives to counter standard arguments for the inferiority of women. Isabella d'Este takes first place, and is accorded the most extensive and fulsome description amongst all the contemporary women discussed. She is characterised as level-headed and incisive in her conduct of political affairs.[12] Given her tendency towards plumpness, Isabella is perhaps somewhat idealistically praised for the classical *mediocritas* of her figure.[13] Equicola in particular praises her for three personal traits: her beauty, her political ability and her cultural sophistication. This last is highlighted in terms of her musicianship, and especially of her 'divinely inspired' skills as a lyre player. In this, Isabella is comparable to Apollo, a parallel that may already have been suggested in Mantegna's *Parnassus* (see pl. 29). Hung in her *studiolo* just four years earlier, Mantegna's painting can be interpreted as showing Venus, who has tamed and captured the warrior Mars, presiding over the harmony generated by the dance of the Muses to Apollo's accompaniment. This may in turn suggest that Equicola sought to propose a neo-Platonic interpretation of Isabella as the woman destined to restore harmony to a fractured society. Amongst the flattery, the exaggerations and the idealisations of Isabella, however, there is probably more than a grain of truth in Equicola's assessment of her abilities and achievements.

Isabella maintained close associations with a number of humanist intellectuals based at the Mantuan court. At the time in the later 1490s when

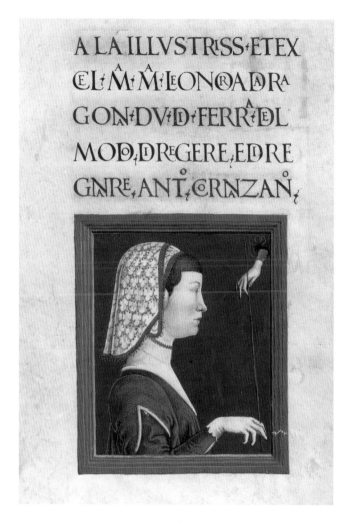

3 Cosmè Tura, *Eleonora d'Aragona*.
New York, Pierpont Morgan Library, MS M.731 fol. 2v

she started to furnish her *studiolo* and to plan the paintings for this impor-
tant display space, the principal court humanists were the ageing Baptista
Spagnoli, known as Mantuanus, and Paride da Ceresara. Born in 1447,
Mantuanus was taught in Mantua by Giorgio Merula and especially
Gregorio Tifernate, and studied philosophy at the University of Padua.[14] He
became a Carmelite monk in 1463, and rose to be Prior of the Mantuan
convent in 1479 and general of the order in 1513. He was tutor to Marquess

Federigo Gonzaga's children, including Francesco II Gonzaga: pendant terra-
cotta busts of Virgil (the most celebrated Mantuan of classical times) and of
Mantuanus originally flanked Francesco Gonzaga's bust (see pl. 76) on the
Porta Nuova at Mantua. His major publication, a series of ten eclogues enti-
tled *De adolescentia*, was dedicated to Paride da Ceresara on 16 September
1498: this became a popular and critically acclaimed textbook in grammar
schools throughout Europe. Paride da Ceresara himself, a wealthy and learned
lawyer noted for his erudition in Greek and Latin, was born in Mantua in
1466 and was already associated with the Gonzaga court by 1494.[15] A letter
that he wrote on 19 March that year to Francesco Gonzaga concerns the dis-
patch of a book, probably a copy of the recently published *Liber chronicorum*
by Hartman Schedel, to the marquess.[16] Early in 1503, by then firmly estab-
lished in Isabella's service, Paride wrote the celebrated programme for the
Battle of Love and Chastity (see pl. 11), to be painted by Pietro Perugino for
Isabella's *studiolo*.[17] It seems likely that Paride had already been involved
in helping to devise the imagery for the two paintings by Mantegna for the
studiolo, the *Parnassus* (see pl. 29), the first painting in the room, mounted
for display in 1497; and the *Pallas Expelling the Vices from the Garden of Virtue*
(see pl. 30), which was probably completed by 1502.

By 1500 or soon thereafter, two other humanists became significant figures
in Isabella's intellectual circle. Battista Fiera incurred Isabella's wrath through
his indecorous interpretation of the representation of Venus and Mars in
Mantegna's *Parnassus*, in which he fairly explicitly identified the adulterous
Venus with Isabella herself.[18] This episode has some significance for our
understanding of that painting, of which the interpretation, in the absence
of a written programme to complement that for Perugino's painting, is prob-
lematical.[19] In his *Sylvae*, Fiera published in 1515 a poem comparing the
different qualities of Francesco Bonsignori and Lorenzo Costa as painters.[20]
But perhaps more important for intellectual activity in Mantua shortly after
the turn of the century was Mario Equicola. Born around 1470 and educated
in Florence by the neo-Platonic philosopher Marsilio Ficino, Equicola's
earliest surviving contact with Isabella is in a letter written from Ferrara on
17 May 1503 in which he sent Isabella birthday greetings and offered her his
loyalty and service. For her birthday in 1506 Mario Equicola wrote an ingra-
tiating treatise, *Nec spe nec metu*, on her favourite motto ('neither elated by
hope nor cast down by fear'), which she herself had devised two years earlier;
and in 1508 he moved to Mantua to become her secretary and tutor.[21] His
principal work was the *Libro de natura de amore*, written for the most part in
1509–11 although not published until 1525, which includes not only an infor-
mative description of Isabella's *grotta* but also considerable discussion of the

nature of love that casts light on the imagery of the *studiolo* paintings and their meanings for Isabella and her contemporaries.[22] Equicola may well have lent a hand in devising the *invenzioni* for Lorenzo Costa's two canvases for Isabella's studiolo;[23] and it was also he who a few years later wrote the programmes for the paintings made by Titian and others for the *camerino d'alabastro* of Isabella's brother Alfonso, Duke of Ferrara. These 'fables' (*favole*) were based on texts by Catullus and Philostratus: the manuscript of the first vernacular translation, by Demetrius Moschus in around 1510, of Philostratus's *Imagines* was dedicated to Isabella in the prefatory letter by Equicola. This was the book that in a letter of 1515 Isabella asked her brother to return, reminding him that she had lent it to him 'already several years' earlier.[24]

Isabella d'Este had been provided with the best humanist education that Ferrara could offer in the later fifteenth century.[25] Both her parents were themselves highly educated, and her mother Eleonora d'Aragona appears to have harboured ambitions for her daughter's intellectual and cultural prowess. Isabella was taught alongside her brothers by important humanists of the time, such as Battista Guarino (son of the celebrated Guarino da Verona), her first tutor. As early as April 1480, when Isabella was not yet six, the Mantuan envoy Beltramino Cusatro, who was sent by Federigo Gonzaga to Ferrara to negotiate the betrothal of Isabella to his son Francesco, wrote that he had 'questioned her on many subjects, to all of which she replied with rare good sense and quickness. Her answers seemed truly miraculous in a child of six, and although I had already heard much of her singular intelligence, I could never have imagined such a thing to be possible.'[26] At times when she was under pressure from domestic matters such as childbirth and child-rearing, and from political and administrative matters when Francesco Gonzaga was absent from Mantua, her pursuit of the knowledge of classical literature may have faltered. Nevertheless, on and off during the 1490s she returned to her studies of Latin; and although she was never an accomplished Latinist, it was probably unjust of Giovanni Gioviano Pontano, the great Neapolitan humanist, to dismiss her in 1499 as 'senza lettere': lacking in classical learning.[27] Writing from Ferrara on 25 March 1490, shortly after Isabella moved to Mantua, her tutor Jacopo Gallino reminded her wistfully that 'on Saturdays [you] would translate for me all of this: all of Virgil's *Bucolics*; the first, second and part of the third book of Virgil; several of Cicero's Epistles; part of the *Herotimate*; and many other grammar materials'.[28] For a while at least, Isabella d'Este also tried to write vernacular poetry. Antonio Tebaldeo, who claimed to have been Isabella's tutor at one time, commented on her talent for poetry; and in 1504 Vincenzo Calmeta sent her 'some precepts and observations pertinent to composing poetry in the vernacular'.[29] Recently, however, her efforts

have been perhaps a trifle unjustly dismissed as 'written in a language that is inadequate, unharmonious, quite unacceptable';[30] and it does not appear that she continued for long with these ambitions.

Whether ultimately successful or not in her own literary endeavours, Isabella d'Este was certainly one of the most prolific letter-writers of her time. As will become increasingly evident, the bulk of the evidence and of the historical record on which studies of Isabella d'Este are based comes from her correspondence.[31] The Gonzaga archive in the Archivio dello Stato in Mantua includes one of the largest holdings of letters to and from a single individual to survive from the Renaissance period. The collection is not, of course, comprehensive: there is evidence in surviving letters that further correspondence is now lost. Nevertheless, some 28,000 letters written to Isabella d'Este, and some 12,000 copy-letters, have survived to manifest her extraordinarily prolific letter-writing activity.[32] As a Renaissance noblewoman, she was expected to conduct a wide-ranging correspondence. Much can be learned from the letters of women like Isabella 'about Renaissance communication networks . . . about the letter as a medium for personal contact, political agency, news-gathering and self-construction'.[33] The range of her correspondents, who included major figures within the politics and administration of courts, cities and the Church throughout the peninsula, is exceptional for a woman of the Renaissance. It demonstrates the high regard in which her political and diplomatic intelligence and sophistication were held. In this way, too, she was able to encroach into the essentially male preserve of political negotiation through the exchange of letters.[34] Her correspondents also include innumerable agents who supplied her with information on the political and cultural activities of other people and other cities, as well as sending goods to cover the physical needs of her life: foodstuffs, spices, antiquities and works of art, luxury goods, jewellery, and above all textiles and clothes.[35] Isabella's letters provide us with 'a remarkably full portrait of a woman who adopted the letter as a key arena of her political influence and her affective relations'.[36]

An exceptionally large body of correspondence was retained by Isabella's secretariat, and copies of a large number of her own letters were made and filed. This suggests that she was very conscious of the historical importance of the record thus assembled of her life and times, and of her activities as a prominent figure within the court and the state of Mantua. The letters served as a record of actions and decisions which Isabella was able to refer back to. She may also have had posterity and the judgements of history in mind when she decided to retain and to establish as an archive such a large collection of letters. This is another significant instance of Isabella's male-orientated thought. The archive provides posterity with as much information about

Isabella as we have for the political, diplomatic and cultural activities of men such as Lorenzo 'il Magnifico' de' Medici, and considerably more than survives for many statesmen of the period.

ISABELLA'S *STUDIOLO* AND *GROTTA* IN THE CASTELLO DI SAN GIORGIO

Few women in fifteenth-century Italy owned or fitted out *studioli* in their apartments. The study was almost exclusively a very private, male preserve: as Alberti has one of his speakers in *Della famiglia* say, 'I never gave my wife permission to enter my study, either with me or alone.'[37] The history of the *studiolo* in the later fifteenth century, from that established in around 1450 by Leonello d'Este, Isabella's uncle, at Belfiore outside Ferrara, to those of Federigo da Montefeltro in Urbino and Gubbio, dating from the late 1470s, shows that they formed part of the suite of apartments belonging exclusively to the prince. Probably similar was the *studiolo* fitted out in the Castello of Mantua for Federigo Gonzaga, Isabella d'Este's father-in-law, by his architect Luca Fancelli in 1478.[38] In the cases of Piero de' Medici's *studietto* of around 1460 and Federigo da Montefeltro's *studiolo* in Urbino, it is clear that these were the innermost, most private rooms of the suite, reached only after passing through public reception rooms and through progressively less public antechambers.[39] Access to such spaces would be limited to an elite group of close allies and friends, probably almost exclusively male.

Isabella d'Este, however, belonged to a family line of intelligent, well-educated women. These powerful women felt that they were in a strong enough position to assert their cultural and intellectual independence within the male-dominated world of the later fifteenth-century courts. Even before Isabella's mother, Eleonora d'Aragona, had a *studiolo* constructed for her in the Castello Vecchio at Ferrara, Ippolita Sforza, wife of Alfonso, Duke of Calabria (later King Alfonso II of Naples), wrote to her mother, Bianca Maria Sforza, in 1466 that 'my *studio* for reading and writing in occasionally' was complete. She asked that portraits be sent to her of her parents and siblings, 'for beyond the adornment of my *studio*, looking on them would give me continual consolation and pleasure'.[40] Since Ippolita Sforza was her sister-in-law, Eleonora d'Aragona would have known this intimately female study space before she left Naples in 1473 to marry Ercole d'Este. Like Ippolita, Eleonora was well educated and intellectually vigorous; in this respect, too, she was an important role model for her daughter Isabella. From 1480 until her death in 1493, Eleonora was active in reorganising and redecorating two suites of rooms, the earlier of which, in the Castello Vecchio, included a

studiolo with bookshelves. On her visit to Ferrara in July 1494 Isabella d'Este saw also the second suite, of garden rooms, that her mother had recently had furnished and decorated.[41] She also revisited her father Duke Ercole's *studiolo*, and gained advice from him as to how she might decorate and furnish hers. Moreover, she stayed with her sister-in-law Elisabetta Gonzaga, and Elisabetta's husband, Guidobaldo da Montefeltro, in Gubbio and in Urbino in April 1494. On this visit Isabella would have been interested not only in both of Federigo's *studioli* but also, in all probability, in the layout and furnishing of Elisabetta's own suite of rooms in the Urbino palace. Isabella had been well educated in Ferrara, and she was brought up accustomed to the idea that courtly women might identify spaces for use specifically as personal *studioli*, for the purposes of study, writing, music-making and contemplation. All these experiences perhaps encouraged her to believe that it was not just possible but also appropriate for the ruler's consort to aspire towards the possession of rooms that were as private and personal as those of the princes of the day.

It comes, then, as no surprise that once married to Francesco Gonzaga in 1490, Isabella d'Este lost little time before establishing her own *studiolo* in the Castello di San Giorgio of the Gonzaga palace in Mantua. Her early projects for appropriating and furnishing two rooms in the Castello were already in hand in 1491. By 1493 the *studiolo* served Isabella as a retreat where she could read undisturbed.[42] In establishing and decorating her *studiolo*, Isabella set out to emulate her male peers, and to compete with them on their own ground. Possession and decoration of a *studiolo* implied a level of intellectual aspiration and achievement that Isabella seems to have seen as a necessary facet of her self-fashioning. Although her *studiolo* was somewhat larger than Federigo da Montefeltro's in Urbino, she needed some twelve years later to expand her private space by furnishing a second, similarly sized room that became known as her *grotta*. This was needed to accommodate her growing collections, especially of antiquities. Isabella d'Este's *studiolo* and *grotta* were two of a suite of at least five rooms on several levels of the Castello di San Giorgio, and connected by a series of stairways with the Sala delle Armi on the Castello's upper floor.[43] The *studiolo*, and below it the *grotta*, accessed originally by a separate staircase from the Sala delle Armi but later by a narrow staircase from the *studiolo* itself, were located at the centre of the suite. Work on decorating her suite of rooms had started by November 1491, less than two years after Isabella had arrived in Mantua, when the Mantuan painter Gianluca Leombeni decorated the walls of the *studiolo* with a frieze showing Gonzaga arms and devices.[44] When in January 1493 Francesco Gonzaga ordered a consignment of Pesaro tiles to be laid in his *camerino della maioliche* in the villa at

Marmirolo, Isabella appropriated the unused residue for flooring in her *studiolo*, laid in July 1494.[45] These tiles (pl. 4) also showed Gonzaga devices and coats of arms,[46] so that in the mid-1490s her *studiolo* was defined as a Gonzaga space. Only later were devices personal to Isabella introduced, to distinguish the *studiolo* as her own private domain. In May 1496 one 'Zoanantonio taiapreta' acquired marble in Venice from which to carve a window-frame for the *studiolo*. With him in Venice was the painter Bernardino Parentino, buying pigments probably for the fresco decoration of the vault and perhaps also the wainscoting.[47] Nothing is known of the subjects or imagery of any such decoration. From 1497, however, Isabella's personal stamp began to make itself clearly felt, as earlier frescoes were gradually replaced by the canvas paintings installed between 1497 and 1510.[48]

Music-making was one of the activities that Isabella pursued vigorously in her *studiolo*. The quality of her singing voice was renowned, and she also played both the cittern and the *lira da braccio*, instruments traditionally used to accompany singing.[49] There was much musical talent in Isabella's generation of the Este family. Both she and her sister, Beatrice, were also skilled

4 Pesaro ceramicist (?Antonio dei Fedeli), six floor tiles. London, Victoria and Albert Museum

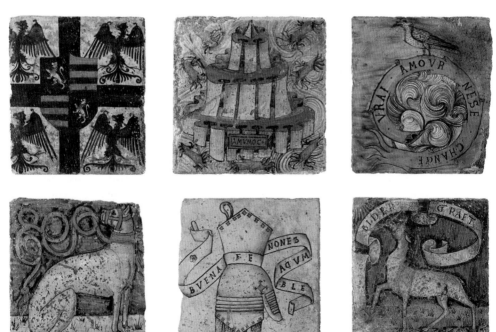

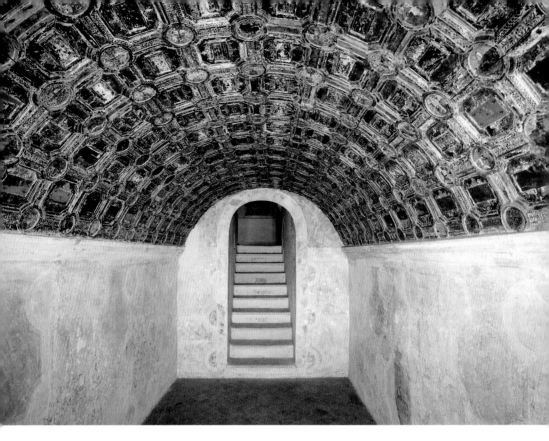

5 *Grotta*, vault, Mantua, Palazzo Ducale, Castello di San Giorgio

lutenists and clavichord players,[50] and their brother, Alfonso, later Duke of Ferrara, was a proficient violinist. It may be that they inherited their musicianship from their mother, Eleonora d'Aragona, who played the harp. In Isabella's very first letter to the celebrated instrument-maker Lorenzo Gusnasco da Pavia, on 12 March 1496, she asked him to make her a clavichord 'of the beauty and excellence that conforms to your fame';[51] and nine months earlier, on 30 June 1495, she had discussed with another agent, Marco Nigro, the payment for three viols made for her in Brescia.[52] The correspondence with Lorenzo da Pavia includes reference to several lutes made, or repaired, for Isabella. On 13 March 1500, for instance, he sent her a large Spanish-style lute; and by that time a second lute had been ordered from him.[53] Some sixteen months later Isabella wrote to him that the clavichord that he had built for her sister Beatrice had been given to her: she felt sure that 'you will be glad to hear it was in my hands, being as it is your work, and so excellent an instrument that it must always be very dear to me'.[54]

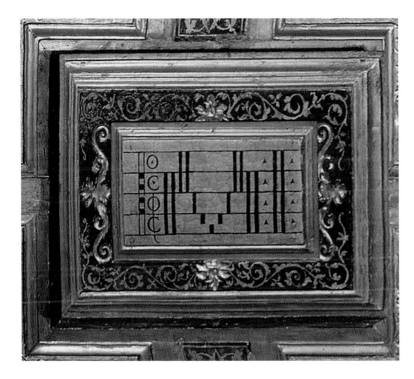

6 *Grotta*, vault, detail of 'musical pause' *impresa*,
Mantua, Palazzo Ducale, Castello di San Giorgio

By the time that Leonardo da Vinci visited Mantua late in 1499, Isabella's collection of musical instruments had been growing for several years, and would have taken up more and more space within the small *studiolo*. Moreover, the original function of the room, as a space for retreat, reading and contemplation, was starting to be eroded by the needs of collection display. Isabella was increasingly active in acquiring antiquities, and in particular small pieces of Roman sculpture: this is considered in detail in chapter five. While the pictorial decoration of her *studiolo* developed, she set in train plans for a second private space. Whereas the space of the *studiolo* would continue to be used for reading and music-making, the *grotta* was fitted out as a dedicated space for her collections, especially the growing collection of small antiquities. With the installation of cabinets to hold her antiquities collection in 1508, Isabella declared that her *grotta* was complete.[55] Her collections were transferred into the *grotta* in that year, and there displayed to those privileged enough to gain access to her private spaces. The vault of the *grotta* was orig-

inally frescoed with the Gonzaga device of a winged ring on a blue ground, but between 1506 and 1508 the space was provided with the still-extant wooden vault, decorated with Isabella's personal devices (pl. 5).[56]

Isabella's adoption of personal *imprese*, hitherto a predominantly masculine activity, is a further example of her readiness to step onto male territory.[57] While she was not the first court lady to devise mottoes and *imprese* for herself, she appears to have entered into the cryptic, intellectually elaborate spirit of the *impresa* with more commitment than her female peers.[58] As noted, in 1506 Equicola dedicated to Isabella his treatise on her own motto, *nec spe nec metu*, which reflects her wish to retain balance and equanimity in all her activities. This echoes the meaning of her favourite device, the 'musical pause' (pl. 6), which appears prominently on the intarsiated ceiling of the *grotta*. Isabella seems to have used this first as a decoration embroidered onto the *camorra* that she wore at one of the events that took place in Ferrara early in February 1502 to celebrate the marriage of her brother Alfonso with Lucrezia Borgia. The device 'consists of an alto clef, three different mensuration signs, an entirely balanced arrangement of rests, and a repetition sign which refers both backwards and forwards', indicating 'infinite time and infinite silence' and visually suggesting symmetry and harmony.[59] Over the following years Isabella developed further *imprese* to reinforce her ambition to be seen as an equal of her male peers, such as the Roman numeral XXVII, in Italian 'ventisette', which sounds like 'vinti sète' (you are defeated), and the sheaf of white tickets in a lottery urn (to signify, it is suggested, 'that she had tried several remedies to obtain the peace of her soul').[60] The latter is seen alongside the 'musical pause' on the vault of the *grotta*.

Display of her collections was for Isabella a necessary corollary to acquiring collectable objects, progressively more often small antiquities. In her time collecting, especially of classical sculpture and artefacts, was another almost exclusively male activity.[61] This was one way for a wealthy man to establish his intellectual credentials and to help to enhance antiquarian endeavour. In a recent book it has rightly been restated that 'the most celebrated collector in Renaissance Mantua was undoubtedly Isabella d'Este', but it is not there acknowledged that Isabella is the only female collector anywhere in Italy in the first half of the sixteenth century whom the author cites.[62] Of the major princely courts of northern Italy, Mantua was one of the smaller; and in the 1490s Isabella d'Este certainly had less disposable income than her sister Beatrice, Duchess of Milan, and probably less also than her sisters-in-law Elisabetta Gonzaga, Duchess of Urbino, and later Lucrezia Borgia, who was Duchess of Ferrara from 1505.[63] But collecting ran in the Este blood: both her half-uncle Leonello and her father Ercole assembled considerable collections

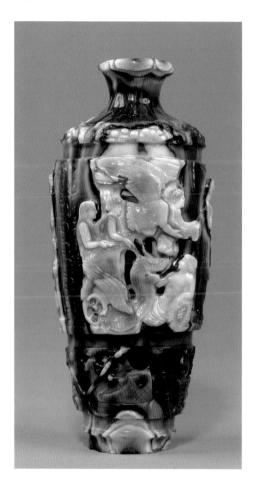

7 Roman, onyx vase. Brunswick, Herzog Anton Ulrich-Museum, inv. no. 300

of small antiquities. Isabella also recognised that collecting antiquities was another means by which she could demonstrate that her intellectual aspirations and achievements were equal to those of her male peers in the courts of north Italy. Isabella steadily built up a network of contacts and agents to supply her with items for her antiquities collection, and to advise her when important objects were coming onto the market. The auction of the collection of Michele Vianello in Venice after his death in 1506 is a good example of this practice: Lorenzo da Pavia reported to her from Venice on the forthcoming auction, and on Isabella's behalf he bid for and acquired a carved onyx hardstone vase, perhaps that now in Brunswick (pl. 7).[64]

Collecting antiquities was also an activity close to the hearts of several male
members of the Gonzaga family and their entourage, notably Cardinal
Francesco Gonzaga, who died in 1483, Bishop-Elect Ludovico Gonzaga, and
the court painter Andrea Mantegna. Isabella's readiness to acquire costly pieces
became more evident when she bought from the elderly and ailing Mantegna
his beloved bust of the *Empress Faustina* in July 1506, just two months before
he died, for the considerable sum of 100 ducats.[65] Four years earlier she had,
like Bishop-Elect Ludovico and also indeed her father Ercole d'Este, been
interested in acquiring one or more classical hardstone vases from the collec-
tion of Lorenzo 'il Magnifico' de' Medici, which came onto the market in
1502.[66] Isabella emulated her Mantuan peers by assembling her growing col-
lection of cameos, gems, coins and medals and other small antiquities in her
studiolo, and from 1508 in her *grotta*. She developed and consolidated her intel-
lectual position in the court in part by appropriating physical space for col-
lection display. It is, however, very difficult to chart the history of Isabella's
collection of antiquities. The great inventory of Isabella's possessions compiled
by Odoardo Stivini, three years after her death, provides us with an overview
of her collection and its display in the *grotta* in the Corte Vecchia in 1542.[67]
This probably closely reflects the contents of the *grotta* when Isabella moved
into her new apartments in 1522; and in turn that display may well have
reflected the layout of the collection from 1508 to 1519 in the old *grotta* in the
Castello di San Giorgio. If so, the record suggests that at least from 1508
Isabella made conscious decisions about the display of her antiquities, espe-
cially in juxtaposing objects to encourage comparative study. The problem-
atical question of the early development of Isabella's collection of antiquities
is considered in more detail in chapter five. Unfortunately, however, rather
little can be said definitively about the contents of the collection, or how
it was displayed, at the time that Leonardo da Vinci was in Mantua early
in 1500.

In a range of fields of activity, a range unprecedented for a woman of the
Renaissance, Isabella d'Este determinedly set about to fortify her position
within the social, political and cultural framework of Mantua in the decades
either side of 1500. She made important contributions to the city's musical
life, both in her own performance as singer, lute and clavichord player, and
as a force in the development of the *frottola*, a popular, unaccompanied secular
song.[68] She commissioned her own portrait medal for circulation to friends,
courtiers and others whose loyalty she sought to preserve.[69] She was one of
the first Renaissance women to develop her own personal imagery in the form
of devices and *imprese*. She sent, received and preserved in her personal files
an incomparable archive of correspondence dealing with a broad range of

issues from the international to the domestic, from political intrigue to the mail-order purchase of everyday commodities. She appropriated spaces for her private use, and formed the most celebrated female *studiolo* of the Renaissance period. This she had decorated with moralising allegorical paintings with subjects and themes that reflected her own view of her personal attributes of virtue; and she approved programmes for these paintings that incorporated figures from classical mythology and history in complex and intellectually sophisticated ways. Finally, she competed on the male territory of collecting, especially of antiquities. In this pursuit she was sufficiently successful as to require for collection display a second private space, her *grotta*, which from 1508 served as her 'kunstkammer' *avant la lettre*.

Isabella d'Este herself recorded that she desired to assemble in her *studiolo* 'pictures with a story by the excellent painters now in Italy'.[70] To this end she commissioned three allegorical paintings from Francesco Gonzaga's court painter Andrea Mantegna, two of which were completed before his death, one from Pietro Perugino and two from Lorenzo Costa – the second replacing Mantegna's unfinished canvas. She also sought, unsuccessfully, further paintings for her *studiolo* from Giovanni Bellini and Leonardo da Vinci. Her relations with all these painters are considered in some detail in chapter two. She tried to acquire a canvas by Giorgione shortly after his death in 1510, and she also obtained small paintings by Giovanni Santi, Giovanni Bellini, Francesco Francia and others, and, later, two further allegorical paintings by Antonio Allegri, il Correggio, and her portrait by Titian. In the final analysis, as we shall see, she was less successful in taking possession of works that she asked Leonardo da Vinci to provide than of paintings she commissioned from other painters of the time. Nevertheless, the works that Leonardo carried out for Isabella (albeit largely incomplete and now lost), the communications between them concerning these works, and Isabella's dealings in general with him offer further instructive insights into relations between a painter and his patron – the most active and most powerful female patron of the period – at the height of the Renaissance.

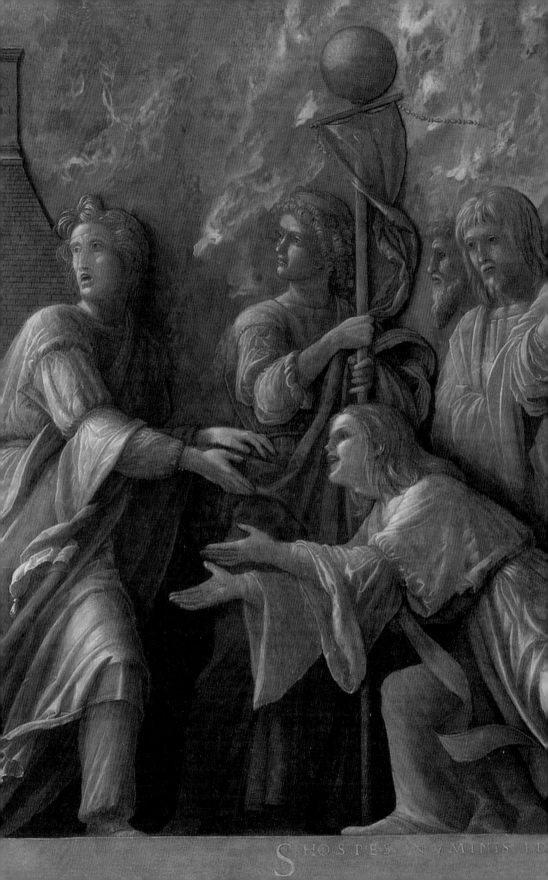

II

ISABELLA AND HER ARTISTS

On a number of occasions in her correspondence with painters, or with agents while negotiating the acquisition of paintings, Isabella d'Este used critical terms and phrases that suggest that she was visually more perceptive than other observers of her time. She had, it seems, a refined and experienced eye when scrutinising the aesthetic quality and merit of works of art. Her written comments, which are considered in more detail later in this chapter, suggest also that she was skilled in crystallising critical ideas in a few subtle, well-chosen words. Isabella's visual sensibilities could already have been developed during her early years in Ferrara, before her marriage to Francesco Gonzaga at the age of sixteen in 1490. Since the time of her half-uncle Leonello d'Este in the 1440s, the Ferrarese court had been a sophisticated centre of art patronage and production. The principal Ferrarese painter of the second half of the fifteenth century, Cosmè Tura, cultivated an individual style of unusual visual intricacy. This he combined with an immaculate technique much indebted to contemporary Netherlandish art, which allowed him to depict objects, materials and surface textures in the finest detail. This virtuoso manner of painting may best be explained as intending to call forth informed comment from visually educated court observers. 'Tura's art seems calculated to produce extreme responses, and to make extraordinary bids to claim the viewer's attention,' wrote one recent critic, suggesting further that his style 'can be characterised as curious or attention-seeking'.[1] Just as Isabella's *studiolo* paintings were devised at least in part to prompt erudite intellectual discussion of their

8 (*facing page*) Andrea Mantegna, *Introduction of the Cult of Cybele in Rome*, detail. London, National Gallery.

imagery, so also Tura's inventive, inimitable style probably evolved as it did in part to provide material for the exercise of visual critical skills.

Isabella d'Este's visual criticism would probably have been further developed during the 1490s in Mantua, perhaps even under Andrea Mantegna's direct tutelage. Besides prompting discussion of their imagery, Mantegna's paintings for Isabella's *studiolo*, like Tura's for the Ferrarese court, were probably also intended to provoke comment on matters of pictorial style and aesthetic. This is suggested by features such as the technically brilliant, microscopic sharpness of Mantegna's depiction of natural detail and his radiant, high-key palette. Written correspondence about his work was apparently little required, presumably because Mantegna was on hand in the Mantuan court. As a result, few comments by Isabella on the artistic and aesthetic qualities of Mantegna's paintings in the last fifteen years of his life survive. Nonetheless, her intellectual upbringing would have predisposed her to continue to develop her visual perceptiveness once in Mantua. This is further suggested by her readiness to make comparisons between similar works by different artists, as a way of enhancing both her visual discrimination and her ability to translate such discrimination into words. *Paragone*, the comparison between works of art or between different liberal arts, was a rhetorical tool used increasingly often in theoretical and scholarly debate during the Italian Renaissance. Isabella kept up with her intellectual peers in acknowledging the growing value of this technique, and in exploiting it for her own assessments of artistic and aesthetic quality.

PARAGONE

During the years in which she sought paintings by Leonardo da Vinci, Isabella d'Este acquired two marble carvings of the *Sleeping Cupid*. One was by Michelangelo (acquired by 21 July 1502) and the other, purchased in 1506, was then thought to be by Praxiteles.[2] These acquisitions are considered in more detail in chapter five. The Stivini inventory of 1542 shows that in the *grotta* of the Corte Vecchia Isabella displayed these two works close together.[3] We cannot know for sure, but it seems likely that this arrangement replicated their display from 1506 in her *studiolo* in the Castello di San Giorgio, and from 1508 in the new *grotta*. It was devised deliberately to encourage viewers to make comparisons between ancient and modern treatments of the theme. Comparison of works of art in order to elucidate, identify and characterise features of one work in the light of another has long been a standard technique of the art historian, typified in the use of double slide projection in the

lecture-room. It is, of course, a natural way to differentiate between artists and their styles, or their abilities in different arenas; and it was used in the earliest post-classical writings on art. In his *De remediis utriusque fortunae*, written between 1354 and 1366, Francesco Petrarch had already set out a number of paired contrasts, such as between ancient and modern, between the informed and the ignorant observer, between matter and form, or between nature and art.[4]

In the following century the *paragone*, initially primarily the comparison between the liberal arts, was often the subject of intellectual debate. Writers on the visual arts quite often sought to demonstrate that painting deserved to be counted amongst the liberal arts, arguing that it was equal, if not superior, in affectiveness to poetry, for example, or to music. Early commentators who compared painting to poetry extrapolated from comments made by Horace in his *Ars poetica*. These are notably his celebrated aphorism 'ut pictura poesis' (*Ars poetica* 361–62) – 'as a painting, so a poem' – and the more elaborate 'pictoribus atque poetis/Quidlibet audendi semper fuit aequa potestas' (*Ars poetica* 9–10): 'painters and poets have always had equal powers of venturing'.[5] Filippo Villani wrote in 1381–82 that Giotto 'showed himself so far a rival of poetry that keen judges consider he painted what most poets represent in words'.[6] By the middle of the fifteenth century such judgements were becoming commonplace: in his *De viris illustribus* of 1456, for example, Bartolommeo Fazio maintained that 'there is . . . a certain affinity between painters and poets; painting is indeed nothing else than a wordless poem'.[7]

Fifteenth-century comparison of painting and poetry, or painters and poets, culminated in the obsessively repetitive observations on the theme in Leonardo da Vinci's notes for his *Trattato della pittura*. Around 1500 'comparisons were all the rage';[8] and Leonardo's writings are the most prominent example of this intellectual fashion. Through accumulation of comparisons favourable to painting, Leonardo sought to establish incontrovertibly the superiority of painting over other visual arts, especially sculpture. Perhaps more important here is his further *paragone* between painting and liberal arts such as poetry and music. This is not the place to rehearse the full range of his arguments; a few examples will be enough. 'If you assert', he wrote, 'that painting is dumb poetry, then the painter may call poetry blind painting . . . but painting remains the worthier in as much as it serves the nobler sense' (that is, the sense of sight).[9] Similarly, 'Music is not to be regarded as other than the sister of painting, in as much as she is dependent on hearing, second sense behind that of sight';[10] and, moreover, 'Painting excels and is superior in rank to music, because it does not perish immediately after its creation, as happens with unfortunate music.'[11]

The variety of Leonardo's arguments reflects the popularity of this type of thinking at the turn of the century. Comparison was, however, used to establish not only intellectual worth but also the character and quality of artistic output. For Leonardo the practice of *paragone* was directed essentially towards comparisons between the visual and the liberal arts. For Isabella d'Este, on the other hand, comparison was a technique used not so much to discern the relative intellectual status of different art forms as primarily to judge quality and skill – and not of works of art alone. It might, for example, be used in assessing the quality of a pigment by comparison with a high-quality sample, or of a fabric and the skills of its weavers. When Bernardino Parentino went to Venice in July 1496 to buy pigments for fresco decorations in Isabella's *studiolo*, Isabella sent her agent Giorgio Brognolo 'a list of certain colours that we desire . . . and I am sending the "parangoni" in a little box'. Five weeks later she wrote again, agreeing that Brognolo could buy a blue pigment of a different colour from her azurite *paragone*, but requiring that it should be 'the most beautiful that can be found in Venice'.[12] Several years earlier she had written to Brognolo in Venice about a cape that she wanted to have made. She asked him to 'send eight *braccia* of the best crimson satin which you can find in Venice, and it should be from the *paragon*, because we want to use it to make the said cape'.[13] The *paragon* was a viewing session that provided an opportunity for prospective purchasers to inspect luxury goods, not least fabrics such as crimson satin. Goods displayed at the *paragon* were open to comparison by expert dealers, who judged whether they were of high enough quality to be offered to their clients.[14] Brognolo's purchase at the *paragon* ensured that Isabella's length of satin was of guaranteed quality.

In addition, Isabella used comparative methods to decide on a painter's ability to produce a portrait acceptable to her as sitter, or to comment on the qualities of an allegorical painting for her *studiolo*. Perhaps even before Leonardo had written extensive notes on the comparisons between the arts, and certainly before he arrived in Mantua in December 1499, Isabella had used the technique of comparison to make a qualitative judgement about one of his works. In April 1498 she wrote to Cecilia Gallerani, a former mistress of her brother-in-law Ludovico Sforza, Duke of Milan. She asked for the loan of Leonardo's portrait of Gallerani, executed in around 1490 or 1491, in order to compare it with portraits by Giovanni Bellini that she had with her at the time.[15] Gallerani was not entirely happy about lending the portrait, since it had been painted some eight years earlier and did not show her as she looked in 1498; but it may have appeared incautious to refuse such a request from one of the most powerful courtly women of the time. Unfortunately, we do not know what Isabella concluded from the comparison that she was

able to make between the portraits by Bellini and Leonardo. We can speculate about this, however, and suggest reasons why Isabella commissioned a portrait of herself from Leonardo while he was briefly in Mantua, but not – as far as we know – a portrait by Bellini. These questions will be explored further in chapter four.

Given the practice that Isabella gained in making comparative judgements about portraits, or about fabrics from which fine garments could be made, it is no surprise that she applied the same technique to the paintings and antiquities that she acquired for the collections in her *studiolo* and *grotta*. The probable juxtapositions in her *studiolo* display of her 'Augustus and Livia' cameo and her own medal cast in gold for her by Gian Cristoforo Romano in 1503,[16] and of her two carvings of the *Sleeping Cupid*, were intended to encourage the practice of making *paragoni* between ancient and modern works of art. In this light, the comments in her correspondence about comparing one *studiolo* painting with another seem to take on a sharper resonance. In a letter of 22 November 1502, Isabella's agent Vincenzo Bolsano was asked to caution Perugino that he must 'ensure that his work would do honour to his reputation' because it would be compared with the paintings by Mantegna.[17] In the event, however, Perugino's painting suffered in this comparison: as Isabella wrote, 'if it had been more carefully finished, it would have been more to your honour and our satisfaction, since it is hung near those of Mantegna, which are painted with rare delicacy'.[18] Similarly, in a letter of 27 November 1504 to Antongaleazzo Bentivoglio in Bologna, Isabella wrote that Lorenzo Costa's painting should be of high quality, in order to stand in company and in comparison with the other excellent painters.[19] On 12 February 1505 Isabella wrote again to Bentivoglio saying she did not doubt that the painting would indeed stand comparison with the others in its company.[20] The musical-instrument maker Lorenzo da Pavia also perceptively compared painters' particular skills: the *Nativity* that Giovanni Bellini had painted for Isabella d'Este was a 'truly beautiful thing, better than I thought it would be . . . in this picture [Bellini] has made a great effort to do himself honour, most of all in respect of Messer Andrea Mantegna. True it is that for invention he cannot approach Messer Andrea, who in this is excellent beyond compare.'[21] Ten days later Lorenzo wrote further that 'no one can rival Mantegna for invention, but Bellini is excellent in colouring . . . , and the things in his pictures are well finished and deserve close inspection'.[22] It is perhaps not surprising that Bellini was reluctant to attempt an allegorical painting for Isabella's *studiolo*, 'because he knows Your Ladyship will judge it in comparison with the work of Master Andrea'.[23]

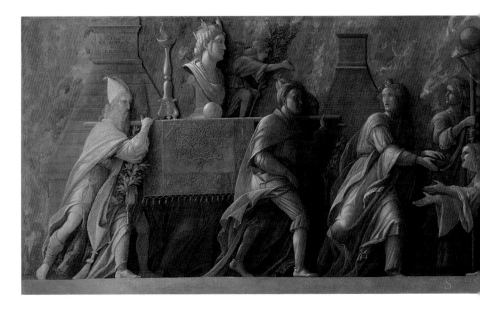

9 Andrea Mantegna, *Introduction of the Cult of Cybele in Rome.*
London, National Gallery

Had Giovanni Bellini completed a *studiolo* painting, the sort of *paragone* that Isabella could have made between her Mantegna and Bellini canvases is open to us in comparing Mantegna's *Introduction of the Cult of Cybele in Rome* (pl. 9) with Giovanni Bellini's *Episode from the Life of Publius Cornelius Scipio* (?*Continence of Scipio*) (pl. 10). Mantegna's painting was the first of four commissioned, through the good offices of Francesco Gonzaga, by Cardinal Marco Cornaro for his brother Francesco.[24] Mantegna prepared all four canvases for painting, but at the time of his death in September 1506 he had

10 Giovanni Bellini, *Episode from the Life of Publius Cornelius Scipio* (?*Continence of Scipio*). Washington, D.C., National Gallery of Art, Samuel H. Kress Collection

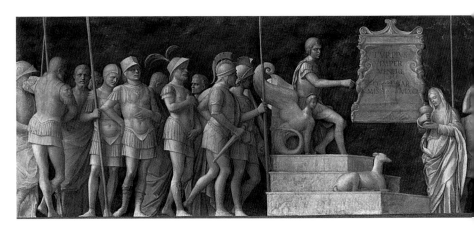

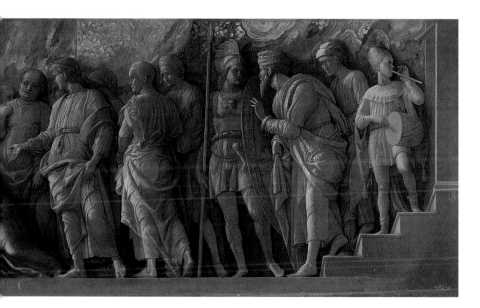

finished only the first of them. The commission probably for all the other three was transferred to Bellini, but he too completed only one canvas. Perhaps Bellini's patron, or indeed Bellini himself, was dissatisfied with his work in comparison with Mantegna's exemplar. The series of canvases was probably to be hung well above eye-level, perhaps as a *spalliera* frieze above the wainscoting in a small *studiolo* in the Cornaro palace at San Polo in Venice. If Mantegna had completed all four canvases, we can imagine that they would have had a powerful visual impact. Mantegna's dramatic narrative scene is rendered as a frieze of monochrome figures seen from a low viewpoint, and set against a colourful variegated marble background. It focuses in on the dramatic confrontation of the half-kneeling, youthful Scipio Nasica with the

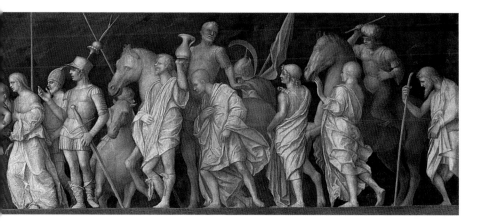

bust of Cybele, borne towards him on a litter.[25] It is itself an exercise in the *paragone* between painting and sculpture: Mantegna sought to show that his painted sculptural figures can tell the story more dramatically and affectingly than could a carved marble relief.

Even at the end of his life, and dogged by ill-health, Mantegna could still paint a classical scene with convincing antiquarian authenticity. Bellini, however, never engaged with the antique with Mantegna's learned enthusiasm, and his treatment of narrative themes never shared Mantegna's figural and emotional dynamism. In his pendant canvas, Bellini did not adopt as low a viewpoint as Mantegna, and his scene is relatively static. In contrast with Mantegna's fluently developed narrative composition, it shows a number of rather disjointed figure groups. Moreover, painting in grisaille denied him his acknowledged advantage over Mantegna as a colourist. The relative weakness of his figures' poses, their limited movements and subdued narrative expressiveness may, of course, be due in part to workshop intervention.[26] If so, handing the work over to assistants may itself be a sign of Bellini's reluctance to complete a painting that could be so immediately and unfavourably compared with his brother-in-law's – even though Mantegna was no longer alive to make the comparison for himself. Perhaps at first Bellini felt that he could not refuse to take on a commission from the Cornaro, one of the great patrician families of Venice. Nevertheless, he had to confront Mantegna on the latter's terms – antiquarianism, grisaille painting, and engagement with dramatic narrative – and none of these was a strength in his painterly armoury. Bellini thus laid himself open to negative comparative criticism here in just the way that he was anxious to avoid in Isabella d'Este's *studiolo*.

Paragone in the visual arts could take forms other than straightforward comparison of the treatment of subjects from classical history in the work of two painters. Once identified as a rhetorical technique for reaching judgements on artistic style or aesthetic quality, it could be used to explore other intellectual issues in other contexts. Increasingly important in discourse on the visual arts at the turn of the fifteenth century, the *paragone* is a recurring theme in the discussion that follows in later chapters about the arts in Mantua, and of Leonardo da Vinci's contribution to them, around 1500.

ISABELLA AND HER DEALINGS WITH HER ARTISTS

Over recent decades Isabella d'Este has had a mixed press as a patron of art. Some, basing themselves especially on the production history of Perugino's *Battle of Love and Chastity* (pl. 11), see Isabella as a demanding and ungrate-

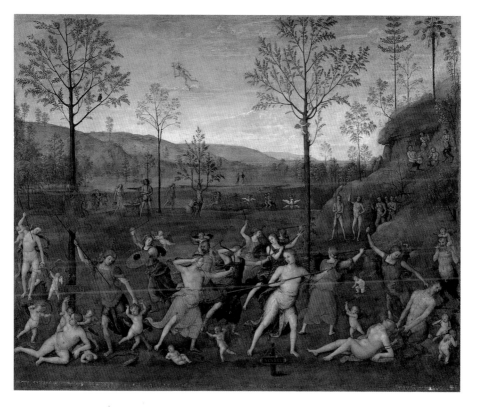

11 Pietro Perugino, *Battle of Love and Chastity*. Paris, Louvre

ful patron. Others, on the other hand, basing themselves especially on the correspondence about Giovanni Bellini, are impressed by her tolerance and her readiness to accept her painters' opinions and preferences. These commentators would argue that Isabella recognised that her artists generally had greater visual and aesthetic sensibility than she did, and that she respected their views on artistic matters. Leonardo da Vinci's experience at her hands seems to bear this out. However, it is true that she was not always sympathetic to the difficulties that painters might have in producing aesthetically and visually satisfying paintings from the complex and elaborate textual materials she presented them with. At times, moreover, she showed her impatience with the temperamental idiosyncracies of the creative artist; her comments are echoed in some that she received in return from her agents or intermediaries. These characteristics of Isabella's dealings with artists are especially clear in the correspondence concerning Pietro Perugino's *Battle of Love and Chastity*.

When Perugino's *studiolo* painting finally reached Mantua, Isabella's letter of thanks to the painter, written on 30 June 1505, was double-edged in its balance between gratitude and criticism:

> The picture has reached me safely, and pleases me, as it is well drawn and coloured; but if it had been more carefully finished, it would have been more to your honour and our satisfaction, since it is hung near those of Mantegna, which are painted with rare delicacy. I am sorry that the painter Lorenzo [Leonbruno] of Mantua advised you not to employ oils, for I should have preferred this method. . . .[27]

adding that she knew oil painting was Perugino's 'particular expertise and is of greater loveliness'.[28] Elements of this criticism seem a little unfair. To judge from the somewhat contrived composition, Perugino did have some problems in translating Paride da Ceresara's complex *invenzione* into visual form. Indeed, the rather poor reception that the painting has had in some recent discussion results principally from perceived weaknesses in the composition. Isabella, however, found that the painting 'is well drawn', so this does not seem to have been her difficulty. She was unhappy with the finish, but was unjustly critical of Perugino for working in egg tempera. Leonbruno's advice was doubtless well intentioned, and given in the belief that Isabella would be best served if Perugino matched Mantegna's technical procedure as closely as possible. But Perugino himself was not at ease with this, for in his response to Isabella on 10 August 1505 he too regretted that he had not worked in oils, which he found easier to use and which would have produced a more delicate result.[29] His fame, still high at the turn of the century, was based in part on the skill with which he handled the oil technique, as Isabella recognised. Indeed, he is unlikely to have painted in tempera after his early apprenticeship, since from the 1470s painting in oils had become standard technical practice, not least in the workshop of Andrea del Verrocchio, in which Perugino appears to have trained.[30]

Earlier, on 19 February 1505, two years after Isabella had sent Perugino the 'poetic invention' devised by Paride da Ceresara for the *Battle of Love and Chastity*, she wrote to Agostino Strozzi, Abbot of Fiesole, clearly disturbed by what she has heard of Perugino's progress:

> Domenico Strozzi has informed me that Perugino is not following the scheme for our picture laid down in the drawing. He is doing a certain nude Venus and she was meant to be clothed and doing something different. And this is just to show off the excellence of his art. We have not, however, understood Domenico's description very well, nor do we remem-

ber exactly what the drawing was like; so we beg you to examine it well together with Perugino, and likewise the instructions that we sent him in writing. And do your utmost to prevent him departing from it, because by altering one figure he will pervert the whole sentiment of the fable. . . .[31]

Isabella was understandably anxious that the integrity of Paride da Ceresara's programme for the painting should be preserved. But, in fact, Paride's instructions allowed Perugino considerably more licence than in the event he took. After the initial copious description of his 'poetic invention' in the letter of 19 January 1503, which ultimately Perugino followed in all but a few small details, Paride wrote:

But if you think that perhaps there are too many figures in this for one picture, it is left to you to reduce them as you please, provided that you do not remove the principal basis, which consists of the four figures of Pallas, Diana, Venus and Cupid . . . You are free to reduce them, but not to add anything else. . . .[32]

Further small indications of Perugino's freedom to make artistic choices are also contained in the instructions:

the most chaste nymphs in the trains of Pallas and Diana, in whatever attitudes and ways you please, have to fight fiercely with a lascivious crowd of fauns, satyrs and several thousand cupids; and these cupids must be smaller than the first [the god Cupid himself], and not bearing gold bows and silver arrows but bows and arrows of some baser material such as wood or iron or what you please. . . .[33]

Isabella was happy in other circumstances to leave the entire subject of a work to the craftsman to invent, within a broad indication of the genre to which he should conform. When she wrote on 17 April 1496 to her Venetian agent Giorgio Brognolo asking him to order an intaglio gem from the jeweller and gem-cutter Francesco Anichino, she added that 'the invention [fantasia] shall be for him to choose, as long as it is something that represents antiquity'.[34] A little over a month earlier, she had written on 12 March 1496 to Lorenzo da Pavia about her clavichord: 'You . . . may make it in your own fashion. . . . The sooner you serve us, the more it will please us, and we shall be content with your price,' leaving Lorenzo full control over both design and cost.[35]

More often than not, Isabella was equally ready to be flexible in meeting her *studiolo* painters' preferences and capabilities. She seems to have realised that if she was to acquire pictures 'by the excellent painters now in Italy' as

she hoped,[36] she needed to work in concert with her painters and to adapt her wishes to whatever they felt able to offer. On 28 June 1501 Isabella wrote to Michele Vianello, one of her agents in Venice, that 'if Giovanni Bellini is so unwilling to do this story as you write, we are content to leave the subject to his judgement, so long as he paints some ancient story or fable with a beautiful meaning'.[37] She was equally ready to accommodate Lorenzo Costa's wishes over a *studiolo* painting that she commissioned from him, the often-titled *Allegory of the Court of Isabella d'Este* or, more recently, the *Coronation of a Woman Poet* (pl. 12).[38] As in the case of Perugino's painting, she left it to Paride da Ceresara to devise the allegorical subject, hoping that 'it will not disturb you to endure more labour to compose a new invention satisfying to you, from which our satisfaction will depend', as she wrote on 10 November 1504;[39] and on 27 November she sent Paride's text – 'the narration of the poesia' – and a drawing to Costa in Bologna.[40] Unfortunately, neither the drawing nor the text has survived, which has meant that full understanding of the meaning of the painting has proved elusive.[41] Her agent reported back on 1 December that 'the fantasy of Your Excellency pleases him [Costa] greatly' but that 'he wishes to work in his own way, not staying in every respect with the invention but improving it'.[42] In reply, on 14 December, Isabella agreed to any modifications and 'improvements' that Costa felt were appropriate. Just as Perugino was at liberty to omit minor details in Paride da Ceresara's instructions, so also Costa could make adjustments in the interests of visual effect. Several years after her artistic relationship with Leonardo da Vinci had ended, Isabella wrote on 6 February 1511 to Francesco Francia concerning his contribution to the *studiolo*: 'We urged [our agent] to learn whether the invention of the painting pleased you', and she asked him 'to indicate your view and opinion before we send the canvas, since we always want to accommodate your judgement and pleasure'.[43] All these examples of the artistic licence that Isabella allowed are at odds with the view that she was inflexible and prescriptive in her treatment of the artists and craftsmen who worked to her commission.

Isabella could, however, be critical of the more eccentric sides of her painters' temperaments. On 10 November 1504 she wrote to Paride da Ceresara, with reference to both Bellini and Perugino:

> We do not know who finds the slowness of these painters more wearisome, we who fail to have our *camerino* finished, or you who have to devise new schemes every day, which then, because of the bizarre ways of these painters, are neither done as soon nor drawn in entirety as we would have wished. . . .[44]

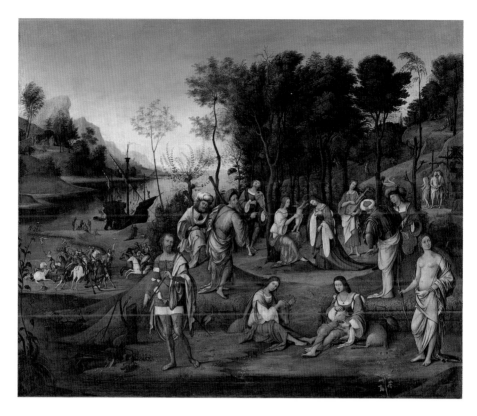

12 Lorenzo Costa, *Coronation of a Woman Poet*. Paris, Louvre

Negative evaluations of painters' characters, and the difficulties faced by patrons in dealing with them, were, however, becoming familiar by the turn of the century. Already in 1480 Isabella d'Este's father-in-law Federigo Gonzaga had written of Mantegna that 'commonly such excellent masters have something fantastic in their natures, and one must make do with what one can get from them'.[45] Likewise, in a reply to Isabella on 22 February 1505, Agostino Strozzi was also critical of Perugino:

> The behaviour of this man . . . I fear will make me seem a liar to Your illustrious Ladyship . . . he intends to finish the work hastily and spoil it, which will cause me unbelievable annoyance and displeasure . . . I do not know what to say of this man, who does not seem to have the wit to make any distinction between one person and another. I shall be very astonished if art can accomplish in him what nature has been incapable of showing.[46]

However, the reputation that Isabella has earned as a result of her treatment of Perugino and his painting is not more widely deserved.[47] In her dealings with other artists, Isabella was considerably more conciliatory and adaptable. It becomes clear from her correspondence about acquiring paintings by Giovanni Bellini, for example, and by Leonardo da Vinci that her first concern was to possess works by painters who were at the height of their powers and fame. Such paintings did not need to fall within the programmatic cycle that decorated the walls of her *studiolo*, initiated by Mantegna's *Parnassus*. A good example is her attempt to acquire a work by Giorgione, by 1510 the rising star of painting in Venice. In a letter of 25 October 1510 Isabella appears to have heard – wrongly it seems – that 'a very beautiful and singular night scene' might be available from the painter himself.[48] Her agent Taddeo Albano replied that 'the said Giorgione died some days ago, of plague, and . . . no such picture is among his inheritance'. He has, however, heard tell of two night scenes by Gorgione, but 'from what I have been told, neither picture is for sale at any price; [their owners] had them painted for their own enjoyment'.[49]

Nearly a decade earlier she had sought from Giovanni Bellini an allegorical painting to match Mantegna's *Parnassus*, but she soon settled for a more modest work from the Venetian master. Michele Vianello wrote from Venice on 2 March 1501 that he had told Bellini 'of the requirement and desire of Your illustrious Ladyship and the story in the manner you wished'.[50] Bellini 'replied that he was under an obligation to the illustrious government to continue the work he had begun in the [Doge's] palace'; and moreover, Vianello warned, 'The said Bellini has a great deal of work on his hands, so that it will not be possible for you to have it as soon as you wanted.'[51] Bellini's continuing reluctance to paint an allegorical work is clear from another letter written by Vianello some three months later, in which he says that Bellini

> told me that he was very anxious to serve Your Ladyship, but . . . in the story he cannot devise anything good out of the subject at all, and he takes it as badly as one can say, so that I doubt whether he will serve Your Excellency as you wish. So if it should seem better to you to allow him to do what he likes, I am most certain that Your Ladyship will be much better served.[52]

Isabella took heed of this advice, at least to the extent of withdrawing the commission for a painting to compare with Mantegna's *Parnassus*. As we have seen, she wrote to Vianello on 28 June 1501 that 'we are content to leave the subject to his judgement, so long as he paints some ancient story or fable with

a beautiful meaning'.[53] Fifteen months later, she fell back yet further from her original request, writing to Vianello:

> You may remember that many months ago we gave Giovanni Bellini a commission to paint a picture for the decoration of our studio . . . Since it seemed clear that we should never obtain what we desired, we told him to abandon the work . . . but he now begs us to leave him the work and promises to finish it soon. As till now he has given us nothing but words, we beg that you will tell him in our name that we no longer care to have the picture, but that if instead he would paint a Nativity, we should be well content. . . .[54]

Unfortunately, however, she injudiciously added that 'we want this Nativity to contain the Madonna and Our Lord God and St Joseph, together with a St John the Baptist and the animals'. To this Bellini objected 'that he was happy to serve Your Excellency, but that the said saint [St John the Baptist] seemed out of place in this Nativity'. However, 'if it pleases Your illustrious Ladyship he will do a work with the infant Christ and St John the Baptist and something in the background with other fantasies which would be much better'.[55] The painting that Isabella finally asked Bellini to hand over to Lorenzo da Pavia, begging him 'to pack it in such a way that it can be carried here easily and without risk of damage',[56] was not completed until July 1504: 'If the picture which you have done for us corresponds to your fame,' wrote Isabella to the painter himself, '. . . we shall be satisfied and will forgive you the wrong which we reckon you have done us by your slowness.'[57]

This painting is no longer identifiable, but we hear from another letter written by Isabella to Giovanni Bellini on 19 October 1505 that it was indeed a Nativity scene, 'which we like very much and are as fond of as any picture we possess'.[58] She was, it seems, remarkably tolerant in accepting what Bellini felt able to produce for her. And despite the long history of Bellini's reluctance and delay, she returned to the improbable hope of obtaining a *studiolo* painting from him. In the same letter she wrote that he would remember very well

> how great our desire was for a picture of some story painted by your hand, to put in our studio near those of your brother-in-law Mantegna; we appealed to you for this in the past, but you could not do it on account of your many other commitments . . . but . . . now . . . we write begging you to consent to painting a picture, and we will leave the poetic invention for you to make up if you do not want us to give it to you. . . .[59]

Two and a half months later, on 1 January 1506, Pietro Bembo reported to Isabella:

> I have been with Bellini recently and he is very well disposed to serve Your Excellency, as soon as the measurements of the canvas are sent to him. But the invention, which you tell me I am to find for his drawing, must be adapted to the fantasy of the painter. He does not like to be given many written details which cramp his style; his way of working, as he says, is always to wander at will in his pictures, so that they can give satisfaction to himself as well as to the beholder. Nevertheless he will achieve both ends by hard work. . . .[60]

This is the last that we hear of Bellini's projected painting for Isabella's *studiolo*. Perhaps patron and artist were unable to agree on a subject and treatment that would appropriately match Mantegna's canvases. Alternatively, perhaps renewed concern about the unfavourable comparisons that could be made with Mantegna's paintings persuaded Bellini to abandon Isabella's *studiolo* commission, despite its high prestige. From this extensive correspondence we may, however, deduce that Isabella acknowledged her artists' idiosyncracies. She evidently came to see, as she does not seem to have done in Perugino's case, that she would not gain the outcome she hoped for if she attempted to domineer in her negotiations with Bellini. If she was to succeed in acquiring a Bellini painting, she had to leave the choice of subject matter and treatment, and the timing of its execution, largely to him.

The experience of Bellini, Costa and Francia at Isabella's hands shows that Isabella was ready to defer to her artists' greater understanding and authority in visual matters, and to be flexible on questions of subject matter and imagery. This suggests that Perugino's more negative experience was the exception. The letters about paintings for her *studiolo* generally indicate that Isabella was almost always ready to be adaptable in order to do her best to secure paintings, even when her patience was not unreasonably put under strain. Some of the same issues arose also in her dealings with Leonardo da Vinci over paintings that she hoped he might execute for her. Isabella's letters about work commissioned from Leonardo again show both her flexibility and her recognition of his special artistic qualities.

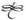

ISABELLA AND LEONARDO: THE TEXTUAL RECORD

Isabella d'Este's brother-in-law Ludovico Sforza, Duke of Milan, fled before the French invaders in August 1499. Leonardo da Vinci left Milan some four months later, and arrived in Mantua, presumably at Isabella's invitation, probably shortly before Christmas that year. He did not stay long: he was already in Venice in mid-March 1500, and he was back in Florence at the end of the month. By the time of this visit to Mantua, Isabella probably knew Leonardo's works and style better than she knew Giovanni Bellini's, and certainly better than she knew Perugino's. She may, to be sure, have had opportunities to see major altarpieces and other public works by Bellini on her visit to Venice in mid-May 1493. There is no evidence, however, that she could ever have seen Perugino's Certosa di Pavia altarpiece commissioned by Ludovico Sforza, which was still not complete in May 1499. Isabella visited her sister Beatrice, Duchess of Milan, in January 1495, but was presumably not able to gain access to Leonardo's *Last Supper*, which may by then have been in progress in the refectory of Milan's principal Dominican convent. She could certainly have seen his *Madonna of the Rocks* in San Francesco Grande (see pl. 47), however, and probably also other paintings made for Ludovico Sforza or for his courtiers. She would, moreover, have known of Leonardo's work in the Sforza court as deviser of theatrical and other entertainments. As noted above, she borrowed his portrait of Cecilia Gallerani (see pl. 58) in 1498, to study it in comparison with portraits by Giovanni Bellini. She may also have had the chance to see paintings by Leonardo in his possession at the time of his Mantuan visit in 1499–1500. And as we shall see, when in 1501 she wrote seeking a painting by Leonardo for her *studiolo*, she had owned a portrait drawing of herself made by him a year earlier, although her husband Marquess Francesco Gonzaga had already inexplicably given this away.[61] So she was in a better position than with any of her other painters except Mantegna to make well-informed comments on Leonardo's style. Her comments show a visual and aesthetic sophistication that is very rare in the textual sources of the period.

Writing on 27 March 1501 to her former confessor, the Carmelite friar Fra Pietro da Novellara, in Florence, Isabella asked him to sound Leonardo out

as to whether he would undertake to paint a picture for my studio. If he should consent, I will leave the invention and the timing to his judgement. But if you find him reluctant, endeavour at least to induce him to carry out for me a small picture of the Virgin, devout and sweet as is his natural style. . . .[62]

Once more she is surprisingly, indeed one might think unwisely, non-pre-scriptive about the subject and timetable for this proposed *studiolo* painting. Her phrase 'devout and sweet as is his natural style' seems to show that she acknowledged that Leonardo worked with a particular aesthetic to lend his paintings an individual and affecting visual sensibility. Moreover, she seems to have been aware that this sensibility might be unsuited to executing a paint-ing appropriate to her *studiolo*, since she proposed the alternative project of 'a small picture of the Virgin'. Her perceptive recognition of Leonardo's special artistic qualities was reiterated in her request, on 14 May 1504, that he paint her a figure of the youthful Christ 'done with that sweetness and gentleness of expression which is the particular excellence of your art'.[63] Here she found exceptionally subtle words to characterise Leonardo's pictorial treatment of human expression, and she made a special point of saying that this was the visual quality in which he excelled. She paid Leonardo a double compliment in her desire to persuade him to paint for her. Moreover, she asked Leonardo to set his own price, and in almost exaggeratedly elegant terms she put herself at his service:

> If you please me in my great desire, know that apart from the payment which you yourself will determine, I will be so indebted that I should not think of anything else but gratifying you, and from now on I am ready to be at your service. . . .[64]

Such was Isabella's concern to secure this painting that some five months later she followed this letter up, writing again directly to Leonardo himself in similarly forbearing, understanding terms:

> Some months ago I wrote to you that I wanted to have a young Christ of about twelve years old by your hand. You sent me your reply through Messer Angelo Tovaglia that you would willingly do it, but owing to the many commissioned works that you have in hand I fear you have not remembered mine; therefore I decided to write these few lines begging you – when you have had enough of the Florentine history – to begin this small figure as a diversion, for it would be pleasing to me and useful to you.[65]

Isabella's tone in these letters is tolerant almost to the point of indulgence. Hardly anywhere is there any echo of the frustration that surfaced in the cor-respondence about Perugino's painting for the *studiolo*, or of her irritation over Bellini's procrastinations – feelings that she might understandably have experienced also in her dealings with Leonardo. She had perhaps learned from

her sister and brother-in-law in Milan that if she was to have any hope of securing paintings from his hand, Leonardo had to be approached with care and with gentle persuasion, however fulsomely he may have expressed his desire to please. Nor is there any hint in this correspondence of Isabella as an impatient, overbearing patron of the arts. She wished to equip her *studiolo* with fine paintings by celebrated painters, as one of the strategies through which she could both forward her ambition to be known for her cultural excellence and seek to stand on equal terms with her male peers. And she knew that if she was to succeed in securing a painting by Leonardo, she had to negotiate with him in subtle ways, offering him both licence and praise.

Isabella's enquiry in the March 1501 letter about a painting by Leonardo for her *studiolo* is all that is known of this project. There is little reason to suppose that Leonardo ever put any thought towards a painting that to conform with Andrea Mantegna's *Parnassus* (see pl. 29) should have been based, like Perugino's, on a 'poetic invention'. On the other hand, there is some reason to imagine that he did not, given that the nature of Isabella's preferred subject matter was less than appropriate to his interests at the time. When in Mantua in early 1500 he may have seen the *Parnassus*, on display in Isabella's *studiolo* by July 1497; and if he visited Mantegna's workshop he would probably have seen also the second *studiolo* painting, the yet unfinished *Pallas Expelling the Vices from the Garden of Virtue* (see pl. 30). But he might well have considered that such elaborate mythological allegories painted in such a light tonality were well outside his compass, in both content and style. It is true that while at the Sforza court in Milan, Leonardo did make drawings of political and moral allegories. Two examples are sheets dating from the later 1480s at Christ Church, Oxford, that show allegories of Envy, Pleasure and Pain, the political state of Milan, and other themes.[66] But unlike such Florentine contemporaries as Botticelli, Piero di Cosimo or Filippino Lippi, Leonardo never, as far as we know, tackled a multi-figure mythological allegory along the lines of Mantegna's two *studiolo* paintings. Such material does not seem to have been any more appropriate to his creative temperament than it was to Giovanni Bellini's.

Leonardo might also have shared Bellini's reluctance to attempt an allegorical painting of this type for the *studiolo* because it would be compared with Mantegna's *Parnassus*. Characteristically, Mantegna painted his *studiolo* canvases in tempera, not in the oil technique that by 1500 had been almost universally adopted throughout Italy. Perugino fell foul of this technical issue, as noted earlier: although he was a skilled oil painter, he sought in his *studiolo* painting to emulate Mantegna's tempera technique. Leonardo too

worked in oils from the outset of his independent career: in such works as the Paris *Madonna of the Rocks* (see pl. 47) he exploited in particular the tonal depth and rich density of colour that he could achieve only through the use of oil glazes. It seems highly unlikely that he would have been prepared either to experiment with tempera or to seek to match Mantegna's bright, high-key tonality, whether in tempera or in oils. When in mid-April 1501 Fra Pietro da Novellara approached him about the project, Leonardo would almost certainly have recognised that any contribution he might make to the *studiolo* series could not meet Isabella's expectations. It would have been out of keeping both with Isabella's aims and ideals for the imagery of the decoration, and in stylistic and technical terms with the work thus far done on the series. It is worth recalling, however, that when Giovanni Bellini expressed reluctance over painting a moralising allegorical subject for the *studiolo*, Isabella was 'content to leave the subject to his judgement', and finally asked him to make for her instead a small devotional painting of the *Nativity*, a subject and format much more to his taste. Likewise, in March 1501 Isabella wrote that if Leonardo was prepared to contribute to her *studiolo* decoration, the painting's subject should be of his own choosing – although evidently she still hoped that he would provide one in the series launched by Mantegna's *Parnassus*. It is probable that he failed to do this, but there remains a slight possibility, to be explored further in the next chapter, that Leonardo had Isabella's wish for a work by him in mind when working on the composition of his lost painting of *Leda and the Swan*.

Although, as we shall see in chapter five, Leonardo sent a drawing commissioned by Isabella's husband Francesco to Mantua a few months later, he was in April 1501 so preoccupied with other activities that he had neither time nor (one suspects) desire to respond to Isabella's requests. In his first letter to Isabella, Fra Pietro da Novellara wrote in some detail about the *Virgin and Child with St Anne* cartoon that Leonardo displayed that year in Santissima Annunziata. He also, however, observed that Leonardo 'gives pride of place to geometry, having entirely lost patience with the paintbrush';[67] and on 14 April he wrote similarly that 'his mathematical experiments have so distracted him from painting that he cannot endure his brush'.[68] There is no evidence that Isabella met with any greater success in her later attempts to persuade Leonardo to produce a painting for her. As far as is known, neither the portrait that Leonardo promised to paint on the basis of the drawing that he made of Isabella in Mantua at the start of 1500, nor the 'small picture of the Virgin' that she proposed as the alternative to a *studiolo* painting – nor, indeed, the painting of the young Christ that she asked him to make for her

in 1504 – was ever completed. She may, of course, have vented her frustration with Leonardo, and with his inability to conform with her desires, in letters that no longer survive to Florentine agents. In the correspondence that does survive, however, she maintained throughout a tone of complimentary politeness, and of respect for Leonardo's particular qualities and talents as a painter.

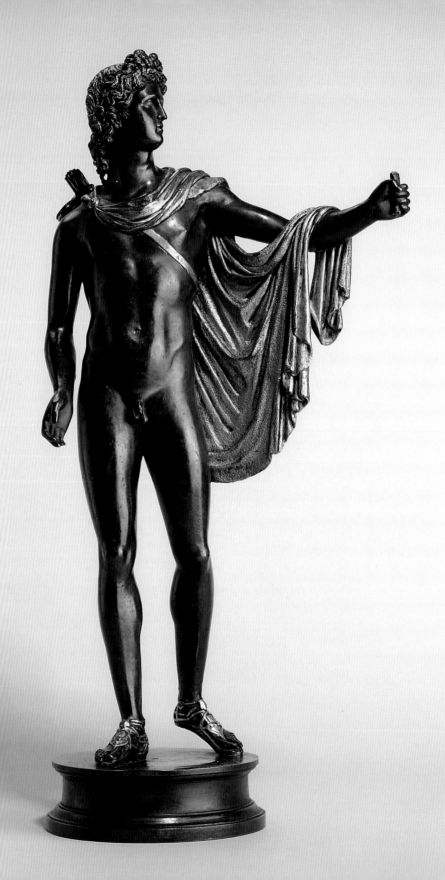

III

THE ARTS IN MANTUA AROUND 1500

There is space here only for a brief consideration of artistic activity in Mantua in the first decade and a half of Isabella d'Este's reign as marchioness, from 1490 to 1506, when her correspondence about acquiring a painting by Leonardo da Vinci dries up. What follows therefore concentrates on three major figures and their works for Gonzaga patrons, seeking to sum up the principal characteristics of their artistic temperaments that provide art in Mantua around 1500 with its very individual quality. The chapter closes with some speculative consideration as to how Leonardo da Vinci may have responded to Mantuan art and its individuality during the ten or so weeks that he stayed in the city early in 1500.

MANTEGNA AND THE ANTIQUE

Artistic activity in Mantua in the years before and immediately after Leonardo da Vinci's brief stay was dominated by an almost obsessive concern for the classical heritage.[1] The works of the major figures in the Mantuan artistic scene demonstrate a more purist response to the antique than those of other major artists and artistic centres on the peninsula. This can in part be attributed to the development within Mantuan intellectual circles of a more rigorous antiquarianism than elsewhere. In turn, this antiquarianism was stimulated by the humanistic, classical educational curriculum of Vittorino da Feltre's celebrated school, in which Marquess Ludovico Gonzaga (1412–

13 (*facing page*) Antico, *Apollo Belvedere*. Frankfurt-am-Main, Liebieghaus

1478) and his generation of the intellectual elite were educated early in the fifteenth century.[2] Another factor was the growing interest in the formation of collections of antiquities: that of Cardinal Francesco Gonzaga, Ludovico's second son, was one of the finest of its time. The dispersal of Cardinal Francesco's collection after his death in 1483 was watched with eager anticipation and cupidity by other collectors such as Ercole d'Este, Duke of Ferrara, and Lorenzo 'il Magnifico' de' Medici.[3] Artists who evidently found the unusually authentic regeneration of the antique at the Mantuan court attractive included Gian Cristoforo Romano and Pier Jacopo Alari-Bonacolsi, better known by his appropriate nickname 'Antico'.

But the figure around whom Mantuan artistic activity revolved at this time was the ageing Andrea Mantegna, the principal court painter from 1460 until his death in September 1506, five months after the final exchange of correspondence between Isabella, her agents and Leonardo da Vinci.[4] Building on the Mantuan climate of informed appreciation of the Roman past, Mantegna responded perceptively and intelligently to the rich visual stimulus of the classical world. While artists elsewhere evolved individual, and sometimes eccentric, interpretations of the visual record of the classical past, Mantegna's approach was more archaeologically learned. He benefited from the opportunity to work for two years – from June 1488 to September 1490 – in Rome itself, while painting a chapel for Pope Innocent VIII in his Villa Belvedere.[5] During this time he studied the relics of the classical Roman civilisation, making drawings like his copy (pl. 14) of a Trajanic relief incorporated in the fourth century into the Arch of Constantine.[6] While in Rome he also began to form his own collection of antiquities. He acquired a classical bust of a woman that, several years after his return to Mantua, Isabella d'Aragona asked her friend Isabella d'Este to send her, since she had heard that it looked very like her.[7] Isabella replied on 28 February 1498 that Mantegna 'values this bust very much for its high quality, and he is a professor of antiquity'.[8] He had suggested sending Isabella d'Aragona a bronze cast, but she demanded the original, and at Isabella d'Este's behest Mantegna had to part with it.[9] And as noted in chapter one, he also owned a much-prized bust of the Empress Faustina (see pl. 92) that famously he sold to Isabella d'Este when he was close to death in the summer of 1506. Mantegna's art in the last fifteen years of his life was, however, by no means characterised by a dry, academic dependence on the antique. In his religious and devotional works he developed a very personal expressive voice, and his secular and allegorical paintings, drawings and engravings are highly individual, both in their often moralising programmes and in their formal and stylistic inventiveness.

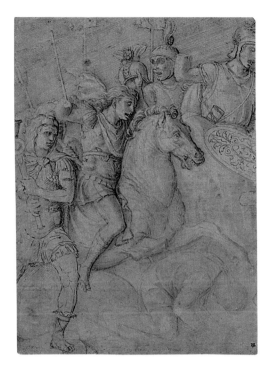

14 Andrea Mantegna, *Study of a Trajanic Relief.*
Vienna, Albertina, inv. 2583r

Also crucial to artistic activity in Mantua around 1500 was the patronage
of major members of the ruling family, and not least of Isabella d'Este.[10] Of
all the artistic projects started in Mantua during the first twenty years of
Isabella's presence there, from 1490 to 1510, the decoration of her *studiolo* has
perhaps rightly gained the highest profile in the art-historical literature, fol-
lowed by her commissions of portraits. This focus may, however, be due
largely to the extraordinary richness of the documentation on these projects
in the correspondence files of the Gonzaga archive. Certainly there were other
important patrons in the Gonzaga family, such as Isabella's husband Francesco
and his uncles Gianfrancesco and Bishop-Elect Ludovico Gonzaga.[11]
Throughout the 1490s Mantegna continued his work for Francesco Gonzaga
on one of his greatest projects, the series of canvases of the *Triumphs of Caesar*.

The *Triumphs* are first mentioned in August 1486, when Isabella d'Este's
father Duke Ercole visited Mantua and went to see the work in progress.[12]
Isabella had therefore probably already heard tell of the project from her father

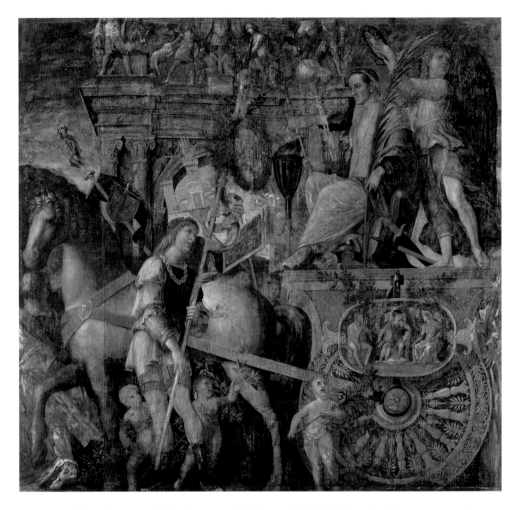

15 Andrea Mantegna, *Julius Caesar on his Triumphal Chariot* (*Triumphs of Caesar*, canvas 9).
Hampton Court, Royal Collection

several years before she arrived in Mantua. It seems now to be generally agreed that
the nine canvases were painted in three groups of three. Mantegna was working on
the first of these groups, then probably intended as a discrete 'triptych' that included
the ninth canvas, *Julius Caesar on his Triumphal Chariot* (pl. 15), when, calling him
an 'excellent painter, whose equal our age has not seen', Francesco Gonzaga allowed
him to travel to Rome in June 1488 to paint Innocent VIII's chapel in his new
Belvedere villa.[13] Although executed first, these ultimately became the last three
canvases in the series.[14] The second group of three canvases, including the *Trophy*

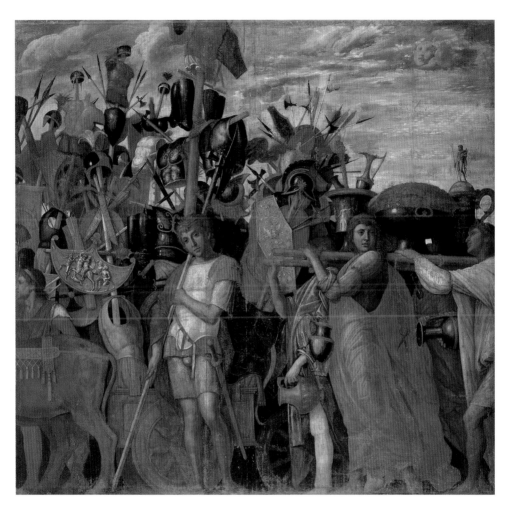

16 Andrea Mantegna, *Trophy Bearers* (*Triumphs of Caesar*, canvas 3). Hampton Court, Royal Collection

Bearers (pl. 16), was probably painted during the later 1490s: inscriptions on the first two concerning Caesar's defeat and occupation of Gaul may refer to Francesco Gonzaga's victory over the French at the Battle of Fornovo in 1495. These may have been the best examples of Mantegna's work that Isabella could see in progress when presumably in 1496 she commissioned the *Parnassus* for her *studiolo*. The middle three canvases, including the *Vase Bearers* (pl. 17), united the two ends of the triumphal procession when completed shortly before Mantegna's death. In April 1505 Isabella wrote to her husband

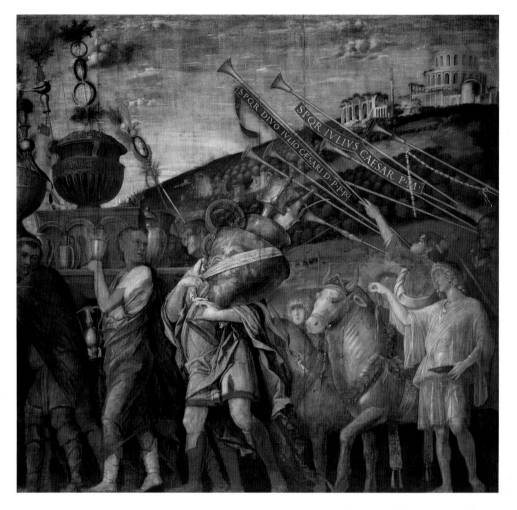

17 and 18 (*above and facing page*) Andrea Mantegna, vase bearers (*Triumphs of Caesar*, canvas 4).
Hampton Court, Royal Collection

Francesco, concerning a favour she wanted him to grant to Mantegna, 'if we
want him to live and finish our works, your Excellency must satisfy him'.[15]
These yet-unfinished works may have included the last three canvases of
the *Triumphs*.

In a letter of 16 July 1491 to Francesco Gonzaga concerning decorations
at his new villa at Marmirolo, Bernardo Ghisolfo suggested that canvas, as
used by Mantegna, was especially satisfactory as the support for large-scale

decorative paintings.[16] Indeed, the scale on which the *Triumphs* were painted would have ruled out painting on panels, which would have been too heavy and cumbersome to move. On 6 July 1477 Mantegna had written to Marquess Ludovico Gonzaga that if he wanted to send portraits he had requested over a distance, they could be painted on thin canvas and wrapped around a stick for transport.[17] He evidently recognised that one of the advantages of painting on canvas is the ease of transporting the finished work from painter's workshop to final destination. Similarly, the *Triumphs* were executed on canvas rather than in fresco in part so that they could be moved and displayed in different venues. Another series of paintings that had to be on canvas because of their monumental scale was Antonio del Pollaiuolo's lost set of three *Labours of Hercules* painted in 1460 for the *sala grande* of the Palazzo Medici in Florence. These were still important and innovatory paintings when Mantegna visited Florence in summer 1466, and he might well have been shown them at that time. He may still have had Pollaiuolo's *Hercules and Antaeus* in mind when later he designed a very similarly posed figure-group for an engraving on that theme.[18] Moreover, at various times during the last four decades of the quattrocento, members of the Bellini family provided large paintings on canvas to decorate rooms in the Doge's Palace and the *scuole grandi* of Venice. However, Mantegna painted on canvas much more frequently than any of his contemporaries, and his technical practice was unusual in Italy at the time. His use of casein or, in the case of the *Triumphs*,[19] animal glue as his binding medium was probably adopted from the technique frequently used by Netherlandish painters for works painted on canvas or linen supports.[20] One example of this technique that Mantegna very probably knew was an altarpiece by Dieric Bouts that was apparently on public view in Venice from around the early 1450s.[21] Mantegna's mastery of the technique is impressive, as was his ability to paint fine, archaeologically sound details of Roman artefacts, such as the armour and weapons in the *Trophy Bearers* (pl. 16), despite the grand scale of his canvases.

It is possible that the *Triumphs* were originally intended to decorate a room in the Domus Nova constructed by Luca Fancelli for Federigo Gonzaga, Marquess of Mantua from 1478 until his death in July 1484. Like his father, Ludovico, and his son, Francesco, Federigo Gonzaga was a *condottiere* who may well have been pleased to be compared with Julius Caesar. However, all references to the *Triumphs* appear in documents dating from Francesco's reign, who was himself not infrequently called 'Caesar'. The first three canvases were therefore probably commissioned by Francesco shortly after he succeeded his father as marquess.[22] Mantegna wrote of his *Triumphs* to Francesco from Rome on 31 January 1489 that he was in truth 'not ashamed of having made

them, and I hope to make more, if it pleases God and Your Excellency'.[23] Francesco's response to Mantegna on 23 February 1489 suggests that it was indeed he who had commissioned the *Triumphs*. In this letter he reminded Mantegna that

> here too you have works to finish for us, especially the *Triumphs*, which, as you say, are an excellent work and one that we would be very pleased to see completed. Good order has been taken to keep them safe, for although they are the work of your hands and genius, we glory none the less in having them in our house, where they shall be a monument of your loyalty and talents.[24]

When on 15 February 1490 Isabella d'Este arrived from Ferrara to join Francesco Gonzaga in Mantua, Mantegna was still in Rome. Returning to Mantua six months later, Mantegna's main priority was to complete the first triad of canvases of the *Triumphs*. A decree written for Francesco Gonzaga on 14 February 1492 in Mantegna's favour mentions the painter's 'Triumph of Julius Caesar [which] he is now painting for us with figures that are almost alive and near breathing, inasmuch as the action seems to be happening rather than to be represented'.[25] By the end of 1492 at least the first group of canvases was complete and on public view. In a letter of 10 December that year to Isabella d'Este, Matteo Antimaco mentioned 'the triumphs' along with other 'delightful works' by Mantegna that had been shown to the Venetian ambassador.[26] On 2 March 1494 Isabella wrote to Francesco Gonzaga that she herself had shown both the Camera Picta and the *Triumphs* to Giovanni di Pierfrancesco de' Medici.[27] Neither writer states how many canvases had been completed, but probably at that stage the project was limited to what are now the final three in the series.

By 1494 this group of paintings had evidently become one of the major artistic attractions for visiting dignitaries. They could also be used as temporary decorations: on 14 January 1497 Fedele da Forlì wrote to ask Francesco Gonzaga whether it would not be better to cover the courtyard of the palace with a wooden roof rather than with canvas. Francesco intended to exhibit many precious objects there, including the *Triumphs*, and were it to rain these would be at risk.[28] On 13 February 1501 'the six paintings of the triumphant Caesar by the hand of the singular Mantegna' decorated one side of the temporary theatre built in the Corte Vecchia for the performance of classical comedies:[29] the second group of three canvases was probably therefore painted in the later 1490s. By the time of Mantegna's death in 1506, Francesco Gonzaga was having a gallery designed in his new Palazzo di San Sebastiano especially to display the canvases; seven were installed there around 1507.[30]

Earlier than this, finished canvases in the series were to be seen elsewhere in the Gonzaga palace.

The antiquarian erudition shown by Mantegna in this great work became increasingly a feature of the intellectual interests of the Gonzaga court, and not least of Isabella d'Este, during the 1490s. As an introduction to Mantegna's recent style and artistic interests on her arrival in Mantua, the *Triumphs* might, however, have appeared somewhat daunting to Isabella. Certainly they are unlike anything that she would have known by Ercole d'Este's court painter Ercole de' Roberti, or by any earlier Ferrarese court artist. Mantegna knew the visual language of the classical past intimately, both through antiquarian drawings and from his first-hand experience of classical Rome. His inventive and resourceful use of this visual material provides not only historical and archaeological precision, but also a personal classicising idiom that he deploys consistently and consciously. His primary dependence on classical writers such as Plutarch and Appian, Suetonius and Livy, and also on more recent descriptions of Roman triumphs in Flavio Biondo's *Roma triumphans* (published in Mantua in 1472), of which there was a copy in the Gonzaga library, and in Valturio's *De re militari* (published in Verona also in 1472), gives the *Triumphs* an authentically classical solemnity and grandeur.[31] This may have chimed well with Isabella's own humanistic education, and may have inclined her to see Mantegna as the ideal interpreter of the complex mythological and allegorical imagery of the first paintings commissioned to decorate her *studiolo*.

MANTEGNA'S LATER RELIGIOUS PAINTINGS

Mantegna's other major work for Francesco Gonzaga in the 1490s was the *Madonna della Vittoria* (pl. 19), the altarpiece for a new church dedicated to the Madonna della Vittoria.[32] This church was built within a year to commemorate the victory of the Venetian army, led by Francesco, over the French at the Battle of Fornovo on 6 July 1495. In this way Francesco gave thanks for his survival in that battle, which he ascribed to the Virgin's intercession in his support. Mantegna was paid the considerable sum of 110 ducats for the altarpiece, the amount that an unfortunate Jew was fined for incautiously defacing a fresco of the *Madonna and Child with Saints* above the doorway of a house that he had recently acquired.[33] Like the church, the altarpiece was also complete by 6 July 1496, when it was displayed outside San Sebastiano as the centrepiece of a religious *tableau vivant* devised by Isabella d'Este and her brother-in-law Sigismondo Gonzaga. Subsequently, it was carried in

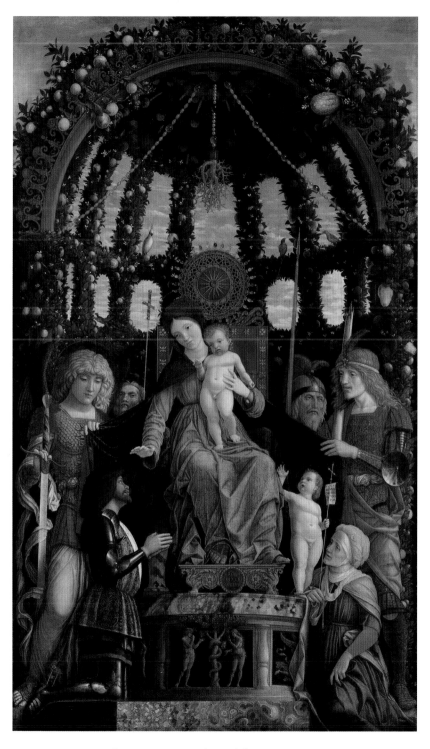

19 Andrea Mantegna, *Madonna della Vittoria*. Paris, Louvre

20 Andrea Mantegna, *Madonna della Vittoria*, detail. Paris, Louvre

procession to be installed on the high altar of the church of the Madonna della Vittoria.

Painted on canvas, like the *Triumphs*, the altarpiece shows in spectacular fashion the close attention to fine detail and to the surfaces and textures of materials, observed with almost Eyckian precision, that is characteristic of Mantegna's refined and polished pictorial treatment. Francesco Gonzaga

(pl. 20) kneels before the protective Virgin and blessing Christ Child, sheltered by her mantle which is held out by St George and St Michael, the 'bringers of victory, one to the body and the other to the soul'.[34] Reflected light glints off Francesco's armour – the very suit that he wore at the Battle of Fornovo and that he hung beside the altarpiece as a votive offering. It brightly defines the pearls and precious stones that decorate the halo-like medallion above the Virgin's head, and the coral and crystal beads that form paternosters hanging from the summit of the wooden arch. Through and behind the arch grows a verdant arbour liberally provided with lemons, oranges and gourds, which serves as a perch for a variety of exotic birds. The pedestal on which the Virgin's throne stands, and the step on which Francesco Gonzaga kneels (pl. 20), offer a virtuoso display of Mantegna's representation of multicoloured stones. Fictive reliefs of the Creation story that decorate the pedestal focus on the Fall of Man, brought about by Eve's sin but redeemed by the Virgin, in which a quasi-marble figure-group is set against a slab of porphyry. If the *Triumphs of Caesar* demonstrate the fidelity and finesse of Mantegna's eye for antiquarian and archaeological detail, the *Madonna della Vittoria* shows the late development of his exceptional ability to define surface textures, and to represent natural forms, whether they be flora and fauna or metals and stones, with a high degree of naturalism and verisimilitude.[35]

The deceptively lifelike treatment of natural forms shown in the *Madonna della Vittoria* is an acknowledgement of Mantegna's responsiveness to the microscopic detail of fifteenth-century Netherlandish painting. Equally, the mood of deep piety that pervades several of his late religious easel paintings seems to have north European sources. Perhaps the finest example of the very individual expressive edge of Mantegna's late devotional paintings is the *Ecce Homo* (pl. 21) in the Musée Jacquemart-André in Paris, which probably dates from around 1500.[36] Exceptionally well preserved for a painting by Mantegna in distemper on canvas, this work is a trenchant display of Christ's suffering. Mantegna exploited the contrast between the dignified, if blemished, beauty of Christ's face and the grotesque barbarity of the Jews to either side. Again reflecting the sometimes strident pathos of Netherlandish representations of similar themes, such as those of Dieric Bouts (pl. 22), Mantegna described without hesitation the lacerations left by the whips used in his flagellation on Christ's shoulders, arms and torso, and the trickles of blood from the crown of thorns on his forehead. His lowered and reddened eyelids and half-open, down-turned mouth further emphasise the pain he has experienced. But the orderly curls of his hair and beard and the relatively unlined facial skin mark him out as youthful and divine, in contrast with the much-creased, rebarbative features of his tormenters who call for him to be crucified. Some three

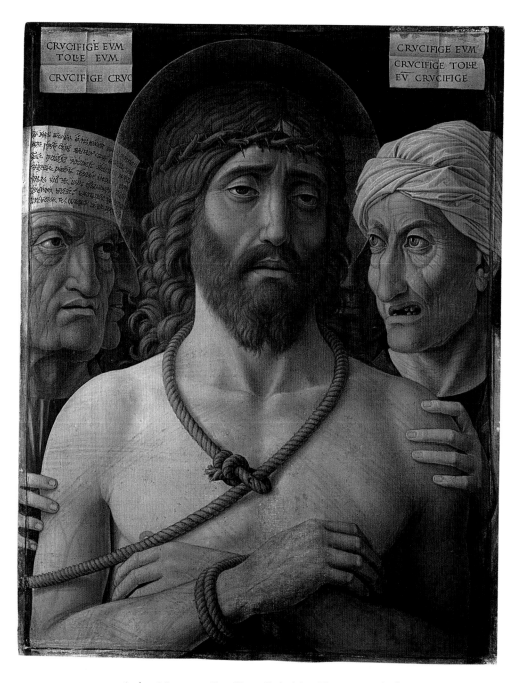

CRVCIFIGE EVM
TOLLE EVM
CRVCIFIGE CRVC

CRVCIFIGE EVM
CRVCIFIGE TOLLE
EV CRVCIFIGE

21 Andrea Mantegna, *Ecce Homo*. Paris, Museé Jacquemart-André

22 Dieric Bouts, *Christ Crowned with Thorns*. London, National Gallery

decades earlier, Antonello da Messina had already paraphrased Netherlandish images of the Ecce Homo, and Mantegna may have known devotional works such as his Piacenza *Christ at the Column*.[37] He is as likely, however, to have had direct knowledge of paintings on similar themes by Bouts or Memling; and in the Jacquemart-André *Ecce Homo* he produced his emphatically personal, discordant variation on the theme.

Equally personal in expression, and equally strident and affecting, is Mantegna's late *St Sebastian* (pl. 23).[38] This small altarpiece can very probably be identified with a painting of the subject mentioned in the letter from Mantegna's son Ludovico to Francesco Gonzaga on 2 October 1506. The painting was still in Mantegna's studio shortly after the artist's death, and he

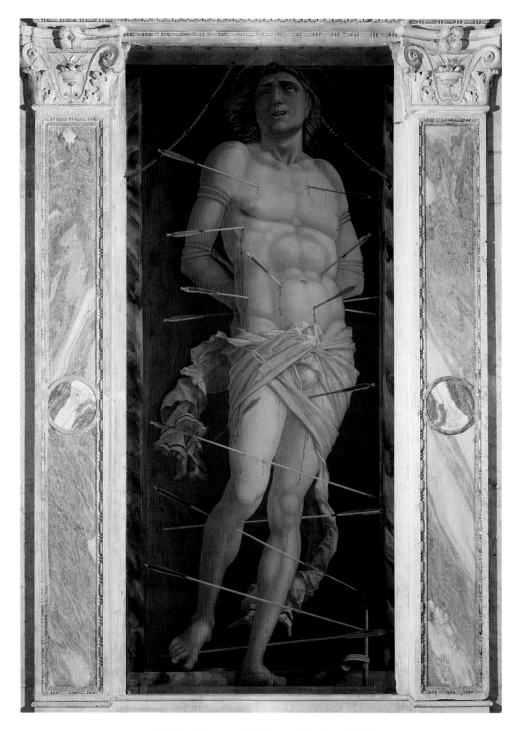

23 Andrea Mantegna, *St Sebastian*. Venice, Ca d'Oro

had required his sons to give it to Bishop-Elect Ludovico Gonzaga.[39] If the identification is correct, it suggests that this is a late painting, perhaps made originally by Mantegna for himself. It is a highly expressive visual echo of the inscription, which also appears to be Mantegna's own invention. NIL NISI DIVINUM STABILE EST CAETERA FUMUS – 'nothing stands firm except the divine: the rest is smoke' – is written on a scroll that twists around an extinguished, smoking taper at bottom right. The heroic, semi-nude figure, liberally pierced by arrows, appears to be stepping out of a shallow niche into the observer's space. Mantegna often employed this type of transgression of the interface between painted and real space in order to seize forcibly the beholder's attention. The saint's head is superimposed on a string of coral and crystal beads that is itself suspended in front of the frame of the niche, but from within the outer painted frame. The instability of St Sebastian's pose is emphasised by the irrational, dramatically cascading drapery that is apparently swept up by the momentary gust of wind that also blows aside the saint's hair. All this agitation fully bears out the message of the inscription that 'nothing stands firm'. The coloured marble of the niche, the glinting crystal beads and the grey, metal-pointed arrows with coloured, feathered ends show Mantegna's ever-meticulous eye for distinctions between inorganic materials. These stylistic characteristics reinforce the compellingly affective strength of the saint's upcast eyes, and of his mouth open in agony. St Sebastian was a popular plague saint, often invoked by devotees in the hope of escaping the disease. A serious outbreak of plague in Mantua early in 1506 could have prompted Mantegna to paint this highly charged image. If, however, we read the inscription as a personal statement of belief in the futile transitoriness of life, it may be possible to understand his pictorial treatment of St Sebastian as an anguished presentiment of his mortality, no more than a few months perhaps before he died. Be this as it may, the coupling of inscription and searing image suggests that Mantegna was intent on generating a devotional image of refined and powerful immediacy.

CLASSICAL SUBJECT-MATTER IN MANTEGNA'S
LATE PRINTS AND DRAWINGS

A number of secular designs that Mantegna produced late in his career, some of which were made for wide circulation in the form of engravings, also have complex meanings. The iconographically rich engraving usually known as the *Allegory of the Fall and Rescue of Ignorant Humanity* (pl. 24) is based on a model provided by Mantegna to the engraver Giovanni Antonio da Brescia;

24 Giovanni Antonio da Brescia, after Andrea Mantegna, *Allegory of the Fall and Rescue of Ignorant Humanity*, engraving

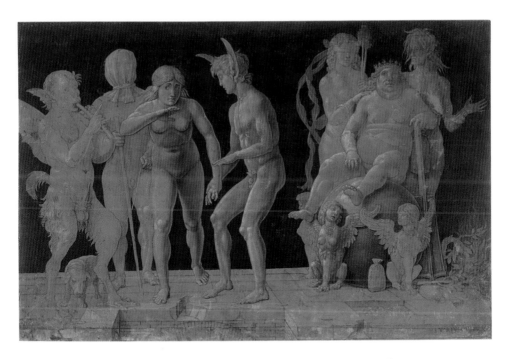

25 Andrea Mantegna, *Allegory of the Fall of Ignorant Humanity*. London, British Museum, Pp. 1–23

the upper half of this model survives in an elaborate, coloured drawing now in the British Museum (pl. 25).[40] Datable to the first years of the sixteenth century, while Mantegna was working also on the *Pallas Expelling the Vices from the Garden of Virtue* (pl. 30) for Isabella d'Este's *studiolo*, the print was engraved on two plates: impressions are somewhat uncomfortably joined horizontally slightly above the mid-point. It shows an allegorical scene of considerable programmatic complexity. It is not an illustration of any single classical text or group of texts, but rather 'an allegory that would throw into relief a moral idea'.[41] In this respect it is similar to the programmes that, to judge from Isabella's letter of 19 January 1503 to Perugino describing the content required in his *Battle of Love and Chastity*, lay behind the paintings for the *studiolo*. Isabella appears to have had a developed taste for this type of moralising allegory, and it could be that a humanist in the Mantuan court, such as Paride da Ceresara who devised the programmes for Perugino's painting and for Lorenzo Costa's *Coronation of a Woman Poet*, also contrived the allegory for the *Fall and Rescue of Ignorant Humanity*. This allegory revolves around the idea that while humanity may fall from grace through ignorance,

it may be rescued by Mercury, god of knowledge and inventor of the arts. In the upper part to the right, Ignorance is enthroned on an unstable globe, bracketed by Ingratitude and Avarice; beside her the laurel branches of Virtue are in flames. To the left Humanity, shown as a blind, naked female, is guided to the edge of a pit by Error, who is encouraged on by Lust and (probably) Fraud. Below, Virtue reappears at the left as 'Virtus Deserta', metamorphosed into a tree like Daphne in the face of Apollo's pursuit, and a close parallel to the tree-figure in the same position in Isabella's *studiolo* painting of *Pallas Expelling the Vices*. At lower right, Mercury drags one of the fallen humans out of the pit. Humanity can be saved if guided by reason rather than by ignorance. At the bottom left corner a stone bears the inscription VIRTUTI S.A.I.: *Virtuti semper adversatur Ignorantia* – 'Ignorance is always opposed to Virtue' – was an aphorism used by Mantegna himself in letters of 1489 and 1491 to Francesco Gonzaga.[42]

The drawing (pl. 25) that is intimately related to the upper half of the *Fall and Rescue of Ignorant Humanity* engraving is on the scale of a small painting. Although some figures, for example Lust and Fraud at the left, are not fully completed, it shows in many places a high degree of finish, including the use of colour. This strongly suggests that it was intended to stand as an autonomous art work. In 1549 Michelangelo Biondo saw in the Palazzo di San Sebastiano in Mantua a painting 'on a sheet of paper [mounted] on canvas' that appears to have corresponded with the lower half of Giovanni Antonio da Brescia's engraving.[43] The two drawings may originally together have served as the model for the engraving, and separately as two finished art works. The colouration of the *Fall of Ignorant Humanity* drawing is often, and very reasonably, compared with Greek or Etruscan red-figure vase-painting. There is no evidence to show that Mantegna knew such wares, but it does not seem improbable that he did. Ancient ceramics were being collected by this time, as is shown by the gift in 1491 of a Greek vase from the Venetian Zaccaria Barbaro to Lorenzo 'il Magnifico' de' Medici;[44] and Vasari later reported that his grandfather also gave Lorenzo four Etruscan vases.[45] These are much the sort of small-scale antiquities coveted by collectors in Mantua also at the turn of the century. Mantegna himself could certainly have acquired ceramics of this sort for his own collection.

Much the same type of moralising idea that best elucidates the *Fall and Rescue of Ignorant Humanity* engraving lies behind the programme for Mantegna's *Calumny of Apelles* drawing (pl. 26), which probably dates to a few years later, almost at the end of the artist's life.[46] In this case the imagery was provided by the Greek writer Lucian, who described an allegorical painting by Apelles, perhaps the most celebrated painter of ancient Greece. Lucian's

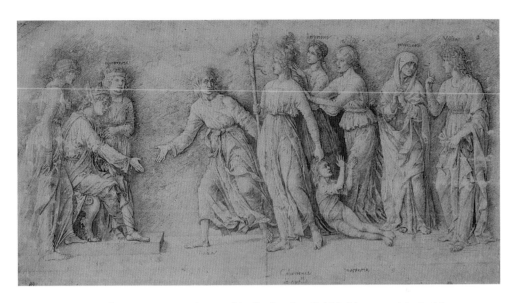

26 Andrea Mantegna, *Calumny of Apelles*. London, British Museum, 1860-6-16-85

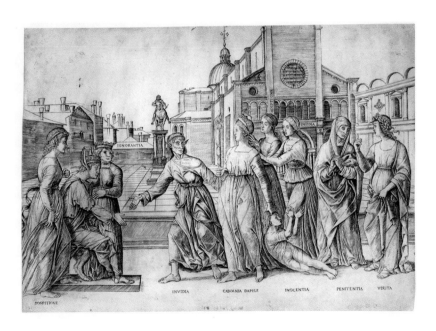

27 Girolamo Mocetto, after Andrea Mantegna, *Calumny of Apelles*, engraving

text had been translated into Latin by Guarino da Verona, the major humanist working at the Este court in Ferrara earlier in the fifteenth century. Mantegna could best have known the allegory through Leon Battista Alberti's paraphrase of Guarino's translation in his *Della pittura*. At the left a crowned figure, framed by Ignorance and Suspicion, extends a welcoming hand towards Calumny, who is introduced by Envy. Calumny drags Innocence forward by the hair, and is encouraged onwards by Treachery and Deceit. To the right, Repentance and Truth wind up the procession. We will probably never know if Mantegna made this drawing because he, like Apelles, had been slandered. It seems likely, however, that he specifically sought to recreate a celebrated painting of classical times in a style that he imagined closely reflected Apelles'. It could, in other words, have been seen as a *paragone* between ancient and modern, like Isabella d'Este's two carvings of the *Sleeping Cupid* (see pl. 88), even though the ancient original was not available for comparison.

Later, Mantegna's *Calumny* drawing was used as the basis of an engraving by Girolamo Mocetto (pl. 27), in which the frieze of figures is incongruously set against a view of the Campo SS Giovanni e Paolo in Venice. Whether Mantegna himself intended his drawing to be reproduced in printed form remains, however, an open question. The unconventional direction of the figures' movement, from right to left, in the drawing may suggest that reversal was intended; and Calumny holds a blazing torch in her right hand, not in her left as described by both Lucian and Alberti. However, all other expressive gestures – those of the king, of Envy and of Truth, for instance – are made with the figures' right hands: with reversal these would have been inappropriately left-handed. It should also be noted that neither in Mocetto's *Calumny* engraving nor in the engraving after Mantegna's *Fall of Ignorant Humanity* drawing is the figure-composition reversed.

Another possibility is that, despite the careful finish with close and detailed hatching into the shadows, this drawing was the preliminary design for an elaborately finished presentation drawing, which might have been similar in pictorial treatment to the drawing for the upper part of the *Fall of Ignorant Humanity* engraving (pl. 24). In the *Calumny* drawing the hatching external to the figures seems to imply that they are set against a backdrop onto which they cast hazy shadows. It is as though the drawing represents a high-relief sculpture, with the figures carved out largely in the round from the block of marble. Mantegna may well have intended his *Calumny* drawing to be seen as a representation of a classical relief: although it is more fully worked up than his study after a Trajanic relief on the Arch of Constantine (pl. 14), the graphic handling, especially the vigorous use of external parallel hatching,

28 Andrea Mantegna, *Battle of the Sea Gods*, detail, engraving

is quite similar. In this respect, it could have been intended as a preparatory design for a grisaille painting like the probably near-contemporary *Introduction of the Cult of Cybele in Rome* (see pl. 9).

Also inventively derived from classical works and the principles of classical art, and also allegorical in theme and meaning, is the rather earlier engraved *Battle of the Sea Gods* (pl. 28).[47] This elaborate, frieze-like composition engraved on two plates derives from a Roman sarcophagus relief probably known to Mantegna through a copy-drawing. It is an allegory of human Envy, the emaciated old woman holding forth a tablet inscribed INVID[IA] at the top left of the composition. Perhaps Mantegna is here commenting on the belligerent strife that can be provoked by envy – the envy, for example, of sculptors who were jealous of Mantegna's ability to emulate classical sculpture in the two-dimensional medium of an engraving. If so, we have here an early manifestation of Mantegna's interest in the *paragone* debate. Usually dated as early as the 1470s, one half of the engraving was copied in a drawing by Albrecht Dürer dated 1494, so this composition considerably pre-dates Mantegna's allegorical paintings for Isabella d'Este. It is, however, a significant example of the sort of work that might have guided her recognition that his treatment of mythological allegory made him the ideal artist to launch the *studiolo* cycle.

MANTEGNA'S PROJECTS FOR ISABELLA

One of Mantegna's first moves on returning to Mantua from Rome in September 1490 was to introduce himself to Isabella, through her former tutor Battista Guarino. Guarino wrote to her from Verona on 22 October that

> gifted and virtuous men like [Mantegna] have no need of recommenda-
> tion to Your Excellency, for of yourself you are exceedingly inclined to love
> and favour those who are deserving . . . Thus I pray you to entertain him
> lovingly and hold him in good esteem, for in truth besides his excellence
> in his art, wherein he has no equal, he is all courtesy and kindness, and
> Your Ladyship will get from him a thousand good conceits in designs and
> other things that will befall.[48]

Encouraged perhaps by this warm recommendation from a trustworthy source, Isabella d'Este commissioned a portrait of herself early in 1493, to be sent to Isabella del Balzo, Countess of Acerra. This project did not work out to her satisfaction: in April she wrote that 'the painter has done it so badly that it has nothing of our likeness'.[49] In its place Isabella commissioned a por-trait from Giovanni Santi, court painter to Guidobaldo da Montefeltro of Urbino, whose portrait was sent to Isabella del Balzo on 13 January 1494.[50] Despite this setback, Mantegna gained the commission for the first of the series of canvases for her *studiolo* that from spring 1496 Isabella ordered from famous painters of her day. As noted in chapter one, Mantegna's *Parnassus* (pl. 29) was in place in the *studiolo* by 3 July 1497; and varnish for the *Pallas Expelling the Vices from the Garden of Virtue* (pl. 30) was purchased in Venice in July 1502.[51] By the summer of 1506, shortly after her correspondence with Leonardo da Vinci appears to have ground to a halt, Isabella had commis-sioned a third painting by Mantegna for her *studiolo*. On 13 July that year Mantegna wrote that he had nearly completed the design for the painting of *Comus*, which he would continue with 'whenever my imagination inclines me'.[52] Work stopped at Mantegna's death on 13 September 1506, however, and the commission was not fulfilled until Lorenzo Costa completed his own *Comus* (pl. 31) no earlier than 1510.

The meanings of Mantegna's paintings for Isabella d'Este's *studiolo* have given rise to a considerable number of interpretations, not all of which are mutually inclusive.[53] No programmatic texts like Paride da Ceresara's *favola* for Perugino's *Battle of Love and Chastity* survive to cast light on Mantegna's works. But although there are further complexities of subject and meaning in secondary figures and activities to provide Isabella and her courtiers with more opportunities for erudite thought and discussion, the essential meanings of the paintings seem clear enough. The moral message embedded in the

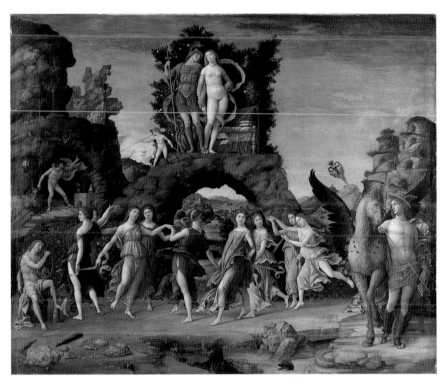

29 Andrea Mantegna, *Parnassus*. Paris, Louvre

30 Andrea Mantegna, *Pallas Expelling the Vices from the Garden of Virtue*. Paris, Louvre

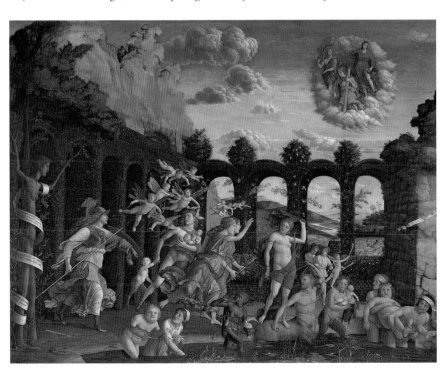

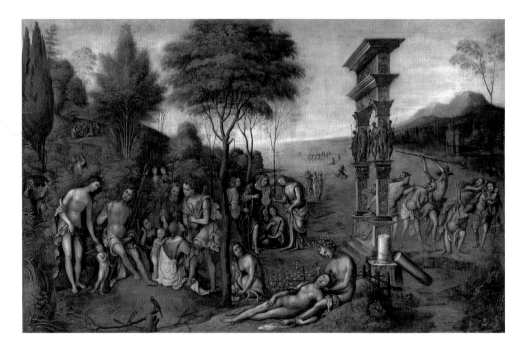

31 Lorenzo Costa, *Comus*. Paris, Louvre

Parnassus, that harmony and concord prevail under the authority of Venus and Mars (and by association of Isabella and Francesco Gonzaga), is communicated by the actions and gestures of deities and other mythological figures. The *Pallas Expelling the Vices from the Garden of Virtue*, on the other hand, balances the Christian cardinal virtues against the vices, who are portrayed as allegorical personifications and are put to flight by the chaste Pallas, goddess of wisdom, learning and poetry in classical myth. Just as Perugino's painting (pl. 11) shows the hard-won victory of chastity over earthly love, Mantegna's second contribution shows the triumph of virtue over vice. Mantegna's paintings are, as Isabella herself wrote, 'painted with rare delicacy': numerous acutely observed details are minutely painted, filling the picture surfaces with intricate and often surprising, often witty visual incident. They appear to have been hung opposite each other towards the back of the room, furthest from the principal window.[54] This helps to explain Mantegna's use of a bright tonality, fostered in turn by the technique of tempera painting with a casein medium, to make the scenes more visible in dim natural light. There was much here to catch and to captivate Isabella's eyes as, seated in her private space, she contemplated the first two canvases of her *studiolo* cycle.

Isabella offered Mantegna a number of further opportunities to display his constant interest in the classical world and its visual culture during the last fifteen years of his life. Another project on which he collaborated with Isabella was her proposal to erect a monument to Mantua's most celebrated classical writer, the poet Virgil. On 17 March 1499 Jacopo d'Atri, the Mantuan ambassador in Naples, reported that he had mentioned Isabella's project to the great Neapolitan humanist Giovanni Gioviano Pontano, who had heaped praise on the idea, admiring Isabella for her enterprise although she was young and unable to read Latin.[55] In her response to Jacopo d'Atri, written in May 1499, Isabella gratefully accepted Pontano's offer to write an epigram to serve as the inscription on the plinth of the Virgil monument. By this time Mantegna had already been requested to produce a design for the monument, although no sculptor had yet been identified, and it is not clear whether it had yet been resolved whether the figure should be in marble or bronze. Pontano and d'Atri had mulled this question over together, thinking bronze more noble but risky. They perhaps had in mind Ludovico Sforza's recent sale to Ercole d'Este of the bronze originally intended for Leonardo da Vinci's equestrian monument to his father Francesco Sforza, to be used for casting cannon.

A much reworked drawing (pl. 32), apparently from Mantegna's workshop, probably reflects his design proposal, although it does not correspond in all details with the discussion of the monument in the textual sources.[56] The inscription, P.VIRGILII MARONIS A AETERNAE SUI MEMORIAE IMAGO, is a variant of Pontano's suggestion and was perhaps written by Battista Fiera, who was closely involved with the project. Fiera had identified what was believed to be an authentic portrait bust of Virgil, and Pontano's advice was that this should be used as the prototype for the monument. The figure should be simple and self-effacing, he further recommended, in the manner of the ancients. He should wear a simple laurel wreath, classical sandals and either a mantle over a toga knotted at the shoulder or senatorial dress. In the drawing Virgil stands, robed in a classical toga, on a plinth that was probably modelled in design on the base of the Column of Titus in Rome. Although the monument was never realised, the evidence about it in the correspondence bears witness to Isabella's enthusiasm for a project that sought to recreate an authentic likeness of the classical writer. It also shows that she recognised that, on account of his archaeologically precise classicism, Mantegna was the ideal designer of such a project.

32 Workshop of Andrea Mantegna,
Design for a Monument to Virgil. Paris, Louvre

MANTEGNA'S GRISAILLE PAINTINGS

Isabella d'Este owned two grisaille paintings 'finto de bronzo' – in feigned
bronze: these were almost certainly by Mantegna, and were quite likely made
to Isabella's commission.[57] Mantegna's paintings in grisaille offered him an
important outlet for exploring the *paragone* between painting and sculpture.[58]
The grandest of his grisaille paintings, the *Introduction of the Cult of Cybele*
(see pl. 9), is, as noted earlier, a superlative exercise in demonstrating the supe-

riority of painting over sculpture. It has already been considered also in terms of the opportunities that Francesco Cornaro's decoration offered observers to compare the qualities and abilities of two major painters of the time. The very notion of painting in grisaille shows the artist's desire to imitate sculpture, either carved in marble or cast in bronze. From his days as a young apprentice painter in Padua, Mantegna would have known the grisaille 'sculptural' figures of *Virtues* and *Vices* painted by Giotto along the dado of the Scrovegni Chapel. His interest in the genre could moreover have been further stimulated by Netherlandish works in northern Italy, for the exterior wings of Netherlandish altarpieces frequently show figures painted in grisaille, sometimes specifically as imitation marble sculpture. Mantegna's interest in depicting sculpture in his paintings is already clear in early works such as the Ovetari Chapel *St James Brought before Herod Agrippa*, in which carved reliefs decorate the triumphal arch set in the middle-ground. A series of 'carved' *all'antica* roundels is set into the architectural pavilion that encloses the figures of the San Zeno altarpiece, completed in 1459. Soon after Mantegna joined the Mantuan court of Marquess Ludovico Gonzaga in 1460, he also for the first time painted fictive bronze reliefs, to decorate the lunettes in the architectural backdrop of his Uffizi *Circumcision*.

Early comments on Mantegna's figure-models for the Ovetari Chapel frescoes, reported by Bernardino Scardeone in 1560, conversely suggest that he thought of his painted figures as lightly polychromed statues:

> [Mantegna] approved more of pictures taken from Roman sculptures than from living bodies, and principally for this reason, because the statuaries and sculptors of antiquity were wont to choose from many bodies the parts that were perfect so as to form those parts without fault.[59]

Vasari's commentary on this issue paraphrases the purported criticisms of Mantegna's teacher Francesco Squarcione. He apparently felt that Mantegna was over-dependent on classical statuary, and advised that it would be better that he painted in grisaille:

> He [Squarcione] singled out for attack the paintings that Andrea had done in the chapel of St Christopher, saying that they were inferior work since when he did them Andrea had imitated marble statues. Stone, said Squarcione, was essentially a hard substance and it could never convey the softness and tenderness of flesh . . . Andrea would have done far better, he suggested, if he had painted his figures not in various colours but just as if they were made of marble, seeing that his pictures resembled ancient statues and suchlike things rather than living creatures.[60]

As though thus encouraged, Mantegna did indeed paint figures like his *St Sebastian* now in the Louvre, Paris, almost as though it was carved from marble with only slight colouration applied.[61] In the Camera Picta of the Gonzaga palace, completed for Marquess Ludovico in 1474, Mantegna exploited for pictorial and thematic effect the deliberate contrast between the richly coloured portraits of the Gonzaga family and their contemporaries and the grisaille medallions of Roman emperors and mythological scenes that decorate the vault. Later still in his career, he recapitulated his lapidary figure-treatment in a series of paintings of high-relief marble carvings set against brightly coloured, veined-stone backdrops. A work like the *Samson and Delilah* (pl. 33) is as much a self-conscious display of pictorial ingenuity and pretension as a biblical narrative painting.[62] This painting is very probably the pendant to a *Judith and Holofernes*, now in Dublin: showing one wicked and one virtuous woman of the Old Testament, they make a complementary pair of a type that was thematically very much to Isabella's taste. Mantegna again seems to declare the art of painting's superiority by 'carving' in paint more than a sculptor himself could have achieved. In the *Samson and Delilah*, for example, the leaves of the grape-vine that rambles through the tree growing beside the figures are so undercut that they are paper-thin and impossible to carve in marble without the material fracturing; the unclipped locks of Samson's hair flow freely from his head in a manner that no marble sculptor before Gianlorenzo Bernini would risk; and the spout of water from the spring into the water butt and out again could not be reproduced in carved marble.

An apposite parallel can nonetheless be drawn between Mantegna's small grisaille paintings that appear deliberately to imitate marble and the series of circular reliefs, such as those of *Minerva* (pl. 34) and three Muses (including *Clio*, pl. 35), set into the portal (pl. 36) that now frames the entrance from the *studiolo* to Isabella d'Este's *grotta*.[63] This work was designed by Gian Cristoforo Romano in around 1497; carving was in progress around 1500, and it was complete by June 1505.[64] The reliefs are carved with great delicacy: much attention is paid to showing precise details of costume and natural forms through fine, minute chiselling. In the *Clio* roundel the depth of relief carving is sensitively graded from *rilievo stiacciato* effects in the background to a figure that is carved almost in the round, resulting in a subtle relief pictorialism that offers the converse of Mantegna's 'carved marble' grisaille paintings. Although no colour is included in these reliefs, they are set off by the slabs of richly coloured hardstones inlaid into the architectural members of the door-frame, much as in his grisailles Mantegna's 'marble' figures are set against coloured and veined marble backdrops. In their different media, Gian Cristoforo

33 Andrea Mantegna, *Samson and Delilah*. London, National Gallery

34 (*above right*) Gian Cristoforo Romano, *Minerva*, *studiolo* of Isabella d'Este,
detail of door-frame. Mantua, Palazzo Ducale, Corte Vecchia

35 (*facing page*) Gian Cristoforo Romano, *Clio*, *studiolo* of Isabella d'Este,
detail of door-frame. Mantua, Palazzo Ducale, Corte Vecchia

Romano and Mantegna seem to have been working towards parallel out-
comes: works that could be discussed as exercises in how both sculpture and
painting might tend to appropriate the integrity of the other.

36 Gian Cristoforo Romano, door-frame, *studiolo* of Isabella d'Este.
Mantua, Palazzo Ducale, Corte Vecchia

SCULPTURE IN MANTUA AROUND 1500

Gian Cristoforo Romano was one of the two major sculptors active in the Gonzaga circle in Mantua at the time of Leonardo da Vinci's visit to the city; the other was Pier Jacopo Alari-Bonacolsi, known as Antico. Born in Rome around 1465, Gian Cristoforo was trained as a marble carver, initially probably by his father, the sculptor Isaia da Pisa, who was active in Rome between 1447 and 1464,[65] and subsequently by Andrea Bregno. He and Isabella d'Este were in contact from 1497, when Gian Cristoforo moved from Milan to Mantua, until 1510. In 1505 Pope Julius II called him to the papal court in Rome, and in June 1511 appointed him to superintend the construction of the Santa Casa at Loreto, and to provide it with carved marble reliefs; but Gian Cristoforo died a year later, on 31 May 1512, in his late forties.[66] Dogged by ill health, which may already in the 1490s have been affecting his productivity, Gian Cristoforo Romano's sculptural output was small. In his time, indeed, his reputation as a courtier of distinction may have been higher than his reputation as a sculptor. He was celebrated as a singer: Isabella d'Este heard in a letter of 18 October 1491 from Marchesino Stanga in Milan that he sang with her sister Beatrice and others wherever they went. Gian Cristoforo was cultured and well educated. His classical erudition and humanistic interests complemented Isabella's intellectual aspirations well. In his *Libro de natura de amore*, of 1509–11, Mario Equicola declared that he had been 'very much helped by the most excellent sculptor and most virtuous courtier Gian Cristoforo Romano, who no less than I has exerted himself so that this interpretation . . . be rendered to the reader in Italian as well as in Latin'.[67] As a courtier, Gian Cristoforo's principal claim to fame now is his appearance in Baldassare Castiglione's *Il Cortegiano*, in which he speaks as an apologist for sculpture in the section in the book dealing with the *paragone* between painting and sculpture. 'I maintain', Castiglione has him say, 'that working in stone is far more difficult [than painting], because if a mistake is made it cannot be remedied . . . and the figure must be started again; whereas this is not the case with painting.'[68] Gian Cristoforo was here joining the popular *paragone* debate with Emilia Pia and Count Ludovico da Canossa, at the highest social level.

Early in 1491 Gian Cristoforo Romano was in Ferrara, where he was commissioned to carve the *Bust of Beatrice d'Este* (see pl. 56), probably as a betrothal gift to Ludovico 'il Moro' Sforza, whom Beatrice married in that year.[69] He appears to have moved to Milan in Beatrice's cortège, for on 22 June that year Isabella d'Este wrote to her sister asking that she and her husband allow Gian Cristoforo to come to Mantua. Isabella wanted him to

carve for her a portrait bust 'like the one he had done of Beatrice'.[70] Gian Cristoforo himself wrote to Isabella on 1 July 1491, saying that he was ordered to stay in Milan by Ludovico, but promising to come to Mantua as soon as he could get away from his work on the tomb of Gian Galeazzo Visconti. He also suggested that Isabella acquire in Venice two blocks of marble: these should be of three *palmi* by two by one – much the same size as the block from which he had carved the *Beatrice d'Este* bust.[71] This might have allowed him to carve two busts – pendant portraits, perhaps, of Francesco Gonzaga and Isabella – although he asked for two blocks 'because one might not be good' and he wanted to have another in reserve.[72] However, Ludovico Sforza did not allow his move to Mantua, and there is no record of a bust of Isabella at this time.

On 3 April 1497, exactly three months after Beatrice d'Este's death in child-birth, Isabella wrote to Ludovico Sforza again asking him to permit Gian Cristoforo Romano to come to Mantua 'for certain works that I wish to have made'.[73] These probably included her medal, cast in 1498, and the marble door-frame for the *studiolo*, completed by Gian Cristoforo in 1505.[74] She was presumably aware that the sculptor had completed his work on the tomb of Gian Galeazzo Visconti in the Certosa of Pavia: the final payment was made on 4 April 1497. This time her request was granted. Gian Cristoforo moved to Mantua and was it seems quickly assimilated at court: already on 9 September 1497 Isabella could describe him as 'Zoancristophoro romano nostro sculptore et familiare'.[75] On 12 July 1505, by which time he was in Julius II's service in Rome, Isabella wrote to acknowledge receipt of a piece of jasper for the decoration of a 'porticina'. This was probably one of the coloured *pietra dura* slabs inlaid in the *studiolo* door-frame. By this time the door-frame was virtually complete and already in place: in a letter to Isabella on 17 June 1505 Margherita Cantelmo noted 'that blessed little room with its lovely exit'.[76] In her 12 July letter Isabella also thanked Gian Cristoforo for sending a drawing for the tomb-monument commemorating the Beata Osanna Andreasi, a local Mantuan nun whom Isabella venerated highly for her piety, and who had died earlier that year. This was the principal large-scale project on which he worked for Isabella. When the Milanese goldsmith Caradosso Foppa visited Mantua in 1505, he brought with him Gian Cristoforo's drawing for the Beata Osanna tomb, which he discussed with Isabella.[77] Although the first plans incorporated bronze putti and candelabra, the monument finally erected in San Domenico, Mantua, in 1508 appears to have been relatively modest, with an effigy of Beata Osanna beneath a black marble baldachin supported on four Carrara marble columns.[78]

In the letter of 9 September 1497 Isabella asked Benedetto Tosabezzi in Venice to acquire further blocks of marble: it seems likely that she again wanted Gian Cristoforo Romano to carve some portrait busts. No marble busts of Mantuan sitters by Gian Cristoforo Romano survive, but his terra-cotta bust of Francesco Gonzaga (see pl. 76) might have been the model for, or a reflection of, one such marble portrait bust. Another terracotta bust (see pls 74–75), generally attributed to Gian Cristoforo, has been identified as a portrait of Isabella d'Este. It is possible that this too might be a *modello*, for the patron's approval, for a proposed marble bust of Isabella.[79] Gian Cristoforo's best-known works for Isabella are cast medals, although there is no evidence that prior to his arrival in Mantua the sculptor had ever worked in bronze. Three Gian Cristoforo medals are recorded in a letter written to Isabella d'Este on 24 October 1507 by Jacopo d'Atri, the Mantuan ambassador in Naples.[80] Two of these were of Pope Julius II[81] and of Isabella d'Aragona: the latter was still in the process of being modelled when Jacopo d'Atri wrote, 'it is a beautiful and very ingenious work . . . it is not yet fin-ished: only the face and the head are done'.[82] In its completed state the obverse shows a profile portrait of the duchess and the motto CASTITATI VIRTUTIO INVICTAE ('Chastity and Virtue invincible'), and the reverse shows Chastity, a semi-nude female figure, and a palm branch, denoting victory, peace or more probably in this case Virtue, around which is curled a snake, perhaps sym-bolising Prudence.[83] Allegorical images like this one echo the sentiments that lie behind the moralising allegories in the paintings that Mantegna produced in these years for Isabella d'Este's *studiolo*.

The third medal noted by Jacopo d'Atri had been given to him by Gian Cristoforo Romano himself: it was of Isabella d'Este and was 'a thousand times beautiful, as you are yourself'.[84] This medal was complete by 10 Septem-ber 1498 when Giacomo Filippo Faella wrote that he had composed a now-lost sonnet – 'un'opera trista' – in its praise.[85] It must have been cast sometime during summer 1498, for the inscription on the reverse, BENEMERENTIUM ERGO, was suggested to Isabella d'Este by her kinsman Niccolò da Correggio, a humanist and poet at the court of Ferrara, in a letter of May 1498.[86] Isabella's own prestige example (pl. 37a and b) was cast in gold in 1503 and richly framed. Her portrait on the obverse, which will be considered further in the next chapter, is a classically idealised profile. Portraits on classical coins and medals were generally regarded in the early Renaissance as illustrating the sub-jects' exemplary personalities: they were visual parallels of descriptions in bio-graphical texts.[87] Experienced in the styles of classical sculpture and artefacts, Gian Cristoforo Romano was well placed to reinterpret Isabella's actual

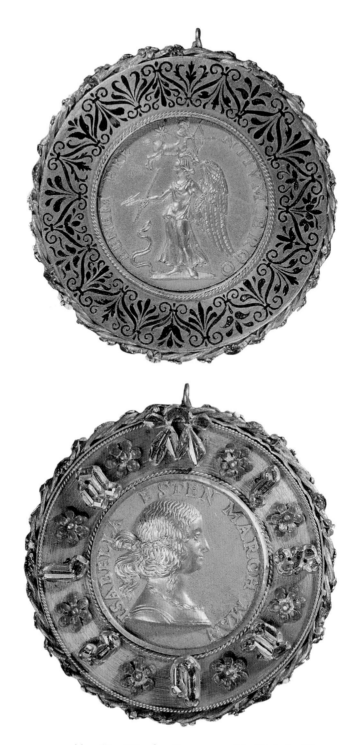

37a and b Gian Cristoforo Romano, medal of Isabella d'Este.
Vienna, Kunsthistorisches Museum

physiognomy in the light of classical idealisation, to emphasise her own exemplary character.

Gian Cristoforo Romano's work before he joined the Sforza court and executed the Gian Galeazzo Visconti tomb has been characterised as having 'a courtly neo-classical style of carving which made systematic use of decorative motifs from imperial art'.[88] A classicising style and decorative vocabulary recurs throughout his work. The reverses of Gian Cristoforo's medals show evident reflections of classical coins in the figures' poses and draperies. The *Beatrice d'Este* bust (see pl. 56) is truncated in a manner that reflects classical portrait busts, and that Mantegna also used in his bronze self-portrait bust at the entrance to his memorial chapel in Sant'Andrea, Mantua. Like the roundels on the *studiolo* door-frame, the *Beatrice d'Este* bust is carved with consummate delicacy in a style of cool classicism. The clarity and sharpness of detail are especially notable in the carving of her hair, and of the decorative motifs on her torso and on the band of drapery over her left shoulder. The pilasters of the lower order of the Gian Galeazzo Visconti tomb are richly carved with classical trophies and armour, a classicising decorative vocabulary echoed both in the fine heraldic and martial detail on the armour of Francesco Gonzaga's terracotta bust and in Mantegna's *Triumphs of Caesar*. During his years in the Gonzaga court at Mantua, from 1497 to 1505, Gian Cristoforo shared with Mantegna his antiquarian enthusiasm and his archaeological approach to classical art and artefacts, and with Isabella an evolved humanistic and courtly sophistication. Mantua might well have seemed to Gian Cristoforo an ideal court environment for the exercise of his cultural, intellectual and artistic qualities.

Small Bronzes

The second important sculptor active in Mantua around 1500 was Pier Jacopo Alari-Bonacolsi.[89] His self-conscious adopted name Antico is a clear indication of his stylistic affinity and debts to classical art. Indeed, some of his small bronzes are fairly exact, small-scale replicas of celebrated classical sculptures. Born presumably in Mantua in about 1460 and trained as a goldsmith, his earliest works are four medals dating from 1479, two of which are already signed with his nickname, 'ANTI'. These medals commemorate the marriage of Francesco Gonzaga's uncle Gianfrancesco Gonzaga, Count of Ródigo and Lord of Bozzolo and Sabbioneta, to Antonia del Balzo. By 1487 Antico was working in the service of Gianfrancesco Gonzaga at his castle at Bozzolo, where he made the so-called *Gonzaga Vase*, which is decorated with the personal devices of Gianfrancesco and his wife. This work is the only extant

example of a Mantuan speciality: an updated, *all'antica* equivalent, cast in metal, of the classical hardstone vases that were much sought after in the later fifteenth century by collectors like Lorenzo de' Medici and Ercole d'Este. Already as early as 1483, Marquess Federigo Gonzaga had commissioned a group of *all'antica* urns and vases, cast in silver by the goldsmith Gian Francesco Roberti after designs by Mantegna.[90] These may well have reflected Mantegna's antiquarian interests, and perhaps resembled the gold and silver vessels carried by some of Caesar's triumphant soldiers in two of the canvases in the *Triumphs of Caesar* series (see, for example, pl. 17). Again similar, perhaps, were the first items listed in the inventory of Gianfrancesco Gonzaga's property made after his death in 1496: 'two small vases of silver gilt from the hand of Antico'.[91] It was, moreover, for Gianfrancesco and his heir Bishop-Elect Ludovico Gonzaga that Antico made his earliest small bronzes.

Recently a previously unknown gilt-bronze *Marsyas* (pl. 38), later adapted to represent 'St Sebastian', has been attributed to Andrea Mantegna and identified with an entry in the 1542 Stivini inventory.[92] 'Una figura nuda legata a un tronco' (a nude figure bound to a tree trunk) is the description of one of the 'cose di brongio sopra li cornisotto' in Isabella's *grotta* in the Corte Vecchia. The casting technique of this bronze suggests that it is Mantuan in origin, for it is similar to the technique of Antico.[93] If the generally persuasive attribution is correct, the bronze provides new evidence of Mantegna's work as a sculptor. It also suggests that small bronzes of classical subjects were already being produced in Mantua at around the time that Antico cast his first group of reduced replicas of major classical marbles. The evidence for Mantegna's activity as a sculptor is equivocal, although in January 1482 he produced a design on paper for a tomb monument to Barbara of Brandenburg, wife of his great patron Marquess Ludovico Gonzaga, many years before he designed the Virgil monument for Isabella d'Este (pl. 32).[94] It is now generally agreed that he was also responsible, perhaps in the early 1480s, for modelling, and perhaps for casting in bronze, his own bust placed at the entrance to his funerary chapel in Sant'Andrea in Mantua.[95] The attribution of the *Marsyas* bronze now reinforces the literary testimony: in an epitaph on Mantegna the scholarly poet Julius Caesar Scaliger called him 'pictor et plastes' – painter and modeller – and Giovanni Santi's lengthy appraisal of Mantegna in his *Cronaca rimata*, written around the time of Federigo da Montefeltro's visit to Mantua in 1482, includes a rhyming triplet that may be translated:

> Nor has he overlooked relief, with soft attractive
> Methods by which to show to sculpture too
> What heaven and good fortune gave to him.[96]

38 (*facing page*) ?Andrea Mantegna, *Marsyas*. Vienna, Liechtenstein Museum

This evidence may suggest that when Antico started to produce small-scale bronze versions of classical statuary, the ground in Gonzaga Mantua and its surroundings had already been well prepared. The 1496 inventory of Gianfrancesco Gonzaga's estate includes the earliest records of bronze figures by Antico, replicas of large-scale classical statues in Rome of *Meleager* ('a figure of metal called the Villanello'),[97] a *Hercules with a Club* (probably that now in Madrid, Museo Arqueológico), and reductions in bronze of one of the Quirinal horse-tamers and of the *Marcus Aurelius* equestrian group.[98] The *Meleager* in the Victoria and Albert Museum (pl. 39), the sole surviving example of this bronze, is very probably the one cast for Gianfrancesco Gonzaga.[99] Identical to this in facture, and set on an identical oval bronze base, is a small bronze of *Hercules and Antaeus* (pl. 40), also in the Victoria and Albert Museum.[100]

In 1519 Antico wrote to Isabella d'Este that he proposed to have one Maestro Iohan, who had been in the service of Bishop-Elect Ludovico Gonzaga since 1501, make recasts for her of a group of eight bronzes that he had modelled for the bishop some twenty years earlier. Among those listed by Antico is 'l'Ercule che amaza Anteo, che la piú bella antiquita che li fusse'.[101] A cast of the *Hercules and Antaeus* now in Vienna bears under the base the inscription D[OMINA]/ISABEL/LA/M[ANTUA]E/MAR[CHIONISSA], showing that it is one of the bronzes cast for Isabella in 1519. The example in the Victoria and Albert Museum was therefore very probably cast for Bishop-Elect Ludovico Gonzaga. After Gianfrancesco's death, Ludovico succeeded him in residence in his palace at Bozzolo while Gianfrancesco's nephew and heir Pirro was still a minor, and from 1498 Antico was working there for his former patron's brother. A letter written by Ludovico Gonzaga on 29 November 1498 refers to wax models of an *Apollo*, and a *Nude Kneeling on a Tortoise*, in Antico's *bottega*.[102] The first of these is almost certainly the model for the version of Antico's *Apollo Belvedere* reduction (pl. 13) now in the Liebieghaus, Frankfurt-am-Main, the only known small bronze signed by the artist.[103] Over the next few years reduced versions in bronze were produced of a range of classical sculptures, including the *Apollo Belvedere* and the *Spinario*.

Antico's work in the late 1490s evidently captured Isabella d'Este's imagination, and may have stimulated her first request for a work by him. This request was conveyed to the sculptor at Bozzolo by Gian Cristoforo Romano, who on 27 March 1500 discussed with him Isabella's desire for some decorative work for a door-case in her *camerino*; but next day Antico wrote to Isabella that he had too much work in hand and could not take on her commission.[104] However, a year later, on 26 March 1501, Isabella wrote to Antico to thank

39 (*above left*) Antico, *Meleager*. London, Victoria and Albert Museum

40 (*above right*) Antico, *Hercules and Antaeus*. London, Victoria and Albert Museum

him for making a cast of the *Spinario*, presumably from the mould that he had made for Bishop-Elect Ludovico Gonzaga's example, that Ludovico had presented to her: this is probably the version now in the Wrightsman collection, New York (pl. 41).[105] In a letter of 29 January 1503 Isabella asked Ludovico to have Antico cast a pendant bronze, which almost certainly represented 'Andromeda', saying that because 'I wish to place it above a doorframe cornice [in the *studiolo*] opposite to the little putto, to give it symmetry, it must be made in the same proportions' as the *Spinario*.[106] Several months

41 (*above*) Antico, *Spinario*. New York, Wrightsman Collection

42 (*facing page*) Antico, *Nymph*. New York, Robert H. Smith Collection

later, on 9 September 1503, Ludovico Gonzaga wrote to her, sending a bronze *Nymph* (probably the cast in the Robert H. Smith collection; pl. 42) – 'a small figure in bronze of the size of the little putto with a thorn' – to serve as the companion piece for the *Spinario*.[107] A similar display of figure-sculpture set on the cornices of door-frames (pl. 43) is the pair of nude figures, apparently in gilt bronze, in Giovanni Mansueti's *Healing of the Daughter of Ser Niccolò Benvegnudo of San Polo*, a canvas painted in about 1505 for the decoration of the Albergo in the Scuola Grande di San Giovanni Evangelista, Venice.[108] The 1542 inventory of Isabella d'Este's possessions at her death includes several items that can be identified as Antico bronzes: these were at that time displayed in her new *grotta* in the Corte Vecchia on a cornice that ran around the whole room.

43 Giovanni Mansueti, *Healing of the Daughter of Ser Niccolò Benvegnudo of San Polo*, detail.
Venice, Accademia

Anthony Radcliffe has suggested that 'the characteristic type of the
Mantuan bronze', of which Antico was the principal proponent, if not the
inventor, 'with its archaeological correctness, its precision of finish, its clean
hard surfaces and firm outlines can be seen as the sculptural counterpart of
Mantegna's painting'.[109] The analogy can be illustrated in a comparison
between Antico's *Hercules and Antaeus* (pl. 40) and Mantegna's representation
(before 1474) of the same subject, in reverse, on the vault of the Camera Picta
(pl. 44).[110] Antico's group is a small-scale reproduction of the classical marble
Hercules and Antaeus now in the courtyard of the Palazzo Pitti in
Florence, but earlier included in Pope Julius II's collection of classical sculp-
ture in the Vatican Belvedere. This was presumably on view in Rome at least
as early as around 1470 and so would have been known to Mantegna at the
time of his visit to Rome in 1488–90 and to Antico when he visited Rome
early in 1497.[111] Mantegna's painted version of 1474 may also have derived

44 Andrea Mantegna, *Hercules and Antaeus*, Camera Picta, vault, detail.
Mantua, Palazzo Ducale, Castello di San Giorgio

from the marble *Hercules and Antaeus*, of which he could possibly have seen
a drawing in time for the Camera Picta vault lunette, or perhaps more likely
from the reverse of a bronze medal of the Emperor Hadrian.[112] This parallel
nevertheless suggests that Antico may have had in mind the possibility of
making a *paragone* between painted and cast versions of a classical group, and
that he set out to meet the challenge posed by Mantegna in his Camera Picta
version. If there was indeed a sense of comparison and even of competition,
this would constitute the reverse of the *paragone* set up rather later by
Mantegna in his paintings 'finto de bronzo' that were displayed alongside
Antico bronzes in Isabella d'Este's *studiolo*.

Unfortunately, no *bronzi finti* (feigned bronze) paintings by Mantegna for
Isabella d'Este have been identified. The 1542 Stivini inventory lists only two
such paintings, 'a painting "finto de bronzo" above the said door [the entrance
to the *studiolo*], by the hand of messer Andrea Mantegna, with four figures

in it', and 'another painting "finto de bronzo" set above the door at the entrance to the *grotta*, by the hand of the said Mantegna, in which is painted a sea ship, with a number of figures in it, and one who falls into the water'.[113] Once again, it seems likely that the 1542 layout reflects Isabella's arrangement of the paintings and sculptures as she assembled them in the *studiolo* during the first decade of the sixteenth century. Neither of these works, which may have shown narrative subjects that were already obscure by 1542, survives. Mantegna also, however, painted two *bronzi finti* canvases showing *Judith* (pl. 45) and *Dido* (pl. 46), two exemplary women of antiquity and the Old Testament – imagery decidedly to Isabella's taste.[114] These were probably originally two of a group of four canvases which could conceivably have been mistaken by Stivini as a single painting with four figures, although they are not shown *di sotto in sù* as paintings set above a door might normally have been. The parallel with Antico's gilt-bronze figurines is produced by innumerable fine highlights in ground gold pigment hatched over a brown middle-tone, glazed with black into the shadows; and the 'bronze' figures are set against a dark green veined-marble ground. A direct link with Antico that further suggests Mantegna's intention to produce a *paragone* with bronze sculpture is the head of *Dido*, which is closely similar in features and in the curls of her hair to Antico's bust of *Cleopatra* (Boston, Museum of Fine Arts). 'The effect is of highly chased gilt bronze figures, much like those [by] Antico . . . [that] could be translated into bronze statuettes with few adjustments or simplifications.'[115]

After Gianfrancesco Gonzaga's death in 1496, Antico continued in the service both of his brother Ludovico and of his widow, Antonia del Balzo, in residence with her at the palace at Gazzuolo, but he also undertook further commissions for Isabella d'Este. He cast for her a gold statuette of *St John the Baptist* in 1504, and in 1505 a group of small works in silver: none of these survives. He was also employed in restoring classical sculptures for Isabella, and in advising on acquisitions such as the *Empress Faustina* bust (see pl. 92) that she purchased from Mantegna in 1506. Besides the eight further classicising bronzes that he cast for Isabella in 1519, he also made a number of bronze busts that by 1542 were displayed on a second cornice, above that for the figure sculptures in the *grotta*, alongside classical busts, encouraging further *paragoni* between ancient and modern. During the first decade of the sixteenth century Antico became increasingly important to Isabella as an advisor on works of art and on the acquisition of small antiquities.[116] Strongly influenced by Mantegna and by the artistic and cultural authority that the painter held in Mantua at the turn of the century, Antico was consciously a classicising sculptor but by no means merely an unimaginative replicator of classical figures. Although never a *familiare* of Francesco Gonzaga's court,

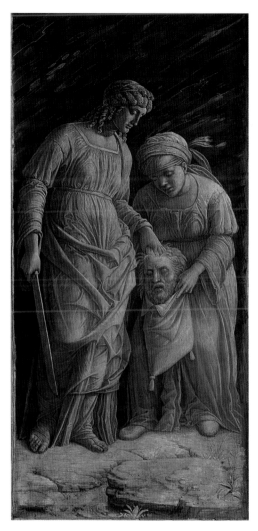 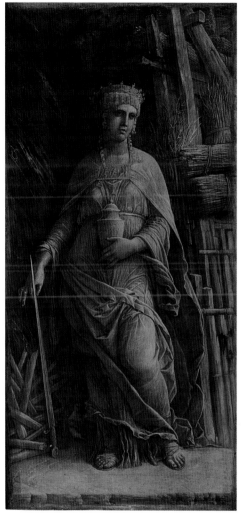

45 (*above left*) Andrea Mantegna, *Judith*. Montreal, Museum of Fine Arts,
John W. Tempest Fund, inv. 1920, 103

46 (*above right*) Andrea Mantegna, *Dido*. Montreal, Museum of Fine Arts,
John W. Tempest Fund, inv. 1920, 104

since he worked principally for Francesco's uncles, he was an important and
discerning figure in the process of consolidation of the purist classicism of art
in Mantua at the turn of the century.

LEONARDO DA VINCI AND MANTUAN ART AROUND 1500

How might Leonardo da Vinci have responded to artistic activity in Mantua at the turn of the century, and particularly to the paintings of Mantegna to which he could have gained access? He might have been flattered by the evident reference in the Virgin's hand gesture in Mantegna's *Madonna della Vittoria* (pl. 19) to that of his own Virgin in the *Madonna of the Rocks* (pl. 47). But supposing that Leonardo was invited to visit Isabella d'Este's *studiolo*, what might he have made of Mantegna's *Parnassus* (pl. 29)? The conclusion reached in a brief consideration of this question in chapter two was that there are elements of Mantegna's style, especially his use of high-key tonalities and a bright palette produced by the unusual technique of distemper (an animal glue or casein medium) on canvas, with which Leonardo would not have been in sympathy. But Leonardo and Mantegna, in fact, had a number of artistic interests in common. Prominent among these was the *paragone* between painting and sculpture: Leonardo wrote extensively about this in his innumerable notes in preparation for the *Trattato della pittura*, and as we have seen Mantegna commented on it visually in various ways in his paintings. The two painters also shared an interest in geology and rock formations. If Leonardo saw the *Parnassus*, his attention might well have been captured by Mantegna's imaginative setting for his figures, especially the natural arch on which Venus and Mars stand, the crystalline formation that appears to grow out of the rock-face above Vulcan's cave, and the foreground rich in pink marble and fossilised shells. In other works also Mantegna explored elaborate, improbable geological formations, such as the extraordinary burst of volcanic basalt, found naturally at Monte Bolca between Vicenza and Verona, behind the Virgin in his *Madonna of the Quarries* (Florence, Uffizi).[117]

As early as around 1480 Leonardo had written on rocks and geological formations;[118] he included fantastic, jagged cliffs as early as the mid-1470s in the background of his Munich *Madonna of the Carnation*, and he had created an inventive rocky landscape in the cavernous background of his Paris *Madonna of the Rocks*. Some of his later studies of mountains and rock formations suggest an admiration similar to Mantegna's, and perhaps even to a degree inspired by Mantegna, for the natural wonders of geology. Indeed, the Christ Child in his *Madonna of the Yarnwinder* in the collection of the Duke of Buccleuch leans over a formation of 'fine-grained platy limestone of a variety found in central Italy' that is one of the most noteworthy passages in this panel.[119] This *Madonna* is the composition, and possibly the very painting, on which Leonardo was occupied in April 1501 when Fra Pietro da Novellara

47 Leonardo da Vinci, *Madonna of the Rocks*. Paris, Louvre

reported to Isabella on his activities.[120] The rock formation is executed with
microscopic delicacy – much the same as that shown by Mantegna in the
similar striated rocks on which Mercury and Pegasus stand in the *Parnassus*.
Perhaps Leonardo's virtuoso treatment of the foreground rock here was
directly prompted by a study of Mantegna's canvas in Isabella's *studiolo*.
Associated with Mantegna's interest in geology is the accuracy and relish
with which he represented semi-precious stones, such as the magnificent

multi-coloured vase in the fourth canvas of the *Triumphs of Caesar* (pl. 17), or the slab of vari-coloured marble on which Francesco Gonzaga kneels in the *Madonna della Vittoria* (pl. 20), or the richly coloured and veined marble backdrops to his grisaille paintings. In similar fashion (as will be explored in chapter five), Leonardo was especially pleased by the 'diversity of astounding colours' of the multicoloured jasper used to carve a classical vase, of which he made a drawing for Isabella d'Este.[121]

Leonardo might have been impressed also by Mantegna's treatment of the water that emerges with a convincing sense of fluid movement from the Hippocrene spring in the foreground of the *Parnassus*, and that spills in a widening waterfall from Mount Parnassus in the background behind Mercury and Pegasus. The movement of water, and the effects of hydrodynamic turbulence generated by the flow of water around obstacles in its path, were abiding scientific interests of Leonardo's, on which he made copious notes towards an unwritten treatise.[122] Another quality of Mantegna's study of the natural world with which Leonardo might have been in sympathy is his botanically precise and detailed description of plants. The citrus bushes that form a natural arbour behind Mars and Venus in the *Parnassus*, the fertile garden behind Apollo and the dancing Muses, and the fruit and vegetables of the *Madonna della Vittoria* show acute accuracy in depicting nature. Leonardo resonantly echoed this keen naturalism not long after his visit to Mantua in the plant studies that he drew for his lost *Leda and the Swan*. Finally, although Leonardo might have found the drama of the pose, movement and expression of a work like the Ca d'Oro *St Sebastian* (pl. 23), had he ever seen it, wilfully exaggerated and unnatural, he might have responded positively to other aspects of Mantegna's expressive vocabulary. The affecting contrast in the Jacquemart-André *Ecce Homo* (pl. 21) between the idealised if pained refinement of the head of Christ and the ugliness of his tormenters is paralleled throughout Leonardo's work in his almost obsessive juxtaposing of beautiful and grotesque faces. However, as Keith Christiansen observed when writing of this very painting, 'if in this instance the expressive goals of the two artists coincided, their approach to painting was poles apart. Mantegna must have found Leonardo's work as distressingly imprecise in its use of *sfumato* as Leonardo would have found Mantegna's hard and literal.'[123]

Indeed, the sharp lucidity of Mantegna's pictorial lighting, as for example in the *Parnassus*, where a clear, bright light picks out the forms and details with crystalline clarity, is in diametric opposition to the deep shadows and suffused lighting of Leonardo's *Madonna of the Rocks*. Mantegna's uncompromising realism in the representation of objects, their surfaces and textures,

resulted in a view of the natural world very different from Leonardo da Vinci's. Isabella d'Este is hardly likely to have spoken of a painting by Mantegna as 'done with . . . sweetness and gentleness of expression', the description she used of Leonardo's treatment.[124] It was indeed his determined, hard-focus realism that led Mantegna towards ruthless physiognomic description in his portraiture. His portraits lack the atmospheric ambiguity of expression and characterisation sought by Leonardo in his Milanese portraits of Cecilia Gallerani or Lucrezia Crivelli. They are almost equal in precision to those of his Netherlandish contemporary Hans Memling, whose portraits were highly valued by Italian (and especially by Florentine) expatriates living and working in Bruges in the latter decades of the fifteenth century. In his portraiture, as in other features of his art, Mantegna was strongly influenced by Netherlandish art. Unfortunately no Mantegna portraits, aside from the relatively impersonal profile of Francesco II Gonzaga (pl. 20) as donor in the *Madonna della Vittoria*, survive from the end of his career. A good earlier example, however, is the painting traditionally identified as a portrait of Carlo de' Medici (pl. 48), which dates from the mid-1460s.[125] Here the powerful structure of the head, the craggy strength of the sitter's features, the sharply described lines and creases in the skin surface on the forehead and around the eyes, and the sallowness of colouring that reflects the sitter's half-Circassian parentage suggest that the painter was pitiless in his observation and recording of Carlo de' Medici's likeness. It is no wonder that Isabella d'Este rejected the portrait of herself that Mantegna painted in 1493, if it possessed this type of physiognomic realism. She claimed that 'it has nothing of our likeness,'[126] but her real reason for rejecting it was perhaps because it was mercilessly lifelike. On the other hand, having seen the portrait of Cecilia Gallerani, Isabella seems to have welcomed the chance to commission her portrait from Leonardo, and for several years she pressed him to complete it.

During the years covered by the correspondence between Isabella d'Este, her agents and Leonardo, from 1500 to 1506, Leonardo engaged more strongly with classical art than at any other stage in his career. He was perhaps in part guided in this by his experience in early 1500 of the learned classisicm of art in Mantua around 1500. Leonardo would have known of Mantegna's high reputation throughout Italy in the later decades of the fifteenth century. His artistic temperament was very different, but Leonardo did, it seems, respond positively in some of his early sixteenth-century works to Mantegna's art. Leonardo wrote that 'it is better to imitate the antique than modern work'.[127] His work of the first decade indeed tends 'towards a new classicism',[128] but this is unlike either the antiquarianism of Gian Cristoforo Romano and

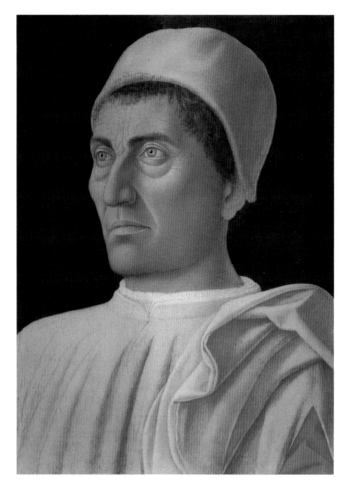

48 Andrea Mantegna, *Carlo de' Medici*. Florence, Uffizi

Antico, or Mantegna's archaeologically inspired reconstruction of the classi-
cal past, that seem to pervade and to define the particular character of art in
Mantua around 1500.

There is no evidence that Leonardo ever painted multi-figure allegorical
compositions like Mantegna's for Isabella's *studiolo*, but in the early years of
the new century he did work on several less complex classical themes. Around
1504 he made a presentation drawing of *Neptune* for the Florentine Antonio
Segni; and in around 1506 he drew studies for a Hercules project, perhaps in
competition with Michelangelo for a Florentine sculptural commission.[129] Of

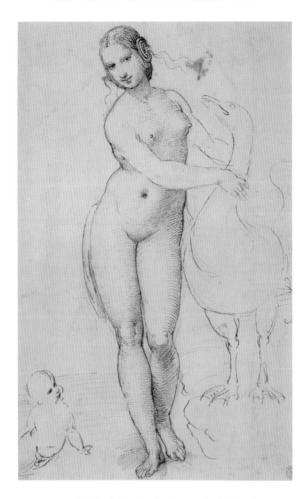

49 Raphael, *Study after Leonardo da Vinci's*
'Leda and the Swan'. Windsor, Royal Library, RL 12759

greater interest here is that around the same time he worked on a painting, apparently lost in France sometime in the eighteenth century, of *Leda and the Swan*. This composition started its life as his response to a classical 'Kneeling Venus' figure: the early drawings, dating perhaps around 1504, show Leda about to rise but still with one knee on the ground.[130] During the next two years, however, and certainly before Leonardo left Florence in May 1506, he transformed the composition into a standing figure-group, as copied in a drawing by Raphael (pl. 49) and in later paintings by artists in Leonardo's Milanese circle (pl. 50). This second design has uncanny resemblances, in

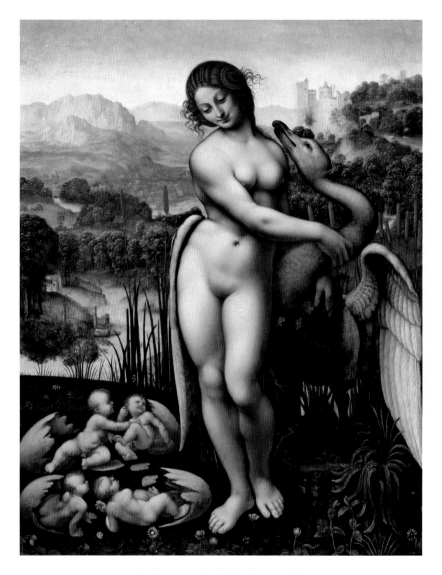

50 After Leonardo da Vinci, *Leda and the Swan*.
Salisbury, Wiltshire, Wilton House, Earl of Pembroke Collection

reverse, to the Venus and Mars group in Mantegna's *Parnassus* (pl. 51). Both
Mantegna's Venus and Leonardo's Leda are almost flagrantly naked. The pose
and movements of Leda's head and right arm provide her upper body with a
more fluent, more sensuous twist than Venus shows. But her lower body, from

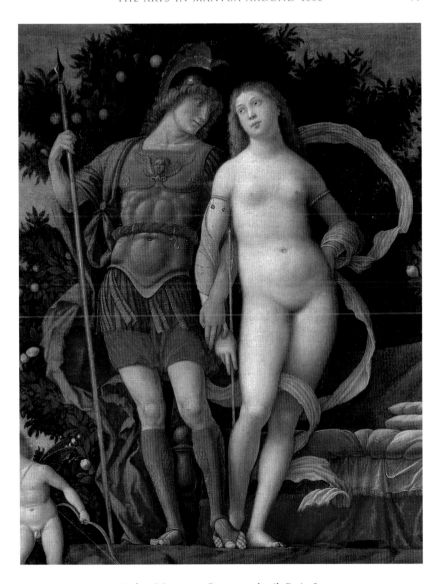

51 Andrea Mantegna, *Parnassus*, detail. Paris, Louvre

abdomen downwards and specifically in the set of her feet, is a very close
mirror-image of the pose of Mantegna's Venus. Moreover, the movement of
her left arm as it is linked with the swan's neck echoes the intertwining of the
arms of Venus and Mars. It is as though in his second formulation of the Leda

52 Mantuan sculptor, *c.*1510, *Leda and the Swan*.
Vienna, Kunsthistorisches Museum

and the swan group Leonardo took inspiration from his memories of the
amorous linking of Mantegna's figures.

It remains a remote but teasing possibility that Leonardo responded to
Mantegna's Venus and Mars group in this way because his *Leda and the Swan*
was to hang in the same room – Isabella d'Este's *studiolo* – as the *Parnassus*,

and to be open to direct comparison with Mantegna's masterpiece. There is, however, no evidence that this painting was ever in Isabella's collection: nothing is known of its patron or of its intended location. A series of copies by Milanese followers indicates that Leonardo took the panel with him to Milan in 1506; and later it seems that it went with him to France, since it is recorded in the inventory of the property of Leonardo's pupil Salaì at his death in 1525. Isabella's interest in both the theme and in the intertwined composition of nude female and swan is, however, suggested by a small marble sculpture (pl. 52) carved in around 1510 by an unidentified (presumably Mantuan) sculptor. This carving, in which Leda's pose again bears a close resemblance to those of Leonardo's Leda and Mantegna's Venus, is recorded in the 1542 Stivini inventory amongst a group of marbles, both ancient and modern, in one of the cupboards in Isabella's *grotta*.[131]

All the observations made in this final section of chapter three are speculative rather than evidence-based, and may perhaps be set on one side. We must recall that little firm evidence survives as to what art works Leonardo was able to see in Mantua early in 1500, and none as to what his responses to them were. Indeed, some doubt is occasionally cast on whether Leonardo visited Mantua at all, let alone whether he met Mantegna or had any opportunity to study his Mantuan paintings.[132] However, remarks in Isabella's correspondence make clear that Leonardo had stayed, if briefly, in Mantua; and the single extant work that he completed for Isabella, the portrait drawing in the Louvre, has all the appearance of a finished study based on first-hand experience of his patron's likeness. This drawing lies at the heart of the discussion in chapter four, which deals with questions arising from the projected portrait of Isabella d'Este, its place within the history of portraiture in Italy at around the turn of the century, and the artistic and technical processes that lay behind its production.

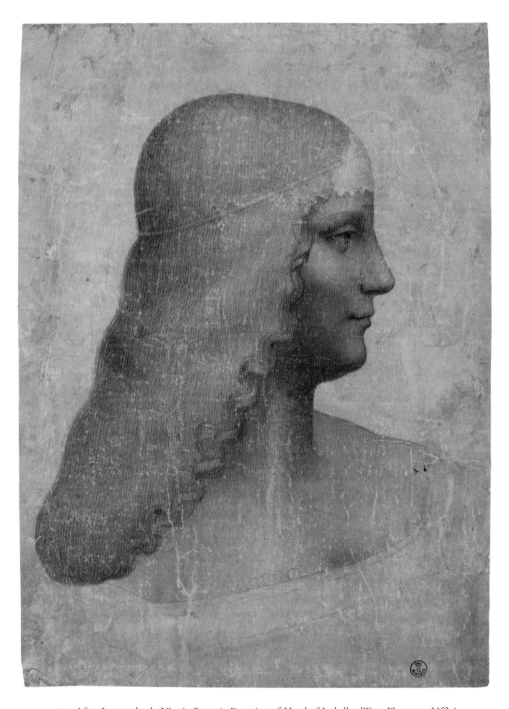

53 After Leonardo da Vinci, *Portrait Drawing of Head of Isabella d'Este*. Florence, Uffizi

IV

LEONARDO'S PORTRAIT DRAWING

OF ISABELLA

ISABELLA AND HER PORTRAITS

Writing to Leonardo da Vinci from Mantua on 14 May 1504, Isabella d'Este admitted that for him to produce a portrait 'in colours' based on the chalk drawing that he had made in Mantua 'would be almost impossible, since you are unable to move here'.[1] There would, in fact, have been no need for Leonardo to return to Mantua. It was standard practice for a portrait to be painted on the basis of a drawing, or of another painting, rather than directly from life. Leonardo could therefore perfectly well have painted the portrait from his drawing, without seeing Isabella again. Indeed, this seems to be implied by Isabella when she wrote in the same letter, 'When you were in these parts, and did my likeness in charcoal, you promised me you would portray me once more in colours.' Sitting for a portrait would normally therefore only have taken the relatively short time needed for the artist to make a portrait drawing, on which a painted portrait could later be based. Even so, it was regarded as a tedious occupation. Isabella's brother, Cardinal Ippolito d'Este, wrote to her on 21 December 1494 that it was out of affection for her that he was prepared to submit to the boredom of sitting for his portrait.[2] On 26 September 1511 Isabella herself wrote to her half-sister, Lucrezia d'Este Bentivoglio, that 'the last time my portrait was taken the necessity of sitting still and without moving for a long while became so tiresome that I never mean to do it again'.[3]

Consequently, as in a number of recorded cases, portraits of Isabella could be painted without any contact between sitter and portrait painter. The portrait that Francesco Francia painted in Bologna in September 1511, for example, was based on a drawing that was probably a copy of a portrait made some four years earlier by Lorenzo Costa, supplemented by descriptions of Isabella given him by Lucrezia Bentivoglio. In turn, this portrait served over twenty years later as the model from which in 1534 Titian painted his celebrated portrait of Isabella (pl. 54), without seeing her afresh. Writing in 1493 to Isabella del Balzo, Countess of Acerra, of a portrait that the latter had sent her, Isabella d'Este observed that she would 'often look at it, replacing the painter's defects with information from . . . Jacopo [d'Atri] and others who have seen you, so that we will not be deceived at all in our concept of you'.[4] These circumstances and opinions provide fruitful indications that the Renaissance portrait tended, and needed, to be first and foremost an idealised image – of beauty or of nobility, for example – rather than necessarily a likeness.

The number of references in Isabella d'Este's correspondence to portraits of herself suggest that self-presentation in this form was of considerable interest and importance to her. She often had portraits made to send to relatives and friends living in courts spread across the Italian peninsula. On 13 March 1499 she wrote to her brother-in-law, Ludovico Sforza, Duke of Milan, 'I am afraid that I shall bore not only Your Highness but all Italy by sending out these portraits of myself.'[5] In this letter she asked if she might send to Milan a portrait by Giovan Francesco Maineri intended for Isabella d'Aragona, 'even though it is not very like me, because it makes me look fatter than I am'.[6] Letters addressed to Isabella indicate that these portraits could serve a number of different functions for different recipients. The court portrait often played a part in the process of negotiating a betrothal or a marriage. The portrait bust of Beatrice d'Este (pl. 56) by Gian Cristoforo Romano, for example, was probably made to commemorate her betrothal or her marriage in 1491, at the age of 15, to Ludovico Sforza. An early portrait of Isabella, painted on panel, was sent to Francesco Gonzaga in Mantua in 1480, to coincide with the visit of Gonzaga envoys to Ferrara to negotiate the betrothal of Francesco to Isabella. Cosmè Tura, then court artist to Isabella's father, Ercole d'Este, was paid for this now-lost portrait of the six-year-old Isabella on 30 March that year.[7] This diplomatic portrait served as part of the exchange of gifts to seal the betrothal that led to Francesco and Isabella's marriage in 1490.

A second purpose of the court portrait can be discerned from Isabella d'Este's earliest depiction (pl. 55), in a manuscript dating from 1479 or 1480 that sets out the recent Este genealogy.[8] Here she is shown at the age of around

54 Titian, *Isabella d'Este*. Vienna, Kunsthistorisches Museum

55 Anonymous, *Genealogy of the Este Family.*
Modena, Biblioteca Estense L.5.16, Ital. 720, fol. 3v

five years, posed in profile within a roundel with her hands held piously together as though in prayer. In the top three roundels are shown Ercole d'Este between two natural children Lorenzo and Lucrezia; in the second row Isabella confronts her mother Eleonora d'Aragona, while the roundel to their right, inscribed with the name of her sister Beatrice, and the three roundels below, named for three of her brothers, are left blank. Although this is evidently incomplete, it seems that through these portraits Ercole d'Este was constructing a family-tree lineage, seeking perhaps to reinforce the genealogical

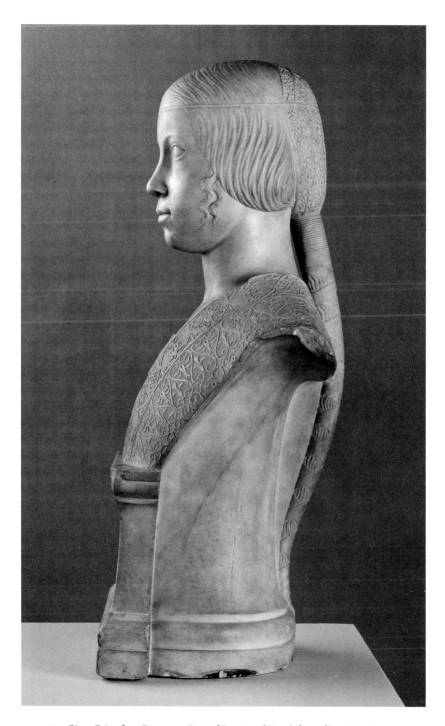

56 Gian Cristoforo Romano, *Bust of Beatrice d'Este*, left profile. Paris, Louvre

strength and continuity of the family by showing how alike they all looked. Much later in her life, Isabella sent another child portrait to Ferrara for another family comparison. In November 1531 her great-niece Anna d'Este was born to Renée of France, wife of Isabella's nephew Ercole d'Este.[9] The following January Isabella arranged for a portrait of herself made, she wrote, when she was three years old to be sent to Ferrara; and she asked her brother Alfonso to confirm the resemblance between herself as a child and his new granddaughter. Moreover, she also arranged for another portrait of herself, made shortly after her marriage, to be 'refreshed' and sent to the Ferrarese court, so that Anna d'Este's features could be compared also with this. Renée of France was apparently very pleased with the portraits, finding that the resemblance between Isabella and her daughter was indeed striking, and asking if she could keep the portraits until she had had copies made from them. Portraits were here 'used in a dynamic, social relationship between the courts of Mantua and Ferrara', further to emphasise and strengthen family connections.[10]

Once mature, married and independently in a position to commission portraits of herself, Isabella clearly recognised the potential of portraits in social and diplomatic communication. As a reward for loyalty and service, a portrait could strengthen the ties of courtiership between the recipient and herself. On 15 September 1495, Isabella d'Este wrote to Gian Cristoforo Romano to ask if he would make 'quello intaglio sculptura', probably meaning a cast medal.[11] However, as noted above, Gian Cristoforo was not able to move into Isabella's service in Mantua until the summer of 1497, and it was a year later that he cast her medal (pl. 57).[12] The inscription on the medal reverse, BENEMERENTIUM ERGO, is perhaps best translated 'on account of high merits' (or sometimes 'for those who deserve well') (see pl. 37b). Isabella's adoption of this inscription implies that she intended to circulate copies as gifts, or rewards, to those who had served her faithfully.[13] Her medal could also disseminate her image, so that it could become an object of admiration amongst courtiers and noblewomen of other princely courts. In his letter of 24 October 1507, Jacopo d'Atri recorded that Gian Cristoforo Romano had brought to Naples an example of his medal of Isabella, and that

> he has shown it as a divine thing to all these Queens, who looked at it with the greatest admiration. The Queen Consort [Germaine de Foix] saw it before she went to Spain, and seemed as if she would never be tired of looking at it, saying that, besides rare beauty of feature it showed signs of great intelligence . . . All the others who saw your portrait praised it in the highest terms, especially the . . . daughters of [Gonsalvo de Cordova,

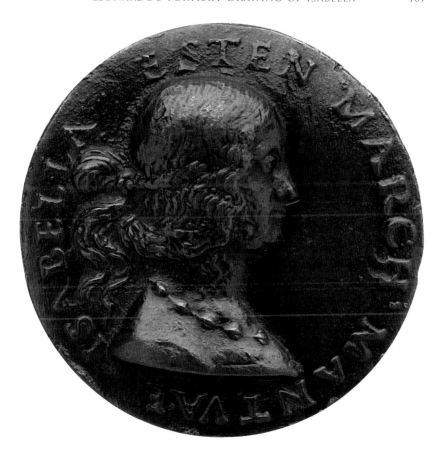

57 Gian Cristoforo Romano, medal of Isabella d'Este, obverse.
London, Victoria and Albert Museum

Viceroy of Naples] who, after looking at it again and again a thousand
times over, kissed the beautiful medal, saying that they too had often heard
of your talents and virtues.[14]

Painted portraits, or portrait drawings, of Isabella could stimulate similar
admiration. On 1 June 1505 Margherita Cantelmo, whose life in the courts of
Ferrara and Mantua was closely bound up with Isabella's, wrote that she had
shown a portrait of Isabella that had been painted for her by a 'maestro
Francesco' (presumably Francesco Bonsignori) to her friends in Milan, and
they had studied it contemplatively several times together.[15] A later portrait
of Isabella d'Este that became the focus of admiration and social exchange

was that painted from a drawing by Francesco Francia in 1511. When the por-
trait was finished in October that year, Lucrezia Bentivoglio wrote to Isabella
that Francia considered his portrait better than its model, and that 'if you
compare it with the original sketch which was sent from Mantua, it is no less
like nature than that one, while it is far more perfect in point of art. All those
who know you in this city agree in saying that in Francia's portrait they seem
to see your living image.'[16] On receiving the portrait, Isabella wrote to Francia
saying, 'You have indeed made us far more beautiful by your art than nature
ever made us.'[17] Nevertheless, she evidently felt that the portrait was not as
good a likeness as she wished, and that her eyes should be lighter. Francia
was, however, unwilling to rework it; and not long after this exchange, Isabella
gave the portrait away. Through the good offices of the Ferrarese courtier-
poet Battista Stabellino, she sent it to another Ferrarese courtier, Gian
Francesco Zaninello, in return for his gift to her of an illuminated manuscript
copy of sonnets by his friend Antonio Cammelli, il Pistoia. Stabellino wrote
on 21 March 1512 to Margherita Cantelmo that he had handed on 'the most
beautiful portrait' of Isabella d'Este to Zaninello, and that the latter had been
so pleased with it that he had at once held a dinner specifically to display it
unexpectedly ('all'improviso') to his guests. His female guests had been so
delighted by this impromptu viewing that they had not known 'which way
to turn'.[18] A few weeks later, Stabellino reported to Isabella on another dinner
party given by Zaninello at which once again he displayed 'unexpectedly the
beautiful portrait of your illustrious lady'.[19]

Possession of a portrait of Isabella could serve to keep her image, and the
memory of her personality, present in the heart and mind of its owner. On
10 April 1495 a Ferrarese acquaintance, Beatrice de' Contrari, wrote that she
had been brought a portrait of Isabella, and that 'when I go to my table I set
it up opposite me, so that I can imagine myself at table with Your Ladyship'.[20]
Similarly, in his 21 December 1494 letter Cardinal Ippolito d'Este wrote that
he would sit for a portrait that Isabella had requested, but in return he would
then send the artist to make a portrait of Isabella, praying that she agree to
this because he wished 'to place it as though a holy image at the head of my
bed'.[21] Margherita Cantelmo wrote on 5 August 1505 about her new portrait
by Maestro Francesco, that 'being deprived of Your Ladyship's presence . . . I
am helped by that sweet portrait as much as possible'.[22] The correspondence
provides a valuable introduction to the ways that Renaissance viewers
responded to portraits, and especially to the range of potential responses to
portraits of Isabella d'Este. These questions need to be kept in mind when
we examine how Leonardo da Vinci represented Isabella in the portrait

drawing that he made in the weeks immediately after the turn of the fifteenth century.

At issue also is how Leonardo da Vinci negotiated between the various qualities that Isabella d'Este herself wished to find represented in her portraits: the correspondence again shows their importance in projecting Isabella's self-image. However, no portraits of Isabella other than Leonardo's drawing that are known to have been made within the first fifteen years of her life in Mantua survive, so it is impossible to marry up her comments with likenesses of herself.[23] The most fully documented early portrait of Isabella is the one that she commissioned from Andrea Mantegna early in 1493. This was to be sent as a gift to Isabella del Balzo, Countess of Acerra, who had asked Isabella d'Este for a portrait in exchange for two of herself that she had sent to Isabella. About these, Isabella wrote to the countess on 2 April 1493 that she did not think they looked much like her, but that she knew 'how difficult it is to find painters who perfectly imitate the natural face'.[24] Very soon she experienced this problem for herself. As noted in chapter three, she wrote to Isabella del Balzo again on 20 April 1493, after she had seen Mantegna's finished portrait, saying that she could not send it to her because 'the painter has done it so badly that is has nothing of our likeness'.[25] She continued that she would get a replacement made by another painter 'who is said to imitate nature well': this was Giovanni Santi, court painter to Isabella's sister-in-law, Elisabetta Gonzaga, Duchess of Urbino. Santi's portrait must have satisfied Isabella, since she sent it to the Countess of Acerra eight months later, on 13 January 1494.

Since none of these portraits survives, it is impossible now to judge what Isabella may have meant by 'likeness', or by 'to imitate nature', or by 'the natural face'. To judge from the sometimes strident realism of Mantegna's portraiture, it is probably correct to think that his portrait of Isabella was, in fact, too accurate a likeness, and not flattering or idealised enough to be acceptable to her.[26] Perhaps, indeed, 'it did not embody the aspects of her character that she thought a portrait, "al naturale" should depict'.[27] What was required in the portrait of a noblewoman, and what synthesis of likeness and idealisation best communicated the necessary messages about social status, were questions that Leonardo da Vinci too had to grapple with. Because Isabella d'Este was deeply concerned about her position and authority within the Mantuan state, her public image had to be carefully constructed. Portraits had to be recognisably of her, but they also had to convey those particular strengths of her character, and of her cultural and intellectual sophistication, that she sought to present to her audience.[28]

ISABELLA AND A PORTRAIT BY LEONARDO

Isabella d'Este's wish to have a portrait by Leonardo da Vinci may have developed as a result of her knowledge of Leonardo's work at the court of Milan, where her younger sister, Beatrice, was duchess from January 1491 until her early death in childbirth in January 1497. Early in her time as Marchioness of Mantua, Isabella had expressed an interest in having Gian Cristoforo Romano carve a portrait bust of her like that of Beatrice (pl. 56); but no attempt to secure a portrait by Leonardo da Vinci is recorded during the 1490s. The first intimation of her interest in Leonardo's work comes in an exchange of letters with Cecilia Gallerani, Ludovico Sforza's former mistress, who had retired from court life shortly after Beatrice d'Este arrived in Milan to marry the duke.[29] As noted above, on 26 April 1498 Isabella wrote to Cecilia:

> Having happened today to see some fine portraits by the hand of Giovanni Bellini we began to talk about the works of Leonardo, desiring to compare them [*de vederle all parangone*] with these paintings that I have. And recalling that he painted you from life, I beg you to send me this portrait of you by the present courier, whom I have sent with this in mind. For, apart from allowing the comparison [*perchè ultra ch'el ne satisfarà al parangone*], I should gladly see your face. And as soon as the comparison has been made, I will return it to you.[30]

Cecilia Gallerani responded with reservations a few days later:

> I have seen what your Excellency wrote to me about wishing to see my portrait, which I am sending to you. I should send it more readily if it resembled me more. Do not, your Excellency, attribute this to a defect on the part of the master, because in truth I think there is none to be found who equals him; rather it is merely that the portrait was done when I was at an immature age. Since then, I have changed so much from that likeness that to see it and me together, no one would judge that it had been made of me[31]

That Cecilia indeed sent the portrait to Mantua is indicated by her second letter to Isabella, of 18 May 1498, which while not referring directly to the portrait suggests that she had received it back.[32] This portrait is now generally identified as the female portrait by Leonardo da Vinci in Kraków (pl. 58). Unfortunately, no female portraits by Bellini survive, so we cannot follow Isabella in making a comparison between the two masters' portrait representations of women. Nor indeed can we be certain that the Bellini

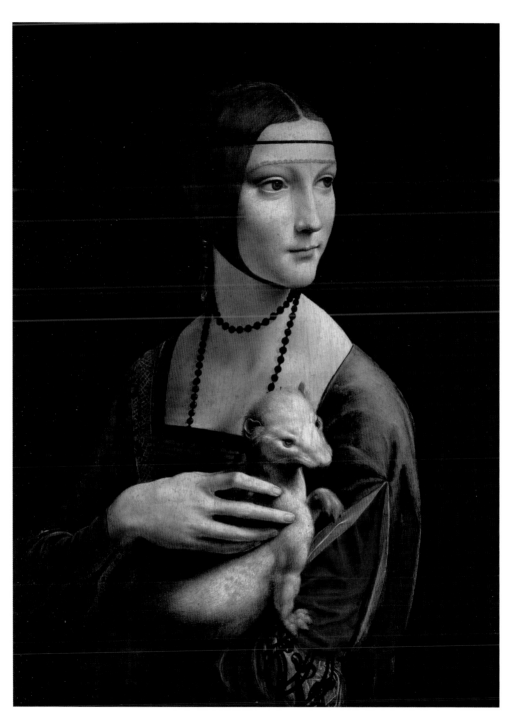

58 Leonardo da Vinci, *Cecilia Gallerani*. Kraków, Czartoryski Museum

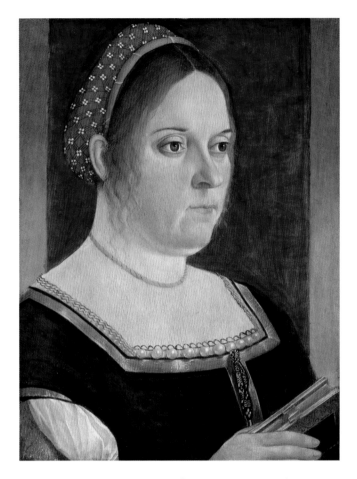

59 Vittore Carpaccio, *Portrait of a Woman*. Denver, Col., Denver
Art Museum, gift of the Samuel H. Kress Foundation, 1961.168

portraits that Isabella 'happened . . . to see' on 26 April 1498 were of women.
If they were, it may reasonably be hazarded that they either were in profile
or perhaps more likely were bust-length, three-quarter view portraits. A char-
acteristic Venetian example of the latter type is the *Portrait of a Woman*
(pl. 59) by Vittore Carpaccio in the Denver Art Museum, Colorado, dating
probably from the late 1490s. Since she holds a book in her right hand, the
sitter is likely to be a literary woman, or like Isabella a woman with preten-
sions towards learning. She has been identified as the poet Girolama Corsi
Ramos, who composed a sonnet praising a portrait that Carpaccio had

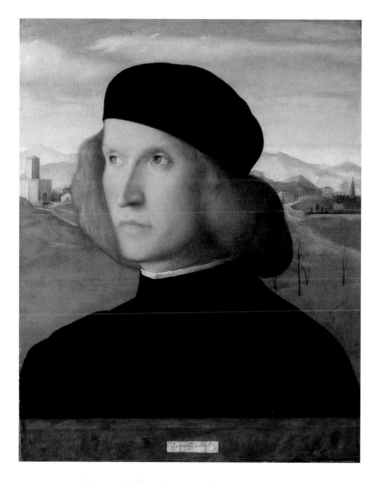

60 Giovanni Bellini, *Portrait of a Man* (?Pietro Bembo).
Hampton Court, Royal Collection

painted of her.[33] Carpaccio no longer used the idealising profile format, which had been conventional in Venice for female portraits until the later fifteenth century: the Denver portrait shows the sitter in three-quarter profile looking out of the picture space to the viewer's right. Her features are individualised, although not strikingly so; but there is little sense of engagement with the viewer, or of the communication of a defined personality.

This compositional formula was used by Giovanni Bellini for male portraits of the 1490s, such as the *Portrait of a Man* at Hampton Court (pl. 60). Here the sitter, sometimes identified as Pietro Bembo, is placed, in three-

quarter view, behind a parapet against an atmospheric landscape background. The parapet helps to define the sitter's position within the pictorial space, distancing him from the observer. A comparison of this portrait with Leonardo's of Cecilia Gallerani emphasises the relatively static pose of Bellini's sitter, who looks abstractedly out of the picture space over the onlooker's left shoulder. The lack of any sense of movement, and the lack of hands or other articulation below the shoulders, strengthens the analogy that is often drawn between such a portrait and a polychromed sculpted portrait bust. Another comparison that might cast brighter light on Isabella d'Este's *paragone* is between Leonardo's *Cecilia Gallerani* and Bellini's depiction of half-length female saints, such as that on the Virgin's right (pl. 61) in the *Madonna and Child with Two Female Saints* (Venice, Accademia), perhaps dating to the early 1490s. It has been noted that here Bellini's 'preoccupation with extreme subtleties of chiaroscuro modelling and with the effect of bodies emerging from darkness into light recalls not only the precept but forcibly also the practice of Leonardo'.[34] The comparison with Leonardo's *Gallerani* portrait is inevitably inexact, however, since Bellini's female saints are of generalised types and typically look downwards with lowered eyes and devout expressions. It is also inexact because the background of the Kraków portrait has been repainted in very dark hues, but originally appears to have been a mid-tone grey-blue, lighter to the right than to the left of the portrait.[35]

By the early 1490s both Bellini and Leonardo had developed a handling of paint that stresses soft, smooth modulations of tone in which light and shade blend seamlessly, without hatching or contour lines. As might have been the case also in Isabella's Bellini portraits, Cecilia Gallerani looks out of the pictorial space of her portrait over the viewer's right shoulder. She twists round, apparently spontaneously, in response to a stimulus within the viewer's space – the arrival of Duke Ludovico, perhaps. In contrast, however, Bellini's portrait sitters, like his female saints, regularly appear remote and introspective, and unresponsive to the world around them or to the observer. In the Gallerani portrait Leonardo has moreover brought to a refined pitch the subtle variation in the play of light across the features to emphasise the contrasting textures of skin, lips and eyes. His treatment has a restrained clarity of description that further enhances the impression of his sitter's actuality; it appears that he has captured a split second in the continuity of her movement, and this adds emphasis to her liveliness. In his sonnet on the *Cecilia Gallerani* portrait, Bernardo Bellincioni noted in particular that 'Cecilia is today the one most beautiful,/Whose splendid eyes cast the sun into shadow', and points out to Nature that 'the more alive and beautiful she is,/The greater will be your glory in the future'.[36] It was perhaps this quality of decorous but living

61 Giovanni Bellini, *Madonna and Child with Two Female Saints*, detail of female saint on the left. Venice, Accademia

presence, shown by Leonardo in the *Gallerani* portrait, to which Isabella d'Este herself referred when she wrote of 'that sweetness and gentleness of expression which is the particular excellence of your art' in her letter to Leonardo of 14 May 1504.[37]

Leonardo da Vinci seems to have left Milan a little over two months after the French troops entered the city on 6 October 1499, following Ludovico Sforza's flight in August 1499. On 14 December he sent the considerable sum

of 600 florins to Florence, an indication that he was preparing to leave Milan and to return to Tuscany or to move even further to the south. In a brief note in the so-called 'Ligny Memorandum' in the Codex Atlanticus, which reads as though it is a list of tasks he had to undertake before leaving Milan, he told himself to 'find Ligny and tell him that you will wait for him in Rome and that you will go with him to Naples'. His initial plan may therefore have been to move down the peninsula to Naples, perhaps in the company of Count Louis de Ligny, a French nobleman who had come to Milan with Louis XII.[38] However, in the event Leonardo travelled eastwards to Venice, pausing for a while in Mantua. The evidence for this comes in a letter of 13 March 1500 from Lorenzo da Pavia, the celebrated musical-instrument maker who often acted as an agent for Isabella d'Este in Venice. In this letter Lorenzo announced that he was sending Isabella a large black and white lute, adding that 'there is in Venice Leonardo da Vinci, who has shown me a portrait of your Excellency which is very like you. Indeed it is so well done that it is not possible to improve on it.'[39]

Aside from the implication in this statement that Leonardo made the portrait in Mantua, we have no record as to why and how long he stayed there. Perhaps he was invited to Mantua by Isabella d'Este herself in October 1499, after the fall of Milan. It could well be that she had been hoping to commission a portrait from Leonardo ever since she made the *paragone* between the *Cecilia Gallerani* portrait and those by Bellini that she 'happened . . . to see' on 26 April 1498, around eighteen months earlier. In the lengthy correspondence between Isabella and her agents in Venice a few years later about acquiring a painting by Giovanni Bellini, no mention is made of an earlier portrait commission.[40] This may suggest that the 1498 portrait comparison had turned out in Leonardo's rather than Bellini's favour. The fall of her brother-in-law Ludovico Sforza and Leonardo's departure from Milan provided Isabella with the chance to secure his services. However, Leonardo clearly could not have spent long in Mantua since he was still in Milan on 14 December 1499, and was in Venice at latest by 13 March 1500, working for the Venetian Republic as a military consultant. By the end of that month he had returned to Florence.[41] He must therefore have stayed in Mantua for at most a little under three months: not long enough for him to produce a painted portrait, especially at the slow pace at which he tended to work. Indeed, as Isabella later reminded him, 'When you . . . did my likeness in charcoal, you promised me you would portray me once more in colours.' This portrait drawing was clearly as far as the project reached during that time.[42]

From the correspondence, it is known that at least two portrait drawings of Isabella were made during Leonardo's sojourn. The first is the one men-

tioned in Lorenzo da Pavia's letter of 13 March 1500. The second is recorded by Isabella herself, in a letter written by her secretary on 27 March 1501 to Fra Pietro da Novellara. Formerly Isabella's confessor, Fra Pietro was the Vicar-General of the Carmelite Order in Florence, and he served as one of her agents in Florence at this time. As noted in chapter two, Isabella asked Fra Pietro to explore whether Leonardo might feel inclined to paint a picture for her *studiolo*; or if not, whether he might be persuaded to make her a small painting of the Madonna and Child, 'devout and sweet as is his natural style'. She also asked Fra Pietro to request Leonardo to send another drawing of her portrait, because 'his Excellency my husband has given away the one he left for me here'.[43] It is worth noting in passing that Isabella asked for 'uno altro schizo del retratto nostro' (another sketch of my portrait). The term 'schizo' might now suggest a considerably less formal or finished portrait drawing than either of those that survive. But for Isabella it probably meant a drawing made in preparation for a work in a more permanent medium. Indeed, in his reply Fra Pietro uses exactly the same word to characterise a lost cartoon of the *Virgin and Child with St Anne*, the only work that Leonardo had started since returning to Florence: 'facto solo . . . uno schizo in uno cartone: finge uno Christo bambino de età cerca uno anno' (he has only done one sketch, a cartoon which depicts a Christ child of about one year old). Moreover, he observes that 'questo schizo ancora non è finito' (this sketch is not yet complete).[44] Again the implication is that this was intended to be a finished drawing, a cartoon that in appearance was probably similar to the Burling-ton House cartoon in the National Gallery, London. Vasari's account also indicates that this was the case: after keeping his clients, the friars of Santis-sima Annunziata, waiting for a long time, Leonardo 'finally did a cartoon showing Our Lady with St Anne and the Infant Christ', and 'this cartoon was subsequently taken to France'.[45] Fra Pietro described the unfinished cartoon as a 'schizo', and in parallel Isabella d'Este asks for 'uno altro schizo' of her portrait, implying that the drawing left by Leonardo in Mantua was also, for her, a 'schizo'.

The possibility that Leonardo acceded to Isabella's request for another version, and that a third portrait drawing once existed, should be borne in mind. However, Fra Pietro's response to Isabella cannot have sounded promis-ing to her. He wrote on 3 April 1501 that

> as far as I know, Leonardo's life is changeable and greatly unsettled, because he seems to live from day to day. Since he has been in Florence, he has only done one sketch, a cartoon . . . He has done nothing else except that two of his assistants have been making copies, and he occasionally puts his

own hand to some of them. He gives pride of place to geometry, having
entirely lost patience with the paintbrush.[46]

Fra Pietro followed up this account in another letter eleven days later, writing:

> During this Holy Week I have learnt of the painter Leonardo's intention
> through Salaì, his pupil, and a few other of his devoted friends, who, to
> apprise me further, brought him to me on the Wednesday of Holy Week.
> In short, his mathematical experiments have so distracted him from paint-
> ing that he cannot endure his brush. Nevertheless, I was tactful enough to
> ensure that your Excellency's opinion was made known to him . . . seeing
> that he was most willing to gratify your Excellency, for the kindness you
> showed him in Mantua . . . But anyway, once he has delivered a small
> picture which he is doing for a certain Robertet, a favourite of the King of
> France, he would do the portrait immediately and send it to your Excel-
> lency . . . This is as much as I have been able to do with him.[47]

Given this report to Isabella about Leonardo's activities in spring 1501, it
seems unlikely that Leonardo produced for her a third version of her portrait
drawing: it is probably safe to assume that there were originally only two. At
any rate, only two versions of a large portrait drawing of Isabella d'Este
survive: a seriously damaged drawing (pl. 62) by Leonardo da Vinci himself
is in the Louvre, and a copy made in Leonardo's workshop (pl. 63) is now in
the Ashmolean Museum, Oxford.[48] It is reasonable to assume that these two
drawings are the two mentioned in the correspondence. Unfortunately, we do
not know which of them was the one that Lorenzo da Pavia saw in Venice in
March 1500, and which was the one that her husband Francesco Gonzaga
gave away a year or so later. On balance, however, it seems more likely that
the autograph portrait drawing in the Louvre was the one left in Mantua by
Leonardo, given its higher quality and its greater degree of finish, extending
to the heightening of the face and dress with the addition of colour. If so, the
drawing seen by Lorenzo da Pavia in Venice was presumably the copy now
in Oxford, which has more than enough detail to have served as the model
on which the projected portrait 'in colours' would be based.

It is normally assumed that Isabella's portrait 'in colours' was to be a fin-
ished painted portrait: this is very probably correct since she herself refers to
the highly finished drawing as merely a 'sketch' of her portrait. As far as we
know, however, Leonardo never completed a painted portrait based on either
version of the Isabella d'Este drawing, and he probably never even began one.
He certainly did not stay in Mantua long enough to finish – or probably even
to start – such a painting: indeed, had he done so, Isabella would not have

needed to remind him in May 1504 that he had promised to portray her 'in colours' one day.[49] In this same letter, however, she finally absolved Leonardo of the portrait project. She hoped that instead he would paint for her not the 'small picture of the Virgin' that she had asked Fra Pietro to commission for her, but a painting of the twelve-year old Christ. In 1506 she appears to have given up hope of obtaining this or any other work by Leonardo da Vinci. The Louvre portrait cartoon remains, therefore, the only surviving autograph work made by Leonardo for Isabella d'Este.

THE LOUVRE DRAWING OF ISABELLA

The portrait drawing in Paris is on an unusually large scale for a Renaissance drawing, measuring 610 by 465 millimetres; the slightly larger copy in the Ashmolean Museum measures 626 by 483 millimetres.[50] Being life-size, the Louvre drawing is also unusually large for a female portrait made in northern Italy at the turn of the century: the portrait that Leonardo promised to paint would have been considerably more monumental in scale than almost all female portraits of the time.[51] The drawing is in black chalk, to which red and white chalk highlights were added for the modelling of the face. It has at times been suggested that the yellow-ochre pigment that colours details of the sitter's dress was added in pastel form. The most recent analysis, in the catalogue of the exhibition of Leonardo da Vinci drawings held at the Louvre in 2003, has cast doubt on this.[52] It is there stated that the drawing is essentially in black chalk, using chalks of different tonalities of dark grey into black, into which is fused some red chalk especially around the profile and on the face, the hair and the right hand. To this, it is suggested, was added yellow-ochre chalk for the upper border and on the ornamental stripes of the sitter's chemise, and a very lightly applied white heightening on her throat, cheek and forehead. However, the use of yellow-ochre chalk would be unique in Italian Renaissance drawing: there is no evidence that this material was quarried and exploited in drawing as early as 1500. It remains a possibility that the touches of yellow-ochre were applied with a pastel: this too would have been technically unusual, but it is not unique in drawing in Italy at the time.

In the 'Ligny Memorandum' in the Codex Atlanticus, Leonardo da Vinci reminded himself to 'get from Jean de Paris the method of dry colouring and the method of white salt, and how to make coated sheets, single and many doubles; and his box of colours; learn the tempera of flesh tones, learn to dissolve gum lake'.[53] Given the context, including the comment on preparing 'coated sheets', 'dry colouring' probably here refers to colouring drawings with

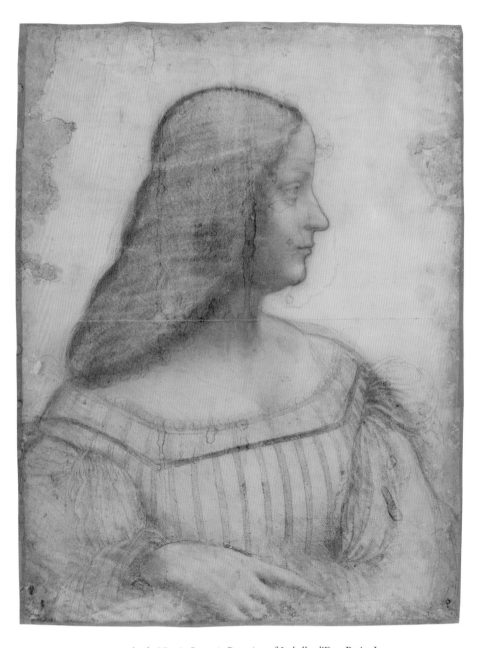

62 Leonardo da Vinci, *Portrait Drawing of Isabella d'Este*. Paris, Louvre

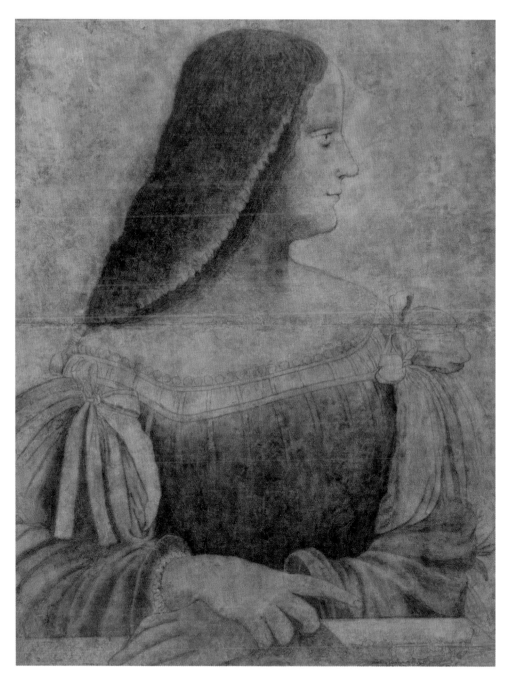

63 Leonardo da Vinci, *Portrait Drawing of Isabella d'Este*. Oxford, Ashmolean Museum

a dry technique rather than with watercolour washes. This memorandum is normally dated to autumn 1499, soon after the fall of Duke Ludovico Sforza. It has recently been suggested, however, that Jean de Paris, who is identifiable as the French painter Jean Perréal, also came to Milan in 1494 with the French king Charles VIII.[54] Meeting then with Perréal, Leonardo could have learned as early as 1494 the 'method of dry colouring' – the French technique 'à trois crayons' (drawing in black, red and white chalks). This method was used by the draughtsman, very possibly Leonardo himself, of the recently discovered portrait of Bianca Sforza (pl. 72), which is datable to 1496.[55] However, it might also be that Perréal's 'box of colours' was a set of synthetic chalks in which pigments were bound in a medium such as gum to make pastel sticks. If so, he seems to have been responsible for introducing to Italy the French genre, later much used by Jean Clouet amongst others, of the portrait 'au crayon'. Leonardo's colleague Boltraffio, who hitherto had made drawings with a fine silverpoint, responded readily to the opportunities presented by Perréal's new technique for making coloured drawings. Three drawings made by Boltraffio between 1500 and 1502 show his increasingly accomplished handling of pastels. His *Head of a Woman* (Uffizi 17184F), in pastels and white heightening, was made as a study for the head of the Madonna in the Pala Casio, originally dated 1500. Two drawings in the Biblioteca Ambrosiana, a *Study of a Youth* and especially the *Study for the Head of a Woman* (pl. 64), for the *St Barbara* commissioned for Santa Maria presso San Satiro, Milan, in October 1502, demonstrate Boltraffio's rapid assimilation of the pastel technique.[56] Leonardo also may have learned the technique from Perréal, and may have used a yellow-ochre pastel in the Isabella d'Este portrait drawing.

We cannot, however, be sure now that the yellow-ochre colouration is pastel, because of the severely rubbed state of the Louvre drawing. The sheet has been considerably trimmed, especially at the left-hand side and along the base; and the drawing is generally in poor condition – it is fragile, folded horizontally across the centre, much stained and discoloured, and a good deal reworked in later times. Its damaged condition led critics in the past to doubt that it is an autograph Leonardo drawing, or that it was the drawing intended as the prototype for the painted portrait that Isabella d'Este had commissioned. Kenneth Clark, for example, in his celebrated monograph on Leonardo, not unreasonably pointed out that 'the right arm [is] in a position anatomically false. The arm is shown correctly drawn in an otherwise feeble replica at Oxford, and the natural inference is that the Louvre cartoon never was Leonardo's original.'[57] The pose and anatomical articulation of the right arm is indeed an apparent weakness, although another explanation for this may be preferable to Clark's deduction. Recent critics have tended to be more

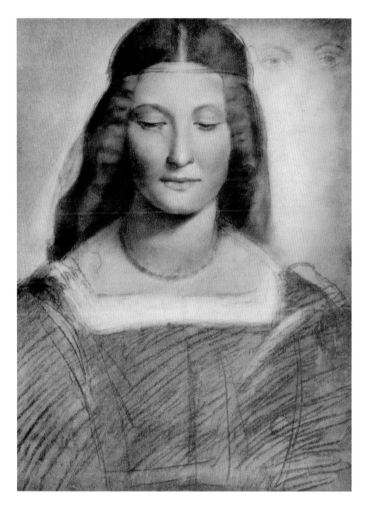

64 Giovanni Antonio Boltraffio, *Study for the Head of a Woman*. Milan,
Biblioteca Ambrosiana

positive about the quality and status of the Louvre cartoon, affirming for example that 'both an exquisite treatment of surface and a highly refined use of medium would seem to confirm the long-standing traditional attribution to the great master'.[58]

The Louvre portrait drawing is richly worked and highly finished. Its autograph status is confirmed by traces of parallel diagonal hatching lines drawn from upper left to lower right, characteristic of Leonardo's left-handed drawing technique. For the most part, however, the tonal variation across the

65 ?Andrea Mantegna, *Portrait Drawing of Francesco II Gonzaga.*
Dublin, National Gallery of Ireland

surface is continuous: Leonardo used smudging or stumping to generate infinitely subtle tonal gradients, thus producing a close analogy with the *sfumato* effects of his painting technique. The black chalk articulation of the forms was laid in over a light underdrawing, probably also in black chalk, which charts the contours of the structure of the forms around, for example, the facial features and the top of the right hand. Over this were added light, smoothly stumped touches of red chalk, to heighten the warmth and texture

of the flesh parts, especially over the cheek. Delicate white highlights were also added to help to define further the three-dimensional relief of the profile.

In early 1500 the Louvre drawing was presumably to have served as the basic compositional prototype for Leonardo's promised portrait 'in colours'. The complexity of the technical treatment, combining a number of applications of different chalks over a slight whitening of the paper around the head, implies, however, that the drawing could well also have been intended as a finished portrait in its own right. The Louvre drawing is perhaps the most sophisticated and finely finished example of the genre of autonomous portrait drawing that evolved in northern Italy towards the end of the fifteenth century. Finished portrait drawings of the mid-century survive in the oeuvre of Pisanello; and Mantegna's enquiry to Ludovico Gonzaga in 1477 as to whether a group of commissioned portraits should be merely drawings or should be painted in colours demonstrates that the genre was current in Mantua some twenty-five years before Isabella's portrait drawing was made.[59] If Isabella's portrait was indeed understood as a work of art in its own right, it might perhaps be seen as her response to a portrait drawing of her husband Francesco Gonzaga (pl. 65), made probably by Andrea Mantegna in the mid-1490s.[60] The differences between the two are, however, suggestive. The direct appeal of this full-face portrait of Francesco, whose eyes engage disarmingly with the viewer, is comparable with portraits by Mantegna included within the figure groups of the Camera Picta. It is an unusual, and unusually frank, exploration of how to establish eye contact to encourage the viewer to recognise, and relate to, the sitter's individuality. The Louvre drawing, commissioned presumably by Isabella herself, is considerably larger and more sophisticated in execution than her husband's portrait drawing. But the psychological detachment inevitable in the idealised, profile format of Isabella d'Este's portrait makes a telling contrast with the vivid engagement of her husband in his drawn portrait.

THE PRICKING, AND THE COPIES, OF THE LOUVRE DRAWING

Conclusions about what, if any, uses were made of the Louvre cartoon depend on how best the pricking of the sheet should be interpreted.[61] So refined is the drawing's finish that it may seem hard to imagine that Leonardo, or indeed Isabella herself, could originally have intended it to be pricked. But at this time the standard technical procedure for the transfer of a design from one surface to another was to prick along the outlines of the drawn forms through to a second, blank sheet of paper laid beneath the drawing. This 'secondary

cartoon' was then laid over the surface onto which the design was to be trans-
ferred, and charcoal dust was pounced through the pinpricks to leave lines of
spolvero dots. There is no sign of pouncing dust on the surface of the Louvre
portrait drawing, which indicates that Leonardo indeed pounced through a
secondary cartoon to transfer the design onto another sheet for the second
version of the drawing that Lorenzo da Pavia saw in Venice on 13 March 1500.
As noted, this was probably the workshop copy in the Ashmolean Museum,
which is not pricked and so was presumably not intended (or at least, not
used) as a cartoon for design transfer, but as guidance for Leonardo when he
came to work on the promised painted portrait. It does, however, show some
spolvero dots, indicating that it was worked up from a pricked cartoon.
Leonardo could later have used the secondary cartoon to transfer the design
also onto a prepared panel for the painted portrait; or indeed to another sheet
of paper for the third version of her portrait drawing requested by Isabella in
April 1501 – if either of these works was ever started.

 At the right-hand lower corner of the verso of the Louvre portrait drawing,
a little below the point on the recto where the sitter's right elbow abuts the
edge of the paper, a small rectangle of paper has been stuck to the sheet to
provide support at a particularly delicate and damaged point.[62] The paper
used here is coarser than that of the cartoon proper, and the patch may very
well have been applied a considerable length of time after Leonardo da Vinci's
lifetime. Clearly it cannot have been attached as reinforcement until such time
as a few centimetres had been trimmed off the bottom of the sheet, presum-
ably because it had been damaged through wear and tear. The extra patch too
is pricked, and this has been taken as evidence that the entire drawing was
pricked long after it was originally drawn. But these prick-holes are slightly
larger in diameter than across the rest of the sheet, and were therefore made
with a different needle and, it may be presumed, at a different time from the
pricking of the sheet as a whole. Throughout the sheet the prick-holes are
evenly spaced, irrespective of the relative significance of the outline being
pricked. This differs from Leonardo's own normal practice, to be seen for
example in the black chalk grotesque portrait at Christ Church, Oxford
(pl. 66).[63] Here the density of pricking varies widely in relation to the impor-
tance of nuance and detail of the line being pricked. The pricking around the
back and top of the head, and on the neck and shoulder, is more widely spaced
than the fine pricking around the bulbous, almost deformed features of the
nose, mouth and jaw; and the vigorous curls of the hair are not pricked at
all. It seems very likely that the Louvre drawing of Isabella d'Este was evenly
and monotonously pricked not by Leonardo himself, but by a careful crafts-
man entrusted with this mechanical task. This assistant might have been his

66 Leonardo da Vinci, *Portrait Drawing of a Man* (?Scaramuccia, Captain of
the Gypsies). Oxford, Christ Church Gallery

pupil Giacomo Salaì, who was with Leonardo in Florence in 1501 and prob-
ably travelled with him from Milan to Mantua in December 1499.[64]

While the recto of the Louvre sheet shows no sign of pouncing dust, there
are clear signs of such a dusting on the verso, and some pouncing charcoal
survives within the prick-holes. This suggests that the design was pounced

through from the back, resulting in a reversed *spolvero* design on a surface beneath it. In this case, however, the sitter, facing to the left, would be making her downwards-pointing gesture with her left hand: this can hardly have been intended by Isabella herself. It is possible that the pouncing from the reverse was done in preparation of a finished work in which the image would be reversed, such as an engraving. However, the portrait engraving is a rare genre as early as 1500, and despite the opportunity it would have offered for the reproduction and dissemination of Isabella's portrait, it seems unlikely that an engraving on this scale would, or even could, have been made at this date. A woodcut could perhaps have been made on the basis of the reversed design, but no impression from such a block survives, and once more a woodcut print on this scale would be exceptional: this possibility therefore remains entirely hypothetical. Alternatively, the charcoal dusting on the verso might have been used as a sort of 'carbon paper', and the design transferred by lightly drawing a stylus along the outlines on the recto; there is, however, no sign of such incisions, which would have made the drawing even more fragile.

On balance, it seems unlikely that Leonardo himself was responsible either for the pricking or for the transfer of the design through a secondary cartoon to the Ashmolean sheet, or indeed for much if any of the execution of this drawing. The draughtsman of the Ashmolean copy seems to have made determined efforts to conceal the *spolvero* marks left by the pouncing process. Despite this, on close examination some *spolveri* can be identified on this sheet, in the decorative circles that run across the top of the border of Isabella's dress, in the stripes that vertically cross this border, and in the highlighted ripple of curls of her hair. That the Ashmolean drawing was duplicated from the Louvre sheet by a mechanical process also seems to be confirmed by the identical scale and dimensions of the two profiles. However, the copy shows several quite significant differences from the Louvre drawing, which may indicate changes of mind at the time that the chalk drawing was made over the *spolveri*. There are noteworthy changes in her dress, in particular the addition of elaborate bows that tie her sleeves onto her robe at the shoulders. The patterning of stripes across the border of her robe and onto her torso has also been regularised, such that each stripe is continuous, which is not the case in the original: the draughtsman of the Ashmolean sheet has not followed the *spolveri* precisely in this area.

Perhaps the most significant change between the two drawings appears in the copyist's treatment of the sitter's right shoulder and arm. The hypothesis that the Louvre drawing was pricked by a relatively unaccomplished assistant within Leonardo da Vinci's entourage in Mantua might also explain the awkwardness, attributed by Kenneth Clark to a copyist, in the articulation of the

sitter's right arm. Comparison of the measurements of the copy and the Louvre drawing indicates that the height of the original is 16 millimetres less, and the width 18 millimetres less, than the copy. The trimming of the Louvre sheet along the left-hand side has rendered the anatomical structure of Isabella's right arm considerably more difficult to decipher than in the Ashmolean copy, in which it is reproduced more accurately and more per-suasively. Moreover, the modelling in black chalk of the forms of the right arm has all but entirely disappeared through rubbing over time, and the lines of prick-holes provide little information about the forms beneath the sleeve. By lengthening the torso and lowering the hands the copyist was able to correct the discomforting effect of the anatomical structure of Isabella's right arm, as articulated in the pricking of the Louvre original.

In the Ashmolean drawing the figure of Isabella d'Este is set considerably higher up the sheet than in the Louvre original. This has allowed the copy-draughtsman to correct the rather squat proportions of the figure's lower section. He introduced a gap of some two centimetres at the right shoulder between the termination of Isabella's hair-net and the top of her robe. The insistent ripple of the contour of the hair at the back of Isabella's head is also modified down: one of the results of this is that the band that runs from the back of the head to the forehead to hold the hair in place cuts less deeply into the bulk of the sitter's hair at the back. Either through poor drawing or through the effects of abrasion and restoration over time, or both, Isabella's right hand in the Ashmolean copy is weakly articulated: it has little of the sense of bone structure of the right hand to be seen in the Louvre original. Tellingly, the index fingernail is shown 'full-face' rather than foreshortened from the right, as though the sitter's finger is twisted round as it points down towards the book. Although the position of the hands has been altered, the contours exactly match those of the Paris original, which implies again the mechanical transfer of this feature, but to a slightly different position with respect to the rest of the figure.

As previously noted, the Ashmolean copy also shows that the Louvre drawing has been substantially cut at the base, presumably because the lower edge of the paper had become damaged and had deteriorated. It was trimmed by at least two centimetres, and only after this trimming was the extra patch of paper stuck for support to the right bottom corner of the verso. The Ashmolean sheet also shows signs of damage at the base, which has been made good at some time in the past. If, as seems likely, Isabella's left hand as well as her right was originally complete, this sheet itself may have lost two or three centimetres at the base, which implies that the Louvre sheet may orig-inally have extended downwards by as much as a further five centimetres. It

can be seen from comparison with the Ashmolean copy that the two horizontal lines of prick-holes close to the bottom of the Louvre sheet represent the top cover of a book that originally lay on a parapet in front of the sitter. The presence of the book explains the demonstrative, pointing gesture of Isabella d'Este's right index finger; the book was included as an attribute presumably of particular significance for her.

The Ashmolean drawing has been heavily and rather coarsely reworked, especially in the lower half. Here a considerable amount of chalk and white heightening was pastily applied to the torso and the drapery folds of the sleeves at some later date. In some passages, however, the drawing is of higher quality than is generally acknowledged, especially in the subtle modelling of the sitter's features and on the jaw, throat and neck area. It may also be noted that the copyist corrected the relative weakness of Isabella's chin in the Louvre drawing, by extending the jaw back towards the neck and by pressing the chin slightly forward. In drawing the contour through the *spolvero* dots, he introduced an added element of idealisation that would be appropriate to the painting that was to be based on the Ashmolean drawing.

The copy-drawing in the Ashmolean Museum therefore provides useful and important evidence about Leonardo da Vinci's treatment of his sitter and her portrait, over and above that to be gleaned from the worn and damaged original. Further evidence is offered by a series of four copies apparently of Isabella d'Este's profile head and shoulders in the Louvre drawing. These are now in the Uffizi, Florence (pl. 53), in the British Museum, London (pl. 67),[65] and two in the Staatliche Graphische Sammlung, Munich (pls 68–69). All four portraits were drawn in smoothly stumped red chalk, over traces of light black chalk underdrawings, in a technique and style that suggest the work of Lombard draughtsmen in Leonardo's broader circle. These draughtsmen probably belonged in a single workshop, perhaps located in Mantua. They might have been assistants in the workshop of one of Francesco Gonzaga's court artists, or they might have come to Mantua specifically for the purpose of making drawings that reproduced Isabella's image. The drawings are not likely to date later than 1510.[66] According to Isabella herself, however, by 27 March 1501 Francesco Gonzaga had given away the portrait drawing (very probably the Louvre drawing) that Leonardo had left in Mantua.[67] It is not now known to whom Francesco gave it, or why; nor therefore do we know where this drawing was in around 1510, and how it might have been available to a copyist. No such object as the Louvre portrait drawing appears in any Gonzaga inventory, least of all in the 1542 Stivini inventory of the contents of Isabella d'Este's apartments, which suggests that it did not remain in Gonzaga hands. Nothing, in fact, is known of the whereabouts and

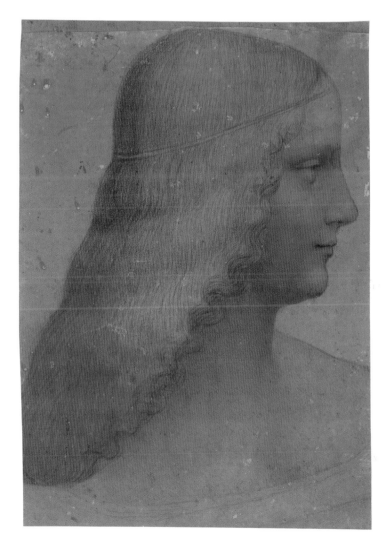

67 After Leonardo da Vinci, *Portrait Drawing of Head of Isabella d'Este*.
London, British Museum, 1940-4-13-59

provenance of the Louvre drawing before it was acquired by the Louvre, as the drawing of 'une jeune dame de profil, superbe dessin au crayon noir', at the sale in 1860 of the great Giuseppe Vallardi collection.[68]

The Uffizi drawing, the finest of the series, may well have been copied from the Louvre drawing itself: the profiles shown in the two drawings are almost identical in scale and closely similar in likeness, and no other example of the

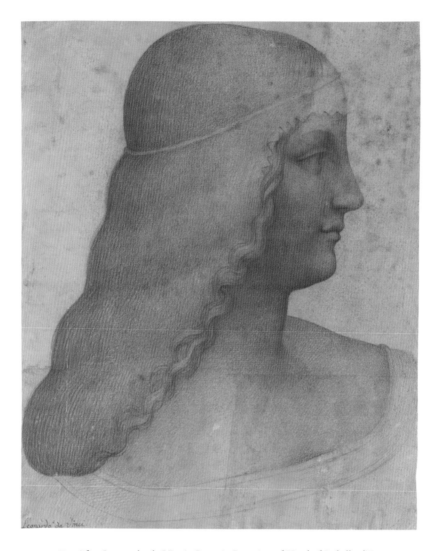

68 After Leonardo da Vinci, *Portrait Drawing of Head of Isabella d'Este*.
Munich, Staatliche Graphische Sammlung

portrait is known that could have served in early sixteenth-century Mantua as the prototype for the Uffizi copy. Francesco Gonzaga might have given the Louvre portrait drawing to somebody who was ready to encourage and assist in the production of replicas of Isabella's profile face, perhaps for further dissemination of her image. Indeed, either Francesco or Isabella herself might have commissioned the drawings as graphic equivalents of her cast-bronze

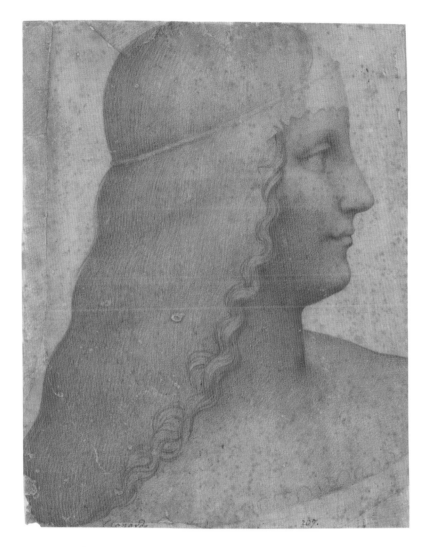

69 After Leonardo da Vinci, *Portrait Drawing of Head of Isabella d'Este.*
Munich, Staatliche Graphische Sammlung

medal. If so, the group would appear to be the earliest example of a female
portrait drawing being reproduced in copy-drawings for distribution. The
other three drawings may in turn be copies of the Uffizi sheet rather than of
Leonardo's original itself. However, none of these drawings shows any sign of
spolvero dots, or of any other method of mechanical transfer; indeed, had they
been transferred by *spolvero* there would have been no need for the brief black

chalk underdrawings. Small differences in measurements, of for instance the setting of facial features with respect to the profile outline, and in how the forms and features are articulated, also indicate that each drawing is an independent freehand copy. That they were not produced by design transfer suggests that they were not, in fact, intended as a formal 'edition' of an Isabella d'Este portrait. Any such edition would have been most easily generated by transferring the design by pouncing, although that would have entailed spoiling the Louvre drawing by pouncing charcoal dust onto its surface, for Leonardo had presumably taken the 'secondary cartoon', apparently used for transferring the design onto the Ashmolean sheet, with him to Florence in March 1500. This group of copies is therefore perhaps best explained as the result of a workshop exercise in copy-drawing, using a celebrated image as prototype. It might also, of course, have been in the workshop master's mind that these drawings might have some retail value in early sixteenth-century Mantua.

Like the other copies, the Uffizi portrait drawing (pl. 53) differs from the Louvre original principally in that Isabella d'Este's nose is slightly less protruding, and her lengthened hair spills over the border of her robe at her right shoulder. These small changes may have been an attempt to make Isabella appear slightly younger, prettier and less formal than in Leonardo's original. Otherwise, this drawing appears to be a precise copy that offers some evidence of what badly abraded passages in the Louvre drawing, such as the lights in the hair and the curls of hair running down beside her cheek and neck, may originally have looked like. All four copies also show what is now difficult to read from the Louvre and Ashmolean drawings: that Isabella wore a veil over her hair, which fell in a crimped edge across her forehead. The band holding the veil, running across the sitter's forehead and round to the back of her head, presses more firmly into the hair than is shown in the Ashmolean copy. In this respect the red chalk drawings follow the Louvre original more faithfully. The British Museum version (pl. 67) seems less refined in handling than the other three, especially in the articulation of the hair and of the hair-band. The modelling of the face and features lacks the subtlety of the Uffizi version, and the small eye is relatively inexpressive. In both the versions in Munich (pls 68–69) the eyes are larger and the mouth curves up at the corner more than in the other copies. The treatment of the top border of Isabella's chemise also varies, further suggesting that the British Museum sheet and both the Munich drawings may have been copied independently from the higher-quality version in the Uffizi.

The exact status and function of these four closely comparable copies of Isabella d'Este's profile will probably never be definable. Nevertheless, their

production probably sometime between 1500 and 1510 suggests that the draughtsmen took a special interest in this image, and perhaps that there was an identifiable consumer demand for it in Mantua at the time. It remains possible that they were made at Isabella d'Este's own request, as replicas of a valued image of herself, perhaps for distribution to friends or courtiers to keep her likeness in their presence and memory. Although they contain less information than does the Louvre original about Isabella's self-fashioning, they do conform with the idealised image of herself that she appears to have sought to disseminate in the first decade of the new century.

THE IMAGE OF ISABELLA IN AROUND 1500

The first historian to identify the Louvre drawing as a portrait of Isabella d'Este, and indeed as the 'portrait in charcoal' to which Isabella referred in her 14 May 1504 letter to Leonardo, was Charles Yriarte, in the first of a celebrated series of articles on Isabella and the artists of her time.[69] A major argument in favour of the identification was the parallel between the sitter's profile and the medal of Isabella (pl. 57) cast in 1498 – some eighteen months earlier than Leonardo's drawing – by Gian Cristoforo Romano. By cutting out the head for copying from the rest of Isabella's body shown in the Louvre drawing, the draughtsmen of the four red chalk copies perhaps intentionally produced an image that looks even more like an *all'antica* medallic profile. Despite the difference in scale of the medal and the Louvre drawing, the similarity between them is striking: the comparison immediately suggests that in presenting her profile for Leonardo to draw, Isabella intended that Leonardo's promised portrait 'in colours' should possess a medallic character. A later parallel is the relationship between frontally posed torso and the profile head, based on a medal rather than on life, of King François I in Titian's celebrated portrait in the Louvre (pl. 70).[70] However, in the Louvre drawing of Isabella d'Este the sense of distanced, idealised dignity, which a medallic profile frequently possesses, contrasts with the qualities of inherent life and of emotional engagement in painted portraits by Leonardo. The misnamed *La Belle Ferronnière* (pl. 71), probably to be identified as Lucrezia Crivelli (like Cecilia Gallerani, a mistress of Ludovico Sforza), twists her neck round over her left shoulder almost to make eye contact with the observer. Similarly, as observed earlier, Cecilia Gallerani is captured in fleeting movement as she responds vividly to a stimulus that she sees or hears to the observer's right. Leonardo's experience in these two female portraits, and the 'concetti dell'anima' – the movements of the mind – that he successfully sought to

70 Titian, *King François I*. Paris, Louvre

represent in them, may have been a factor in his failure to produce the portrait that he had promised to base on the Louvre drawing. The sharp twist of Isabella's profile head against the slight turn of the shoulders and the delicate pose of the hands does communicate a certain sense of vitality. But Isabella turns away from the viewer and is thus unable to engage or to communicate her personality or feelings directly. It is not likely that Leonardo would have wished to portray her thus, had he had any choice in the matter. As noted earlier, in 1498 Isabella borrowed Cecilia Gallerani's portrait to compare it with portraits by Giovanni Bellini, and perhaps on the basis of this very comparison she later chose to have herself portrayed by Leonardo. It seems ironic that by requiring the profile pose for her head she should have rejected those

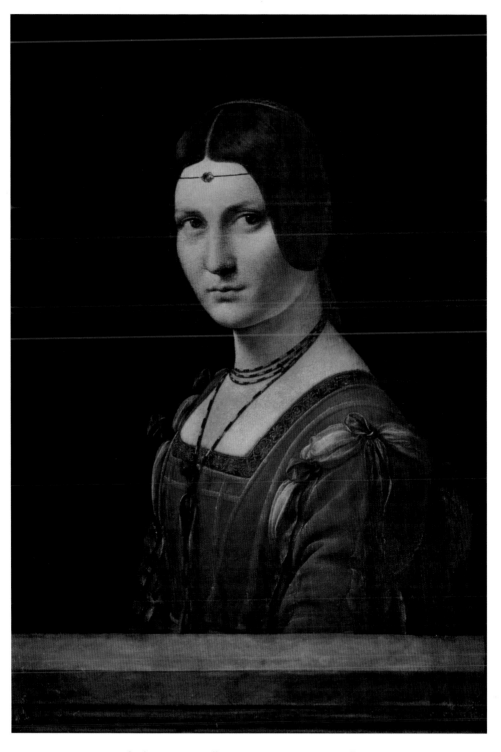

71 Leonardo da Vinci, *La Belle Ferronnière* (?Lucrezia Crivelli). Paris, Louvre

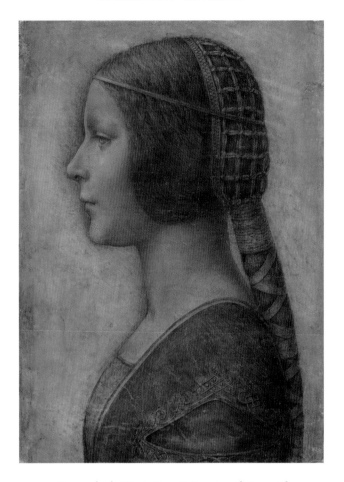

72 ?Leonardo da Vinci, *Portrait Drawing of Bianca Sforza*.
Private collection

very qualities of immediacy and vitality at which Leonardo excelled in earlier
portraits.

This is not to say that Leonardo on principle eschewed the profile repre-
sentation of the heads of his figures: that is far from being the case. Indeed,
it has recently been suggested that 'Leonardo generally preferred to draw the
head in profile'.[71] This is certainly true for his numerous grotesque heads, if
only because the character of a physiognomy is probably more readily cap-
tured in the profile contour. By extension, it is true of the pairs of confronted
beautiful and ugly heads that Leonardo often drew;[72] and it is true of classi-
cised, ideal portraits such as the drawing on vellum of Bianca Sforza (pl. 72)

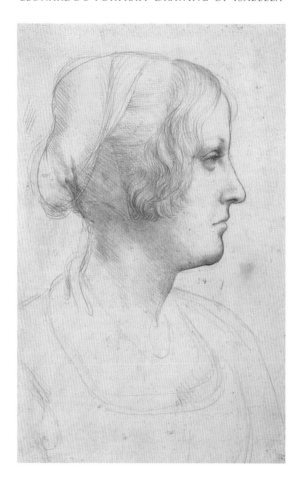

73 Leonardo da Vinci, *Profile Portrait of a Woman.*
Windsor, Royal Library, RL 12505

recently attributed to Leonardo, or those drawn towards the end of his career that are sometimes identified as portraits of Salaì.[73] A number of rapid pen-and-ink sketches of profile heads, of both men and young women, appear on a very early, large sheet of miscellaneous studies;[74] and an exquisite silverpoint drawing (pl. 73) of the later 1480s was probably made very deliberately as a study in physiognomy, an objective record of facial contour and features.[74] But aside from studies of grotesque types and the portrait drawing of Isabella d'Este, none of Leonardo's surviving depictions of women made after the mid-1490s, whether drawings or paintings, whether portraits or studies for such paintings as the lost *Leda and the Swan*, shows the head in profile. It is diffi-

cult to believe that Leonardo could have wished to depict Isabella in this pose: the choice was almost certainly Isabella's. Why she should have chosen to be shown in pure profile requires explanation.

Casts of Gian Cristoforo Romano's medal of Isabella (pl. 57) were in circulation by September 1498, and it seems very likely that Leonardo had an example of it before him as he worked on his portrait drawing. When in 1503 Gian Cristoforo cast the example of the medal in gold (see pl. 37) that became a prize exhibit in Isabella's *studiolo* and later in the *grotta*, he reworked the mould for the obverse. He enriched the detail of the curls of her hair and omitted the last four letters of the original inscription ISABELLA ESTEN MARCH MANTUAE so as to emphasise the truncation of the bust. In the 1498 version the curls and curves of hair that flow down across her cheek are fully defined, as they also appear sharply drawn in the four head-and-shoulders copies after the Louvre drawing. Her hair in the medal is, however, looser than in Leonardo's portrait drawing, where it is held in place by the band that stretches from her hair-line on the forehead to the back of her head and is more firmly restrained within a thin veil. This veil is now largely invisible in the Louvre drawing, but indications of it can be seen in the loose, sketchy black chalk lines in front of her forehead and the curvilinear pricked line across her forehead. This 'correction' of the relative freedom of the hair in the medal, where two tresses escape to fall vertically down to her right shoulder and the hair is bunched up at the back of her head, may suggest that Isabella wished for even greater formality in her proposed portrait 'in colours'.

Another influence on Isabella d'Este's choice of the profile for her head in Leonardo's portrait drawing was the strength of convention in female portraiture in the fifteenth-century North Italian courts, and not least in the Este court at Ferrara. Paradigmatic is the portrait of her mother Eleonora d'Aragona in the frontispiece of the dedication copy of Antonio Cornazzano's *Del modo di regere e di regnare* (New York, Pierpont Morgan Library, M.731; see pl. 3). Isabella is likely to have known this book: dedicated to Eleonora, it contains a discussion of the personal qualities needed in a ruler. It was probably written around 1479, because it includes a reference to Ercole d'Este's absence from Ferrara on military duties during 1478–79 and Eleonora's adoption of the reins of power in Ferrara in his place. The pure profile miniature portrait, recently reattributed to Cosmè Tura, almost certainly idealises and enhances Eleonora's features, but does not rob her of individuality or personality.[76] In the portrait Eleonora retains an expression of thoughtful intelligence, as though she evidently possessed the virtues required, according to Cornazzano, of the ruler: justice, wisdom, prudence and strength. With her right hand she receives the sceptre of rulership; and it has been suggested that

her hand gesture perhaps signifies relaxed gentility, feminine grace and the well-being of the state.[77] In the treatment that Isabella d'Este had Leonardo da Vinci adopt for her own profile, she may have been seeking to echo her mother's self-presentation. The distant but controlled, intelligent personality that resonates from Leonardo's drawing indicates that Isabella possesses the same set of personal attributes required to register the power and authority of a ruler. To complement these qualities, Isabella's gesture with her right hand, the index finger pointing firmly towards the book on the parapet before her, adds a dimension of cultural ambition to her image.

This desire for dignified formality, implied by the choice of the profile format, could be subverted in a portrait bust. Isabella's earliest approach to Gian Cristoforo Romano suggests that she had in mind a carved portrait bust, analogous to that of her sister, Beatrice (pl. 56). As already noted, in June 1491 she wrote to Beatrice asking that Gian Cristoforo be sent to Mantua, and the following month she wrote to her agent Giorgio Brognolo in Venice asking him to purchase two blocks of fine marble from which her portrait might be carved. Observing a portrait bust, such as that of Beatrice d'Este, from the side shares with the medallic profile the effect of distancing the sitter from the viewer. However, busts can be viewed from a near-infinite number of angles; and one of the principal angles of view is of course the full face, such that the eyes of the bust can be engaged directly. A terracotta bust formerly in the Thyssen collection and now in the Kimbell Art Museum, Fort Worth (pls 74–75), which is probably by Gian Cristoforo Romano, has been identi-fied as representing Isabella d'Este.[78] The comparisons of the bust seen in right profile (pl. 75) with Isabella's medal and especially with the Louvre portrait drawing (pl. 62) are not conclusive, but the identification remains possible. The hair-style is very similar: the sitter's hair flows elegantly back and down from the crown of the head, across the shoulders and down to her upper back, and is held together in a similar shape of massed hair. Looser, more richly curling strands of hair ripple along the front edge of this mass of hair, close to the jaw and covering the ears. Around the crown of the head the terracotta bust shows the same indentation as in the drawn portraits, as though the band that is evident in the Louvre drawing and in copies such as that in the Uffizi (pl. 53) also once ran across the forehead to the back of the head. Although the sitter's mouth is rather more turned down at the corners, the terracotta bust shows the same slightly bulging structure of the jaw-line, indicative of an incipient double chin, and the outline of the profile is closely similar to that of the Louvre portrait drawing.

The dress worn by the sitter of the Fort Worth bust is also similar to that worn by Isabella in the Ashmolean copy (pl. 63) of the Louvre portrait

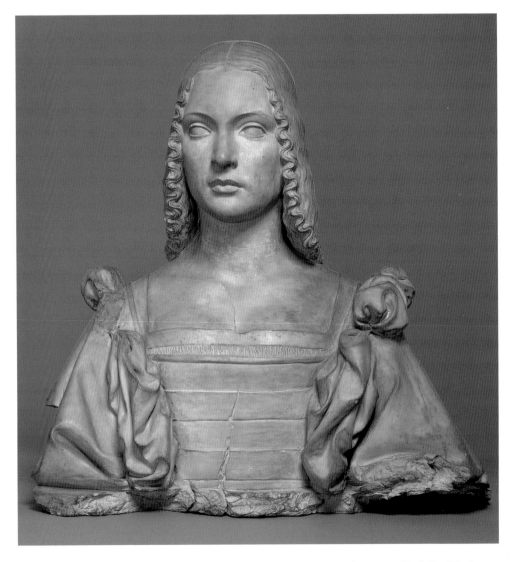

74 and 75 (*above and facng page*) ?Gian Cristoforo Romano, *Bust of a Woman* (?Isabella d'Este). Fort Worth, Texas, Kimbell Art Museum

drawing. Generously flounced, detachable sleeves are tied at the shoulder with large bows. The square-cut bodice is cut lower across the top of the sitter's breasts than in the Ashmolean and Louvre drawings but reveals a similar extent of her throat. However, whereas in the Louvre drawing and in all its copies Isabella's right eye is fully defined and provided with expressive value,

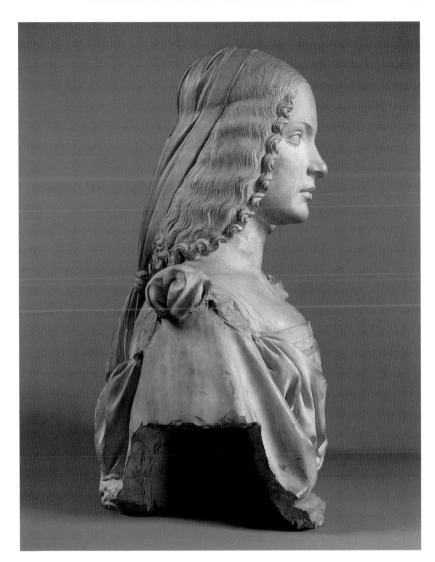

in the terracotta bust the eyes are not modelled but are left blank (pl. 74), without pupils or irises. It is as though the sitter sought specifically to disallow any intimate eye contact or any indecorous engagement by the observer with herself. Just as the Louvre drawing can be seen as Isabella's response to the autonomous portrait drawing, probably by Mantegna, of Francesco Gonzaga (pl. 65), so also – if indeed it represents Isabella – the Fort Worth bust might be seen as her response to Gian Cristoforo Romano's richly

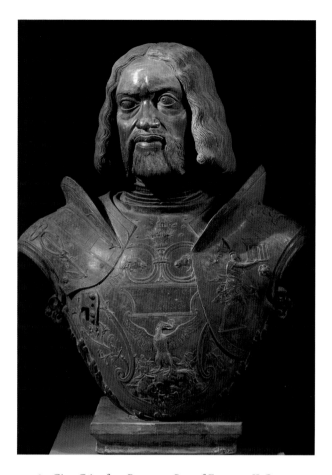

76 Gian Cristoforo Romano, *Bust of Francesco II Gonzaga*.
Mantua, Palazzo di San Sebastiano

detailed and fully finished terracotta bust of her husband (pl. 76). However, the difference between the terracotta busts of Francesco and (?)Isabella are striking. In stark contrast with the expressionless eyes of the Fort Worth bust, Francesco Gonzaga's wide, bright eyes are vivid in their direct, energetic expressive appeal. Francesco's presence is forthright and spirited, belligerent as befits a mercenary general, majestic as befits the prince of a seigneurial state. The sitter for the Fort Worth bust, on the other hand, is noteworthy for her remoteness, for her contained, idealised self-possession. Given the breakage of the right upper arm and the general chipping and fracture at the base, and given the relatively undifferentiated surfaces of the dress, it is,

however, likely that this terracotta bust is not an autonomous work, but was made as a *modello* on the basis of which a marble bust comparable with that of Isabella's sister Beatrice (pl. 56) could be carved. Such a marble bust would have shared the image of detached, noble self-possession that Isabella appears to have sought to disseminate through circulation of her bronze medal, and indeed that she hoped for from her portrait commissioned from Leonardo.

During the fifteenth century types of female portrait varied across the peninsula and across the spectrum of social status and aspiration. The function of a painted portrait and the meanings it was intended to convey may also have affected its composition. In the middle of the fifteenth century, all female portraits, whether made in a court environment such as Ferrara or in centres like Florence, were in the idealising profile format. Surviving portraits of young Florentine women dating from around the 1450s and 1460s are all in pure profile, reflecting the social decorum of the time which constrained young women to keep their eyes lowered and to behave in a demure manner. These are probably almost all marriage portraits, and the sitters in some of them are defined as being essentially the possessions of their husbands. The young woman in the Scolari double portrait dating from the late 1430s by Fra Filippo Lippi (New York, Metropolitan Museum of Art) wears a sleeve richly embroidered with the word 'lealta' (loyalty) in pearls and gold.[79] Similarly, the female portrait by Pisanello in the Louvre (pl. 77), recently identified as Margherita Gonzaga, wife of Leonello d'Este (rather than the traditional identification as Ginevra d'Este), also bears on the sleeve of her robe Leonello's vase device.[80] These women are shown as their husband's wives, rather than as possessing any individual personality. In its exquisite remoteness of treatment, Margherita Gonzaga's profile is analogous in presentation to that of her sister, Cecilia Gonzaga, in a medal by Pisanello (pl. 78). On the reverse of this medal Cecilia is defined by the unicorn that accompanies her as virginal, and she was renowned for her virtue and beauty.[81]

Although three-quarter or full-face portraits of Florentine merchants were being produced from around the middle of the century, this format was unknown in north Italian court circles, where in mid-century male state portraits were also universally in the profile format. As early as 1471, however, Galeazzo Maria Sforza, Duke of Milan, was portrayed in Florence by Piero del Pollaiuolo in a three-quarter view pose: this format was probably adopted in response to Netherlandish convention. It has indeed been suggested that this portrait was based on one by the Milanese court portraitist Zanetto Bugatto, who had trained in Rogier van der Weyden's workshop between 1460 and 1463.[82] By around 1470, three-quarter format portraits by Netherlandish painters were growing in popularity on the peninsula, especially but not exclu-

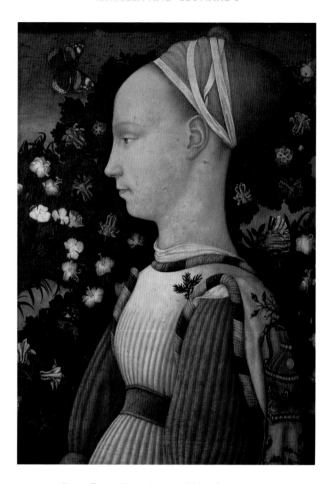

77 Pisanello, *A Young Princess* (?Margherita Gonzaga).
Paris, Louvre

sively in Florence. But for portraits of princesses and noblewomen the profile
format remained current in northern Italy until after the turn of the century,
in order to preserve the appropriate sense of formality and ideal, demure
feminine grace of the sitter. A group of such portraits survives in which
the detached profile figure appears to become primarily a framework for the
display of fashionable dress and costly jewellery. The portrait in the
Ambrosiana, Milan (pl. 79), now attributed to Francesco Francia and
probably therefore representing a Bolognese princess, perhaps Violante
Bentivoglio, shows the sitter in a pearl-bordered snood, with further large
pearls hanging from her hair-band and shoulder.[83] Once again the purity

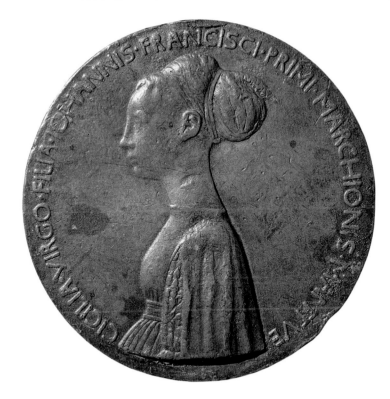

78 Pisanello, medal of Cecilia Gonzaga, obverse.
Washington, D.C., National Gallery of Art, Samuel H. Kress Collection

of the profile emphasises the timelessness and emotional detachment of the idealised type. Another in the group (pl. 80), of Bianca Maria Sforza, the niece of Ludovico 'il Moro', and attributed to Giovanni Ambrogio de Predis, was probably painted to commemorate her marriage to Emperor Maximilian I in 1493. A third, in Christ Church, Oxford (see pl. 2), is also by a Milanese painter and may be of Beatrice d'Este, by analogy with the Gian Cristoforo Romano bust (pl. 56) and with the profile portrait of Beatrice in the Pala Sforzesca (pl. 81). The contrast between the formality of representation of feminine nobility in these portraits with the easy grace of movement and expression in the portrait of Cecilia Gallerani (pl. 58) could hardly be greater. This emphasises the strength of convention in the portrayal of the women of north Italian princely families.

By the 1470s in Florence the profile portrait convention was breaking down. The full-face or three-quarter view had become the usual format for

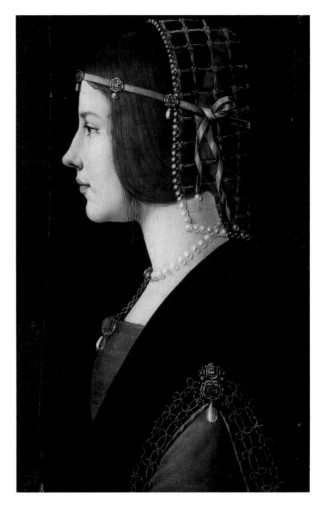

79 ?Francesco Francia, *Portrait of a Woman* (?Violante Bentivoglio).
Milan, Biblioteca Ambrosiana

80 (*facing page*) ?Giovanni Ambrogio de Predis, *Bianca Maria Sforza*.
Washington, D.C., National Gallery of Art, Widener Collection

male portraits, even for a commemorative portrait such as that by Botticelli
of *Giuliano de' Medici* (Washington, D.C., National Gallery of Art) painted
after the sitter's assassination in the Pazzi conspiracy in April 1478. Botticelli's
Young Man Holding a Medal of Cosimo de' Medici (Florence, Uffizi), dating
from around 1470, is a prominent early example of a portrait that follows

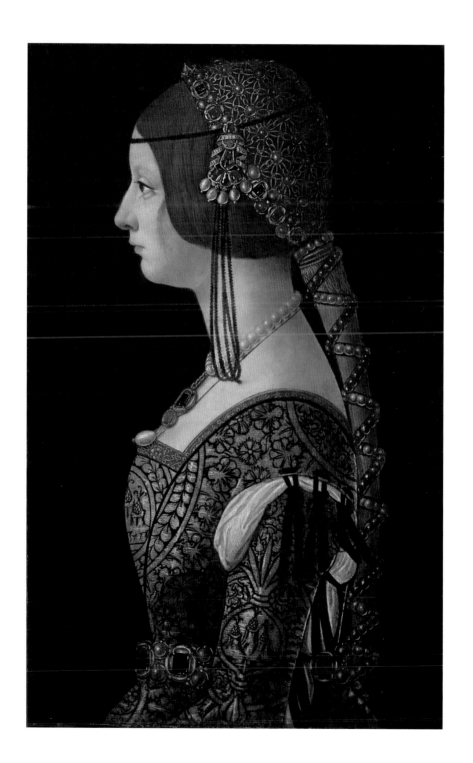

81 (*above*) Master of the Pala Sforzesca, Pala Sforzesca, detail. Milan, Brera

82 (*facing page*) Sandro Botticelli, *Woman at a Window* (?Smeralda Brandini). London, Victoria and Albert Museum

contemporary Netherlandish fashion by showing a full-face male sitter who makes direct eye contact with the viewer. Not long after this the first independent full-face female portraits are to be found. Botticelli's *Woman at a Window* (pl. 82) shows a standing young woman resting her right hand against a window-frame, while with her left hand she gathers a veil across her stomach in a pose that perhaps suggests that she is pregnant.[84] A later inscription on the window-sill identifies her as Smeralda Brandini, who was the grandmother of the sculptor Baccio Bandinelli. Although the painting is of surprisingly large dimensions for a female portrait of the early 1470s, the woman is not represented as of high social status. Indeed, her dress is simple: she wears a light, almost transparent cotton *guarnella* over a red gown which has a restrained embroidered border and is slashed and laced at her forearm; beneath this she wears a white chemise. Equally simple is her jewellery: she wears a black filigree choker but has no rings on her left hand, nor any jewels in her hair. Her spatial placement with respect to the beholder is defined by

the window-frame, and she turns her head slightly against the three-quarter pose of her torso to look out and to engage positively with the viewer. Her large brown eyes and slightly twisted mouth give a sense of a demure but honest and open personality. A direct parallel, in the inclusion of hands, in the simplicity of the dress and in the hair-style with massed curls around the temples, is Verrocchio's *Bust of a Woman Holding Flowers* (pl. 83). Here, however, the pupils of the eyes are not carved in, so that the sitter has a detached, blank expression. As in the Fort Worth terracotta bust, she deliberately eschews the frank expressive contact with the viewer that is a noteworthy innovation in Botticelli's portrait.

Many of the novel features of the so-called 'Smeralda Brandini' portrait are shared by Leonardo da Vinci's earliest surviving portrait, that of *Ginevra de' Benci* (pl. 84).[85] From her pose, surroundings and dress, 'Smeralda Brandini' appears to be of modest social status. Ginevra de' Benci, on the other hand, was from a wealthy banking family of some social prominence: her father Giovanni had been a close and trusted colleague of Cosimo de' Medici in the Medici bank. The reverse of the portrait is also painted, with a laurel and palm wreath, a sprig of juniper (a punning reference to the sitter's name) and a scroll inscribed VIRTUTEM FORMA DECORAT: 'Beauty adorns virtue'. The laurel and palm wreath was the device of Bernardo Bembo, Venetian ambassador in Florence during the later 1470s. The portrait was probably painted at the time of Ginevra de' Benci's marriage to Luigi Niccolini on 15 January 1474, while the device on the reverse was added later, perhaps in 1475–76, after Bembo had adopted Ginevra de' Benci as his platonic, chivalric beloved.[86] The device has clearly been cut at the bottom, and a reconstruction of the complete wreath suggests that the portrait originally extended several centimetres lower. There would have been space for the sitter's hands to be included in the portrait on the obverse, and again the *Woman Holding Flowers* bust by Verrocchio may have served as Leonardo's inspiration in this respect. The beautiful silverpoint *Study of Hands* drawing in the Royal Library, Windsor Castle, is, perhaps correctly, often cited as a preparatory study for these hands, which could have been modelled quite closely on Verrocchio's example.[87] Ginevra de' Benci shares also with the sitters in both the Verrocchio bust and the Botticelli portrait the curls of hair that ripple down across her temples, contrasting with the smoothly combed hair across the crown of the head. Her chemise is also buttoned at the throat in the same manner as in the Verrocchio bust.

Strikingly dissimilar to the blank eyes of Verrocchio's *Woman Holding Flowers* bust, however, are Ginevra's piercing eyes which appear to scrutinise the viewer sharply. Combined with her straight lips curling downwards very

83 Andrea del Verrocchio, *Bust of a Woman Holding Flowers*.
Florence, Bargello

slightly at the corners, Ginevra's eyes engage the viewer's with a distinctly cool hauteur. Her left shoulder recedes into the picture space, so she turns her head to her right to direct her glance towards the viewer. But this is no transitory response to some stimulus in the viewer's space, as is Cecilia Gallerani's expression (pl. 58). At one and the same time Leonardo seems both to fracture the conventions of feminine decorum and to ensure that Ginevra insists on her dignified detachment. He emphasises not only her beauty but also her virtue,

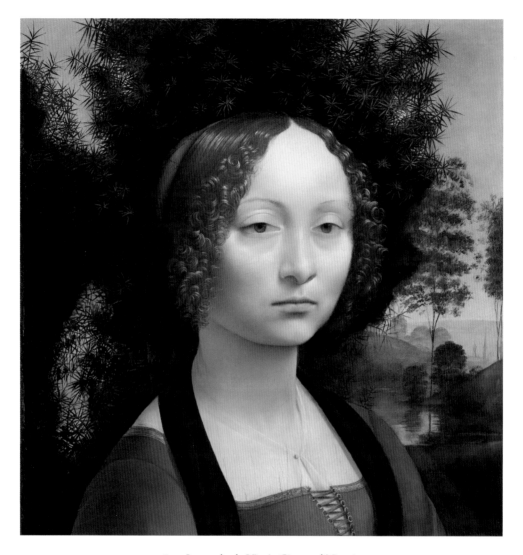

84 Leonardo da Vinci, *Ginevra de' Benci*.
Washington, D.C., National Gallery of Art, Ailsa Mellon Bruce Fund

as her motto proposes. If Verrocchio's bust inspired the inclusion of Ginevra's hands, the compelling directness of the sitter's stare may well have been prompted by Netherlandish portraiture. In the 1492 inventory of Lorenzo 'il Magnifico' de' Medici's possessions is listed a portrait of a French woman by Petrus Christus, with which the Christus *Portrait of a Young Woman* in

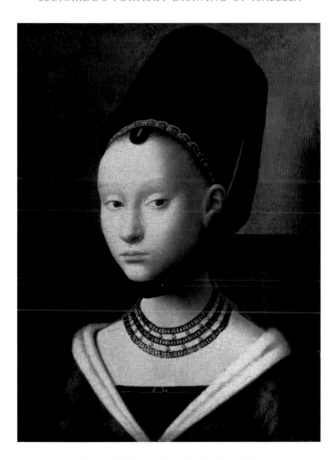

85 Petrus Christus, *Portrait of a Young Woman.*
Berlin, Staatliche Museen zu Berlin, Gemäldegalerie

Berlin (pl. 85) has often been identified.[88] This portrait and Leonardo's of
Ginevra share almost uncannily in common the facial structure and features,
and a remote, unapproachable expression. Here we see Leonardo exploring
new compositional possibilities for the female portrait, new symbolic possi-
bilities in the device on the reverse and in the attribute (flowers?) that she
may well have held in her right hand, and new expressive possibilities in the
ambiguity between her eye contact with the viewer and her uninviting stare.
It is worth noting that Ginevra de' Benci's torso and hands, if reconstructed
to follow the pattern of those in the Verrocchio bust, are posed in a manner
comparable with that adopted by Leonardo for the Isabella d'Este portrait
drawing; but the angles of the sitters' heads contrast starkly.

The *Ginevra de' Benci* forms a distant backdrop to Leonardo's achievements as a portraitist in the last decade of the fifteenth century. Like Botticelli's *Woman at a Window* (pl. 82), it shows how earlier conventions in female portraiture could be subverted in the changing social and cultural environment of Lorenzo 'il Magnifico' de' Medici's circle. The social forces at play in the Sforza court in Milan, and in other north Italian courts like those of Ferrara and Mantua, during the last three decades of the fifteenth century were evidently less adaptable. The more hieratic manners of the princely court continued longer than in Florence, and the ideal decorum of the princesses of earlier generations, typified in the profile portrait of Margherita Gonzaga (pl. 77), likewise prevailed at least until after the turn of the century, or in the case of Sforza Milan up until the court was destroyed in the French invasion of 1499. Portraits of princesses, like Beatrice d'Este, Duchess of Milan (see pl. 2), and Bianca Maria Sforza (pl. 80), are of necessity in profile. They are moreover bust length without hands, and were primarily intended to display the status and wealth of the sitter's husband through emphasis on her rich dress and jewellery.

Portraits of women of more minor status, however, were not ruled by this idealising and display convention. It is curious but pertinent that, as far as we know, Leonardo da Vinci was not called upon to paint easel portraits of the ruling members of the Sforza family. Perhaps his employers recognised with tolerance that the courtly portrait convention was not an appropriate vehicle for the exercise of his special, individual expressive concerns and abilities. He was, however, employed to paint portraits of lesser women of the court, and in particular of Ludovico Sforza's mistresses, Cecilia Gallerani (pl. 58) and Lucrezia Crivelli (pl. 71). Gallerani, who was well-born but not high in social ranking, became mistress to Ludovico at the age of sixteen in 1489, but she retired from court at Beatrice d'Este's demand not long after the latter became Duchess of Milan early in 1491: Leonardo's portrait may have been a parting gift to her from Ludovico.[89] Lucrezia Crivelli became Ludovico's mistress in 1495, and the painting is generally dated to that year or to 1496.

The complex pose adopted by Cecilia Gallerani develops from the waist-length *Ginevra de' Benci*, but introduces further subtleties of sinuous movement and expression. The sitter gently twists to her left with a subtle movement of the neck against the plane of her shoulders: this provides a sense of inherent, restrained vitality that engages the viewer's attention and empathy. A sheet of studies in silverpoint on pale buff prepared paper (pl. 86) perhaps illustrates Leonardo's process of exploratory sketching as he worked towards defining this very original pose: the quick sketch set against

86 Leonardo da Vinci, *Sheet of Studies of the Head and Torso of a Woman.*
Windsor, Royal Library, RL 12513

the left margin mid-way down the sheet corresponds precisely with Gallerani's pose.[90] The impression of incipient movement is enhanced by the analogous twist of the head of the animal she holds, whose natural proclivity towards movement she restrains with her right hand.[91] Moreover, Leonardo's capture of a transitory moment invests the sitter's face with a fleeting expression of alertness, especially through the characterisation of her candid, quietly thoughtful eyes and the faintest suggestion of a hesitant smile. This expression reflects well her personal qualities of intelligence and charm, for which she was well known.

Her characteristic hair-style can also be seen in portraits of Beatrice d'Este, such as that in the Pala Sforzesca (pl. 81). Here Beatrice's hair is held close to the head, centrally parted and arranged in two ample, curling bands to the sides of the face; at the back is a long plait, the *coazzone*, fitted into a richly ornamented sheath attached to a snood of pearls and gems held to the back of the head by a horizontal band that circles the head across the forehead. Gallerani's hair is more simply dressed with a carefully tied plait at the back, and is constrained by a thin black band that sits horizontally around her forehead and recedes to the back of the head. She is dressed 'alla spagnola', a style that was introduced into Milan by Isabella d'Aragona, wife of Gian Galeazzo Sforza, the rightful Duke of Milan, at the time of her marriage in 1489.[92] It was also favoured in the early 1490s by Beatrice d'Este, whose mother Eleonora, daughter of King Ferrante of Naples, was also a member of the Aragonese royal family. Gallerani wears a simple square-necked robe with, over her left shoulder, a mantle with integral slashed and laced sleeves; and she has a restrained double-looped necklace of black beads. The patterned trimmings on her robe and the slashed sleeve are quite elaborate but are understated rather than ostentatious. Gallerani's hair-style and dress are, in other words, fittingly modest and restrained, although at the height of fashion in around 1490. Isabella d'Este is also dressed in the latest fashion in her portrait drawing: she follows the French style of 1500, with a more loosely fitting bodice with a broad neckline and generously puffed sleeves.[93]

In the Lucrezia Crivelli portrait (pl. 71), Leonardo continued to explore the expressive possibilities of an almost direct engagement with the viewer. For the first time in Leonardo's female portraiture the sitter is removed spatially from the viewer by being placed behind a parapet. Originally a device for defining the spatial relationship between sitter and viewer developed by Netherlandish fifteenth-century painters, the parapet became a commonplace in Italian portraiture in the later quattrocento, for example in Giovanni Bellini's male portrait sometimes identified as of Pietro Bembo (pl. 60). The parapet conceals the lower bust and cuts the left arm off just above the elbow:

in this case Leonardo was deprived of the expressive potential of the sitter's hands. He was able, however, to exploit the turn of her head against the recessive line of the shoulders so as to develop an impression of movement and engagement. The sitter's bust is in near profile, with the right shoulder pressing forward and round towards the viewer, while she turns her head into a nearly full-face pose, swivelling her eyes round to look out across her left shoulder and just to the right of the viewer's gaze. Her movement seems more calculated, less transitory than Gallerani's, and her demeanour less spontaneous and unaffected. The portrait is nevertheless, like Gallerani's, a study in the capture of a personality, an exercise in the depiction of the movements of the sitter's mind.

We do not know if Isabella d'Este ever saw the Lucrezia Crivelli portrait, and it is almost certain that she did not know Ginevra de' Benci's. But the correspondence demonstrates that she did know the Cecilia Gallerani portrait: she had probably closely examined it in her *paragone* with Bellini portraits, some eighteen months before Leonardo's arrival in Mantua in December 1499. She could, therefore, have made informed judgements about the representational characteristics and artistic qualities of Leonardo's earlier work. She was in a good position to decide which features of the Gallerani portrait were, and which were not, appropriate to a portrait commissioned from Leonardo of herself, according both to the conventions of courtly decorum and to her own cultural and intellectual aspirations. Isabella's choices in these respects seem entirely appropriate to her position as Marchioness of Mantua, and to her ambition to be accepted and valued in the exercise of political authority within the state. She seems to have seen clearly the possibility of exploiting Leonardo's expressive use of hands and hand-gestures to comment visually also on her cultural credentials. To be seen best in the Ashmolean copy, she settles her left hand on the parapet before her. Across this her right hand is placed in a variant of the conjoined hand pose of Verrocchio's *Bust of a Woman Holding Flowers* (pl. 83). In the Cecilia Gallerani portrait the sitter's left hand is tucked away around her waist, and it appears that it was never fully defined and completed. But the example of Gallerani's beautifully poised and depicted right hand, with its fingers delicately positioned to restrain the ermine's movements, would have indicated to Isabella the scope for subtle suggestiveness that hands represented by Leonardo could possess. Isabella d'Este's right hand is disposed so that her index finger points out to the viewer a book placed on the parapet to her left: again this is clear from the Ashmolean copy. The book is an attribute indicating that, even if her ability to read Latin had its limitations (only the year before the humanist Pontano had noted that she was 'sanza lettere'), she sought to impress on

viewers of her portrait her aspirations to intellectual and cultural prowess and recognition.

On the other hand, Isabella would have recognised from the Cecilia Gallerani portrait that the pose and movement of the sitter's head, and the suggestion of momentary response shown in her eyes, would be inappropriate in her own portrait. Such treatment of the head and facial features did not conform with the demands of courtly decorum. Isabella may very reasonably have felt that she had to follow the conventions set out during the 1490s in portraits of Milanese princesses, such as her sister Beatrice, and other north Italian noblewomen. She also may have wished to reaffirm her commitment to the classical idealism of the medallic profile at just the time that she was increasingly turning her attention as a collector to the acquisition of antiquities, including classical Roman coins and medallions. It was, therefore, virtually inevitable that she would require Leonardo to show her face in pure profile. This would undoubtedly have been her choice, and it was almost certainly not the choice that Leonardo would have made. Her choice presented Leonardo with a compositional problem that, it may be felt, not even he could solve entirely successfully. The slight twist of Isabella's torso, with her left shoulder receding into the pictorial space, reinforces the movement and pointing gesture of her right hand. But the sharper leftward twist of her head runs counter to this implied communication of meaning. By showing her right profile Isabella withdraws from emotional contact with the viewer into a remote impersonality. Although the profile doubtless presented a good – if perhaps a tactfully improved – likeness of Isabella, Leonardo's drawing became a portrait of status rather than a study of an individual personality. It is difficult to imagine that this portrait could be used to generate the sort of intimate reflections on an absent friend that are recorded in letters to Isabella from correspondents such as Beatrice de' Contrari or Margherita Cantelmo.

Nor can it come as any surprise that, despite the pressure put on him by Isabella d'Este's reminder in her letter of 14 May 1504 that 'you promised me you would portray me once more in colours', and despite the report that he felt especially indebted because of the kindness shown to him when he was in Mantua, Leonardo ultimately failed to paint Isabella's portrait. None of his easel portraits shows the sitter in profile, although he made numerous drawings of heads in profile in order to encapsulate individual physiognomic types. Two such drawings are especially pertinent in the present context, for they could be seen as experiments from which the Isabella d'Este portrait was extrapolated. One is the recently identified portrait on vellum of a young Milanese noblewoman (pl. 72); the other is a profile portrait drawing of a

young woman (pl. 73) that appears, to judge from the exploratory, repeated contours along the facial features, to have been made from life.[94] It is a silver-point drawing on pale buff prepared paper, and it appears in style and technique to date from the later 1480s, perhaps no more than two or three years earlier than the Cecilia Gallerani portrait. As noted above, it is a cool, objective record of facial outline, with delicate hatching added to explore, for example, the structure and texture of the sitter's right eye. Clearly not of high social status, the sitter wears a simple dress and loose, curling hair. As in the Isabella d'Este portrait drawing, her torso is placed in three-quarter view with the left shoulder receding into space, and her head twists to the left to present her right profile. But by 1500 Leonardo had developed a style of portraiture of unprecedented spontaneity and expressive engagement, and he had explored fully how to communicate expressive feeling through the movement, gesture and facial expression of the Apostles in the *Last Supper*, completed some three years before his brief sojourn in Mantua. It seems improbable that he would willingly have reverted, in a post-Milan portrait, to the detached objectivity of the profile shown in the Windsor drawing.

By May 1504, when Isabella wrote to Leonardo da Vinci asking him to paint her a devotional picture of the young Christ instead of her portrait, she had evidently conceded that it was no longer practical to expect him ever to produce her portrait 'in colours'. This might have been a particular disappointment, for although she gave many portraits away to friends or relatives, it seems likely that she intended to keep the Leonardo da Vinci portrait for herself: the life-size scale of a painting based on the Louvre drawing might have seemed inappropriate in a gift. She had critical comments to make about several of the portraits recorded to have been made of her, but not about Leonardo's drawing, which she pressed him to do 'once more in colours'. The painted portrait would have been both a noble image 'al naturale' of herself in her mid-twenties, and also her prime example of the work of Leonardo, to complement her paintings made by other celebrated painters at the turn of the century.

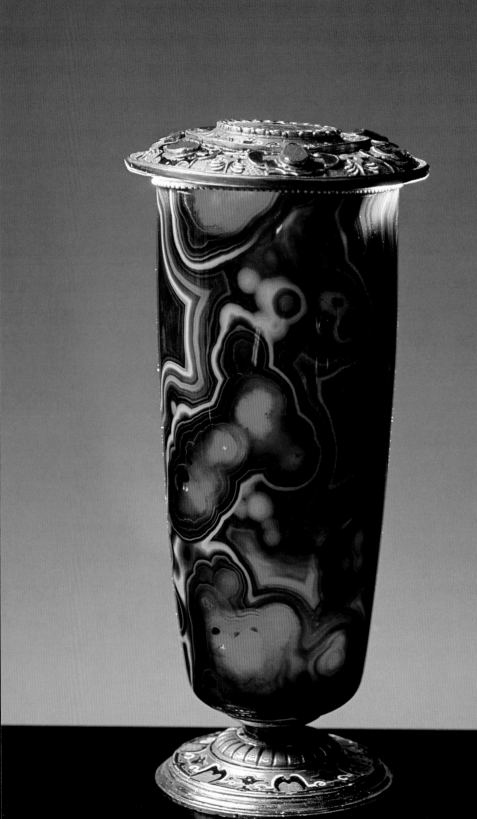

V

ISABELLA AND HER COLLECTION OF
ANTIQUITIES

In May 1502 Isabella d'Este wrote to Francesco Malatesta, a Gonzaga agent in Florence, asking him to have Leonardo da Vinci make drawings of a group of four hardstone vases, similar to that illustrated in plate 87, formerly in Lorenzo 'il Magnifico' de' Medici's collection. On the basis of these drawings she could decide whether or not to pursue negotiations for the purchase of one or more of the group. This letter is considered fully later in this chapter, but first we should look in more detail than in chapter two at Isabella's achievement as a collector of small antiquities, and at the formation of her collection.[1]

Had Isabella purchased any of the ex-Medici hardstone vases, they would not have been the first such classical objects that she acquired. In 1499 Giovanni Lucido Catanei had sent her one from Rome: 'By Capelleto', he wrote, 'I am sending Your Majesty an antique *broncino* of mixed colour, which I have found in the estate of a very aged and noble doctor.'[2] Nor, indeed, would they have been the last: as noted in chapter one, in 1506 she acquired an onyx vase at the auction in Venice of the collection of the recently deceased Michele Vianello.[3] Integrating the first of these into her still embryonic collection of antiquities may have stimulated her wish to acquire more such relics of the classical world that, as we have seen, was the predominant force in the visual culture of Renaissance Mantua. By the time that Leonardo visited Mantua late in 1499, Isabella d'Este's activity as a collector of antiquities was well under way. It was not until 1507 that she made her memorable comment

87 (*facing page*) Roman, jasper vase. Florence, Museo degli Aregenti, inv. 1921.491

about her 'insatiable desire for antique objects', in a letter of 2 January of that year to Niccolò Frisio.[4] Having just taken delivery from Frisio of two classical portrait busts carved from alabaster, she wrote that she looked forward to his obtaining for her a series of reliefs representing the Labours of Hercules. But already on 18 June 1491, some seventeen months after her arrival in Mantua, she had written to her kinsman Niccolò da Correggio that 'because we are by nature greedy, objects are dearer to us the more rapidly we have them'.[5] In a letter of 29 March 1499 to Jacopo d'Atri, Isabella wrote that 'you know how great is our appetite for these antiquities';[6] and in a letter to her brother Cardinal Ippolito d'Este she wrote on 30 June 1502 that because 'I have great interest in collecting antique objects to grace my studio, I greatly desire to have them'.[7]

These are just isolated references in Isabella's voluminous correspondence to her growing preoccupation with the collecting of antiquities. Unfortunately, very few of the objects mentioned in these letters can with certainty be identified with works listed in later inventories, let alone with objects that survive. There are, in fact, considerable difficulties in reconstructing the early development of Isabella's collections. The correspondence includes some helpful information, but references are as often to objects that Isabella did not acquire as to those that she did. Only a very approximate estimate can be made of the state of her collection of antiquities at the time that she was last in communication with Leonardo da Vinci in 1506, shortly before her new *grotta* was ready to house the collection. The final state of her collection, the number and types of the objects it included, and full detail of its layout in the *grotta* of the Corte Vecchia are known from the comprehensive inventory drawn up by Odoardo Stivini in 1542, three years after Isabella's death.[8] The arrangement of her collections on mouldings at the top of the wainscoting, over the doors, and in showcases along the lower walls can be reconstructed from this inventory. Although the evidence is not robust, it seems likely that this reflected in general the way that her collections were displayed in the *grotta* of the Castello di San Giorgio, vacated when Isabella moved to her new apartment in the Corte Vecchia in 1522. However, as discussed earlier, the original *grotta* was not in fact complete and ready for the display of the collections until 1508, so at the time that she asked for drawings by Leonardo of the ex-Medici hardstone vases, her antiquities were presumably still housed in her *studiolo*.

At the outset of her career as a collector, Isabella concentrated her attention on carved intaglios, cameos and other gems. In 1490 and 1491 the Venetian craftsman Giorgio Brognolo, who served also as her agent in acquiring such objects, obtained for her a number of modern incised gems, decorated both with figures and with inscriptions.[9] In an early letter, of 27 March 1490,

Isabella asked Brognolo to 'use all diligence to find someone who has good intaglie'.[10] Another early reference to her interest in acquiring carved gems comes on 9 May 1492, when she wrote to Brognolo that 'the carving of these gems is extremely pleasing to me'.[11] In January 1492 Ludovico Agnello had obtained for her a number of 'petre intagliate'; four 'intagli' followed in May and two more in December. That year she also acquired several gems incised with letters by the celebrated Venetian jeweller Francesco Anichino, from whom she commissioned a turquoise carved with a seated Orpheus based on a drawing received by Brognolo on 16 March 1496.[12] A month later Isabella ordered from Anichino another intaglio of which 'the *fantasia* is his to choose as long as it is something that represents antiquity'.[13]

There is no evidence that any of these intaglios were classical in origin. Foremost among her carved gems later on, however, was a large classical cameo that was the very first object recorded in the Stivini inventory of 1542. There it was described as 'a large cameo . . . with two busts in relief of [Augustus] Caesar and Livia'.[14] We do not know exactly when she acquired this cameo, but in 1542, and very possibly already early in the first decade, it was displayed close to the version of Isabella's medal that Gian Cristoforo Romano cast in gold for her in 1503 (see pl. 37a and b). This piece is listed as item seven in the Stivini inventory, 'a medal in gold with the portrait of Madamma of happy memory, when she was young'.[15] As noted in an earlier chapter, her medal was originally cast in bronze five years earlier in 1498, and was intended for wide circulation. We may reasonably surmise that there was some particular purpose in Isabella's mind for having this new version of her medal cast in gold and elaborately framed. Like the gold medal, the Caesar and Livia cameo was also provided with a rich frame: a gold wreath with green enamelled laurel leaves and a pendant pearl. It seems likely that Isabella intended by this that a *paragone* between ancient and modern – between the portraits of Caesar Augustus's wife and herself – could be made as soon as both works were in her possession.[16] This may imply that Isabella had acquired the Caesar and Livia cameo before 1503, and that this acquisition triggered the commission from Gian Cristoforo Romano of the gold cast of her medal, which she then had richly and elaborately framed.

COLLECTING ANTIQUITIES

In his *De splendore*, published in 1498, the Neapolitan humanist Giovanni Pontano wrote that 'the acquisition of gems, pearls and precious stones of all sorts confers . . . a fascinating splendour' on their possessor.[17] Up to about that time Isabella d'Este might well have agreed wholeheartedly. But from

around 1497 she expressed increasing interest in acquiring small antiquities, and especially sculpture. In a letter to Giovanni Andrea de Fiori dated 4 April 1498, for example, she explicitly stated, 'I would like to have other objects than cameos . . . We desire also much more to have various little figures and busts of bronze and of marble.'[18] This shift in her collecting priorities occurs at just the time when, with the commission of Mantegna's *Parnassus*, she set out to decorate the walls of her new *studiolo* with allegorical paintings filled with figures from classical mythology. It is as though, with its many mythological figures and its classicising style, Mantegna's painting was intended to complement the growing collection of classical figurines on display in that room. By then Isabella had, in fact, already acquired a number of small antiquities. On 20 December 1496 Ludovico Mantegna, the artist's younger surviving son, sent Isabella a classical medallion 'because I know you delight in them extremely'.[19] Made perhaps for diplomatic reasons, to ingratiate the donor with Isabella, gifts of this sort were important to the growth of her collection. Possession of classical medallions might have stimulated Isabella's decision, unconventional for a woman, to commission her own medal in 1498. Her friend the Marchioness of Crotone sent to Isabella a further twenty classical medallions on 23 March 1503; and she was sent another, unearthed during foundation digging in Urbino, by one Fra Serafino on 7 February 1505.[20]

On 5 February 1497, the bronze sculptor Antico wrote from Rome to Francesco Gonzaga to thank him for an introduction to protonotary Ludovico Agnelli, who had shown him some fine antiquities.[21] This may suggest that Antico was in Rome initially to acquire antiquities for Francesco Gonzaga himself, but Francesco took little interest in classical objects.[22] So it was Isabella to whom Agnelli wrote on 15 May that year – a letter brought to Isabella by Antico himself – telling her that he had done everything he could to help Antico to carry out his mission. This he had done both for Isabella and on account of Antico's 'worthy and abundant virtues'.[23] This seems to be the earliest record of an artist working for Gonzaga patrons who on a visit to Rome acquired antiquities specifically for Isabella. If this is the correct interpretation of Agnelli's words, we have evidence that as early as 1497 Isabella was seeking to develop her collection of antiquities, and specifically perhaps of classical sculpture, which was most readily available in Rome. On 22 February in the same year, Tolomeo Spagnolo had informed Isabella of a visit he had made to Agnelli, who said that he 'continues to think about adorning [your] *camerino*, and that he has to hand a work that is one of the beauties not only of Rome but of the world'.[24] As a result, Agnelli wrote on 5 February 1498 that he had 'the arm of a classical bronze figure' that was hers to

command.[25] Isabella replied on 7 March saying that his brother 'had given me the bronze arm, than which, because of our wish for many antiquities with which to embellish a studio that has been started, I could not have a more welcome work'.[26] Next day she wrote to her brother Cardinal Ippolito d'Este in Rome, expressing the hope that through his good offices she might be able to add to her collection. She asked him if he would 'write to his friends in Rome, remembering when writing to ask for antiquities both in marble and in bronze'.[27] He replied on 9 April saying that he had done what she asked of him,[28] but it is not known whether Isabella obtained any objects as a result of this exchange. Her brother also seems to have responded positively to another approach in the letter of 30 June 1502, when Isabella asked him to help in negotiations with Cesare Borgia towards the acquisition of Michelangelo's *Sleeping Cupid* and a small classical marble *Venus* from the Montefeltro collection in Urbino.[29]

The acquisition of Michelangelo's *Sleeping Cupid* offers an instructive example of Isabella d'Este's changing collecting preferences. As observed in chapter two, her two marble carvings of the *Sleeping Cupid* provided an excellent *paragone* between classical and contemporary sculpture. Michelangelo's carving was discussed in two letters to Isabella from Count Antonio Maria Pico della Mirandola. On 27 June 1496, he wrote of 'a reclining cupid with his head on one hand', saying that 'some people believe [this] to be modern while others claim it to be an antique'.[30] Writing again on 23 July, he confirmed that it was indeed modern, although so perfectly carved that many people had been deceived by it; given this, she could probably get it inexpensively, but since it was not antique she might not want it.[31] Michelangelo had probably based his design for this figure on an antique *Sleeping Cupid* given to Lorenzo de' Medici in 1488 by King Ferdinand I of Naples, which the sculptor could have seen in Lorenzo's Giardino di San Marco in Florence. He was advised by Lorenzo di Pierfrancesco de' Medici to age the marble artificially and to sell it in Rome as a classical piece. It was purchased by Cardinal Raffaello Riario, but he returned it to the dealer Baldassare del Milanese when he discovered that it was a modern work. Isabella also failed to take her chance to acquire Michelangelo's *Sleeping Cupid* at this point, probably on the same grounds. However, her viewpoint changed, perhaps when she recognised the opportunity it presented for a *paragone* between ancient and modern. By 1502 Michelangelo's *Sleeping Cupid* belonged to Guidobaldo da Montefeltro of Urbino, husband to Isabella's sister-in-law and close friend Elisabetta Gonzaga. On 21 June 1502, just nine days before Isabella wrote to her brother Cardinal Ippolito on the matter, Cesare Borgia invaded Urbino and took possession of Michelangelo's *Cupid*. Responding to Isabella's

request, however, he had by 21 July sent the sculpture to her, along with the small classical marble of *Venus*. The next day Isabella wrote to Francesco Gonzaga saying of Michelangelo's *Cupid* that 'for a modern work, it has no equal'.[32]

At this time Isabella took up with renewed energy negotiations to acquire a pendant *Sleeping Cupid*, which was then believed (rightly or wrongly: we will never know) to be by Praxiteles. The piece finally reached Mantua, along with a classical bust, in February 1506. On 30 May 1496 Floramonte Brognolo had written to Francesco Gonzaga about it: the Praxitelean carving was originally offered not to Isabella but to her husband.[33] At that point Isabella was apparently not interested in purchasing it, but her acquisition of the Michelangelo *Sleeping Cupid* six years later probably spurred her to renew her efforts to acquire also the Praxitelean version. In a letter of 22 October 1502, a few months after she had been given the Michelangelo carving, she expressed her determination 'to have an antique Cupid that is with the sons of the late Messer Giulio Bonatti, who will give it over at such time as one of their brothers has obtained a 100 ducat benefice either here or in Rome'.[34] Negotiations were concluded in December 1505, and the work reached Mantua two months later. Isabella was then able, if she wished – and it seems very likely that she did so wish – to display the two *Sleeping Cupid* sculptures close enough together for detailed comparison, just as the Stivini inventory shows that in 1542 they were placed on either side of the window in the *grotta* of the Corte Vecchia.

Both the Michelangelo *Sleeping Cupid* and its Praxitelean *paragone* were acquired with the Gonzaga collection by King Charles I of England; and both, it is assumed, were destroyed in the Whitehall Palace fire in 1698. Both are presumably sketched on sheet no. 8914 of the *Busts and Statues in Whitehall Gardens* album in the Royal Library at Windsor Castle (pl. 88). Opinions have in the past differed as to which of the three sketches of Sleeping Cupids on that page represent Isabella's marbles, but it now seems almost certain that the Praxitelean figure, which was presumably similar in type to the *Sleeping Cupid* now in Turin, Museo di Antichità (inv. 286; pl. 89), is that shown at the upper right corner of the sheet (landscape format), numbered 29.[35] The Michelangelo *Sleeping Cupid* would then be no. 28 (lower right corner of the sheet), with his legs spread, head resting on the left arm, and poppy pods in his right hand. This appears to be very similar to a *Sleeping Cupid* in the Uffizi (inv. 1914.392; pl. 90), which is probably the ex-Medici sculpture that Michelangelo could have studied in Lorenzo 'il Magnifico' de' Medici's collection.

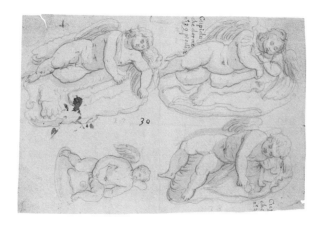

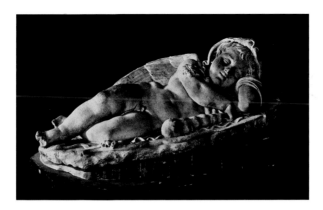

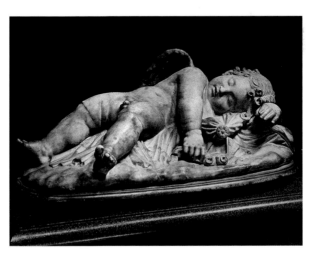

88 (*top*) Anon. draughtsman, *The Four Gonzaga Cupids*. From *Busts and Statues in Whitehall Gardens*, sheet no. 8914. Windsor, Royal Library

89 (*above centre*) Praxitelean, *Sleeping Cupid*. Turin, Museo di Antichità, inv. 286

90 Roman, *Sleeping Cupid*. Florence, Uffizi

By the turn of the century Isabella d'Este's collection of small pieces of classical sculpture was evidently growing. In 1501 Bishop-Elect Ludovico Gonzaga asked her to have plaster casts made for him of two classical busts, now unidentifiable, that she was then acquiring from Giovanni Sforza, Lord of Pesaro.[36] However, exporting classical figure sculpture, or other materials as apparently insignificant as pieces of porphyry, from Rome without a papal licence was, by the end of the fifteenth century, hedged around with difficulties due to the strict controls imposed by Pope Sixtus IV in 1471. Even when the pope had granted permission for the export, the conservators frequently put up further objections. In a letter of 9 February 1499 Antonio Pico della Mirandola wrote that he wanted to send Isabella a 'most charming' *pietra dura* tabletop that she could use outdoors.[37] However, Pope Alexander VI was reluctant to grant a licence for this export from Rome. Isabella suggested to Jacopo d'Atri that he get around this, and the opposition of the conservators, by sending it in a cart decorated with the coat of arms of a sympathetic cardinal, which would not be stopped and searched. Another exchange of letters, with Onorato Agnelli in 1499 to 1501, concerned the acquisition of busts of Jupiter and of Hercules: Agnelli wrote about the problems of exporting such objects, but nevertheless was able to send the Jupiter under the cover of the enterprising coachman Capelletto.[38] Later, Agnelli wrote to Isabella from Rome on 10 September 1501 that Capelletto had arrived (to collect a slab of marble to decorate a door-frame in her *studiolo*), and that he would send a relief of *Two Satyrs* by the same mode of transport.[39] Presumably Isabella received the marble slab by this means, since the *Two Satyrs* relief reached Mantua later in 1501. This carving (Mantua, Castello di San Giorgio; pl. 91), probably of late Hellenistic or Roman date, is of only moderate significance as a piece of classical sculpture, and it was already seriously damaged when Isabella acquired it. Its importance today is principally that it is a rare survivor from Isabella's collection.[40]

The difficulties of obtaining antiquities from Rome because of the stringent application of export regulations may have stimulated Isabella to search further afield for items for her collection. Imports from the eastern Mediterranean through Venice became an alternative source for acquiring classical sculpture. In 1503 Isabella heard from Lorenzo da Pavia in Venice of the arrival there from Rhodes of a near-life-size bronze youthful nude, the so-called *Adorante* (now in Berlin, Pergamon Museum), that, he said, Gian Cristoforo Romano had already seen in Rhodes; but she declined the opportunity to acquire this.[41] And in 1507 Fra Sabba da Castiglione wrote to Isabella from Rhodes about a classical marble torso recently found in a vineyard in Lindos: this may be identified with the 'nudetto senza brazza e testa de pietra rossa,

91 Roman, *Two Satyrs*. Mantua, Castello di San Giorgio

venuto da Rhodi' later recorded by Marcantonio Michiel in the Vendramin collection.[42]

In 1506 Isabella d'Este acquired, in addition to the Praxitelean *Sleeping Cupid*, Mantegna's bust of the Empress Faustina minore (Hampton Court, Royal Collection; pl. 92) for the considerable sum of 100 ducats.[43] Also that year she received several more classical busts from the Marchioness of Crotone, two of which (one named as *Minerva* in a letter of 1506 from Antico) were restored for her by Antico.[44] Two 'alabaster heads' of Antonia and Faustina were acquired for her by Niccolò Frisio before 27 November 1506 from the collection of Antongaleazzo Bentivoglio: these presumably became available as a result of the expulsion of the Bentivoglio from Bologna in October that year.[45] Isabella also purchased two works from the collection of the late Michele Vianello, who had served her as one of her agents during the negotiations with Giovanni Bellini. His collection was put up for auction in Venice, and included an onyx vase, perhaps that now in Brunswick (see pl. 7), which Isabella secured for 105 ducats, and a painting then thought to be by Jan van Eyck of the *Crossing of the Red Sea*.[46] Urging Gian Cristoforo Romano to search Rome for 'various bronze medals, beautiful and antique', she wrote to him with a note of pleasure, if not of triumph, 'We believe that you may have gathered that we have acquired the agate vase belonging to

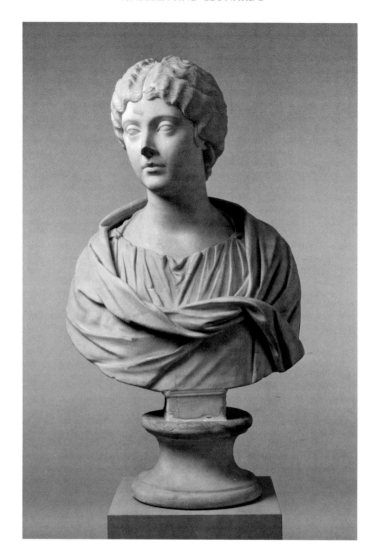

92 Roman, *Bust of Empress Faustina minore*.
Hampton Court, Royal Collection

the late Vivianello, and the "Submersion of Pharaoh". In addition, we have
Mantegna's *Faustina*, and thus little by little we are building up a *studio*.'⁴⁷

If the increasing rate in her acquisition of small antiquities, as recorded in
her correspondence, faithfully reflects an overall acceleration in purchasing,
it is no surprise that Isabella moved ahead with preparing the *grotta* below

her *studiolo*. From the time of its completion in 1508 this space was the principal location for the display of her antiquities collection. By 1506, and the close of her correspondence with Leonardo da Vinci, she had acquired some prize classical pieces. Nevertheless, in sheer quantity her collection could not match those of other members of her family, let alone the large collections that Pope Paul II had assembled by 1471, Cardinal Francesco Gonzaga (uncle to Isabella's husband) by 1483, or Lorenzo de' Medici by the time of his death in 1492. We do not know the size of Isabella's holdings of coins and medals, for example, at this time, but they are unlikely to have come close to the 3,822 coins (3,385 in silver and 437 in gold) listed in her father Ercole d'Este's inventory of 1494,[48] or the nearly 3,500 coins recorded in the collection of Gianfrancesco Gonzaga, another of Francesco II's uncles, at his death in 1496.[49] Nonetheless, despite her relatively limited funds and the restrictions on space available for her collections even when the *grotta* was complete, Isabella's collection of classical objects was almost certainly the largest assembled by a woman in Renaissance Italy. Its gradual formation over the period between 1497 and 1506 vouches for Isabella's growing enthusiasm for the classical heritage that also influenced the imagery of Mantegna's paintings for her *studiolo* and the compositional formula adopted for Leonardo da Vinci's portrait drawing.

ARTISTS AS EXPERTS AND AGENTS

Correspondents like Cardinal Ippolito d'Este, Niccolò Frisio, Jacopo d'Atri, Ludovico and Onorato Agnelli, and Lorenzo da Pavia were among the many individuals whom Isabella sought to press into her service as agents in the acquisition of classical objects. They ranged from high-ranking clerics like her brother to Mantuan diplomats and to merchants and craftsmen resident in Rome, in Venice, or in other cities where antiquities might be sourced. But agents such as these were not necessarily best skilled to judge the quality of classical objects that they had identified for possible purchase. Isabella therefore often sought the views and advice of painters and sculptors on the quality and value of antiquities that she was thinking of acquiring, as correspondence with Antico, and with Gian Cristoforo Romano in 1506, suggests. In another exchange of letters between October and December 1505, Isabella instructed Gian Cristoforo Romano to look closely at the Roman collection of the late Giovanni Ciampolini, who had been a celebrated dealer in antiquities, with a view to advising her on possible purchases.[50] Earlier that year, a relative by marriage, Giovanni Gonzaga, bought on her behalf a bust in ivory, believing

it to be classical. Writing on 28 March 1505 Isabella told him, however, that 'having seen this, Messer Andrea Mantegna and Gian Cristoforo Romano consider it neither antique nor good', and so she did not propose to purchase the piece from him.[51] To act on the advice of an artist who was experienced in scrutinising classical works was by no means new: as early as around 1430 Donatello's advice on the artistic and aesthetic quality of classical objects had been sought by Poggio Bracciolini and others.[52] But Isabella appears to have developed the practice to a greater degree than any earlier collector, so that she could be as confident as possible about the high quality of her collection, and that she was getting value for money – especially important in her relatively straitened financial circumstances. The high regard in which she held both Mantegna and Gian Cristoforo Romano for their knowledge of classical art made them obvious people for Isabella to ask for assessments of quality and value.

It is no surprise, then, that Isabella d'Este should have wished to see drawings by Leonardo da Vinci of the group of classical hardstone vases, formerly in Lorenzo de' Medici's collection, that was on the market in 1502, and to learn his opinions as to their quality. Isabella was not alone in her interest in these works: as we shall see, both her father Ercole d'Este and her uncle-in-law Bishop-Elect Ludovico Gonzaga had already expressed interest in acquiring ex-Medici vases. Perhaps with good reason, Isabella may have felt that it was important to move swiftly to obtain advice from a trusted artist who was on the spot in Florence. Leonardo had, in fact, been called upon earlier to provide drawings for a potential patron in Mantua. Early in 1500, it seems, at about the time that Leonardo stayed briefly in Mantua, Isabella's husband Francesco Gonzaga visited Florence. While there, he apparently visited the villa that had recently been built for the wealthy merchant Agnolo Tovaglia, south of the city between the churches of San Miniato al Monte and Santa Margherita a Montìci. Tovaglia was well known to the Gonzaga: his father Piero had been Marquess Ludovico Gonzaga's procurator in Florence, and he himself served as an ambassador and agent there on their behalf. On his return to Mantua, and perhaps thinking that he might like to incorporate in his own proposed new villa some architectural features of the Villa Tovaglia, Francesco Gonzaga wrote on 7 July 1500 to Francesco Malatesta, asking him to arrange for a drawing and measurements of Tovaglia's villa to be sent to him.[53] Malatesta evidently commissioned a drawing (or drawings) from Leonardo da Vinci, which he sent to Mantua from Florence on 11 August that year. On 18 August, Francesco Gonzaga wrote asking Malatesta to thank Agnolo Tovaglia and Leonardo for their help.[54]

In his letter of 11 August, which accompanied Leonardo's drawing, Malatesta wrote:

> I am sending your illustrious Excellency the drawing of the house of Lord Agnolo Tovaglia made by the hand of Leonardo da Vinci, who commends himself to you as a servant, and to her Excellency likewise. Lord Agnolo says that he should like to come to Mantua to be able to judge as to who would be the better architect, your Excellency or he . . . The aforementioned Leonardo says that to do a perfect thing it would be necessary to be able to transport this site here to where your Lordship wishes to build . . . I did not have the drawing done in colours, or embellished with foliage, ivy, box, cypress or laurel, as they are in reality, because this did not seem necessary to me; however, if your Excellency wishes, the aforesaid Leonardo himself offers to do both a painting and a model. . . .[55]

Leonardo had reservations about Francesco Gonzaga's project, since the hills south of the Arno valley offered terrain very different from the flat plains around Mantua where Francesco's villa was to be constructed. Nevertheless, Malatesta reported that if the marquess was pleased with the drawing, Leonardo was willing to make a more finished drawing or even a model of the Villa Tovaglia for him. Writing again on 2 April 1501, Malatesta proposed that he have a model of the villa made and sent to Mantua; but he also noted that Tovaglia had suggested that the architect of his villa, one Leonardo da Monte Aguto, who was 'an ingenious man and very capable for such a building enterprise', should travel to Mantua to advise the marquess in person.[56]

Almost inevitably, Leonardo's drawing of July–August 1500, and any others of the Villa Tovaglia that he might subsequently have made, are lost. We cannot therefore be certain what sort of drawing Leonardo made for Francesco Gonzaga. In his second letter Malatesta wrote of 'plans', but his earlier comment that 'I did not have the drawing done in colours, or embellished with foliage, ivy, box, cypress or laurel, as they are in reality, because this did not seem necessary to me' suggests that the drawing also included an elevation view of the building's exterior. Two sheets of architectural elevation drawings by Leonardo in the Codex Atlanticus have been associated with the Gonzaga project,[57] but there is no obvious visual correspondence between these drawings and the Villa Tovaglia. In any case, it seems very possible that one unusual feature of an otherwise relatively unremarkable villa in particular interested Francesco Gonzaga: the terracotta barrel-vault of the *gran salone*.[58] If this feature was indeed the principal reason for Leonardo's drawing, it seems likely that the sheet included a ground plan of the villa, on which

the dimensions of the vault and the design of its coffering could have been given. To send drawings to communicate architectural ideas was not uncommon: Lorenzo de' Medici sent to Mantua for plans of Alberti's San Sebastiano and to Urbino for plans of Federigo da Montefeltro's new palace.[59] But it appears exceptional for a painter of the status and prestige of Leonardo da Vinci to be employed in this manner.

The otherwise unknown Florentine architect Leonardo da Monte Aguto had, it seems, been an assistant to Giuliano da Sangallo at the time that the latter was working on the first phase of Lorenzo 'il Magnifico's villa at Poggio a Caiano.[60] This villa remained unfinished at the time of Lorenzo's death in 1492, and was not completed until after the restoration of the Medici in 1512. The H-planned villa consists of two blocks of apartments linked by an impressively large barrel-vaulted *gran salone*. The technique that Sangallo proposed for vaulting the *gran salone*, using precast terracotta blocks for the coffers, was at the time a novel one. At Poggio a Caiano these blocks bear the *imprese* of Pope Leo X and his nephew Giuliano de' Medici, Duke of Nemours, so they cannot have been fired until after 1513 when Lorenzo de' Medici's second son Giovanni became pope; the vault probably dates between 1515 and 1519. The architect of the Villa Tovaglia appears, however, to have known about Sangallo's planned technique for vaulting the substantial space of the Poggio a Caiano *gran salone*, for he made use of this same method for the vault of the Villa Tovaglia *gran salone*. This room is smaller than that of Poggio a Caiano, although at 7.10 by 13.20 metres it is not an inconsiderable area to cover. On his visit to Agnolo's villa in 1500 Francesco Gonzaga might have taken special note of the *gran salone* vault, since half of the coffers moulded in the terracotta blocks that make up the vault show the Gonzaga 'sunburst' device, the use of which had been granted to Agnolo's father Piero del Tovaglia on 10 January 1471.

Moreover, the Villa Tovaglia *gran salone* is consciously *all'antica* in character. The vault reproduces in an enriched, more decorative sense something of the appearance of the vaults of classical buildings like the Basilica of Maxentius; and the technique of using precast terracotta blocks was based on classical precedent. This sort of antiquarian interest in the language of classical architecture chimes well with the classicism of the paintings and sculpture being produced in Gonzaga Mantua around 1500. Less is known of Mantuan architecture at that date, least of all about the architectural vocabulary used in Francesco's destroyed summer villa at Poggio Reale, which he may have had in mind when he expressed interest in the Villa Tovaglia. However, in the wake of Alberti's classicising churches of San Sebastiano and especially Sant' Andrea, which conspicuously uses coffered barrel-vaulting, it might be

predicted that the *all'antica* appearance of Sangallo's terracotta vaulting technique would have been appreciated by Francesco and his Mantuan court at the turn of the century. As the villa at Poggio Reale reached completion in 1508, the architect Hieronymus d'Arcari wrote to Francesco Gonzaga that he was having difficulties with constructing the vaults.[61] This may suggest that he had been asked to use an unfamiliar technique, such as the pre-cast terracotta blocks used by Leonardo da Monte Aguto and very possibly shown on Leonardo da Vinci's drawing.

ISABELLA AND THE EX-MEDICI HARDSTONE VASES

As noted at the opening of this chapter, Leonardo da Vinci's qualities as a draughtsman were called upon again in May 1502, at the time when Isabella d'Este was closely considering the purchase of one or more ex-Medici hardstone vases. Then believed, perhaps correctly, to be of classical date, these were available for purchase from dealers in Florence. The episode opened with an approach by Agnolo Tovaglia to Marquess Francesco Gonzaga, who on 27 March 1502 wrote in response to thank him for 'those drawings of vases on the market'.[62] But he explained that he himself was not in a position to decide on the purchase, and that he could not at that time get his wife's view as to whether they might be objects of interest to her, because she was staying incognito in Venice.[63] On returning to Mantua, Isabella took up the negotiations over the vases: it was she who replied on 3 May 1502 to the letter written to Francesco a week earlier by his Florentine agent Francesco Malatesta. In this letter Malatesta had explained that the vases of which he was sending further drawings were not of silver, as the marquess had understood, 'but are of hardstones, that is of jasper, crystal and amethyst'. He reported that they were provided with gold mounts, as was indicated by written annotations on the drawings. 'They are rare objects, objects suitable for gentlemen, which his Magnificence the late Lorenzo de' Medici held to be very precious,' he wrote, adding that they had fallen into the hands of his creditors after Piero di Lorenzo de' Medici was expelled in November 1494.[64]

On 3 May 1502 Isabella wrote to Malatesta:

> I have seen the drawings of the vases which you sent to my illustrious husband, two of which I have in mind given that they are each in one piece, and are of rare beauty – namely the crystal one and the one in agate. But since they are badly drawn it is hard to evaluate them properly . . . Have them drawn again in the right proportions and painted in their actual

colours, in order that one can recognise the body of the crystal vase and
the agate one by its foot alone, stating moreover whether the cover and
handles are of another kind. I should be pleased if you were to show them
to a person of discernment, such as Leonardo the painter who was in Milan
and is my friend, if he happens to be in Florence now, or else whoever you
think, thereby learning his opinion about both the beauty and the price.[65]

Nine days later Francesco Malatesta wrote a lengthy letter back to Isabella:

Your Excellency, by Alberto my courier I am sending your Ladyship the
drawings of the vases about which you wrote to me on the 2nd of this
month, drawn in the right proportions and coloured with their actual
colours, but not with their real lustre, because it is impossible for painters
to know how to achieve this. And so that your Excellency can choose which
most pleases you, I have decided to send drawings of all four vases. I showed
these to the painter Leonardo da Vinci, as your Excellency instructed me
to do: he praises all of them highly, but in particular, the crystal one because
it is all in a single piece and is very fine, with a foot and outer cover in
silver and gilded; and the aforesaid Leonardo said that he had never seen
a better piece. The one in agate again pleases him since it is rare and is a
large piece, a single piece, except for the foot and cover which are also in
silver and gilded; but it is broken as your Excellency will see from the cracks
in the body of the vase. The plain jasper vase is a fine and unbroken piece
with a foot of gilded silver like the aforementioned vases. The one in
amethyst, or rather jasper, as Leonardo calls it, which is a varied mixture
of colours and is transparent, has a foot of solid gold set with many pearls
and rubies as is indicated by its price of 150 ducats: this one pleased
Leonardo greatly for its novelty and for its diversity of astounding colours.
On the body of each vase the name of Lorenzo de' Medici is incised in
capital letters. As for the prices of the vases, I cannot lower them any more
than I have already indicated, because the sellers say that they were given
as payment for that price, and that in order to regain the full sum they do
not wish to lose a denaro.

And on another sheet, attached to his letter, Malatesta listed the vases and
their prices:

The crystal vase	duc. 350
The jasper vase with pearls and golden base and rubies	duc. 240
The plain jasper vase	duc. 150
The agate vase	duc. 200[66]

Replying on 21 May 1502, Isabella acknowledged receipt of the drawings, with which she was content. She accepted the price of the crystal vase, which pleased her more than the others, and she asked Malatesta to continue negotiations over the value of the Mantuan cloth that the vendors required in payment. She demanded that the vendors must either lower the price hitherto asked or accept the value of the cloth as established on the Mantuan market.[67] Malatesta wrote again on 31 May that he had tried unsuccessfully to beat down the price of the crystal vase; and again on 12 June that the vendors were now prepared to discount the vase from 350 to 300 ducats if Isabella paid in cash immediately. But Isabella wrote back at once that since the vendors were not prepared to accept her proposal on the value of the cloth, she could not accept their price for the vase: it was too much for her to raise at short notice, so she had to withdraw from the purchase.[68]

Nothing is known about the drawings sent by Tovaglia and Malatesta to Francesco Gonzaga, beyond that they were not adequate for Isabella d'Este's purposes. However, the references to these drawings in the correspondence show that the process of commissioning drawings as guides for potential purchasers in Mantua to the appearance of these vases was not new. Moreover, yet another group of drawings of presumably these same vases had been made the year before for Bishop-Elect Ludovico Gonzaga, who at that time was expressing great interest in acquiring hardstone vases from the Medici collection.[69] Bishop-Elect Ludovico was the fourth son of Marquess Ludovico, and therefore was an uncle of Marquess Francesco II; but his relations with the Mantuan Gonzaga family were strained. Born in 1458, Ludovico was destined for high ecclesiastical office. He was elected Bishop of Mantua in 1484, but owing to tensions within the Gonzaga family he was never permitted an episcopal consecration. It may be that to help him to overcome frustrations that he felt through his failure to achieve status in Mantua itself, he invested considerable time and energy in creating a *studiolo* at his villa at Gazzuolo and in acquiring works of art with which to furnish it. This *studiolo* was in a fit state for visits at least by 12 June 1505, when Margherita Cantelmo wrote to Isabella d'Este that she had been to Gazzuolo and had seen the 'studio' and many other things.[70] By then, Bishop-Elect Ludovico had been collecting antiquities for some twenty years: already on 8 June 1484 he had asked his Rome agent Ruffino Gabbioneta to negotiate for classical sculptures recently discovered nearby the house of Bernardino della Valle, in exchange for Mantuan cloth.[71] In 1501 he launched a concerted effort to collect antiquities for his new *studiolo*. In that year he negotiated with the Milanese goldsmith Caradosso Foppa to acquire a group of marble busts then in Caradosso's possession.[72] On 2 January 1501 he wrote to the Milanese miniaturist Francesco

Binasio asking him to provide him with drawings of Caradosso's antiquities, but only of marble figures and busts ('figure e teste di marmore') of the highest quality. Presumably happy with what the drawings showed, Ludovico sent his architect Ermes Flavio de Bonis da Padova to Milan to check the carvings for quality and to reach an agreement on the purchase.[73] On other occasions, too, Ludovico showed special interest in classical busts, and if he was unable to obtain or to afford originals, he made do with plaster casts. We saw earlier that in October 1501 he wrote to Isabella d'Este to ask if she could provide him with casts of two busts that she was acquiring; and he also wrote to Agnolo Tovaglia, in November 1502, that he would like him to have casts made of four more busts, of 'a bearded Hadrian, the older Titus, without a beard, a bearded Geta, and another with neither beard nor name'.[74]

Bishop-Elect Ludovico was also interested in acquiring classical vases. Perhaps as a result of Ermes da Padova's visit to Caradosso, Ludovico then offered the not inconsiderable sum of 300 ducats for a 'large and beautiful vase made up of 49 pieces of crystal bound together with silver-gilt and enamelled and carved'.[75] He did not acquire it, however, since in September 1505 Caradosso brought the same vase to Mantua for Isabella to inspect. On 4 July 1505 Gian Cristoforo Romano had recommended this vase to her, suggesting that she would be an ideal owner since she already had 'a crystal vase for which it would be the perfect companion'.[76] Although it was said to be worth 1,000 ducats, the vase was on offer to Isabella for 400. She decided, however, against the purchase. In her letter of 27 September 1505 to Gian Cristoforo Romano she wrote: 'Caradosso's vase is beautiful and pleases me greatly, but because it is too large for the *studiolo* I have left it in his hands.'[77] Had she indeed paid 400 ducats for it, it would have cost her more than any other of her known purchases of classical objects. Once more, however, the limited size of her *studiolo*, which by late 1505 was probably becoming well filled with antiquities, was the deciding factor.

Earlier on, in letters to Timoteo Benedei in Florence, Bishop-Elect Ludovico Gonzaga enquired about vases formerly in the Medici collection that Ercole d'Este, Duke of Ferrara, had bought or was intending to buy. These might have been among the fifteen such vases that, according to his letter of 9 February 1495 to Ludovico Sforza, Duke of Milan, Caradosso Foppa had been shown in Florence.[78] On 17 March 1502, Bishop-Elect Ludovico expressed special interest in a large vase 'like our large jasper one'; and on 1 April he asked Benedei to give him more details on the types, colours and prices of the vases that Ercole d'Este was acquiring, and on how the negotiations had been carried out.[79] It is significant that Duke Ercole was also in

the market for the ex-Medici vases. Isabella might well have found her father's competition for these antiquities threatening, even though his enthusiasm for such objects had been an important factor in the formation of her own taste and 'appetite' for antiquities. It may well be that Ercole was the unnamed competitor referred to in Isabella's letter of 3 May 1502 to Francesco Malatesta, and again in Malatesta's reply of 12 May, in which he advised Isabella to make haste with her decision 'because there is another person, as elsewhere I have written, who desires to have them'.[80] Already in 1497 Isabella had felt the potential rivalry of her father in collecting antiquities. On 13 November that year she wrote to Benedetto Tosabezzi and Giorgio Brognolo, agents of hers in Venice, about making rapid acquisitions from the collection of the jeweller and dealer Domenico di Piero, who had recently died. 'We have no doubt but that upon reaching Venice our illustrious father, who adores antiquities, will attempt to acquire the best [of the di Piero collection]. It is in our interest that you do everything possible to ensure that they have been crated and shipped to Mantua before His Excellency's arrival.'[81] She very probably knew that Ercole d'Este had acquired a considerable quantity of gold coins and other antiquities from Domenico di Piero over the previous twenty years or so.[82]

It is not known how many – indeed, if any – of the ex-Medici vases Duke Ercole ultimately purchased. Francesco Malatesta's letter that enclosed Leonardo da Vinci's drawings makes clear, however, that at least four were still on the market in spring 1502. Meanwhile, Bishop-Elect Ludovico Gonzaga had had his own drawings of some of the vases made. He had sent one Marco, a Ferrarese goldsmith, to draw the vases; and on 1 November 1501 he wrote to Agnolo Tovaglia that he had seen the sketches and wanted to discuss acquisition with the vendors.[83] On 22 January 1502 he wrote again to Tovaglia, wanting to know more about the schedule for the purchase, referring again to 'those vases of which my Marco brought drawings' and asking him to send sketches and prices of some other vases.[84] A month later, on 22 February, he wrote again to remind Tovaglia that 'of the other vases which you wrote to me about, I await the drawings and the prices of these that you are going to send me'.[85]

However, it seems likely that in the event Bishop-Elect Ludovico was unable to agree to the prices, or perhaps to the cost and value of the cloth that was being demanded in exchange for the vases. As we have seen, Isabella d'Este's correspondence with Francesco Malatesta about the hardstone vases started a little over two months later, in May 1502. This was some five weeks after Francesco Gonzaga had thanked Agnolo Tovaglia for sending drawings

of three vases, and a week after Francesco Malatesta had sent to her husband a drawing of the fourth. These were probably the rather weak drawings on the basis of which Isabella could not judge the quality of the vases. None of Bishop-Elect Ludovico Gonzaga's letters notes that the vases that interested him had formerly been in the Medici collection. It seems very likely, however, that both he and Isabella were negotiating to purchase the same group of vases. They had an illustrious provenance, proved by the letters 'LAUR MED' that Lorenzo de' Medici had had incised on them, as in the cases of many extant vases from his collection. This will have enhanced their value to the Gonzaga collectors. But like Bishop-Elect Ludovico, Isabella foreclosed on the negotiations, on 13 July 1502, having been unable to agree with the Florentine vendors on the value per *braccia* of the Mantuan woollen cloth which they had asked for in exchange for the vases. As earlier for Bishop-Elect Ludovico, the vendors had evidently put a considerably lower value on the cloth than Isabella would have had to pay for it, with the result that their prices apparently turned out to be higher than those listed in the covering letter, and higher than she was willing to pay for the vases, however beautiful Leonardo's drawings may have shown them to be.

LEONARDO'S DRAWINGS OF THE HARDSTONE VASES

Leonardo da Vinci's drawings of the four ex-Medici hardstone vases do not survive. It is, however, possible to speculate about their appearance. Isabella requested coloured drawings, and Malatesta wrote that they were indeed 'drawn in the right proportions and coloured with their actual colours', but he added that they were not drawn 'with their real lustre, because it is impossible for painters to know how to achieve this'.[86] Both Leonardo's colouration of the drawings and the question of this lustre [*lustro*] invite consideration.

The techniques of colouration in the few surviving coloured drawings by Leonardo can be related to their particular functions; and the intensity of Leonardo's colour in these drawings depended in part on the technique he used. Two celebrated coloured drawings made by Leonardo around the date of his drawings of the ex-Medici vases are the *Portrait Drawing of Isabella d'Este* (see pl. 62), and the *Plan of Imola* (pl. 93). The portrait drawing, we know, was made early in 1500; the *Plan of Imola* was presumably made when Leonardo was in the service of Cesare Borgia, who occupied the town in autumn 1502.[87] As noted earlier, the first has light applications of coloured chalks, and also possibly of pastel, over the black chalk of the body of the drawing. The *Plan of Imola*, on the other hand, is drawn in pen and ink over

93 Leonardo da Vinci, *Plan of Imola*. Windsor, Royal Library, RL 12284

a black chalk layout underdrawing, and is coloured with translucent, light-toned washes: light blue for the river Santerno, light blue-grey for the city walls, dull ochre for the open ground and light brown for the buildings. The Isabella d'Este portrait is both the cartoon for Leonardo's promised portrait 'in colours' and, as suggested earlier, a finished drawing that could stand as a work of art in its own right. The *Plan of Imola* also is a finished drawing, but it is essentially a functional diagram rather than an autonomous work of art. It presumably had some military-related purpose that required cartographic accuracy and colour-coding for greater clarity. By this time Leonardo had been exploiting the tonal and graphic clarity of the pen line in the production of exact, diagrammatic studies for over a decade – witness his almost hyper-realistic studies of dissected skulls drawn in 1489.[88] The purpose of Leonardo's vase drawings for Isabella d'Este was to present the vases in their precisely correct shapes, proportions and colours, thus improving on the earlier drawings that Isabella had found less than fully helpful. It seems likely that as diagrammatic demonstrations of the appearance of the vases, with no pretentions to aesthetic quality or independence, the vase drawings were also pen and ink studies to which colours were added.

We may imagine that Leonardo would have relished the process of pro-
ducing coloured drawings of the hardstone vases, and especially of the jasper
vase that 'pleased Leonardo greatly for its novelty and for its diversity of
astounding colours', and that probably closely resembled the vase illustrated
in plate 87.[89] The pleasure that he gained from observing the variety of
multi-coloured stones was perhaps enhanced several years later when he
developed a synthetic material for reproducing them. Several notes in
Manuscript F, written in about 1508, discuss the preparation of 'mistioni'
(mixtures). In these substances Leonardo could model objects and reproduce
in their polished surfaces the design of multicoloured, veined gemstones.[90] It
was earlier noted that Mantegna shared Leonardo's pleasure in reproducing
the complex patterns of multicoloured stone. Indeed, Leonardo's interest in
developing this skill might have been stimulated by having seen Mantegna's
detailed representation of the hardstone used for the plinth on which
Francesco II Gonzaga kneels in the *Madonna della Vittoria* (see pl. 20), or
of that used for the massive vase (see pl. 18) in the *Vase Bearers*, on which
Mantegna was perhaps working in 1500. Leonardo's close scrutiny, and repro-
duction, of the patterns created by the veining of the multicoloured jasper
vase would have reflected his pleasure in looking at

> any walls soiled with a variety of stains, or stones with variegated patterns,
> . . . a resemblance to various landscapes graced with mountains, rivers,
> rocks, trees, plains, great valleys and hills in many combinations. Or again
> you will be able to see various battles and figures darting about, strange-
> looking faces and costumes, and an endless number of things which you
> can distill into finely rendered forms. And what happens in regard to such
> walls and variegated stones is just as with the sound of bells, in whose peal
> you will find any name or word you care to imagine.[91]

Indeed, the 'stones with variegated patterns' of which Leonardo was thinking
in this passage may have been much the same as the multicoloured jasper
carved for one of the ex-Medici vases. Leonardo's interest in the forms that
may be noticed taking shape in the chance patterns of variegated stones or
stained walls is paralleled at the date of his vase drawings in the clouds at the
upper left of Mantegna's *Pallas Expelling the Vices from the Garden of Virtue*
(see pl. 30) for Isabella d'Este's *studiolo*, which have taken the shapes of male
heads.[92] If Leonardo saw this painting in progress in early 1500, he might well
have admired this *invenzione* and the imagination that lay behind it.

To reproduce the veining of the multicoloured jasper stone in the light-
toned watercolour washes used for the *Plan of Imola* might well, however,

94 Andrea Mantegna, *Mars, (?) Venus and Diana*.
London, British Museum, 1861-8-10-2

have seemed to Leonardo visually unsatisfactory, and an impoverished way of communicating to Isabella the vase's colouristic variety. Leonardo's powers of representation in watercolour washes would, moreover, have been tested by the need to replicate as closely as possible the silver-gilt of the mounts, and the pearls and rubies with which the foot of the vase was studded. Greater tonal density and intensity of colour in these drawings would significantly have increased their informative value to Isabella d'Este. Leonardo may there-

fore have built on knowledge of the techniques used by Mantegna and his workshop in coloured drawings of the 1490s. In, for example, the *Mars, (?)Venus and Diana* in the British Museum (pl. 94), the male figure (presumably Mars) and the female figure to the right (Venus, or perhaps Iris) are coloured with tonally dense washes, respectively, in rich red and in places deep blue.[93] The tonality is considerably deeper and the colour is more intense than that used by Leonardo in his *Plan of Imola* and other coloured drawings. Mantegna is celebrated for the range of his painting techniques, including the use of egg tempera and often animal glue (or perhaps casein) for his paintings on canvas.[94] In his coloured drawings, Mantegna generated a richness and depth of hue that suggest that here also he was working with an opaque medium, such as glue or egg tempera, to emulate the characteristics of gouache rather than those of watercolour. This technique could have provided a valuable example to Leonardo when he was confronted with the problem of representing on paper a multicoloured jasper. By using Mantegna's colouristic technique in his vase drawings, Leonardo could best rise to the challenge set by Mantegna's representation of multicoloured stones. Ironically, however, Isabella was most attracted not by the multicoloured jasper vase that pleased Leonardo the most, but by the rock crystal one. The drawing for this vase was presumably only slightly, if at all, coloured.

Francesco Malatesta's remark that Leonardo's drawings could not show the vases' 'real lustre [*lustro*], because it is impossible for painters to know how to achieve this' also cries out for explanation. At first sight, this comment is perverse, but it hinges on what Malatesta meant by the term *lustro*. The term has been defined as 'the bright highlight on shiny surfaces, which, unlike the general pattern of light and shade, moves with the eye of the observer'.[95] Of all Italian painters at the turn of the century, Leonardo was perhaps best equipped to represent a lustrous surface through indications of reflected light. A number of his notes relating to light and the illumination of opaque bodies consider the properties of *lustro*: 'Illumination', he wrote, for instance, 'partakes of light, and lustre is the reflection of this light.'[96] Again, 'lustres which are generated by polished surfaces are virtually of the nature of mirrors'; but conversely, 'opaque bodies which have dense and rough surfaces will never generate lustre at any place in their illuminated portions'.[97]

In a celebrated study on 'Light, Form and Texture in Fifteenth-Century Painting' Ernst Gombrich drew convincing parallels between the treatment of lustre in paintings by Leonardo and by Jan van Eyck. As he rightly observed, Jan van Eyck was the first to master the painting of light reflected from polished surfaces: 'The full potentiality of *lustro* to reveal not only sparkle but sheen', he wrote, 'is a discovery that will always remain connected

with the art of the Van Eycks.'[98] He noted as classic examples of Jan van Eyck's skills in representing surfaces and textures the reflections of the Virgin's red robe in the polished armour of St George in the *Madonna of Canon van der Paele* (Bruges, Groeninge Museen, dated 1436), the sparkle of the jewels in the borders of the Virgin's robe, and the gleaming reflections that emphasise the roundness of the polished marble columns.[99]

Gombrich also observed that Leonardo's theoretical discussion of *lustro* in the notes for his *Trattato della pittura* had practical application, in, for example, the 'loving care with which he picks out the sheen of Ginevra de' Benci's locks . . . an early example of [his] pride in the rendering of surface texture, which he shared with Jan van Eyck'.[100] Leonardo also knew precisely how to apply touches of highlighting to represent the reflections off the pearls and gemstones of the brooches worn by the Virgin in the *Madonna of the Carnation* and the *Benois Madonna*, or off the polished black beads of Cecilia Gallerani's necklace (see pl. 58) as it falls across her right breast. He also knew well how to suggest texture through highlight, as when he sensitively contrasted the texture of the ermine's fur with that of the skin of Gallerani's right hand. By the time Leonardo made the drawings of the ex-Medici vases for Isabella d'Este, he was aiming in his painting practice for a moderated, even subdued tonality rather than for the brilliancy shown in the tonal contrasts in his paintings of the 1470s. Nevertheless, he undoubtedly knew perfectly well how to achieve effects of lustrous reflection: this is shown both in his theoretical writings and in practical terms through his handling of paint. This is certainly not something that it was 'impossible for painters' such as Leonardo da Vinci 'to know how to achieve'.

What, then, lay behind Malatesta's dismissive remark? Its very inclusion in his letter seems to be an acknowledgement of the importance of *lustro* in judgements of works of art at around the turn of the century. This is well exemplified in the letters exchanged late in 1504 between Isabella d'Este and her agent in Bologna, Antongaleazzo Bentivoglio, when negotiations were in progress for a painting by Lorenzo Costa for her *studiolo*.[101] On 1 December 1504 Bentivoglio forwarded to her Costa's concern about the appearance and technique of Mantegna's *studiolo* paintings: 'It is necessary that Your Excellency should advise me as to whether Messer Andrea's work has lustre, and what sort of lustre, or in truth if it is varnished or not.'[102] To this, Isabella responded that Mantegna's paintings 'are not coloured in oils, but rather in tempera [*guazo*], and then varnished after everything is completed. It is up to your painter [Costa] to paint either in oils or with varnish, according to his opinion, art and satisfaction.'[103]

Leonardo would have known that Isabella could see that it was far from impossible for painters to achieve effects of reflected *lustro*. After all, by 1502 Mantegna's *Parnassus* had been hanging for some five years in her *studiolo*, and she would surely have admired, for example, the gleam of the gemstones of Pegasus's bridle, a lustrous effect achieved in spite of Mantegna's use of egg tempera rather than oil as his medium. Leonardo's oil-based painting techniques were considerably more empowering in the pursuit of *lustro* than Mantegna's tempera, or than any of Leonardo's drawing techniques. Nonetheless, in a sheet of masterly studies of horses in preparation for the Sforza monument (pl. 95),[104] Leonardo applied white heightening over his metalpoint drawing on blue prepared paper with such subtle delicacy as to define completely convincingly the sheeny texture of the horse's hide. But by the turn of the century, Leonardo was no longer drawing in metalpoint. His preferred techniques at this time – red or black chalk, and pen and ink – did not easily allow for the display of reflected lustre, although he had recently to good effect painted touches of white heightening over the black chalk of a drapery study for St Peter's arm in the *Last Supper*.[105] Nevertheless, more so perhaps than any other Renaissance draughtsman, Leonardo was sufficiently proficient in his drawing technique to have been able to suggest the reflection of light off polished stone or crystal. This he could have achieved by either leaving the paper spared at that point so that its natural whiteness would shine through, or by applying touches of white heightening over the coloured wash. Both of these methods had been used by Mantegna in the *Mars, (?)Venus and Diana* drawing in the British Museum (pl. 94), notably in the right-hand female figure. As previously suggested, Leonardo might have seen examples of Mantegna's coloured drawing technique when he stayed in Mantua early in 1500. Several years later he used an equivalent technique – white heightening over black chalk and brown wash – when defining the glossy texture of the fabric of the Virgin's robe as it falls across her right thigh in an exquisite drapery study for the *Madonna and Child with St Anne*.[106]

It seems possible that in his remark about *lustro* Malatesta was paraphrasing comments that Leonardo himself had made, as though Leonardo had sought to defend his drawings against criticism in this respect. A happier possibility, however, is that Malatesta was not referring to the *lustro* of reflected light, in the sense that Leonardo used the term. Rather, he was struggling to find a description of the way in which semi-translucent, semi-precious stones, if carved sufficiently thinly, seem to glow when light passes through them.[107] The vase of multicoloured jasper that especially pleased Leonardo was presumably 'lustrous' in this sense, because Malatesta describes it as 'transparent'. Although the term *lustro* may not have been applied to this visual

95 Leonardo da Vinci, *Studies of a Horse*. Windsor, Royal Library, RL 12321

phenomenon earlier, the effect had been described by Ciriaco d'Ancona as early as 1445. Of a rock-crystal gem that then belonged to Giovanni Delfino, and that he thought represented *Alexander*, he wrote, 'When you hold up the gem towards the light . . . , the breathing limbs are seen to shine out with complete solidity, and with luminous crystal shadows in the hollows.'[108] Again, of the *Phaeton* cameo that had been acquired from Giovanni Ciampolini in Rome for Lorenzo de' Medici, his agent Nofri Tornabuoni wrote in early February 1487, 'It has this subtlety, so that one can enjoy it by night as well as by day, because it is no less beautiful to see it by candlelight than in daylight.'[109] Whereas Leonardesque *lustro* can be achieved by white heightening, the coloured glow of light passing through semi-translucent stone might indeed have been impossible even for Leonardo to reproduce in a coloured drawing.

Primarily because Leonardo da Vinci's drawings of the ex-Medici vases do not survive, it has not been possible to identify any of the four vases listed in Malatesta's letter with extant vases inscribed 'LAUR MED'. Almost all such vases are now in either the Tesoro di San Lorenzo in Florence or the Florentine Museo degli Argenti. This suggests that they remained with, or were reintegrated into, the Medici collection until some were lodged at San Lorenzo, and the rest were ultimately absorbed into the Florentine state collections.[110] It is therefore unlikely that any of the surviving vases could have been available for purchase in 1501–2. However, only sixteen hardstone vases incised 'LAUR MED' survive, whereas thirty-three are listed in the 1492 inventory of Lorenzo de' Medici's possessions.[111] Twenty-two such vases were listed as in the hands of the Signoria in an inventory of 19 November 1495:[112] none of these has been identified, but some may have been brought back into the Medici collection at a later date, or may be the group now in the Museo degli Argenti. The vases that Isabella d'Este expressed interest in acquiring in 1502 were others that we know from Malatesta's letter were given to Piero di Lorenzo de' Medici's creditors. What became of these vases later is not known.

Although none of the visual evidence – neither the four vases themselves, nor Leonardo's or other artists' drawings of them – can be identified, this is an episode in the history of Gonzaga collecting that is of considerable interest. It highlights the value of drawings as intermediaries in informing collectors about available classical objects that they were considering purchasing. It may be that other Renaissance drawings after the antique had the same primary function, of informing potential purchasers of the character and quality of the object reproduced.[113] Francesco Binasio provided Bishop-Elect Ludovico Gonzaga with drawings of classical busts that he hoped to buy from Caradosso Foppa; and we know from the correspondence that at least three

sets of drawings of ex-Medici hardstone vases were sent north to Mantua from Florence. Of these sets of drawings, it seems likely that the finest and most informative were those ordered on Isabella d'Este's behalf from Leonardo da Vinci – even though to Francesco Malatesta's regret they were unable to show *lustro*. It was not, however, through any shortcomings of these drawings, but rather through her failure to reach agreement with the vendors, that Isabella's hopes of acquiring the rock-crystal vase she coveted, and than which 'the aforesaid Leonardo said that he had never seen a better piece', ultimately went unfulfilled.

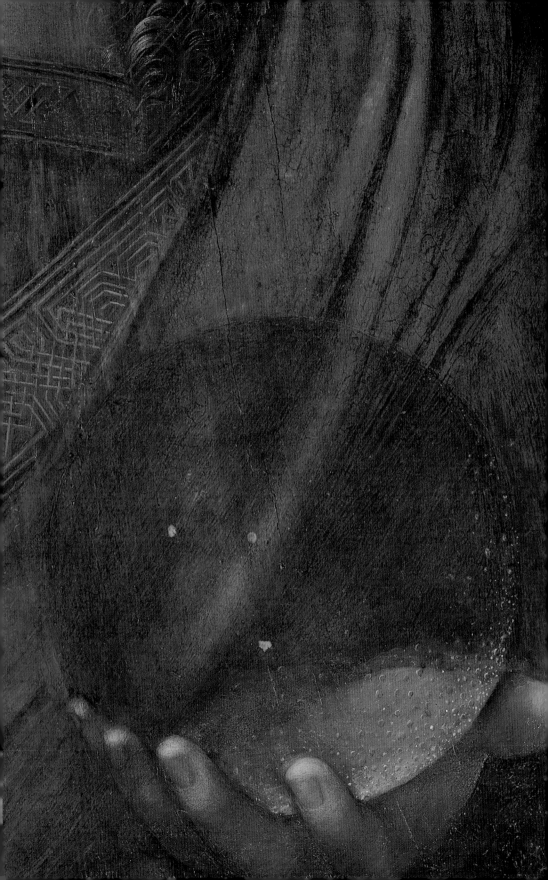

VI

LEONARDO'S LAST PROJECT FOR ISABELLA

In her letter of 14 May 1504 to Leonardo da Vinci in Florence, Isabella d'Este finally conceded that she was not going to be able to persuade him to produce the portrait 'in colours' that he had been promising for over four years: 'this would be almost impossible, since you are unable to move here'.[1] Leonardo had, however, left Mantua with a copy of the portrait drawing of Isabella, and (as noted in chapter four) possibly also a secondary cartoon. At that stage he presumably intended to paint the portrait in Florence on the basis of the copy-drawing rather than from the life in Mantua. Isabella's reason for withdrawing the portrait commission is therefore implausible. It was, however, a convenient rhetorical device for introducing the next project that she hoped Leonardo would undertake. She now turned her attention to a painting of the Young Christ:

> Having learned that you are staying in Florence, I entertain the hope that what I have so much desired, that is to have something by your hand, might be realised . . . I beg you to fulfil your obligation to me by substituting for my portrait another figure that would be even more pleasing to me; that is to say to carry out for me a young Christ of about twelve years old, which would have been the age he was when he disputed in the temple, done with that sweetness and gentleness of expression which is the particular excellence of your art. If you please me in my great desire, know that apart from the payment which you yourself will determine, I will be so indebted that I should not think of anything else but gratifying you, and from now on I am ready to be at your service.[2]

96 (*facing page*) Leonardo da Vinci, *Salvator Mundi*, detail.
New York, private collection

This final attempt to secure a painting by Leonardo shows that Isabella was growing more sensitive as to what sort of subject would best suit his artistic interests and abilities, and to which he might therefore respond positively. A complex moral allegory using mythological figures, on Mantegnesque lines, was evidently not appropriate to Leonardo's interests or abilities; and a profile portrait failed to provide scope for his concern with showing human feeling. But a painting of the 'young Christ of about twelve years old, which would have been the age he was when he disputed in the temple', as she put it in her letter, could offer him the opportunity to paint an ideally beautiful youth, with facial expression and gestures that would call forth all his expressive skills. At the same time Isabella was perhaps inspired to propose this subject because it appealed to the maternal instincts stimulated by her devotion to her four-year-old son Federigo.[3]

The 14 May letter was enclosed within another addressed the same day to the Gonzaga agent Agnolo Tovaglia. In this letter Isabella asked Tovaglia to present her letter to Leonardo, repeating to him, 'Desiring next above all to have something by Leonardo da Vinci, whom I know to be a most excellent painter both by reputation and first hand, I have asked him in the enclosed whether he might make me a figure of a young Christ at twelve years of age.'[4] Tovaglia delivered Leonardo's letter to him, and replied on 27 May to Isabella:

> I have received your Excellency's letters, together with the one for Leonardo da Vinci, to whom I presented it while I persuaded and encouraged him . . . to honour your request at all events, by gratifying your Excellency with that figure of the little Christ. He has repeatedly promised to do it in whatever time he can spare from a work on which he is engaged for the Signoria here. I shall not neglect to urge both Leonardo and Perugino as to the other work. Both artists augur well and it seems that they greatly wish to serve your Excellency: however, I suspect that they will vie with one another in slowness. I do not know in this respect which of the two will outdo the other, but I feel sure that it will be Leonardo who wins.[5]

It seems that Leonardo's progress was indeed slow – if he made any headway at all on the new project at this stage. As we shall see, there is some evidence that he did at least start work on the *Young Christ* at some point during the two years after Isabella's first proposal of this theme. But Isabella evidently heard nothing from Leonardo during the summer of 1504, for five months later, on 31 October 1504, she wrote to him again in person, reminding him that

some months ago I wrote to you that I wanted to have a young Christ of about twelve years old by your hand. You sent me your reply through Messer Angelo Tovaglia that you would willingly do it, but owing to the many commissioned works that you have in hand I fear you have not remembered mine; therefore I decided to write these few lines begging you – when you have had enough of the Florentine history – to begin this small figure as a diversion, for it would be pleasing to me and useful to you.[6]

The 'Florentine history' was, of course, the mural of the *Battle of Anghiari* for the Sala di Gran Consiglio of the Palazzo della Signoria. Leonardo had started work on this by 24 October 1503, when he was given a key to the Sala del Papa in the convent of Santa Maria Novella, a room large enough for him to work on his full-scale cartoon.[7] A year after this, when Isabella wrote for the second time, the design stage was presumably all but complete, since preparatory work had recently started in the Sala di Gran Consiglio itself. Painting proper, however, did not start until sometime in the months before early June 1505. Isabella does not seem to have heard anything more about her *Young Christ* until yet a year later. At this time she evidently appealed to Alessandro Amadori, Canon of Fiesole, and brother to Leonardo's stepmother, for further help in persuading Leonardo to execute her picture. He wrote back to her on 3 May 1506:

> My most illustrious esteemed Lady. Since I am here in Florence again, I am now at all times the agent of your Excellency with Leonardo da Vinci my nephew, and I remain steadfastly at his side. He is prepared to satisfy your Excellency's desire regarding the figure you requested and which he promised several months ago. As he wrote to me in his letter which I showed your aforesaid Excellency, he has promised absolutely to begin the work shortly in order to satisfy the wishes of your Excellency, to whose graciousness he entrusts himself. And while I am here in Florence, if you will let me know that you prefer to have one figure rather than another, I will ensure that Leonardo can satisfy the desire of your Excellency whose every wish I will do my utmost to fulfil.[8]

Isabella replied to this on 12 May: 'I appreciate the skill with which you deal with Leonardo da Vinci to induce him to satisfy me regarding those figures I asked him for. I thank you for everything, beseeching you to continue.'[9] No further letters about the painting of the Young Christ survive in the Gonzaga archive: it may be that Isabella received no further news of progress on it, whether encouraging or negative. In fact, shortly after Isabella's

final letter, Leonardo left Florence and returned to Milan, leaving the *Battle of Anghiari* unfinished, and probably without having started painting any new work for Isabella.[10] The Signoria of Florence had permitted Leonardo a three months' break from his employment in their service, to take up some work that Charles d'Amboise, Louis XII's governor in Milan, wished him to carry out. On 18 August Charles d'Amboise asked the Florentine Signoria for an extension on this three-month period, which implies that the Signoria's permission to Leonardo to leave Florence for Milan was granted shortly before 18 May, perhaps within a week of Isabella's last letter. Isabella did not, it seems, attempt to pursue Leonardo once he was back in Milan. She recognised and accepted, perhaps, that she would have little chance of success in competition with the King of France and his courtiers.

At this point, probably, Isabella d'Este gave up hope of ever obtaining a painting from Leonardo da Vinci. But the tenor of the correspondence outlined and excerpted here raises some interesting questions about their relationship. As far as we can tell from the reports of Agnolo Tovaglia and Alessandro Amadori, Leonardo expressed no impatience with Isabella's pressure, and was apparently consistently courteous in expressions of his desire to serve her well. For her part, Isabella too sounds as conciliatory as she could reasonably be, given the delays that may well have caused her some frustration. In the initial letter asking Leonardo to paint her a twelve-year-old Christ, Isabella put herself at his service and in almost exaggeratedly elegant terms left it to Leonardo to set his own price. Although this ploy did not meet with success, it shows that she was prepared to offer a degree of licence unusual for the patron of a Renaissance painter. In one of the most sophisticated critical comments of the Renaissance, Isabella described the 'sweetness and gentleness of expression' in his execution as the 'particular excellence of [his] art'.[11] Fulsomely complimenting him on his expressive skills, she concluded, 'I will be so indebted that I should not think of anything else but gratifying you, and from now on I am ready to be at your service.' In her second letter, she continued in the same tone: 'Therefore I decided to write these few lines begging you – when you have had enough of the Florentine history – to begin this small figure as a diversion, for it would be pleasing to me and useful to you.'[12] Nothing in her side of the correspondence echoes the irritation that Agnolo Tovaglia appears to have felt when writing of Leonardo's and Perugino's competition in slowness. Nevertheless, Isabella may understandably have felt irked by Leonardo's failure to fulfil his promises. If she did, she kept any such feelings concealed from him behind a formal and polite style of letter writing, just as she had in the correspondence with her agents about the works she sought from Giovanni Bellini.

Nothing can be learned from these letters about how much, if any, progress Leonardo made on the figure of the Young Christ that Isabella asked him to paint for her. On balance, it seems unlikely that he ever made a start with pigments on panel, although there is evidence, considered in detail later, that he may have made some progress with design work for two paintings, of the Young Christ Disputing and of a youthful Salvator Mundi. If this was the case, it may help to explain the curious and ambiguous comments about Isabella's request in the last exchange of this correspondence. In May 1506 Alessandro Amadori asked Isabella 'if you will let me know that you prefer to have one figure rather than another'. In reply she wrote of 'those figures I asked him for', perhaps suggesting that she had asked for samples of both figure compositions.[13] Some items in the correspondence between October 1504 and May 1506 appear to be missing: during this period there was probably further consideration of the subject of the painting asked of Leonardo. Isabella initially requested a painting of 'a young Christ of about twelve years old, which would have been the age he was when he disputed in the temple', indicating a clear preference for the Young Christ Disputing type in the belief that it would be a suitable subject for Leonardo's artistic interests and representational skills. However, Amadori's query raises the possibility that by May 1506 Isabella had thought further, and had offered Leonardo a choice between the Young Christ Disputing and another image, such as the youthful Salvator Mundi, that could still allow the representation of Christ as a twelve-year-old boy.

Another possibility is that by referring in her final letter to 'those figures', Isabella now wished for a painting not of just Christ (at 'the age he was when he disputed in the temple') but indeed of Christ among the Doctors in the Temple. If so, one might think that she could have anticipated that it would probably be even more difficult to coerce Leonardo to complete such a multi-figured painting. On the other hand, this expanded project would have offered Leonardo scope for representing a new range of physiognomic and expressive types in the representation of the doctors. Had he taken up this project, he could have exploited his increasing interest in physiognomy, and in the expressive possibilities associated with different facial types. An earlier experiment in physiognomical study that could have informed any exploration of this theme undertaken by Leonardo in response to Isabella's project is the drawing *Five Grotesque Heads* (pl. 97). This has been seen as showing an idealised profile head crowned with oak leaves, surrounded by representatives of the four humours or temperaments; or, recently and more prosaically, as 'A man tricked by gypsies'.[14] Moreover, it has been plausibly suggested that copies of grotesque heads of these sorts by Leonardo were known to Albrecht

97 Leonardo da Vinci, *Five Grotesque Heads*. Windsor, Royal Library, RL 12495

Dürer when he painted his version of *Christ among the Doctors* (Madrid, Museo Thyssen-Bornemiza) in autumn 1506.[15]

In fact, a Christ among the Doctors composition is one outcome that may have emerged within Leonardo's Milanese circle at about this time, as a result of the Young Christ project. Evidence for this comes in Bernardino Luini's

98 Bernardino Luini, *Christ among the Doctors*. London, National Gallery

Christ among the Doctors in the National Gallery, London (pl. 98).[16] Despite
its poor condition, and the possibility that the face of Christ may have been
substantially repainted later, this painting can be read as an image of the young
Christ, based on a Leonardo prototype, set against (rather than being inte-
grated into) a group of four older, scholarly figures. Christ is significantly
larger in scale than the doctors, and he appears to be placed in a spatial plane
in front of those occupied by the older figures. He is essentially detached from
his surroundings: he is therefore shown not in debate with the doctors, but
with the observer towards whom he gestures rhetorically. Christ's gesture
offers a clue to Luini's source in Leonardo's work, and perhaps in particular
in drawings made in preparation for Isabella's *Young Christ*. In the *Treatise on
Painting* Leonardo advised:

> When you make someone whom you wish to be speaking to many people,
> consider the subject on which he must discourse, and adapt his actions so
> that they are in accordance with the subject. That it to say, if it be a matter

of persuasion, then his actions should fit this purpose. If many different arguments are to be expounded, then he who speaks will grasp one of the fingers of his left hand with two from the right, having closed the two smaller fingers, and with his face turned in readiness towards the throng and with his mouth somewhat open, so that he appears to speak. . . .[17]

Inverting the gestures that Leonardo described here, Luini's Christ counts off his arguments with his right digit finger against two upright fingers of his left hand. Nevertheless, the rhetorical force of his hand gestures carries essentially the same meaning as in Leonardo's description. The prototype for Luini's Christ, evidently a single figure, presupposed that the viewer stands in for the doctors in the temple. It is the beholder who is invited to respond to the arguments conveyed by Christ's gestures, the engaging expression of his eyes, and the words implied by his half-open mouth. This is analogous to another figural composition devised by Leonardo around the middle of the first decade of the sixteenth century: an Angel of the Annunciation is known from several painted copies apparently based on a lost composition by Leonardo. A black chalk copy (pl. 99), made by a pupil after Leonardo's prototype but corrected by Leonardo himself in ink, appears on a sheet dating from around 1506–8.[18] Raising his right arm in salutation, the angel looks directly out towards the observer, who thereby steps into the Virgin Mary's shoes to receive the angelic message of the incarnation of Christ. By analogy, Leonardo's prototype Young Christ, probably known to Luini in graphic rather than in painted form, declaimed his arguments directly to the beholder. In Luini's painting that beholder becomes one of the doctors in the temple.

Returning to Amadori's and Isabella's references to more than one figure, however, it seems on balance more tactful to propose not that Leonardo was requested to design a Christ among the Doctors composition, but rather was offered a choice of two single-figure images to develop into a finished painting. Isabella had written on 27 March 1501 that if Leonardo could or would not paint a *historia* for her *studiolo*, he might at least be induced to paint her 'a small picture of the Virgin'. Similarly, offering him a choice now might encourage him to work with more purpose on one subject or the other. There is no good evidence that Leonardo completed a painting of the Young Christ Disputing, but we now know that a painting of the Salvator Mundi was produced within his workshop. The *Salvator Mundi* (pl. 100) that was displayed for the first time in the exhibition *Leonardo da Vinci: Painter at the Court of Milan* at the National Gallery in 2011–12 is seriously damaged, but has passages of high-quality painting.[19] It seems almost certain that this painting was the version of the Leonardesque *Salvator Mundi* composition that was

99 Assistant of Leonardo da Vinci, *Angel of the Annunciation.*
Windsor, Royal Library, RL 12328r

copied in an etching by Wenceslaus Hollar (pl. 101), made presumably to cir-
culate and popularise this image, and inscribed 'Leonardus da Vinci pinxit.
Wenceslaus Hollar fecit Aqua forti secundum Originale. Ao. 1650'.[20] In the
mid-seventeenth century this painting was evidently accepted as Leonardo's
autograph version of the composition.

 Over-zealous cleaning at some early date has left the surface of the paint-
ing, and especially the figure's face and hair, much abraded, and there are
considerable losses of paint. The face, as reproduced in Hollar's etching and
in a group of derivative paintings made by painters in Leonardo's Milanese
circle, was designed to be hieratic and icon-like, as befits the subject.[21] It has
been suggested that the Salvator Mundi subject 'would have been most uncon-
genial to Leonardo, forcing him to work to an iconic formula that presented
no formal challenge or psychological tensions',[22] and this is indeed true of
Christ's face. There is some evidence from *spolveri*, visible along the top of
Christ's upper lip under infrared light, that his face was based on a cartoon.[23]
This suggests that a mechanical process of design transfer was used in
executing this area, and this Leonardo might have left to an assistant in his

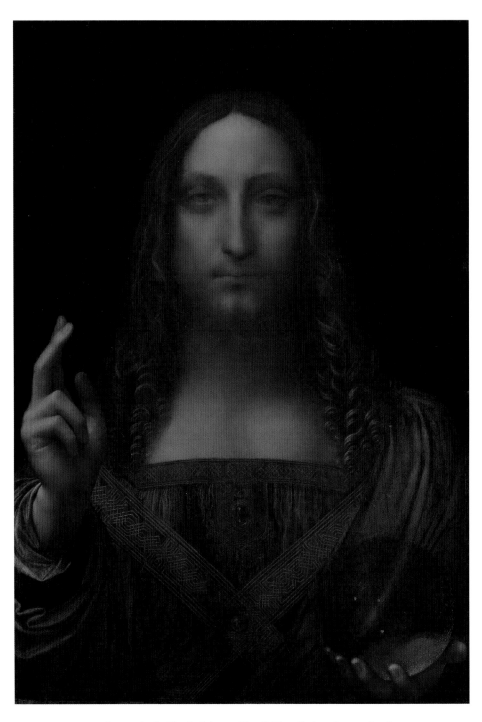

100 Leonardo da Vinci, *Salvator Mundi*. New York, private collection

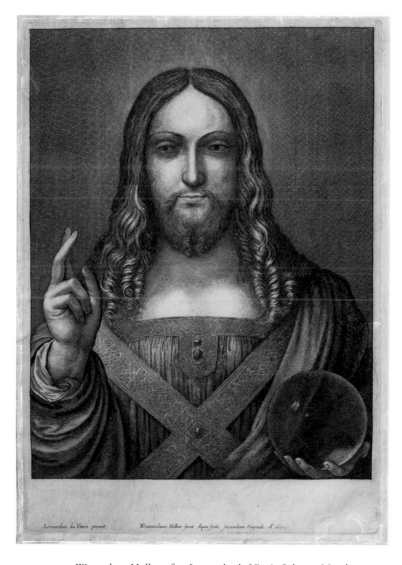

101 Wenceslaus Hollar, after Leonardo da Vinci, *Salvator Mundi*.
Windsor, Royal Library, RL 801855

workshop, which could explain why Christ's face appears now to be of lower quality than his hands. On the other hand, this may simply be a misleading impression left by the effects of abrasion and paint loss in this area. Analysis of cross-sections of the paint surface seems to show that a series of thin layers of translucent coloured glazes was painstakingly applied, which would be

entirely characteristic of Leonardo's own technical treatment. Moreover, the delicately painted, glinting golden reflections off the curls of hair that ripple down either side of Christ's neck and throat are typical of Leonardo's observation and pictorial rendering of effects of light.

If painting the Salvator Mundi's inexpressive face may nevertheless still have been uncongenial to Leonardo, the same may not have been true of representing his hands. Christ's hands, and especially the blessing right hand, are relatively undamaged, and are very finely painted. The foreshortening of the fingers of the left hand, and the remarkable effects of light and colour on the palm of this hand as seen through the transparent spherical orb, which is evidently to be understood as carved of rock crystal, are masterly (pl. 96). The right hand is equally delicately painted with soft tonal gradients across the palm, where shadow is cast by the fourth and fifth fingers: this is fully characteristic of Leonardo's *sfumato* handling of pictorial light and shade. Moreover, there is a significant *pentimento* by which during the course of execution Christ's thumb was repainted in a rather less vertical position.[24] This is again entirely consistent with Leonardo's practice: his constantly active mind encouraged experiment and change, even at a late stage of execution. Here he searched for the ideal solution to the problem of how best he could suggest that the beholder sees Christ's hand at one brief moment in the continuum of the gesture of blessing. Christ's face had to be iconic and impassive, but the pose and implied movement of his hands could – and needed to – convey meaning and expression.

This *Salvator Mundi* is an important new addition to Leonardo da Vinci's oeuvre. If, indeed, Leonardo alone painted the whole panel from start to finish, it may suggest that his patron was too considerable and discerning a figure for any work to be left to assistants. It has plausibly been argued that the painting was ordered by the French King Louis XII and his wife, Anne of Brittany,[25] but the dating of this project is controversial. If it was indeed a royal commission, it might have been started shortly after the king captured Milan in early October 1499. Alternatively, it might have been in progress in April 1501, a work implied in Fra Pietro da Novellara's comment to Isabella d'Este that 'if [Leonardo] could sever himself from His Majesty the King of France without dishonour . . . he would far rather serve your Excellency than anyone in the world . . .'[26] However, it seems more likely that Leonardo undertook this project after he had returned to Milan in May 1506. The clue to this is a pair of surviving drawings in which Leonardo made detailed drapery studies for the torso (pl. 102) and the right, blessing hand (pl. 103) of the Salvator Mundi.[27] Their use for this purpose is confirmed by the close reproduction in both the *Salvator Mundi* and Hollar's copy-etching of the

102 Leonardo da Vinci, *Drapery Study*. Windsor, Royal Library, RL 12525

fold-patterns of the fabrics of which Christ's right sleeve is made up. Several more early sixteenth-century Milanese paintings of the Salvator Mundi show the same debt to Leonardo's prototype. This suggests that Leonardo's preparatory drawings for this painting, and not least these drapery studies, were available to others in his Milanese circle.

These two sheets are drawn in red chalk, with slight touches of black and white chalks, on orange-red prepared paper. Leonardo developed his technique of drawing with red chalk on red-prepared paper apparently in around 1495, specifically for his studies of the heads of apostles in the *Last Supper*. He regularly used it early in the sixteenth century: perhaps the best autograph example drawn shortly after the turn of the century is the study for the *Bust*

103 Leonardo da Vinci, *Drapery Study*. Windsor, Royal Library, RL 12524

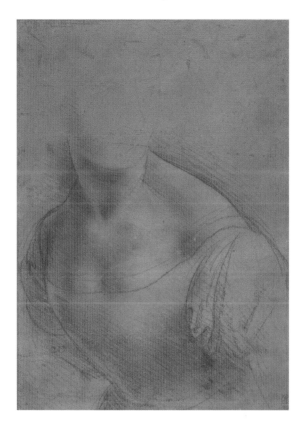

104 Leonardo da Vinci, *Bust of a Woman*.
Windsor, Royal Library, RL 12514

of a Woman (pl. 104), to which Leonardo seems to have looked back in 1501–2 when preparing the *Madonna of the Yarnwinder*.[28] Fra Pietro da Novellara noted in his letter of 14 April 1501 to Isabella d'Este that this painting was in progress for Florimond Robertet, the Secretary to King Louis XII. Leonardo was still using this red-on-red technique as late as around 1510, when he made a beautiful study for the Christ Child in the Louvre *Virgin and Child with St Anne*.[29] The *Salvator Mundi* drapery studies (especially that illustrated in plate 103) are looser in handling, with long, flowing contours to the folds, and richer and deeper in tonality than the study for the *Bust of a Woman*. This freer treatment indicates that the usual dating for these sheets, of around the middle of the first decade of the sixteenth century, is probably correct.

On the first sheet (pl. 102) there are two studies: to the left, above the diagonal dividing line that follows the upper edge of Christ's stole, is a study of

the drapery of Christ's torso and right upper arm; and to the right, below the dividing line, is a study for the drapery at Christ's right wrist. Here, the red chalk hatching is left-handed, and is therefore presumably autograph, but the study is coarsely heightened with white pigment applied with the brush with the right hand, presumably that of one of Leonardo's assistants. This study does not appear to have been reworked in the further preparation of any surviving Leonardesque composition. The fold morphology of the second red-chalk study (pl. 103), for the lower sleeve and cuff of the Salvator Mundi's right, blessing hand, is much closer to the drapery in the recently discovered *Salvator Mundi*, and in near derivations of that composition, than is the white-heightened study on the first sheet. It may, therefore, represent a later stage of Leonardo's thoughts on this detail. It includes a zig-zagged pleat of fabric within the thickness of the leading fold of the drapery that hangs over the forearm. This motif reappears in the *Salvator Mundi*, in the Hollar etching, and in several of the painted versions after Leonardo, although in all these the inner sleeve is of light-coloured fabric rather than the deep-toned sleeve of Leonardo's drawing. In the drawing the inner sleeve is also equipped with a band holding the gathered fabric to the wrist, a motif absent from the *Salvator Mundi* and from all except one of the derivative versions. All this suggests that these two surviving drawings were made within a sequence of studies for this composition. Leonardo may have made similar sequences of drawings for Young Christ figure compositions, in a characteristic process of experiment and exploration towards expressively satisfying solutions to the conundrums set by Isabella's project.

Three other single-figure compositions seem to have been developed in Leonardo da Vinci's workshop at around this time, perhaps prompted by initial stimuli from Leonardo's own imagination and hand. At least two of these stimuli may in turn have been outcomes of his reflections on Isabella's request for a painting of the young Christ. Any such outcomes would very probably have been expressed in drawings – perhaps both creative sketches and more fully worked-up studies for specific details. One of these three compositions is also a Salvator Mundi image, but with a young Christ figure rather than the usual mature, bearded Christ of the rediscovered *Salvator Mundi*. The other two are a Blessing Christ which is less formal, and figuratively more fluent, than the *Salvator Mundi*; and a more evolved, more expressively posed Young Christ who appears in two early paintings by Correggio. Discussion of the variant types of youthful Christ image can only be speculative, since it is prompted largely by pictorial compositions that appear to depend on hypothetical, lost drawings by Leonardo.

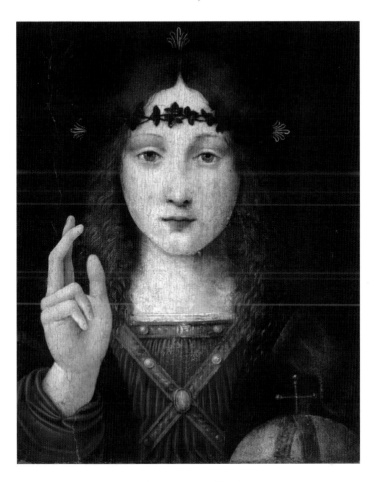

105 Giovanni Antonio Boltraffio, *Salvator Mundi*.
Bergamo, Accademia Carrara

Clearly related to the recently identified *Salvator Mundi* (pl. 100), and knit-
ting this composition in more securely alongside Isabella's Young Christ
project, is a painting by Boltraffio that shows the Salvator Mundi as a boy
aged perhaps twelve years old (pl. 105).[30] Differences in the drapery folds dis-
tance this image from the *Salvator Mundi*, from the surviving red chalk
drapery studies and from Hollar's etching (pl. 101). But the principal contrast
with the etching, which shows that before over-cleaning the *Salvator Mundi*
was richly bearded, is the youthfulness of the physiognomy. Beardless, and
with rather immature, undifferentiated features, the boy engages cautiously,

even timidly, with the observer, as though uncertain of his status. We are left wondering if this youth could make much headway in debate with the learned doctors. This treatment seems an uneasy compromise between the stern formality of the traditional Salvator Mundi iconography and the disarming innocence of a twelve-year old disputant. Such a compromise as this seems improbable within the evolution of Leonardo's own thoughts on the Young Christ project. Moreover, it is difficult to imagine that Isabella d'Este would regard the original of such a painting as one 'done with... sweetness and gentleness of expression'.

Boltraffio's youthful *Salvator Mundi* signals the way towards a group of Leonardesque paintings of the youthful blessing Christ. These lack the conventionally hieratic formula of the Salvator Mundi, but rather provide the figure with some elements of movement, differentiated gesture and expression. To this extent they may reflect more dynamic prototypes from within the range of experimental figure-types for which Leonardo may have produced sketches or more finished studies. The principal member of this group is the *Salvator Mundi* in the Galleria Borghese in Rome (pl. 106) by Marco d'Oggiono. This painting has recently been dated to the later 1490s, perhaps some five years or more before Isabella asked Leonardo to paint her a Young Christ.[31] Since it appears in style to echo Leonardo's design experiments, it could be that this whole group of figure-compositions reflect ideas developed by Leonardo as early as the mid-1490s. Had he made figure-studies that inspired Marco d'Oggiono's painting in the later 1490s, it is conceivable that when Leonardo was in Mantua in 1500 Isabella d'Este might have seen drawings that stimulated her desire for a painting of the Young Christ. On balance, however, it seems more likely that Marco d'Oggiono based this youthful Salvator Mundi's subtle movement and sensitive facial expression on a Leonardo figure-composition that was devised in drawings made in around 1505 in response to Isabella d'Este's proposal.

In Marco d'Oggiono's youthful *Salvator Mundi* the line of Christ's shoulders is no longer parallel with the picture surface, as in the bearded Salvator Mundi group: here his right shoulder is slightly recessed back into pictorial depth. The greater prominence of the left shoulder is emphasised by the rich blue highlights on Christ's mantle. Conversely, Christ's head is slightly turned to his left, so that from shoulders to neck and from neck to head there is a delicate but distinct spiral twist. With this turn of the head the left eye is close to the left contour, while considerably more of the right than of the left cheek and jaw shows. Despite this, Christ's eyes engage fully with the observer and therefore themselves turn slightly from the angle of the head. The eyes and the tonally softened corners of the mouth, turned up slightly as though Christ

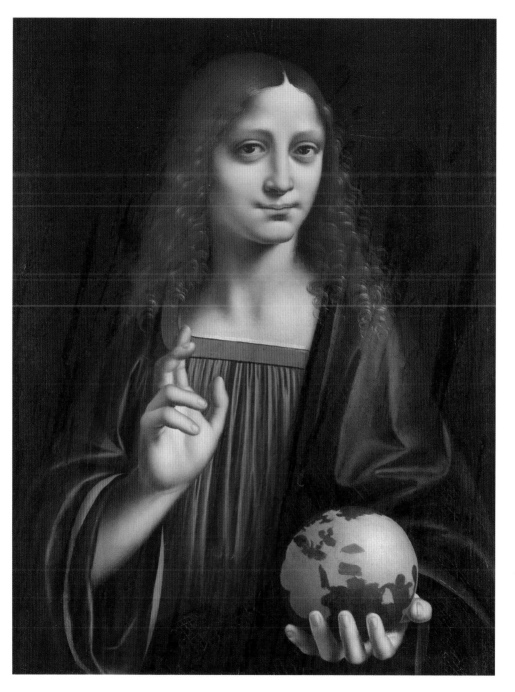

106 Marco d'Oggiono, *Salvator Mundi*. Rome, Galleria Borghese

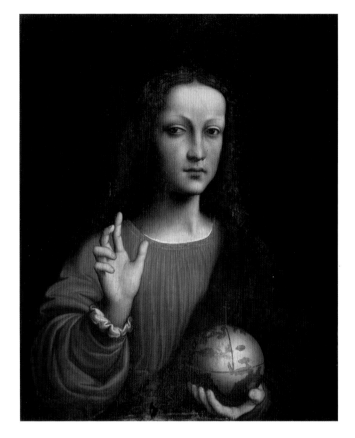

107 Marco d'Oggiono, or Giampietrino, *Salvator Mundi*.
Nancy, Musée des Beaux-Arts

is faintly smiling, give the head an expressive sharpness and individuality not
found in the *Salvator Mundi* (pl. 100) or in Wenceslaus Hollar's etching. These
qualities of both physiognomy and emotional communication are entirely
characteristic of Leonardo's expressive interests at this time, and may well have
been developed out of his own studies in preparation for Isabella's Young
Christ image.

 Linked with Marco d'Oggiono's Borghese *Salvator Mundi* are two smaller
panels, one in Nancy (Musée des Beaux-Arts) perhaps also by Marco
d'Oggiono or by Giampietrino (pl. 107),[32] and rather more distantly a paint-
ing in a private collection in Milan, perhaps by Giovanni Agostino da Lodi.[33]
In neither of these does Christ confront the observer with the motionless,
hieratic symmetry of the Leonardo *Salvator Mundi*: rather, he twists lightly

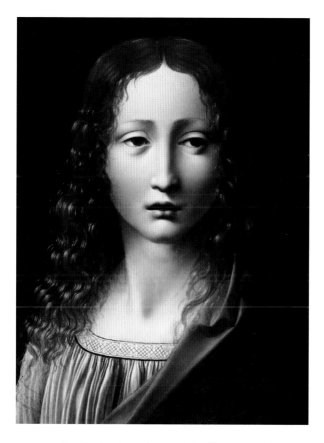

108 Lombard painter close to Boltraffio, *Young Christ*.
Madrid, Fundación Làzaro Galdiano

round to engage us more spontaneously and on more equal, less hieratic
terms. In these versions of the composition it is Christ's left shoulder that
recedes into space, so that his right arm and blessing hand thrust more force-
fully forward. In each case his head is twisted to the right of his torso to catch
the observer's attention. These images of the youthful Salvator Mundi become
progressively more distant from Leonardo's style, and perhaps from an origi-
nal prototype; but the group as a whole reinforces the sense that Leonardo
himself went some way towards developing the 'young Christ of about twelve
years old, which would have been the age he was when he disputed in the
temple' requested by Isabella d'Este in her letter of 14 May 1504.

The best evidence, however, that variants on the theme of the Young Christ
were relatively advanced in Leonardo's own hands survives in a group of three

paintings that show a speaking, rather than a blessing, youth. The first of these is a small panel (pl. 108) sometimes attributed to Giovanni Ambrogio de Predis, sometimes to Boltraffio, and recently to a 'Lombard painter close to Boltraffio';[34] the other two rank among the earliest surviving panel paintings by Correggio. In the first painting the focus is on the young Christ's facial expression: his eyes look fixedly over the observer's right shoulder, and his mouth is half open as though he is in speech, or about to speak. Evidently indebted to Leonardesque idiom are the *sfumato* modelling across the cheeks, down the shadowed side of the nose and on the throat, and, in contrast, the bright highlights on the richly curling hair that falls to the youth's shoulders. The suggestions of speech, and of a facial expression in transition, both here and in Correggio's two versions may reflect what Leonardo's own treatment of the theme might well have looked like.

Born around 1489, Correggio appears to have been working in Mantua in the mid-1500s, perhaps as an assistant to Mantegna in his very last years. He has been associated with the fresco decoration of Mantegna's funerary chapel in Sant'Andrea, Mantua, and in particular with the Evangelist pendentives frescoed in around 1507. Correggio's two versions of the *Young Christ* appear to have been painted in around 1510–12. Probably the earlier of the two (pl. 109), now in the Goldoni collection in Bologna, shows a half-length Christ holding up an open psalter towards the observer. The book is open at Psalm 110, the *Dixit Dominus*, the title of which is carefully transcribed onto the open page for us to read. X-ray analysis of the painting shows that the book was painted over an image of a lamb, the Agnus Dei, symbol of Christ. This overpainting suggests that Correggio consciously changed his subject's iconography, perhaps to assert the importance both of the book and of the implications of this particular psalm. The phrase 'in the beauties of holiness from the womb of the morning: thou hast the dew of thy youth' (Psalm 110:3) may be echoed in the age at which Christ is here represented.[35] Moreover, verse 4 of Psalm 110, 'The Lord hath sworn, and will not repent, Thou art a priest for ever after the order of Melchizedek', is repeatedly interpreted by St Paul, in his Epistle to the Hebrews, as meaning that Christ himself is a priest after the order of Melchizedek, 'king of Salem, priest of the most high God'.[36] He is therefore worthy to sit with the doctors in the temple and to argue with them over points of doctrine.

Correggio's painting certainly shows Christ as a boy, perhaps even specifically as a twelve-year-old boy, with some of the passion of youth: his half-open mouth suggests that he is reciting the psalm to the observer. The asymmetrical position of his hands holding the book open generates a sense of lively inherent movement in the pose: his left hand is raised as he points

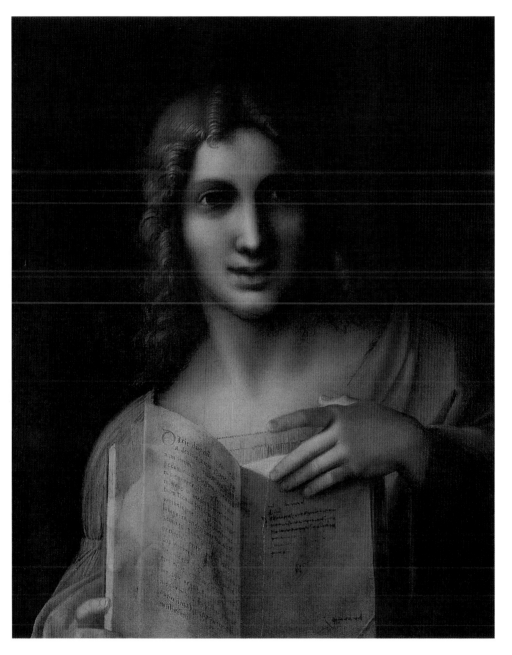

109 Correggio, *Young Christ*. Bologna, Goldoni collection

with his index finger towards the start of the psalm. This movement of his left hand and arm also raises his left shoulder, which is prominently reinforced by the rich deep scarlet of his robe; his right shoulder, on the other hand, drops and recedes into pictorial depth. Against this diagonal shift through space, Christ's neck twists so that he looks to his right and out of the picture space over the observer's right shoulder. The rich *sfumato* modelling into the shadowed depths of the eye sockets and around the mouth, which reinforces the expressive strength of the features, is notably Leonardesque, as is the careful highlighting of the ringlets of hair that catch the light falling from the left onto Christ's forehead and right cheek. Sombre though its colour is, this painting shows Correggio's youthful response to the fresh vitality of movement and expression in Leonardo's works, and perhaps in particular to drawings made in preparing Isabella's Young Christ.

Correggio's second *Young Christ* (pl. 110) is colouristically brighter and expressively rather more subtle. Its figural composition echoes that of the version first considered here, while more clearly reflecting the compositional formula of Leonardo's *Cecilia Gallerani* (see pl. 58). The golden border of Christ's rich pink robe moves diagonally up from his right to his left shoulder, implying again the recessed right and raised left shoulders. His head and face, which is rather thinner and more pinched in feature than in the first version, are once more turned to his left. He presents his face fully towards the observer, but his eyes are turned further to the left to look over and beyond the observer's right shoulder. Once more Christ is open-mouthed, as though in speech; and he points with his right index finger towards a book, one recently turned page held open in his left hand, as though he is expounding on some theological point. Unlike Luini's Christ in the National Gallery *Christ among the Doctors* (pl. 98), who gestures rhetorically with both hands as he counts off the debating points that he is making, Correggio's *Young Christ* in Washington displays his learning through discussion of a passage of text. But whereas in the first version we are told what the text is, here it is not identified. By pointing to the page, Christ alludes to the general authority of text, and perhaps by implication to his capacity to interpret and elucidate it, just as in Leonardo's portrait drawing Isabella d'Este also points to a book as an affirmation of her aspirations towards literary and cultural authority (see pl. 62). Once more in this second *Young Christ* the modelling reflects Leonardo's *sfumato*, and the ripples of highlighted curls of hair that cascade down either side of Christ's thin face are reminiscent of Isabella d'Este's hairstyle, especially in the four head-and-shoulder copies (see pls 53, 67–69) after the Louvre portrait drawing and also of the Salvator Mundi's flowing locks (pl. 100).

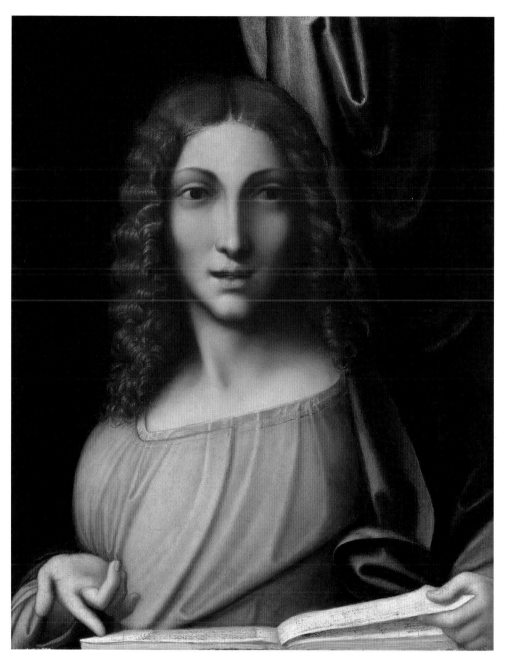

110 Correggio, *Young Christ*. Washington, D.C., National Gallery of Art,
Samuel H. Kress Collection

Correggio's two versions of the *Young Christ* may well reflect Leonardo's own graphic explorations of the theme proposed by Isabella d'Este. If so, they suggest that Leonardo was indeed working on a figure composition that would avoid both the problematical contrast in the Louvre portrait drawing of Isabella d'Este between the almost frontal pose of the bust and the twist of the head into an idealised profile, and the inflexible frontality of his Salvator Mundi image. Correggio's source, or at least his variations upon it, no longer showed the zigzag fold pattern seen in the red chalk drawing for the Salvator Mundi's sleeve and cuff. Rather, in his putative design Leonardo seems to have reached back further, and perhaps reconsidered the sitter's pose in the portrait of Cecilia Gallerani (see pl. 58). If so, history had come full circle, since this was the very painting that provided Isabella d'Este with her *paragone* with portraits by Giovanni Bellini, and that perhaps first prompted her to seek to acquire a work by Leonardo.

Conclusive evidence will probably never be found as to how much progress Leonardo da Vinci made on any of the possible iconographical variants of the Young Christ image proposed by Isabella d'Este. However, it would be as characteristic of Leonardo to start to explore ideas in graphic form when stimulated by a new project as it was characteristic of him to fail to execute a commissioned work that he had promised to undertake. Given the range of painted variations on the Young Christ theme produced in the early decades of the sixteenth century by Boltraffio, Luini, Marco d'Oggiono, Correggio and others, it seems a sound working hypothesis to propose that Leonardo did indeed make drawings in response to Isabella d'Este's project, some perhaps as well worked up as the two red-chalk drapery studies in the Royal Library, and others probably left in sketchier form.

Leonardo drew three sheets of bravura sketches for the central 'Fight for the Standard' section of the *Battle of Anghiari* probably in autumn 1503, at an early stage in the development of this group of battling figures. These sketches suggest the way that Leonardo's fertile creative imagination moved rapidly from one idea to another, each stimulated by the rapid encapsulation of the last in sketch form.[37] Leonardo himself advised that 'The sketching out of the narratives should be rapid, and the arrangement of the limbs not too defined but merely confined to suggesting their disposition. Later at your leisure you can finish them to your liking'; or again, that the painter should 'apply yourself first through draughtsmanship to giving a visual embodiment to your intention and the invention which took form first in your imagination'.[38] One can imagine a very similar process taking place several months after the *Anghiari* sketches were made, in response to Isabella's request in her letter of 14 May 1504. The outcome of this process might well have been a consid-

erable group of swiftly noted, variant ideas for the Young Christ images and for the *Salvator Mundi*. In turn, these could have been the subjects for copies or for more fully worked-up figure drawings made in Leonardo's workshop, or more widely within his Lombard circle. We know now that the group of closely similar paintings of the Salvator Mundi, and Hollar's associated copy-etching of 1650, indeed derived from a finished painting by Leonardo (pl. 100). It would, however, be more tactful to hypothesise no more than drawings on paper in which Leonardo explored the expressive possibilities inherent in Isabella's theme. He advised the narrative painter to 'decide broadly upon the position of the limbs of your figures and attend first to the movements appropriate to the mental attitudes of the creatures in the narrative rather than to the beauty and quality of their limbs'.[39] An analogous procedure would be appropriate for composing the single figure of the Young Christ. In the context of his lifelong search for modes of crystallising on paper (or in paint) the transient qualities of human emotions shown in movements, gestures and facial expressions, it might be expected that Leonardo would respond to the appeal of the Young Christ subject. Certainly, the group of derivative paintings considered here suggests that he did indeed rise to the challenges of representing the lithe movements, the innocent, immature facial expressions and the dynamic emotional enthusiasms of a twelve-year-old youth.

Because much of it is speculative, this discussion of Leonardo da Vinci's work on Isabella d'Este's Young Christ project has ended on a somewhat indeterminate note. But this perhaps echoes the overall character of the artistic relationship between Isabella and Leonardo. In terms of pictorial outcome, it was essentially unfulfilled, and for both protagonists probably therefore unfulfilling: in Isabella's case, as for us today, perhaps frustratingly so. Leonardo made an exquisite, finished portrait drawing, which was pricked for design transfer to a panel for painting, or to further sheets of paper for copy-drawings to be made; but the portrait that he had promised Isabella he would make for her 'in colours' was never achieved. In her first letter of the correspondence about Leonardo's work for her, to Fra Pietro da Novellara on 27 March 1501, Isabella suggested that he sound Leonardo out about making a picture for her *studiolo*; but there is no indication that Leonardo took up this proposal. Indeed, since he probably knew what Mantegna's *Parnassus* looked like, it seems unlikely that he stopped for long to consider the project. Although Isabella wrote that she would leave the subject to him, he knew what sort of

moralising subject matter Isabella appreciated, and this was as inimical to Leonardo as it was to Giovanni Bellini. Moreover, he is very unlikely to have been prepared to match Mantegna's high-key tonality and bright colours, even though these were appropriate to the low light levels in Isabella's *studiolo*. Nor is there any evidence that Leonardo responded to her alternative proposal in the same letter, that he might be induced to paint 'a small picture of the Virgin, devout and sweet as is his natural style'. Leonardo did make a set of coloured drawings for Isabella of four hardstone vases formerly in Lorenzo de' Medici's collection, and advised on their appearance and quality. Although Isabella was clearly stimulated by Leonardo's report to seek to purchase the crystal vase in particular, she failed ultimately to acquire any of them. Bathetically, this was essentially due to a technicality: a mundane, peripheral disagreement about the value of woollen fabric. Finally, Leonardo appears to have made exploratory drawings that were later available to painters within his circle in Lombardy, on Isabella's theme of the 'young Christ of about twelve years old'. But once he was drawn away onto work for the King of France and other patrons of greater political and diplomatic importance than Isabella, any thoughts that he might once have harboured, and any promises that he made to Isabella, about converting these graphic ideas into finished paintings were dissipated, overtaken by events and new projects.

Rather little, therefore, emerged from the relationship in visual, artistic terms, rich though the promise was that Isabella d'Este would gain fine paintings by Leonardo for her collection of works by the most celebrated Italian painters of her time. Isabella would have been justified in thinking that Leonardo did not respond as productively as her solicitude and patience with him deserved. But was their artistic relationship entirely unproductive? We can now perhaps see it in a rather more positive light than it has been viewed in the past. A good deal can be learned from it about attitudes. Both the artistic projects discussed here and Isabella's voluminous correspondence provide valuable information about her attitudes as a collector to the works of art that she assembled. We also learn instructive things about Isabella as a patron, about her aesthetic sensibilities, and about her attitudes to Leonardo the creative artist. More generally, we can learn a good deal about her stances towards the artists from whom she sought works, and conversely about the attitudes of those artists, notably Leonardo da Vinci, to Isabella as a patron.

We can also learn some useful, perhaps even important, historical lessons from the four projects that Isabella asked Leonardo to undertake for her, and that we have surveyed in these chapters. Of these projects only one was fully achieved: the lost set of drawings of the ex-Medici vases. On two others that were intended to be finished paintings Leonardo got no further, as far as we

know, than producing drawings, whether preliminary or finished. The fourth – the *studiolo* allegory – was it seems still-born, as probably was the Virgin and Child alternative that Isabella suggested. But when considering these projects we gain instructive information about practices and functions of drawing. The project for the portrait of Isabella d'Este offers evidence of how Leonardo and artists in his circle used drawings to generate, refine and replicate an image. We have considered how values intrinsic to the proposed portrait were important for projecting Isabella's self-presentation; and we have explored the possibilities offered by copies both as intermediaries in producing a painted portrait and for disseminating the image of Isabella. Although lost, Leonardo's drawings of the ex-Medici vases, and the other drawings of these vases that we know were sent from Florence to Mantua, show something of the role of drawing in conveying information to collectors about antiquities. As collecting became more fashionable and more competitive amongst the elite of late quattrocento Italy, the quality of the visual information that collectors could obtain became more important in assessing the value of particular antiquities within their collections, and the value for money of such acquisitions. The drawings for the *Salvator Mundi* (pls 102 and 103) and the related drawings that can be hypothesised from the existence of paintings based on Leonardesque designs, demonstrate the importance of prototype Leonardo drawings in disseminating figural inventions amongst his circle in Lombardy. Finally, the resonances of the Young Christ project in early sixteenth-century Lombard paintings further indicate the breadth and strength of the response to a figural invention inspired by Isabella d'Este and probably drafted for her by Leonardo da Vinci. From these results, this brief episode in patron–artist relations in early sixteenth-century Italy gains considerably greater historical significance than one might expect from the paucity of the artistic outcomes.

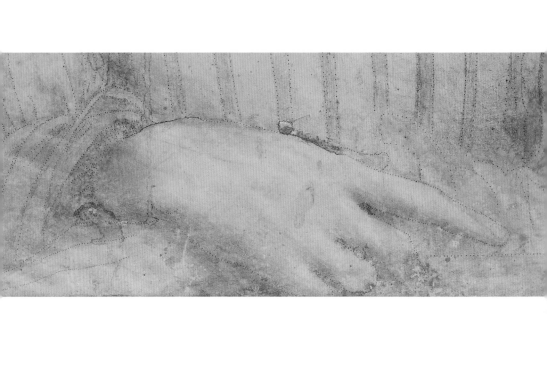

APPENDIX

LETTERS TO AND FROM ISABELLA D'ESTE CONCERNING WORKS FOR HER BY LEONARDO DA VINCI

1 Isabella d'Este to Cecilia Gallerani, 26 April 1498[1]

Dominae Ceciliae Bergaminae.

Madonna Cecilia. Essendone hogi accaduto vedere certi belli retracti de mane de Zoanne Bellino, siamo venute in ragionamento de le opere de Leonardo cum desiderio de vederle all parangone di queste havemo, et ricordandone ch'el vi ha retracta voi dal naturale, vi pregamo che per il presente cavallaro, quale mandiamo a posta per questo, ne vogliati mandare esso vostro retracto, perchè ultra ch'el ne satisfarà al parangone, vederemo anche voluntieri il vostro volto. Et subito facta la comparatione vi lo rimetteremo, dimandandone compiaciute da voi, ne offeremo a li piaceri vostri apparechiate. Mantue 26 aprilis 1498.

Lady Cecilia Bergamini.

Lady Cecilia. Having happened today to see some fine portraits by the hand of Giovanni Bellini, we began to talk about the works of Leonardo, desiring to compare them with these paintings that I have. And recalling that he painted you from life, I beg you to send me this portrait of you by the present courier, whom I have sent with this in mind. For, apart from allowing the comparison, I should gladly see your face. And as soon as the comparison has been made, I will return it to you. With your approval, I am prepared to satisfy your desires. Mantua, 26 April 1498.

III (*facing page*) Leonardo da Vinci, *Portrait Drawing of Isabella d'Este.*, detail. Paris, Louvre

2 *Cecilia Gallerani to Isabella d'Este, 29 April 1498*[2]

Illustrissima et excellentissima domina mea honorandissima, ho visto quanto la signoria vostra me ha scripto circa ad haver caro da vedere el ritratto mio, qual mando a quella: et più voluntiera lo mandaria quanto asimigliasse a me. Et non creda già la signoria vostra che proceda per difecto del maestro, che invero credo non se truova a llui un paro, ma solo è per esser fatto esso ritratto in una età sì imperfecta, che io ho poi cambiata tutta quella effigie talmente che vedere epso et me tutto insieme non è alchuno che lo giudica esser fatto per me. Tuttavolta la signoria vostra prego ad haver caro el mio bon vollere, che non solo el ritratto, ma io sono aparechiata ad fare magior cosa per compiacere a quella ala quale sono deditissima schiava et infinite volte me li reccomando. Ex Mediolano, die 29 Aprilis 1498.

De la excellentia vostra serva Scicilia Bergamini Visconta

(a tergo): Illustrissime et excellentissime domine: domine
marchionisse Mantue sue honorandissime. Mantue.

Most illustrious, excellent and honourable lady, I have seen what your Excellency wrote to me about wishing to see my portrait, which I am sending to you. I should send it more readily if it resembled me more. Do not, your Excellency, attribute this to a defect on the part of the master, because in truth I think there is none to be found who equals him; rather it is merely that the portrait was done when I was at an immature age. Since then, I have changed so much from that likeness that to see it and me together, no one would judge that it had been made of me. However, I do beg your Excellency to appreciate my good will, to the extent that not only will I let you have the portrait but I am ready to do even more to gratify you, whose devoted servant I am, and I commend myself to you unreservedly. From Milan on the 29th day of April 1498.

From your excellent servant Cecilia Viscountess Bergamini.

(on the back): Most illustrious and excellent lady:
Marchioness of Mantua, most honourable lady.
Mantua.

3 *Cecilia Gallerani to Isabella d'Este, 18 May 1498*[3]

Illustrissima Madonna mia honorandissima, non bisognava che la signoria vostra usasse con me termine de ringratiare, perchè ogni mia cosa con me insieme sono alli piaceri di quella. Così la prego ad vollerne disponere con sichurtà, che me troverà, ben ch'io stia in Milano, non mancho vera serva son che se io stesse in quella sua propria citate, ringratio infinite volte la signoria vostra de le humane

profferte a me fatte. Et anchora ch'io me senta indigna, tuttavolta la vera humanitate di quella mi sforzaria, acchadendo, richiedere como ad una singulare patrona; come tengo la signoria vostra. Alla quale ex toto corde sempre mi riccomando. Mediolani die 18 maii 1498

 De la Signoria vostra serva Scicilia Vesconta de Bergamini

(al retro): Illustrissima domine domine Isabelle
marchionisse Mantue sue semper honorandissime

My most illustrious and honourable lady, your Excellency did not need to thank me, because everything I do is contrived to please you. Therefore I beg you to use me as you wish, because although I am in Milan you will find me no less your faithful servant than if I were in your own city. I thank your Excellency greatly for the kindness extended to me. And although I feel undeserving, your real humanity would compel me, if need be, to seek sympathy from you as one would from a singular patron such as I consider your Excellency to be. To whom I always commend myself wholeheartedly. Milan, on the 18th day of May, 1498.

 From your Excellency's servant Cecilia Viscountess Bergamini

(on the back): Most illustrious lady, Isabella,
Marchioness of Mantua, always most honourable

4 *Lorenzo da Pavia to Isabella d'Este, 13 March 1500*[4]

A di 13 di marzo 1500.
Inlustrisima madona, per el portatore di questa ve mando uno liuto grande a la spagnola, naturale de la vose, che credo certo che quela non abia mai sentito el meliore, e in vero a me me pare no' ne avere maie sentito el melio. Ò mandato questo prima perché è pura asai che l'aveva principiato e così, a pocho a pocho, l'ò finito con la quartana la quale non m'abandona e sono stato in mane de uno medicho el quale n'à guarito alcuni e a me l'à fata venire mazore con una debilitade estrema per tal modo che me trovo molto di mala volia e tanto pù non podendo così presto dare espedicione a quelo liuto biancho e negro di quela. Podendeme refare non atendarò ad altero che a darili espedicione e faròlo naturale, a la spagnola sì de forma como de voce. E l'è a Venecia Lionardo Vinci, el quale m'à mostrato uno retrato de la signoria vostra ch'è molto naturale a questa, sta tanto bene fato non è possibile melio. Non altro per questa, de continuno a questa me recomando vostro servo Lorenco [*sic*] da Pavia in Venecia.

On the 13th day of March 1500.
Most illustrious lady, by the bearer of this letter I am sending to you a large lute made in the Spanish fashion of natural tone such that I believe it certain that you

have never heard better; and indeed it seems to me that I have never heard a finer sound. I would have sent you this earlier merely because I had begun it some time ago; and so gradually I finished it with the quartan fever which still has me in its thrall, and I have been under the care of a doctor who has cured other people while he has made it worse in me, causing me such extreme debilitation that I find I am very ill. Moreover, I have been unable to send that black and white lute of yours. When I am able to resume work I will not attend to anything else other than dispatching it, and I am making it like this one after the Spanish manner in shape and likewise in tone. And there is in Venice Leonardo da Vinci, who has shown me a portrait of your Excellency which is very like you. Indeed it is so well done that it is not possible to improve on it. That is all I shall say in this letter and as always, I commend myself to you, your servant Lorenzo da Pavia in Venice.

5 *Francesco Malatesta to Marquess Francesco Gonzaga,*
11 August 1500[5]

Mando a la illustrissima signoria vostra el disegno de la chasa de domino Agnolo Tovaglia facto per man propria de Leonardo Vinci, el qual se rechomanda come servitore suo a quella, et similmente a la Signoria de madona. Domino Agnolo dice ch'el vorà poi venire a Mantua per potere dare iudicio qual serà stato meglior architecto, o la signoria vostra o lui: ben ch'el sia certo de dover essere superato da quella, sì perché facile est inventis ad[d]ere, sì perché la prudentia de la signoria vostra è tale che la non è da equiperare a lui. El prefato Leonardo dice che a fare una chosa perfecta bisogneria potere transportare questo sito che è qui là dove vol fabrichar la signoria vostra, che poi quella haria la contenteza sua. Non ho facto far colorito el disegno, né fatoli metere li ornamenti de verdura, di hedera, di busso, di cupressi, né di lauro come sono qui, per non parerme molto di bisogno; pur, se la signoria vostra vorà, el prefato Leonardo se offerisse a farlo, et de pictura et di modello, come vorà la prefata signoria vostra.

Servitore etc. [Francesco Malatesta]

(al retro): Al mio Illustrissimo et excellentissimo signore e patrone
Marchese Mantue etc.

I am sending your illustrious Excellency the drawing of the house of Lord Agnolo Tovaglia made by the hand of Leonardo da Vinci, who commends himself to you as a servant, and to her Excellency likewise. Lord Agnolo says that he should like to come to Mantua to be able to judge as to who would be the better architect, your Excellency or he, although he is certain he would be surpassed by you, both because it is easy to add to what already exists, and because such is your

Excellency's expertise that his cannot bear comparison with it. The aforementioned Leonardo says that to do a perfect thing it would be necessary to be able to transport this site here to where your Lordship wishes to build, as you should then be contented. I did not have the drawing done in colours, or embellished with foliage, ivy, box, cypress or laurel, as they are in reality, because this did not seem necessary to me; however, if your Excellency wishes, the aforesaid Leonardo himself offers to do both a painting and a model, as your aforementioned Excellency wishes.

Your servant, etc. [Francesco Malatesta]

(on the back): To my most illustrious and excellent lord and patron
Marquess of Mantua, etc.

6 *Isabella d'Este to Fra Pietro da Novellara, 27 March 1501*[6]

Fratri Petro de Nuvolaria

Reverendissime et cetera, se Leonardo fiorentino pictore se ritrova lì in Fiorenza, pregamo la reverenda paternità vostra voglia informarse che vita è la sua, cioè se l'à dato principio ad alcuna opera, como n'è stato referto haver facto, et che opera è quella: e se la crede ch'el debba fermarse qualche tempo lì, tastandolo poi vostra reverentia, como da lei, se'l pigliaria impresa de farne uno quadro nel nostro studio, che quando se ne contentasse remetteresimo la inventione et il tempo in arbitrio suo. Ma quando la lo ritrovasse renitente, vedi almancho de indurlo a farne uno quadretto de la Madonna, devoto e dolce como è il suo naturale. A presso lo pregarà ad volerne mandare uno altro schizo del retratto nostro, peroché lo illustrissimo signore nostro consorte ha donato via quello ch'el ce lassò qua: ch'el tutto haveremo non mancho grato da la reverentia vostra che da esso Leonardo. Offerendome a li piaceri di quella paratissima, et a le orationi sue ne racomandiamo. Mantue, xxvii Martii 1501.

Fra Pietro da Novellara

Most Reverend, etc. If Leonardo the Florentine painter is to be found there in Florence, I beg your Reverend Father to find out what his life is like, that is to say whether he has begun any work, as he is reported to have done, and what work this is. And if you think he might stay there for a while, then sound him out – as you know how – as to whether he would undertake to paint a picture for my studio. If he should consent, I will leave the invention and the timing to his judgement. But if you find him reluctant, endeavour at least to induce him to carry out for me a small picture of the Virgin, devout and sweet as is his natural style. And then you should ask him if he would send to me another sketch of my portrait, for his Excellency my husband has given away the one he left for me

here. If all is done I will be no less grateful to your Reverence than to Leonardo. I am ready to offer myself to please you, and I commend myself to your prayers. Mantua, 27 March 1501.

7 Fra Pietro da Novellara to Isabella d'Este, 3 April 1501[7]

Illustrissima et excellentissima domina, domina nostra singularissima. Hora ho avuta una di vostra excellencia, et farò cum ogni celerità et diligentia quanto quella me scrive. Ma per quanto me occorre, la vita di Leonardo è varia et indeterminata forte, siché pare vivere a giornata. À facto solo, da poi che è in Firenci, uno schizo in uno cartone: finge uno Christo bambino de età cerca uno anno, che uscindo quasi de bracci ad la mamma, piglia uno agnello et pare che lo stringa. La mamma quasi levandose de grembo ad Santa Anna piglia el bambino per spicarlo da lo agnellino (animale inmolatile) che significa la Passione. Santa Anna, alquanto levandose da sedere, pare che voglia retenere la figliola che non spica el bambino da lo agnellino, che forsi vole figurare la Chiesa che non vorrebbe fussi impedita la passione di Christo. Et sono queste figure grande al naturale, ma stano in picolo cartone, perché tutte o sedeno o stano curve, et una stae alquanto dinanti ad l'altra, verso la man sinistra. Et questo schizo ancora non è finito. Altro non ha facto, se non che dui suoi garzoni fano retrati, et lui a le volte in alcuno mette mano. Dà opra forte ad la geometria, impacientissimo al pennello. Questo scrivo solo perché vostra excellencia sapia ch'io ho havute le sue. Farò l'opra et presto darò adviso ad vostra excellencia, ad la quale mi racomando, et prego Dio la conservi in la sua gratia. Florencie 3 aprillis MDI
V. Ex. D.
 Servus frater Petrus Novalariensis
 Observantie Carminis vicarius generalis

(a tergo): Illustrissime et excellentissime Domine domine
Isabelle Marchionisse
Mantue domine et
benefactrici singular.
Mantue

Most illustrious, excellent and singular lady, I have just now had a letter from your Excellency and I shall do as you write with all speed and diligence. But as far as I know, Leonardo's life is changeable and greatly unsettled, because he seems to live from day to day. Since he has been in Florence, he has only done one sketch, a cartoon which depicts a Christ child of about one year old who, practically leaving his mother's arms, seizes a lamb, and appears to be holding it

close. Almost rising from the lap of St Anne, the mother takes the child to detach him from the little lamb (a sacrificial animal) which signifies the Passion. It seems that St Anne, rising slightly from her seat, wishes to restrain her daughter from separating the child from the lamb, which perhaps represents the Church that would not wish the Passion of Christ to be hindered. These figures are all life-size but are set within a small cartoon because all are seated or bending forward, and are placed in front of one another towards the left. But this sketch is not yet complete. He has done nothing else except that two of his assistants have been making copies, and he occasionally puts his own hand to some of them. He gives pride of place to geometry, having entirely lost patience with the paintbrush. I am writing this only so that you may know that I have received your letters. I will do the work and soon advise your Excellency, to whom I commend myself and pray that God keep you in his grace. Florence, 3 April 1501.
V. Ex. D.

> Servus frater Petrus Novalariensis
> Vicar-General of the Carmelite Order

(on the back): Most illustrious and excellent lady,
Marchioness Isabella, Lady of Mantua and singular benefactor.
Mantua.

8 *Fra Pietro da Novellara to Isabella d'Este, 14 April 1501*[8]

Illustrissima et excellentissima Domina domina nostra sing. Questa septimana santa ho inteso la intentione de Leonardo pictore per mezzo de Salai suo discipulo et de alcuni altri suoi affectionati, li quali per farmila più nota me lo menorno el merchordì santo. Insumma li suoi experimenti mathematici l'hano distracto tanto dal dipingere, che non può patire el pennello. Pur me asegurai di farli intendere cum destreza el parere di vostra excellentia, prima como da me, poi, vedendolo molto disposto al volere gratificare vostra excellentia per la humanità gli monstroe a Mantua, gli disse el tutto liberamente. Rimase in questa conclusione: se si potea spiccare da la maestà del Re de Franza senza sua disgratia, como sperava a la più longa fra meso uno, che servirebbe più presto vostra excellentia che persona del mondo. Ma che ad ogni modo, fornito ch'egli havesse un quadretino che fa a uno Roberteto favorito dell Re de Franza, farebbe subito el retrato, e lo mandarebbe a vostra excellentia. Gli lasso dui boni sollicitadori. El quadretino che fa è una Madona che sede como se volesse inaspare fusi, el Bambino posto el piede nel canestrino dei fusi, e ha preso l'aspo e mira atentamente que' quattro raggi che sono in forma di Croce. E como desideroso d'essa Croce ride et tienla salda, non la volendo cedere a la Mama che pare gela volia torre. Questo è quanto ho potuto

fare cum lui. Heri fornì la predica mia, Dio voglia che faza tanto fructo quanto
è stata copiosamente udita. Son certificato de quanto altre volte disse del frate a
vostra excellentia, a la quale me recomando.

Florentie die 14 Aprilis 1501

V. Ex.

> servus Frater Petrus de
> Nuvolaria Car.ne Gen.

(a tergo): Illustrissimae et Excellentissimae
dominae Isabella de Gonzaga, Marchionissa Mantue
domina et benefactrix singularis. Mantue

Most illustrious, excellent and singular lady. During this Holy Week I have learnt
of the painter Leonardo's intention through Salaì, his pupil, and a few other of
his devoted friends, who, to apprise me further, brought him to me on the
Wednesday of Holy Week. In short, his mathematical experiments have so
distracted him from painting that he cannot endure his brush. Nevertheless, I
was tactful enough to ensure that your Excellency's opinion was made known to
him, first as though it came from me; then, seeing that he was most willing to
gratify your Excellency, for the kindness you showed him in Mantua, I told him
all of it freely. He came to the following conclusion: if he could sever himself
from His Majesty the King of France without dishonour, as he hoped to do within
a month, then he would far sooner serve your Excellency than anyone in the
world. But anyway, once he has delivered a small picture which he is doing for a
certain Robertet, a favourite of the King of France, he would do the portrait
immediately and send it to your Excellency. I have left two good advocates with
him. The small picture on which he is working is a Madonna seated as if she were
about to wind yarn; the Child has placed his foot in the basket of yarns and has
grasped the yarnwinder, and gazes attentively at those four spokes which are in
the form of a cross. And as if desirous of this cross, he laughs and holds it fast,
not wishing to yield it to his mother, who seems to want to take it away from
him. This is as much as I have been able to do with him. Yesterday saw me giving
my sermon and, God willing, the outcome will be as rewarding as its eager
reception. I know how many other times the frate has been spoken of to your
Excellency, to whom I commend myself.

> Florence, the 14th day of April 1501.

> servus Frater Pietro de Novellara
> General of the Carmelites

(on the back): Most illustrious and excellent
lady Isabella Gonzaga, Marchioness of Mantua,
singular lady and benefactress. Mantua.

9 *Manfredo Manfredi to Isabella d'Este, 31 July 1501*[9]

Illustrissima et excellentissima domina observandissima, etcetera. La littera ad Leonardo firentino che a questi dì m'indrizò la signoria vostra, affine che fidatamente li desse bon recapito, li consignai in man propria sua, facendogli intendere, se'l volea respondere, che dandomi le littere le mandaria a salvamento a prefata vostra signoria; cusì mi rispose che faria, lecto che lui havesse epsa sua littera. Et finaliter, soprastando al respondere, mandai un mio a lui per intendere quel vorea fare. Fecime rispondere che per hora non li accadeva fare altra risposta a la signoria vostra, se non ch'io la advisasse che epso havea dato principio ad fare quello che desiderava epsa vostra signoria da lui. Questo insomma è quanto io ho potuto retrare da decto Leonardo. Se altro occore ch'io possa servire la signoria vostra, quella mi comande come a suo fidel servitore, a la qualle di continuo mi racomando. Quae felix ac diu benevaleat. Florentie, ultimo Iulii 1501

Illustrissime domine vester servitor Manfredus de Ducalis orator Manfredis

(a tergo): Illustrissime et Excellentissime Domine Domine
Isabelle estensis Marchionisse Mantuae etc. Domine mee observandissime
Mantue

Most illustrious, excellent and esteemed lady, etc. The letter to Leonardo the Florentine that your Excellency recently sent me, relying on me to pass it on, I delivered into his own hand. I gave him to understand that if he wished to answer he should give me the letters, and I would forward them to reach your aforementioned Excellency safely. He replied that he would do this, once he had read your letter. Finally, hesitating to reply, I sent one of my servants to him to ascertain what he wished to do. He sent answer that for the moment he did not need to reply again to your Excellency, except that I was to inform you that he had begun to do what your Excellency wished of him. This is as much as I have been able to obtain from the aforesaid Leonardo. If there is anything else I could do to serve your Excellency, to whom I commend myself always, ask me as you would a faithful servant. May you long be happy and well. Florence, the last day of July, 1501.

Most illustrious lady, your servant Manfredus de Ducalis Manfredis, agent.

(on the back): Most illustrious and excellent lady,
Isabella d'Este, Marchioness of Mantua, etc. My most honourable lady.
Mantua.

10 Isabella d'Este to Francesco Malatesta, 3 May 1502[10]

Francesco de Malatestis.

Francesco, habiamo visto li desigui de vasi che hai mandato al Illustrissimo signor nostro, dui di quali ne vanno per mente, quando siano de uno pezo, et sequenti de beleza: cioè quello de cristallo et di agata; ma perché sono mal designati, non se ne pò fare bono iuditio. Remandiamoteli a fine che li faci una altra volta designare per iusta mesura et dipingerli de li proprii colori che sono, et in modo che se conosca il corpo del christallo et cosi quello de agata, da per sé del pede, coperto et manichi, se sono de altre sorte, et declarandola. Haveressimo piacere che li facesti vedere a qualche persona che ne havesse iuditio, como seria Leonardo depintore, quale staseva a Milano, che è nostro amico, se'l se ritrova adesso a Fiorenza, aut altro che te parerà, intendendo el parer suo così circa la belleza como il pretio. Vederai poi de intendere l'ultimo pretio che ne voriano li venditori, et del tutto ce darai plena informatione, perché piacendone li vasi et lo mercato ce piacerà el partito de pagarli de panni, de li quali se seria facilmente d'acordo, sapendosi molto bene quel che valiano. Et cossì andarai intertenendo la pratica in modo che altri non li habiano finché nui non serimo resolti. Mantue, III maii 1502

Francesco de Malatestis.

Francesco, I have seen the drawings of the vases which you sent to my illustrious husband, two of which I have in mind given that they are each in one piece, and are of rare beauty – namely the crystal one and the one in agate. But since they are badly drawn it is hard to evaluate them properly. I am returning them to you so that you might have them drawn again in the right proportions and painted in their actual colours, in order that one can recognise the body of the crystal vase and the agate one by its foot alone, stating moreover whether the cover and handles are of another kind. I should be pleased if you were to show them to a person of discernment, such as Leonardo the painter who was in Milan and is my friend, if he happens to be in Florence now, or else whoever you think, thereby learning his opinion about both the beauty and the price. Then you will ascertain the most recent price the sellers want, and inform me fully because should the vases and the market please me, the option of paying for them in cloth will please me also. We will easily reach an agreement once it is known full well what they are worth. And in this way you will see to the matter such that others cannot have them until we are resolved. Mantua, 3 May 1502.

11 *Francesco Malatesta to Isabella d'Este, 12 May 1502*[11]

Illustrissima madona mia, per Alberto chavalaro mando a la signoria vostra li disegni de li vasi che quella me ha scripto per la sua de 2 [*sic*] del presente, disegnati per iusta misura et choloriti de li proprii cholori, ma non con el proprio lustro, perché questo è imposibile a li depintori a saperlo fare. Et perché la signoria vostra possa ellegere quello che più li piacerà, m'è parso mandar li disegni de tutti quatro li vasi. Li ho facti vedere a Leonardo Vinci depintore, sì come la signoria vostra me scrive: esso li lauda molto tuti, ma specialmente quello di christallo, perché è tutto de uno pezo integro e molto netto, dal piede e coperchio in fora che è de arzento sopra indorato, et dice el prefato Leonardo che mai vide el mazor pezo. Quello di agata anchora li piace perché è chosa rara, et è gran pezo, et è uno pezo solo, excepto el piede e coperchio, che è pur d'arzento indorato, ma è rotto, sì come la signoria vostra potrà vedere per le virgule signate in el corpo di esso vaso. Quello de diaspis simplice è uno pezo netto et integro et ha el piede come ho ditto de sopra, de arzento sopra dorato. Quello de amatista, overo diaspis, come Leonardo lo bateza, che è di varie misture di cholorii et è transparente, ha el piede de oro masizo, et ha tante perle et rubini intorno che sono indichate di presio di 150 [*sic*] ducati: questo molto piace a Leonardo per essere chosa nova et per la diversità de cholori mirabile. Tutti hanno intagliato nel corpo del vaso littere maiuschule che dimostrano el nome de Laurenzo Medice. Circha a li precii de li vasi, io non li posso far chalar più di quello che ho scripto, perchè li venditori dichono che a loro li furono dati in pagamento per quello precio, et che non ne vogliono perdere uno dinaro per rehavere el credito suo integro.

 Florentie 12 maii 1502.

 Ill.ma D. V.

 Servitor Franciscus de Malatestis etc.

(in foglio allegato):

El vaso de christallo	duc. 350
El vaso de diaspis con perle e piede d'oro e rubini	duc. 240
El vaso de diaspis simplice	duc. 150
El vaso de agata	duc. 200

Your Excellency, by Alberto my courier I am sending your ladyship the drawings of the vases about which you wrote to me on the 2nd [*sic*] of this month, drawn in the right proportions and coloured with their actual colours, but not with their real lustre, because it is impossible for painters to know how to achieve this. And so that your Excellency can choose which most pleases you, I have decided to send drawings of all four vases. I showed these to the painter Leonardo da Vinci, as your Excellency instructed me to do: he praises all of them highly, but in

particular, the crystal one because it is all in a single piece and is very fine, with a foot and outer cover in silver and gilded; and the aforesaid Leonardo said that he had never seen a better piece. The one in agate again pleases him since it is rare and is a large piece, a single piece, except for the foot and cover which are also in silver and gilded; but it is broken as your Excellency will see from the cracks in the body of the vase. The plain jasper vase is a fine and unbroken piece with a foot of gilded silver like the aforementioned vases. The one in amethyst, or rather jasper, as Leonardo calls it, which is a varied mixture of colours and is transparent, has a foot of solid gold set with many pearls and rubies as is indicated by its price of 150 [*sic*] ducats: this one pleased Leonardo greatly for its novelty and for its diversity of astounding colours. On the body of each vase the name of Lorenzo de' Medici is incised in capital letters. As for the prices of the vases, I cannot lower them any more than I have already indicated, because the sellers say that they were given as payment for that price, and that in order to regain the full sum they do not wish to lose a denaro.

Florence 12 May 1502.

Ill.ma D. V.

Servitor Francesco de Malatesta etc.

(on an attached sheet):

The crystal vase	duc. 350
The jasper vase with pearls and golden base and rubies	duc. 240
The plain jasper vase	duc. 150
The agate vase	duc. 200

12 Isabella d'Este to Agnolo Tovaglia, 14 May 1504[12]

Domino Angelo Tobalie.

M. Angelo, per littere nostre scripte in Ferrara haverete inteso che siamo contente ch'el Perusino facci la historia nostra doppo ch'el ce promette finirla far dui mesi e mezo, sì che ve pregamo ad non mancarli de diligentia. Apresso, desiderando nui summamente haver qualche cosa de Leonardo Vincio, il quale et per fama et per presentia conoscemo per excellentissimo pictore, gli scrivemo per l'alligata ch'el vogli farmi una figura de uno Christo giovenetto de anni dodece; non vi rincresca presentarli la littera et cum giunta di quelle parole vi pareranno al proposito confortarlo ad servirne, ch'el serrà da noi ben premiato. S'el se scusasse che per l'opera che l'ha principiata a quella excelsa Signoria non haveria tempo, poteti responderli che questo serrà un pigliare recreatione et exullatione quando da la historia sarà fastidio, pigliando il tempo cum suo piacere et comodo. L'è vero che quanto più presto ce lo darà finito, et tanto magior obligo gli haveremo.

Et alli piaceri vostri ce offerimo. Mantue XIIII Maii MDIIII.

Lord Angelo Tovaglia.

Master Angelo, you will have gathered from my letters written in Ferrara that I am pleased that Perugino is doing my *historia* after he promised me he would finish it in two and half months. Therefore I beg you to stint nothing in your care for him. Desiring next above all to have something by Leonardo da Vinci, whom I know to be a most excellent painter both by reputation and first hand, I have asked him in the enclosed whether he might make me a figure of a young Christ at twelve years of age. Would you mind giving him the letter with the addition of such words as seem most suitable in this respect so as to encourage him to serve me, because he will be handsomely recompensed. If he makes an excuse, that he does not have time owing to the work which he has begun for that supreme Signoria [of Florence], you could reply that when he is tired of the history painting, this would provide recreation and rest, and he can take his own time and work at leisure. It is true that the sooner he gives it to me finished the more obliged I will be to him.

 I await your pleasure. Mantua 14 May 1504.

13 Isabella d'Este to Leonardo da Vinci, 14 May 1504[13]

Domino Leonardo Vincio pictori.

M. Leonardo, intendendo che seti firmato in Fiorenza, siamo intrate in speranza de poter conseguire quel che tanto havemo desiderato, de havere qualche cosa de vostra mane. Quando fusti in questa terra, et che ne retrasti de carbone, ne promettesti farni ogni modo una volta di colore. Ma perché questo seria quasi impossibile, non havendo vui comodità di transferirvi in qua, vi pregamo che, volendo satisfare al obligo de la fede che haveti cum noi, voliati convertire el retracto nostro in un'altra figura, che ne sarà anchor più grata: cioè farne uno Christo giovenetto, de anni circa duodeci, che seria de quella età che l'haveva quando disputò nel tempio, et facto cum quella dolcezza et suavità de aiere che haveti per arte peculiare in excellentia. Se serrimo da voi compiaciute de questo nostro summo desiderio, sapiati che, ultra el pagamento che vui medemo voreti, vi restarimo talmente obligate che non pensarimo in altro ch'a in farvi cosa grata, et ex nunc ne offerimo ad ogni commodo et piacer vostro: expectando da voi votiva resposta, et a li piaceri vostri ce offerimo. Mantue, XIIII maii MDIIII.

Master Leonardo da Vinci, painter.

Master Leonardo. Having learned that you are staying in Florence, I entertain the hope that what I have so much desired, that is to have something by your hand, might be realised. When you were in these parts, and did my likeness in charcoal, you promised me you would portray me once more in colours. But because this

would be almost impossible, since you are unable to move here, I beg you to fulfil your obligation to me by substituting for my portrait another figure that would be even more pleasing to me; that is to say to carry out for me a young Christ of about twelve years old, which would have been the age he was when he disputed in the temple, done with that sweetness and gentleness of expression which is the particular excellence of your art. If you please me in my great desire, know that apart from the payment which you yourself will determine, I will be so indebted that I should not think of anything else but gratifying you, and from now on I am ready to be at your service. I look forward to your desired reply and await your pleasure. Mantua, 14 May 1504.

14 Agnolo Tovaglia to Isabella d'Este, 27 May 1504[14]

Illustrissime Domine mee Singularissime et cetera, io hebbi le littere de vostra signoria insieme con quella de Leonardo da Vinci, al quale la presentai et lo persuadei et confortai con eficaci ragioni ad onere per ogni modo, compiacere la excellentia vostra di quella figura de Christo piccolino, secondo la domanda sua. Lui troppo me ha promesso di farlo ad certe ore et tempi che li sopravanzeranno ad una opera tolta a ffare qui da questa Signoria. Io non mancherò de solicitare et esso Leonardo et etiam lo Perugino de quella altra: l'uno et l'altro mi promecte bene, et pare habbino desiderio grande de servire la signoria vostra; tamen me dubito forte non habbino ad fare insieme ad ghara de tarditate. Non so chi in questo supererà l'uno l'altro, tengho per certo Lionardo habbi a essere vincitore. Tuttavia dal canto mio con abbe dui farò ogni extrema diligenzia perché vostra signoria habbi lo intento suo, perché non ho in questo mondo lo maggiore desiderio che fare cosa sia grata alla excellentia vostra, alla quale ex corde mi racomando. Florentie xxvii Maii 1504.
Illustrissime Excellentie Vestre Servitor Angelus Tovalius.

(a tergo): Illustrissime Domine mee domine
Isebelle de Gonzagha, Marchionissa Mantue
Mantue.

Most illustrious and singular lady, etc., I have received your Excellency's letters, together with the one for Leonardo da Vinci, to whom I presented it while I persuaded and encouraged him by means of efficacious reasons to honour your request at all events, by gratifying your Excellency with that figure of the little Christ. He has repeatedly promised to do it in whatever time he can spare from a work on which he is engaged for the Signoria here. I shall not neglect to urge both Leonardo and Perugino as to the other work. Both artists augur well and it

seems that they greatly wish to serve your Excellency: however, I suspect that they will vie with one another in slowness. I do not know in this respect which of the two will outdo the other, but I feel sure that it will be Leonardo who wins. However, as far as I am concerned both will strive most diligently so that your Excellency might reach your objective, because my greatest desire in this world is to please your Excellency, to whom I commend myself wholeheartedly. Florence, 27 May 1504.

Angelo Tovaglio, faithful servant of your most illustrious Excellency.

(on the back): My most illustrious lady,
Lady Isabella Gonzaga, Marchioness of Mantua.
Mantua.

15 Isabella d'Este to Agnolo Tovaglia, 31 October 1504[15]

Messer Angelo, havemo inteso per più vostre a Francesco Malatesta la diligentia usati circa la historia che dipinge el Perosino et per lettere sue che 'l vi ha scripto comprehendemo che l'ha condutta in buon termine; ma perché suoi pari qualche volta interlassino una opera per l'altra, non bisogna che lo abandonati de sollicitudine, scrivendoli spesso, et driciateli la alligata nostra. Apresso dareti l'altra a Leonardo Vincio, et ultra quello che noi gli scrivemo gli fareti raccordo de quella figuretta di Christo che recircassimo li mesi passati, che ne fareti cosa summamente grata, offerendone et cetera. Mantue, ultimo octubris 1504.

Illustrissime dominationis vestre servitor Angelus Tovalius.

Master Angelo, I have learned through several of your letters to Francesco Malatesta of the great care you have taken regarding the history that Perugino is painting, and I understand from the letters he has written to you that he has considerably advanced this work. But since his colleagues sometimes interrupt one work for another, you should not desist from urging him on, by writing often to him and passing on my letter. Then you will give the other one to Leonardo da Vinci and apart from what I write to him, you will remind him of that small figure of Christ that I requested some months ago, because in this way you will do something highly pleasing to me. I am prepared, et cetera. Mantua, on the last day of October 1504.

To Angelo Tovaglia, servant to your most illustrious ladyship.

16 *Isabella d'Este to Leonardo da Vinci, 31 October 1504*[16]

Leonardo Vincio pictori:
Messer Leonardo. Le mesi passati ve scrivessimo che desideravimo havere uno Christo giovine de anni circa duodeci de mane vostra; mi facesti respondere per messer Angelo Tovalia che di bona voglia el faresti, ma per le molte allegate opere che haveti a le mani dubitamo non vi raccordati de la nostra: perhò n'è parso farvi questi pochi versi, pregandovi che, quando seti fastidito da la historia Fiorentina, vogliati per recreatione mettervi a fare questa figuretta, che ce fareti cosa gratissima, et a vui utile. Benevalete. Mantue ultimo octobris MDIIII

Leonardo da Vinci, painter:
Master Leonardo. Some months ago I wrote to you that I wanted to have a young Christ of about twelve years old by your hand. You sent me your reply through Messer Angelo Tovaglia that you would willingly do it, but owing to the many commissioned works that you have in hand I fear you have not remembered mine; therefore I decided to write these few lines begging you – when you have had enough of the Florentine history – to begin this small figure as a diversion, for it would be pleasing to me and useful to you. Be well. Mantua, the last day of October 1504.

17 *Alessandro Amadori to Isabella d'Este, 3 May 1506*[17]

Illustrissima madona mia observandissima, ritrovandomi qui in Firenze sono ogni hora procuratore di vostra excellentia con Lionardo da Vinci, mio nipote, et non resto con ogni studio di stare appresso lui si disponga a satisfare al desiderio di vostra excellentia circa la figura domandata da voi et da lui promessa già più mesi sono. Come costì per sua lettera a me, mostrai alla prefata excellentia vostra et lui al tutto m'ha promesso comincerà in breve l'opera, per satisfare al desiderio di vostra signoria, alla cui gratia assai si racomanda. Et se infin serò qui in Firenze, mi significherete haver appetito più d'una figura che d'una altra, curerò che Lionardo satisfaccia allo appetito di quella, alla qual sopra ogni altro mio desiderio penso di gratificare. Visitando la illustre Madonna Augustina, con sommo piacere intese da me vostra signoria essere arrivata a Mantova con prosperità. Et io soggiunsi che la excellentia vostra si racomandava et offeriva a sua signoria: il che li fu molto grato, et parse a quella scrivere alla signoria vostra la introclusa. Né altro al presente mi occorre. Idio sempre feliciti la excellentia vostra, alla qual humilmente mi racomando. Florentie iii Maii MDVI.
 Excellentie Illustrissime servitor Alexander de Amatoribus

(a tergo): Illustrissime et Excellentissime Domine Domine
Isabelle Estensis De Gonzaga
Marchionissae Mantuae Domine
suae observandissime.

My most illustrious esteemed lady, since I am here in Florence again, I am now
at all times the agent of your Excellency with Leonardo da Vinci my nephew, and
I remain steadfastly at his side. He is prepared to satisfy your Excellency's desire
regarding the figure you requested and which he promised several months ago.
As he wrote to me in his letter which I showed your aforesaid Excellency, he has
promised absolutely to begin the work shortly in order to satisfy the wishes of
your Excellency, to whose graciousness he entrusts himself. And while I am here
in Florence, if you will let me know that you prefer to have one figure rather than
another, I will ensure that Leonardo can satisfy the desire of your Excellency,
whose every wish I will do my utmost to fulfil. When I visited her Excellency
Lady Augustina, she heard from me with great pleasure that your Excellency had
arrived safely in Mantua. And I added that your Excellency commends and offers
herself to her ladyship – for which she was most grateful – and it seemed fitting
to her to write the enclosed letter to your ladyship. At the moment I have nothing
else to say. May God make your Excellency, to whom I humbly commend myself,
always happy. Florence, 3 May 1506.

 Illustrious Excellency

 Your servant Alessandro Amadori.

(on the back): Most illustrious and excellent lady
Lady Isabella d'Este De Gonzaga
Marchioness of Mantua, most honourable lady.

18 *Isabella d'Este to Alessandro Amadori, 12 May 1506*[18]

Domino Alexandro de Amadoribus.
Messer Alexandro, mi è stato grato per la littera vostra de III instantis intendere
che habiati facto le visitationi nostre alla signoria Confalonera, come per una di
sua signoria siamo anche certificate; né manco ce piace la dextresa che usati cum
Leonardo Vincio per disponerlo ad satisfarmi di quelle figure che gli havimo
rechieste: che dil tutto vi ringratiamo, exhortandovi ad continuare et di novo
recomandomi alla signora Confaloniera. Bene valete. Sachette XII maii 1506.

Lord Alessandro Amadori.
Master Alessandro, I was pleased to learn through your letter of the third of this
month that you have visited my lady the Gonfaloniera, as one of her ladies has

also acknowledged. In the same way I appreciate the skill with which you deal
with Leonardo da Vinci to induce him to satisfy me regarding those figures I
asked him for. I thank you for everything, beseeching you to continue, and once
more I commend myself to my lady the Gonfaloniera. Go well. Sachette, 12 May
1506.

NOTES

1

ISABELLA'S INTELLECTUAL PREOCCUPATIONS

1 For the drawing, see Viatte 1999; Bambach 1999, 111–12; *Léonard de Vinci* exh. cat. 2003, 185–89 cat. 61; *Mantegna 1431–1506* exh. cat. 2008, 326–27 cat. 134; and detailed discussion in chapter four.

2 For discussion of this medal in relation to Leonardo's portrait drawing, see chapter four.

3 For medals of Renaissance women, see Syson 1997b.

4 David Alan Brown, in *Virtue and Beauty* exh. cat. 2001, 182 cat. 28; two other versions, in London, National Gallery, and in the Marubeni Corporation of Tokyo, also face to the right; Lightbown 1978, II, 117–19 cats C5 and C6.

5 Simons repr. 1992.

6 Kemp and Cotte 2010, and Cotte and Kemp 2011

7 Kolsky 1991, 67. On Equicola, see also Santoro 1906 and Equicola 2004, 11–23.

8 Fahy 1956, 40–47. On Agostino Strozzi, see now James and Kent 2009.

9 These are by Antonio Cornazzano (the *De mulieribus admirandis*; see Fahy 1960), Bartolommeo Goggio (the *De laudibus mulierum*, dedicated to Eleonora d'Aragona; Fahy 1956, 30–36) and Sabadino degli Arienti (the *Gynevera de le clare donne*, dedicated to Ginevra Bentivoglio in 1492; see James 1996).

10 Manca 2003, 81; Campbell S. J. 2002, 240–43 cat. 15; see also in chapter four. The manuscript is New York, Pierpont Morgan Library, MS M.731.

11 For Eleonora d'Aragona, see Chiappini 1956; Gundersheimer 1980; Ward Swain 1986; and Manca 2003.

12 Equicola 2004, 38–39; Kolsky 1991, 75.

13 Equicola 2004, 38–39; Kolsky 1991, 74.

14 For details of his career, see Piepho ed. 1989, xv–xx.

15 For Paride da Ceresara, see now the valuable introduction in Comboni ed. 2004, 5–38.

16 The *Liber chronicorum* was published in Nuremberg on 12 July 1493; see Brown C. M. 1979, 83–84.

17 Discussed in chapter two.

18 Dionisotti 1958. For Fiera's ill-judged comments on the *Parnassus*, see Luzio and Renier repr. 2005, 148–52; Jones 1981; and recently Campbell S. J. 2004b, 125.

19 For interpretations of the *Parnassus*, see *inter alia* Wind 1948, 9–20 and 1949; Tietze-Conrat 1949; Gombrich 1963; Verheyen 1971, 35–41; Lightbown 1986, 194–201; Campbell S. J. 2004b, 117–44; and *Mantegna 1431–1506* exh. cat. 2008, 332–33 cat. 137. It is discussed in chapter three.

20 Negro and Roio 1998, 165.

21 Kolsky 1991, 103–5.

22 Kolsky 1989; Kolsky 1991, 249–69 and passim; Campbell S. J. 2004b, 110–13; Villa 2006.

23 Lightbown 1986, 202–9; Kolsky 1991, 105–6.

24 'già più anni'; Zorzi 1997; Campbell S. J. 2004b, 208–9.

25 On Isabella's education, see Cartwright 1903, i, 9–10; Kolsky 1991, 103–4; in general, see Grendler 1989.

26 Cartwright 1903, i, 4.

27 Lightbown 1986, 463–64 cat. 85; *Splendours* exh. cat. 1981, 152–53 cat. 92; and discussion in chapter three.

28 Shemek 2005, 271–72 n. 4.

29 Cannata Salamone 2000.

30 Ibid., 502.

31 On this, see Lorenzoni 1979; Shemek 2005.

32 See most recently Shemek 2005, 277; also Brown C. M. 1972, 121.

33 Shemek 2005, 271.

34 I am grateful to Sarah Cockram for sharing with me the text of a paper on 'Epistolary masks: self-presentation and dissimulation in the letters of Isabella d'Este' read to the Society for Renaissance Studies conference in Edinburgh, July 2006.

35 On Isabella's acquisition of goods by 'mail order', see Welch 2005, ch. 9 and especially 262–70.

36 Shemek 2005, 276.

37 Cited in Thornton 1997, 90. It is worth noting that Thornton's book is (perhaps inevitably) entitled 'The Scholar in *his* Study' (my italics); and as she observes (ibid., 90), 'Women very rarely owned studies – a fact that has much to do with the perceived dignity of women, their education and the problematic status of learned women.'

38 Vasic Vatovec 1979, 177 and 186.

39 Recently, in general on the *studiolo*, see Campbell S. J. 2004b, 29–57; the classic study is Liebenwein 1977 and 1988. On Piero de' Medici's *studietto*, see now L. Syson, 'The Medici Study', in *At Home in the Renaissance* exh. cat. 2006, 288–93.

40 Thornton 1997, 90; Welch 1988, 237 n. 18. Further on Ippolita Sforza, see Welch 1995.

41 Tuohy 1996, 95–115; also Manca 2003.

42 Brown C. M. 2005, 44.

43 Ibid., 43–50.

44 These were devices used by Marquess Francesco, not ones personal to Isabella herself; Bourne 2001, 96.

45 The tiles were ordered in letters between Francesco Gonzaga and Giovanni Sforza, Lord of Pesaro, in January 1493; they were delivered to Mantua on 1 June 1494; see Gobio Casali 1981, 44–45.

46 Six tiles survive in the Victoria & Albert Museum, two in the Museo del Castello Sforzesco, Milan, and several others elsewhere; see Gobio Casali 1981, 44–45; Gobio Casali 1987, 155–64; Mallet 1981, 173–74 cats 127–28; Mallet 1997; '*La Prima Donna del Mondo*' exh. cat. 1994, 189 cat. 175. The tiles in Isabella's *studiolo* were noted in a letter of 8 July 1494 (Verheyen 1971, 11; Thornton 1997, 48) from Violante de Pretis, governess to Isabella's baby daughter, who observed that the tiling was very necessary to contain the mice that infested the space beneath the floorboards.

47 Brown C. M. 2005, 45.

48 In general on the pictorial decoration of the *studiolo*, see *inter alia* Verheyen 1971; *Le Studiolo d'Isabelle d'Este* exh. cat., 1975; and now Campbell 2004b.

49 Fenlon 1997, 353; and see also Shephard 2011.

50 Cartwright 1903, i, 10; Fenlon 1997; Prizer 1982.

51 'uno de la beleza et bontà che se convene a la fama haveti et a la speranza che me tenemo in vui'; Brown and Lorenzoni 1982, 39 doc. 1.

52 Prizer 1982, 92, 104 and 125 doc. 12; in general on Isabella as musician, see Fenlon 1997; Prizer 1999.

53 'per el portatore di questa ve mando uno liuto grande a la spagnola, naturale de la vose';

Brown C. M. 1972, 121; Brown C. M. with Lorenzoni 1982, 51 doc. 29; for this letter, see pages 223–24, Appendix, no. 4.

54 'havereti piacere che sii capitato ne le mane nostre, essendo vostra opera et instrumento tanto excelente, quale tenemo molto charo'; letter of 31 July 1501; Brown C. M. with Lorenzoni 1982, 57–58 doc. 42; translation in Cartwright 1903, I, 154.

55 Gerola 1928–29, 257–58.

56 For Isabella's devices, see further Praz 1981, 65–66; Mumford 1979; and Genovesi 1993.

57 On *imprese*, see recently Caldwell 2004.

58 I am grateful to Dorigen Caldwell for advice on this topic.

59 Fenlon 1997, 361–62; see also Cartwright 1903, I, 205.

60 Praz 1981, 66.

61 For Isabella's problems in this respect, see San Juan 1991; in general, see Fletcher 1981.

62 Rebecchini 2002, 45.

63 On Isabella's income, see Welch 2005, 253–58.

64 Brown C. M. 1972; Welch 2005, 271–73. This episode is examined in greater detail in chapter five.

65 It has recently been persuasively shown that Mantegna's *Faustina* was not the *Bust of Faustina maggiore* now in the Palazzo Ducale, Mantua, but rather the *Faustina minore* at Hampton Court (inv. RCIN 1299); Angelicoussis 2003, 60–61; followed by Rausa in *A casa di Andrea Mantegna* exh. cat. 2006, 416–17 cat. 73; see also *Splendours* exh. cat. 1981, 170 cat. 122 and 230–31 cats 247–48.

66 For this episode, see Brown C. M. 1983; Hickson 2000 and 2001; and in detail in chapter five.

67 For the Stivini inventory, see recently Ferrari 1995, 2001 and especially 2003b, 339–51.

68 Prizer 1985.

69 See chapter four.

70 'picture ad historia deli excellenti pictori che sono al presente in Italia'; Campbell S. J. 2004b, 290 (Appendix Two, 34).

II

ISABELLA AND HER ARTISTS

1 Campbell, S. J. 1997, 1–2.

2 Both are now lost (see chapter five). For the acquisition of the Michelangelo sculpture, see Brown C. M. with Lorenzoni and Hickson 2002, 158; see also Hirst and Dunkerton 1994, 22–24; and Campbell S. J. 2004a, 91–92. For the 'Praxitelean' carving (which may, for all we know, indeed have been by Praxiteles), see Brown C. M. with Lorenzoni and Hickson 2002, 109–11 and 160–72.

3 Ferrari 2003b, 346, items 7257 and 7258.

4 Baxandall 1971, 53–59, especially 58.

5 Ibid., 39, and in translation 98, from a text by Lorenzo Giustiniani, who died in 1446. For further discussion and examples, see Ames-Lewis 2000, 163–68.

6 Baxandall 1971, 71.

7 Ibid., 103.

8 Kemp, in *Leonardo and Venice* exh. cat. 1992, 48.

9 Kemp and Walker 1989, 20.

10 Ibid., 34.

11 Ibid., 35.

12 Respectively 'una lista de certi colori che voria per nostro studiolo et mando li parangoni in una scatoletta'; and 'il più bello che in Venetia se trova'; for this episode, see Verheyen 1971, 12 n. 25.

13 Letter of 12 November 1490: 'mandiate otto braza de raso cremesino del più bello se trovi lì a Venetia et sia da paragone, perchè le volemo per fare dicta albernia'; Welch 2005, 263 and 357 n. 65, citing Luzio and Renier 1896, 455.

14 Welch 2005, 123–25.

15 This correspondence is considered in more detail in chapter four; the letters are transcribed and translated in the Appendix, nos 1–3.

16 See chapter five for further discussion of this pairing.

17 'el non vorrà che la sua opera sii di minore excellentia che sii la fama, maxime andando al parangone de li quadri del Mantegna'; Canuti 1931, II, 210 doc. 312; Campbell S. J. 2004b, 291 (Appendix Two, 39).

18 'quando fusse stato finito cum magiore dili-
gentia, havendo a stare appresso quelli del
Mantinea che sono summamente netti seria
magiore honore vostro et più nostra satisfac-
tione'; Isabella d'Este to Pietro Perugino, 30
June 1505; Canuti 1931, ii, 236 doc. 376; Camp-
bell S. J. 2004b, 175 and 298 (Appendix Two,
102); translation in Chambers 1970, 143 no. 84.
Further on this, see later in this chapter.

19 'l'opera sii bona e digna de stare in compagnia
et al parangone di questi altri excellentissimi
pictori'; Campbell S. J. 2004b, 294 (Appendix
Two, 68).

20 'l'opera serrà da stare al paragone de le altre';
Campbell S. J., 2004b, 296 (Appendix Two,
82).

21 'invero l'è bela cosa, à fato melio de quelo che
me credeva . . . in questo quadro s'è molto sfor-
cato per l'onore, masime per respecto de messer
Andrea Mantegna. Ben è vero che de inven-
cione non se pò andare apreso a messer Andrea
ecelentisimo': Lorenzo da Pavia to Isabella
d'Este, 6 July 1504; Kristeller 1902, 572 doc.
164; Brown C. M. with Lorenzoni 1982, 82–83
doc. 90; translation in Lightbown 1986, 190.

22 'de invencione nesuno non pò arivare a messer
Andrea Mantegna . . . , ma Giovane Belino in
colorir è ecelente . . . et è ben finite quele cose
è da vedere per sotile': Lorenzo da Pavia to
Isabella d'Este, 16 July 1504; Kristeller 1902, 573
doc. 165; Brown C. M. with Lorenzoni 1982, 84
doc. 92; Lightbown 1986, 190.

23 'perché sa il judizio di Vostra Signoria e poi va
al parangone de quele opere de messer Andrea':
Michele Vianello to Isabella d'Este, 25 June
1501; Brown C. M. with Lorenzoni 1982, 159
doc. viii; Chambers 1970, 128–29 no. 68.

24 The problems that arose between Francesco
Cornaro and Mantegna over this commission
are discussed in a lengthy letter from Pietro
Bembo to Isabella d'Este written on 1 January
1506; see Gaye 1839–40, ii, 71–73; Chambers
1970, 131–33 no. 72.

25 For Mantegna's canvas and identification of its
subject, see *Andrea Mantegna* exh. cat. 1992,
412–16 cat. 135.

26 On this painting, see Robertson 1968, 132–33;
Knox 1978; Goffen 1989, 238–39.

27 'el quadro e stato conducto illeso, il quale ne
piace per esser ben dessignato et ben colorito,
ma quando fusse stato finito cum magiore dili-
gentia, havendo a stare appresso quelli del
Mantinea che sono summamente netti, seria
stato magior honore vostro et più nostra satis-
factione. Rincrescene che quello Lorenzo man-
tovano vi disuadesse da colorirlo ad olio, pero
che noi lo desideravamo'; Canuti 1931, ii, 236
doc. 376; Campbell S. J. 2004b, 175 and 298
(Appendix Two, 102); Chambers 1970, 143 no.
84.

28 'sapendo che l'era più vostra professione et di
magior vaghezza'; Canuti 1931, ii, 236 doc. 376;
Campbell S. J. 2004b, 175 and 298 (Appendix
Two, 102).

29 Campbell S. J. 2004b, 298 (Appendix Two,
104).

30 For the problems of identifying Perugino's
hand in Verrocchio workshop paintings, see
recently Covi 2005, 180 and 199–213.

31 'Dominico Strozo mi ha facto intendere chel
Perusino non serva lordine in quella pictura
nostra ch'è notato ne' designo: facendo una
certa Venere nuda et andava vestita et in altro
acto, et questo per volere meglio dimonstrare la
excellentia de larte sua. Noi che non havemo
però ben compreso il parlare de Dominico, ne
se raccordando come stii il designo, vi pregamo
che vogliati insieme col Perusino bene exami-
narlo, et cusi la instructione che in scriptis gli
mandassimo; et operando chel non se parti da
quello, perchè alterando una figura se perver-
tiria il sentimento de la fabula'; Canuti 1931, ii,
228 doc. 356; Chambers 1970, 140–41 no. 81.

32 'Ma parendo forse a voi che queste figure
fussero troppo per uno quadro, a voi stia di
diminuire quanto vi parerà, purchè poi non li
sia rimosso il fondamento principale che è quel
quatro prime, Pallade, Diana, Venere, et Amore
. . . sminuirli sia in libertà vostra, ma non
aggiugnerli cosa alcuna altra'; Canuti 1931, ii,
212–13 doc. 316; Chambers 1970, 135–38 no. 76.

33 'le castissime seguace ninphe di Pallade e Diana

habbino con varii modi e atti, come a voi più piacerà, a combattere asperamente con una turba lascivia di fauni, satiri et mille varii amori: et questi Amori a rispetto di quel primo debbono essere più picholi con archi non d'argento, nè cum strali d'oro, ma di più vil material come di legno o ferro o d'altra cosa che vi parrà'; Canuti 1931, II, 212–13 doc. 316; Chambers 1970, 135–38 no. 76.

34 'la fantasia sia in sua electione purché la sia cosa che representi antiquità'; Brown C. M. 1997, 99.

35 'fatilo mo nel resto a modo vostro. Et quanto più presto ce servireti, tanto ce serrà più grato, ultra che ve contentaremo de la mercede vostra'; Brown C. M. with Lorenzoni 1982, 39 doc. I; for this episode see also Prizer 1982, 92.

36 'desiderando nui havere nel camerino nostro picture ad historia de li excellenti pictori che sono al presente in Italia'; letter of 15 September 1502 to Francesco Malatesta; Campbell S. J., 2004b, 290 (Appendix Two, 34); Chambers 1970, 134 no. 73.

37 'Se Zoanne Bellini fa tanto malvoluntieri quella historia, como ne haveti scripto, siamo contento remetterne al judicio suo, purché'l dipinga qualche historia o fabula antiqua aut de sua inventione ne finga una che representi cosa antiqua et de bello significato'; Brown C. M. and Lorenzoni 1982, 160 doc. IX; Chambers 1970, 127 no. 66.

38 The latter title is used by Campbell S. J., 2004b, ch. 6; in *Mantegna 1431–1506* exh. cat. 2008, 354–56 cat. 150, the painting is given the more explicit title *Isabelle d'Este au royaume d'Amour.*

39 'non ve rinchresca durare anchora faticha di componere una nova inventione satisfacendo a voi medemo dal qual depende la satisfactione nostra'; Luzio 1909, 863 n. 1; for this exchange of correspondence, see Gilbert 1998b, 419–22; Campbell S. J. 2004b, 293–95 (Appendix Two, 65–68 and 70–72).

40 'naratione de la pouesia'; Campbell S. J. 2004b, 191.

41 For the most recent interpretation, see Campbell, S. J. 2004b, 191–204.

42 'volere lavorare al suo modo non preterendo perhò in omni cosa la fantasia di quella ma migliorare'; Campbell S. J. 2004b, 191 and 294 (Appendix Two, 70).

43 Gilbert 1998b, 422; Luzio and Renier 1901, 64.

44 'non sapemo chi habbi in magior fastidio la longheza de li pictori, o nui, che non vediamo finto el nostro camarino, o vui, che ogni dì haveti ad fare nove inventione quale poi per la bizaria d'essi pictori non sono nè cossi presto, nè cossi integramente dessignate come voressimo'; Campbell S. J. 2004b, 293–94 (Appendix Two, 66); Cartwright 1903, I, 372; Chambers 1970, 140 no. 80.

45 'ma communamente questi magistri excelenti hanno del fantasticho e da loro convien tuore quello che se po havere'; Kristeller 1902, 538 doc. 79; Lightbown 1986, 461 cat. 73; most recently Gilbert 1998b, 421.

46 'la conditione di questo homo ... dubito farammi parere bugiardo appresso vostra Ill.ma Sig ... Et freciolosamente vorà finire l'opera et aciavatarla; che a me darà incredibile molestia et dispiacere ... io non scio che mi dire di questo huomo, qual non mi pare che sapia fare per naturale ingegno differentia duna persona a laltra. Maravigliarommi assai se potrà in lui larte, quello che non ha pouto la natrra'; Canuti 1931, II, 228–29 doc. 357; Chambers 1970, 141–42 no. 82.

47 For the most recent review of this question, which this reassessment follows, see Gilbert 1998b, 416–23.

48 'una pictura de una nocte, molto bello et singulare ...'; Pignatti 1970, 160.

49 'ditto Zorzo morì più dì fanno da peste, et ... non esser in ditta heredità tal pictura ... sichondo m'è stato affirmato nè l'una nè l'altra non sono da vendere per pretio nesuno; sicchè mi doglio non poter satisfar al dexiderio de quella'; letter of 8 November 1510; Pignatti 1970, 160; Chambers 1970, 149–50 no. 91.

50 'Avendo narado el bixogno e dexiderio di quella ad eso Zuan Belin e la storia al modo vuol Vostra Illustrissima Signoria'; Brown C. M. with Lorenzoni 1982, 157 doc. II; Chambers

1970, 126 no. 64. For the Giovanni Bellini correspondence, see also Braghirolli 1877.

51 'mi rispoxe eser chonstretto dalla Illustrissima Signoria a proseguir l'opra prinzipiata in pallazo . . . el ditto Zuan Belin si atrova molte altre opere de far, siché non seria possibile che la si avese chusì presto'; Brown C. M. with Lorenzoni 1982, 157 doc. 11; Chambers 1970, 126 no. 64.

52 'me dize eser molto dexideroxo de servir Vostra Signoria. Ma . . . in questa istoria non pole far chose che stia bene, né che abia del buon e falla tanto male volentieri quantto dir si posi, per modo che mi dubito che non servi Vostra Excellentia chome quela dexidera. Siché, s'el parese a quela de darlli libertade fazese quello li piazese, son zertisimo Vostra Signoria molto meglio seria servita'; Brown C. M. with Lorenzoni 1982, 159 doc. VIII; Chambers 1970, 126–27 no. 65, dated 25 June 1501.

53 See above, n. 37.

54 'Ve posseti ricordari che, molti mesi fano, nui dessimo l'impresa ad Zoanne Bellino de farce uno quadro per ornamento d'uno nostro studio . . . conoscendo nui chiaramente non posserlo havere quando lo vorriamo, li havemo facto dire ch'l desisti pure di questa impresa . . . Ma lui ni ha risposto che voliamo lassarli questa cura perché ce lo dará finito in brevi; et perché existimamo che'l ni habii ad dare parole como l'ha facto fin qui, vi preghamo vi piacia dirli in nostro nome che nui non ne curamo più da dicto quadro et se, in loco di epso, el vole farce uno presepio, ne restaremo molto contente . . . Questo 'presepio' desideramo l'habij presso la Madona et nostro Signore Dio, San Isep, uno Santo Zoanne Baptista et le bestie'; letter of 15 September 1502; Brown C. M. with Lorenzoni 1982, 162 doc. XXII; Chambers 1970, 128 no. 67. See also Fletcher 1971 and Fletcher 1981.

55 'chell'era chontento de servir Vostra Excellentia, ma che li parea che'l fuse fuore de propoxito ditto Santo a questo 'prexepio' . . . piazendo a Vostra Signoria Illustrissima, lo faria la Nostra Dona con el puto, eziam el San Joan Batista et qualche luntani et altra fantaxia che molto più se achomaderia a dito quadro et che molto

staria meglio'; letter from Michele Vianello to Isabella d'Este, 3 November 1502; Brown C. M. with Lorenzoni 1982, 164 doc. XXVI; Chambers 1970, 128–29 no. 68.

56 'Faritelo accunziare in modo che commodamente et senza periculo se possi portare'; letter of 9 July 1504; Brown C. M. with Lorenzoni 1982, 83–84 doc. 91.

57 'Se'l quadro de la pictura che haveti facto a nostro nome corresponde alla fama vostra . . . restarimo satisfacto da vui, et vi rimetteremo la iniuria che reputavamo havere recevuto per la tardità vostra'; Brown C. M. with Lorenzoni 1982, 167 doc. XLIII; Chambers 1970, 129–30 no. 70.

58 'qual molto ne piacque tenendolo cossi caro come pictura che habbiamo'; d'Arco 1857, II, 60 no. 73; Chambers 1970, 130 no. 71.

59 'quanto sia el desiderio nostro de havere un quadro depincto ad historia de mano vostra de mettere in lo nostro studio appresso quelli de Mantinea vostro cognato facilmente possete havere inteso li tempi passati che ve ne habbiamo facta instantia, ma per le molte occupationi non havete possuto . . . ma . . . hora . . . scriverve questa nostra con pregarve che voliati disponerve a depingere uno quadro che lasseremo a vui el carico de far la inventione poetica, quando non vi contetaste che noi ve la dessimo'; d'Arco 1857, II, 60 no. 73; Chambers 1970, 130 no. 71.

60 'Il Bellino, con quale sono stato questi giorni, è ottimamente disoosto a servire V. E. ogni volta che le siano mandate le misure o telaro. La invenzione, che mi scrive V. S. che io truovi al disegno, bisognerà che l'accomodi alla fantasia di lui chel ha a fare, il quale ha piacere che molto signati termini non si diano al suo stile, uso, come dice, di sempre vagare a sua voglia nelle pitture, che quanto in lui possano soddisfare a chi le mira. Tutta volta si procaccierà l'uno et l'altro'; Gaye 1839–40, II, 71–73 no. XXII; Chambers 1970, 131–32 no. 72.

61 Letter of 27 March 1501 to Fra Pietro da Novellara; see pages 225–26, Appendix, no. 6.

62 See pages 225–26, Appendix, no. 6.

63 See pages 233–34, Appendix, no. 13.

64 See pages 233–34, Appendix, no. 13.

65 See page 236, Appendix, no. 16.

66 Byam Shaw 1976, I, 36–38 nos 17–18; II pls 9–12.

67 See pages 226–27, Appendix, no. 7.

68 See pages 227–28, Appendix, no. 8.

III

THE ARTS IN MANTUA AROUND 1500

1 In general on this theme, see recently Rausa 2006.

2 On Vittorino da Feltre, see Giannetto ed. 1981; in general, Grendler 1989.

3 Brown, C. M., Fusco and Corti 1989.

4 On Mantegna see *inter alia* Kristeller 1902; Lightbown 1986; *Andrea Mantegna* exh. cat. 1992; and recently *Mantegna 1431–1506* exh. cat. 2008.

5 On this important lost work, see Lightbown 1986, 154–58 and 433–35.

6 Vienna, Graphische Sammlung Albertina, inv. 2583 recto; *Andrea Mantegna* exh. cat. 1992, 445–46 cat. 145; *Mantegna 1431–1506* exh. cat. 2008, 378–79 cat. 159 (as 'Artiste de l'Italie du nord').

7 Isabella d'Aragona was the widow of Gian Galeazzo Sforza (1469–1494), a nephew of Isabella d'Este's brother-in-law Ludovico 'il Moro' Sforza, and the rightful Duke of Milan, whose power had been usurped by Ludovico 'il Moro' while the latter acted as regent during Gian Galeazzo's infancy.

8 'lui che molto extima questa testa per esser de suprema bontà et lui professore de antichità'; Kristeller 1902, 564–65 doc. 149; Brown C. M. with Lorenzoni and Hickson 2002, 131.

9 Kristeller 1902, 217 and 564–65 doc. 149; Brown C. M. 1969a, 142–43; Brown C. M. with Lorenzoni and Hickson 2002, 16, 71, 118 and no. 10.

10 In general, see Yriarte 1895–96; Martindale 1964; Fletcher 1981; Iotti and Ventura 1993; Bourne 2001.

11 On Francesco Gonzaga as patron, see now Bourne 2008a; on Bishop-Elect Ludovico, see Brown C. M. 1983, Hickson 2000 and 2001.

12 Letter of 26 August 1486 from Silvestro Calandra to Francesco Gonzaga: 'andare a vedere li Triomphi di Cesare che dipinge el Mantegna, . . . li quali molto li piaqueno'; Kristeller 1902, 544 doc. 96; Lightbown 1986, 426; Martindale 1979, 181 doc. I; *Andrea Mantegna* exh. cat. 1992, 350. In general on the *Triumphs*, see Luzio and Paribeni 1940; Martindale 1979; Lightbown 1986, 140–53; Hope 1992; and now Elam 2008.

13 'pictorem egregium, & cujus aetas nostra parem non vidit'; Kristeller 1902, 545 doc. 101; Lightbown 1986, 154.

14 *Andrea Mantegna* exh. cat. 1992, 350–56.

15 'Se lo desideramo vivo et chel finisca le opere nostre che V. Ex. lo contenti'; Kristeller 1902, 575 doc. 169; *Andrea Mantegna* exh. cat. 1992, 351.

16 Martindale 1979, 182 doc. 4; Lightbown 1986, 426.

17 Lightbown 1986, 461: 'Se la S. vostra li volesse mandare lontano se possono (?) farli suso tela sottile per poterli avoltare suso un bastonzelo'; see also Kristeller 1902, 534 doc. 69.

18 Lightbown 1986, 96 and 492 cat. 219 and pl. 238b; *Andrea Mantegna* exh. cat. 1992, 300 and 303 cat. 87. On Pollaiuolo's canvases, see Wright 2005, 75–86 and 535–36.

19 *Andrea Mantegna* exh. cat. 1992, 84. Francesco Gonzaga apparently commissioned from Lorenzo Costa a work to be painted *a guazzo* (in distemper), so that in technique it would match the *Triumphs*; Lightbown 1986, 430.

20 For Mantegna's technique, see Lightbown 1986, 227–28; *Andrea Mantegna* exh. cat. 1992, 68–87.

21 For the derivation of a figure in the *Resurrection* predella panel (Tours) from the S. Zeno altarpiece of 1456–59 from the *Resurrection* canvas (Pasadena, Norton Simon Museum) from Bouts's altarpiece, and for possible debts to Bouts's altarpiece in paintings by Venetian painters, see Campbell L. 1998, 44 and 45 n. 50.

22 Hope 1992, 356; Elam 2008, 363; but see Mar-

tindale 1979, 42–46, for the possibility that they were commissioned by his grandfather Ludovico Gonzaga.

23 'perche in verità non me ne vergogno di averli fati, et anco ho speranza di farni deglialtri picendo adio et alla S.a vostra'; Kristeller 1902, 546 doc. 102; Lightbown 1986, 426; Hope 1992, 350.

24 'di quà anche haveti de lopere nostre ad finire, et maxime li triumphi: quali come vui diceti e cosa digna, et nui voluntieri li vedrressimo finiti. Se posto bono ordene ad conservarli: che quantunche sia opera de le mane et inzegno vostro, mai nondimeno ne gloriamo haverli in casa: il che anche sara memoria de la fede et virtù vostra'; Kristeller 1902, 546 doc. 103; Lightbown 1986, 142 and 426; Martindale 1979, 181 doc. 3.

25 'que modo Iulii Caesaris triumphum prope vivis et spirantibus adhuc imaginibus nobis pingit adeo ut nec repraesentari, sed fieri res videatur'; Kristeller 1902, 551–53 doc. 115; Lightbown 1986, 426; Martindale 1979, 182 doc. 5; Hope 1992, 350–51.

26 Lightbown 1986, 426; Martindale 1979, 182, doc. 6.

27 Kristeller 1902, 554 doc. 123; Lightbown 1986, 426; Martindale 1979, 182 doc. 9.

28 Lightbown 1986, 426; Martindale 1979, 182 doc. 12.

29 'Una delle bande era ornata delle sei quadri del Cesareo triumpho per man del singular Mantengha'; letter from Sigismondo Cantelmo to Ercole d'Este in Ferrara; Campori 1866, 5; Kristeller 1902, 568 doc. 156; Luzio and Paribeni 1940, 12–15; Lightbown 1986, 426; *Andrea Mantegna* exh. cat. 1992, 351.

30 Lightbown 1986, 430.

31 Halliday 1994 and 1997; Campbell S. J. 2004a, 92–93.

32 On this project, see recently Bourne 2008b; Agosti 2008.

33 For this episode, see Lightbown 1986, 177–79.

34 Lightbown 1986, 178–79, citing a letter of 29 August 1495 from Fra Girolamo Redini to Francesco Gonzaga.

35 Jones 1987.

36 *Andrea Mantegna* exh. cat. 1992, 245–47 cat. 61; *Mantegna 1431–1506* exh. cat. 2008, 414–15 cat. 183.

37 Piacenza, Collegio Alberoni; for this work, see *inter alia* Sricchia Santoro 1986, 62 pl. 16, and recently *Antonello da Messina* exh. cat. 2006, 238–41 cat. 37.

38 Lightbown 1986, 222–23 and 444–45 cat. 42.

39 'Deinde gliè un San Sebastian il quale nostro padre voleva fossi de monsignor vescovo di Mantua per alcune cose che intenderà poi V. Ill. S. le quali seriano troppo prolixe da scrivere'; Kristeller 1902, 583–84 doc. 190.

40 London, British Museum, Pp. 1–23; Popham and Pouncey 1950, 95–97 cat. 157. The engraving was traditionally attributed to Zoan Andrea, but it has more recently been proposed that 'in fact it is one of Giovanni Antonio [da Brescia]'s best works'; see *Andrea Mantegna* exh. cat. 1992, 456. For the most extensive recent discussion of both engraving and drawing, see ibid., 451–56 cats 147–48; *Mantegna 1431–1506* exh. cat. 2008, 348–49 cats 146–47; *Fra Angelico to Leonardo* exh. cat. 2010, 140–41 cat. 22; also Lightbown 1986, 485–86 cat. 193.

41 Massing 1990, 180–84.

42 Kristeller 1902, 545–46 doc. 102 and 550 doc. 112; *Andrea Mantegna* exh. cat. 1992, 456.

43 Biondo 1549, fol. 18r; cited in *Andrea Mantegna* exh. cat. 1992, 451 cat. 147; also Lightbown 1986, 485 cat. 193.

44 Müntz 1888, 57; Weiss, 1969, 189; Fusco and Corti 2006, 73.

45 Vasari 1878–85, II, 558 and III, 433.

46 London, British Museum, 1860–6-16–85; see Massing 1990, 264–65 cat. 6A; *Andrea Mantegna* exh. cat. 1992, 467–68 cat. 154; *Mantegna 1431–1506* exh. cat. 2008, 350–51 cat. 148.

47 Lightbown 1986, 490 cats 210–11; *Andrea Mantegna* exh. cat. 1992, 285–87 cat. 79; *Mantegna 1431–1506* exh. cat. 2008, 273–76 cat. 108.

48 'li homini virtuosi quale è lui non bisognano apresso la Vostra S. de raccomandatione perche da si la è inclinatissima ad amare et favorire chi lo merita et che pur lo farei: et cossi prego quella lo vogli acarecciare et farni

bona stima, perche in vero lui oltra la excellentia del arte sua in la quale no ha pare, eglie tuto gentile: et la Vostra S. ne pigliare mille boni constructi in designi et altre cose che accadera'; Kristeller 1902, 549 doc. 110; cited in Lightbown 1986, 188.

49 'el pictore ne ha tanto malfacta, che non ha alcuna de le nostre simiglie'; Kristeller 1902, 554 doc. 120; Lightbown 1986, 188 and 463 cat. 81; and for further discussion of this episode, see below, chapter four.

50 Kristeller 1902, 554 doc. 122; see also Dubois 1971.

51 Lightbown 1986, 440–42 cat. 38.

52 'ho quaxi fornito di designare la instoria de Como de Vostra Ex. quale andarò seguitando quanto la fantasia me adiuterà'; Kristeller 1902, 577 doc. 174; Campbell S. J. 2004b, 205.

53 For extensive recent discussion of imagery and meaning in Mantegna's *studiolo* paintings, and of earlier interpretations, see Verheyen 1971; Lightbown 1986, 186–209; Christiansen 1992; Campbell S. J. 2004b; and Romano 2008.

54 For the latest reconstruction of the layout of the paintings in the *studiolo*, see Brown C. M. 2005, 47–48 and 103–4 figs 39–40.

55 'una dona tenera d'eta, senza lettere'; *Splendours* exh. cat. 1981, 152–53 cat. 92; Lightbown 1986, 189 and 463–64 cat. 85.

56 See recently *Andrea Mantegna* exh. cat. 1992, 463 cat. 152; *Mantegna 1431–1506* exh. cat. 2008, 344–45 cat. 144; also *Splendours* exh. cat. 1981, 152 cat. 92; Lightbown 1986, 463–64 cat. 85.

57 On these, see further pages 85–86.

58 On this, see especially Christiansen's essay 'Paintings in Grisaille', in *Andrea Mantegna* exh. cat. 1992, 394–400.

59 Cited by Lightbown 1986, 53.

60 Vasari 1965, I, 242.

61 Lightbown 1986, 134–36 and 420–21 cat. 22.

62 Lightbown 1986, 213 and 449 cat. 50.

63 On the portal's imagery, see most recently Campbell S. J. 2004b, 140–44; see also, Signorini 1991.

64 On this, see further page 74.

65 Pope-Hennessy 1971, 319–20.

66 Pope-Hennessy 1963, III, cat. 49.

67 'Multo me ha iuvato anchora lo excellentissimo sculptore et virtuosissimo cortesano Joan Christophoro romano, quali non meno che io se sono fatigate che questa interpretatione . . . redesse al lector in la Italica che in la antiqua Latina lingua'; cited in Norris 1987, 131–32 and 140 n. 8. See also Ricci ed. 1999, 212.

68 Castiglione 1967, 98.

69 See most recently *Mantegna 1431–1506* exh. cat. 2008, 328–29 cat. 135.

70 Venturi 1888b, 50 n. 2; Norris 1987, 133–34.

71 Norris 1977, 47; Radcliffe, Baker and Maek-Gérard eds 1992, 73.

72 'perche se uno non fosse bono'; Radcliffe, Baker and Maek-Gérard eds 1992, 73. Isabella ordered these blocks from Giorgio Brognolo in Venice in a letter of 11 July 1491; what became of them is not known.

73 'per certa opera ch'io voria fare': see Luzio and Renier 1890, 651.

74 Brown C. M. 1995, 78; later in 1497 Gian Cristoforo discussed plans for a 'porta del Studio' with Isabella: Brown C. M. 2005, 45.

75 Norris 1977, 298; Norris 1987, 140 n. 18.

76 'quello beato camerino dal uscino caro': see Hickson 2004, 126–27 and 331–32; also Ventura in Bini ed. 2001, 78–80; but for another view on the dating of this project, see Signorini 1991.

77 On 27 September 1505 Isabella wrote to Gian Cristoforo: 'Havemo recevuto la littera tua insieme col disegno et monstra de petra per l'archa de la Beata sore Osanna et la scripta del mercato facto et apresso inteso da Caradosso tutto l'ordine'; Brown C. M. and Hickson 1997, 20.

78 It was destroyed in 1797; see Venturi 1888b, 113–14; Cartwright 1903, II, 3; Hickson 2004, 124–25. See also Brown C. M. and Hickson 1997, 20–21, for an illustration of the engraving after the tomb in the *Acta sanctorum*, Antwerp 1701, 672.

79 Norris 1977, 27–29; Radcliffe, Baker and Maek-Gérard eds 1992, 68–73 cat. 5; this work will be considered in more detail in chapter four.

80 For the text, see Venturi 1888b, 151 n. 2; Norris 1987, 140–41 n. 22.

81 Hill 1930, 56 no. 222; Norris 1987, 137–38 and fig. 7.

82 'e bella cosa et molto artificiosa, per respecto de quellj veli; ancora none finita; ma solo il volto et la testa e facta'; Norris 1987, 138.

83 Hill 1930, 56 no. 223; Norris 1987, 138 and fig. 10.

84 'e mille volte bella, come voi medesima'; Norris 1987, 140–41 n. 22. For the medal in general, see Hill 1930, 55–56; Norris 1987, 134–36; and most recently Syson 1997.

85 D'Arco 1845, 299 no. LXVI; Brown C. M. 1973, 158, published Isabella's response written on 15 September 1498.

86 Luzio and Renier 1893, 253–54; Hill 1930, 55–56 no. 221. Early casts, such as that in lead, perhaps a proof (London, British Museum), are inaccurately inscribed BENEMOERENTIUM ERG: the superfluous 'O' had been removed by the time that Isabella's gold display example was cast in 1503. Niccolò da Correggio's first suggestion, BENEMERENTIUM CAUSA, was dismissed by Isabella on the grounds that she had seen it before; he also offered NATURAE OFFICIUM ('the duty [or office or favour] of nature') and GRATITUDINIS STUDIO ('with zeal of gratitude') as alternatives: all possibilities appear to support the hypothesis that Isabella d'Este intended the medal as a reward for services rendered to her; Norris 1987, 134; Syson 1997a, 291–93. See also *Splendours* exh. cat. 1981, 160 cat. 109.

87 Hill and Pollard 1978, 18; Weiss 1969, 170; Syson 1997a, 285.

88 Pope-Hennessy 1971, 80.

89 Radcliffe 1981; Allison 1993–94; see also Allison 1995.

90 Lightbown 1986, 134.

91 'Dui vaseti de argento dorati dello mano de lo Anticho'; Allison 1993–94, 271 doc. 10 (fol. 3v).

92 Signorini 1997; and Radcliffe 1997; also now Furlan 2006, 45. For the 1542 inventory entry, see Ferrari 2003b, 347 item 7284.

93 For which, see Stone 1982.

94 Lightbown 1986, 130–31.

95 *Splendours* exh. cat. 1981, 121–22 cat. 30, with reference to Scardeone, who wrote in 1560 of the bust that '[Mantegna] cast for himself with his own hands' (*quod sibi suis conflaverat manibus*); Lightbown 1986, 131.

96 Gilbert 1980, 97; see also Lightbown 1986, 131.

97 'una figura di metalle ghiamata il villanello'; *Splendours* exh. cat. 1981, 134–35 cat. 54. For the Gianfrancesco Gonzaga inventory, see Allison 1993–94, 271–74 doc. 10.

98 Allison 1993–94, 39.

99 *Splendours* exh. cat. 1981, 134–35 cat. 54; Allison 1993–94, 168–71 no. 21.

100 *Splendours* exh. cat. 1981, 136 cat. 55; Allison 1993–94, 140–41 no. 18A.

101 See *Splendours* exh. cat. 1981, 136 cat. 55.

102 Allison 1993–94, 275–76 doc. 14.

103 See *Splendours* exh. cat. 1981, 137–38, cat. 57; Allison 1993–94, 108–12 no. 13A.

104 Allison 1993–94, 40 and 279–80 docs 31–32.

105 Allison 1993–94, 40 and 210–12 no. 27A.

106 'voria mettere sopra una cornice da uscio al incontro de quello putino per darli conformità, essendo li ussi de una proportione'; Rossi 1888, 176–78; Brown C. M. 1976, 351 n. 62; Allison 1993–94, 281 doc. 37.

107 'uno figuretta de bronze de la grandezza del puttino dal spine'; *Splendours* exh. cat. 1981, 47; Allison 1993–94, 183–85 no. 23A and 281 doc. 38.

108 For this work, see Fortini Brown 1988, 155 pl. 90, 169 pl. XXIII, and 286. Statues also stand over the two doors in St Ursula's bedroom in Carpaccio's *Dream of St Ursula* (Venice, Accademia); Fortini Brown 1988, 58 pl. 28.

109 Radcliffe 1981, 46.

110 *Andrea Mantegna* exh. cat. 1992, 299–300 and fig. 90. The composition was of sufficient interest to prompt a finely finished copy-drawing (Uffizi 1682F; ibid., 307–8 cat. 90), considered by some scholars to be autograph, that may well have been intended, even perhaps as early as the late 1460s, as an autonomous work of art. A variant drawing (ibid., 309–10 cat. 91) is also based on a similar classical prototype.

111 Bober and Rubinstein 1986, 173–74 no. 137.

112 Lightbown 1986, 101; *Andrea Mantegna* exh. cat. 1992, 298–99 and 307–9 cat. 90.

113 'uno quadro finto de bronzo sopra alla dicta porta, qual fu fatto per messer Andrea Mantinea, con quatro figure dentro' and 'uno quadro finto de bronzo, quale è posto sopra la porta nel intrare nella Crotta, fatto per messer Andrea Mantinea, nel quale è depinta una nave del mare, con alcune figure dentro et una che cascha nell'aqua'; Ferrari 2001, 37–38 nos 205 and 207; Ferrari 2003b, 349 nos 7324 and 7326.

114 Now in the Montreal Museum of Fine Arts; see *Andrea Mantegna* exh. cat. 1992, 411–14 cats 133–34; *Mantegna 1431–1506* exh. cat. 2008, 310–12 cats 128–29.

115 Keith Christiansen, in *Andrea Mantegna* exh. cat. 1992, 411 cat. 133.

116 This is discussed further in chapter five.

117 Lightbown 1986, 436.

118 In Codex Arundel, fol. 115r; Kemp 2006, 78.

119 *Leonardo da Vinci: The Mystery of the* Madonna of the Yarnwinder exh. cat. 1992, 20 and fig. 18; *Leonardo da Vinci: Painter at the Court of Milan*, exh. cat. 2011, 294–97 cat. 88; Kemp and Wells 2011, 32 and fig. 13.

120 See Fra Pietro's second letter to Isabella d'Este, pages 227–28, Appendix, no. 8.

121 See pages 231–32, Appendix, no. 11.

122 Kemp 2006, 303–8.

123 *Andrea Mantegna* exh. cat. 1992, 247 cat. 61.

124 Isabella's letter to Leonardo of 14 May 1504, pages 233–34, Appendix, no. 13.

125 Lightbown 1986, 96–97 and 415 cat. 19; *Andrea Mantegna* exh. cat. 1992, 337–39 cat. 102.

126 Lightbown 1986, 463 cat. 81; see also Jacobus 1993, 94.

127 Richter 1970, I, 304 para. 487.

128 Marani 2000, 209: title to the fifth chapter.

129 Associated with the first is a well-known drawing at Windsor (RL 12570; Clark and Pedretti 1968–69, I, 109–10; *Leonardo da Vinci, Master Draftsman* exh. cat. 2003, 512–15 cat. 93); the second project is discussed in Bambach 2001 and in *Leonardo da Vinci, Master Draftsman* exh. cat. 2003, 539–56 cats 101–04.

130 Kemp and Smart 1980; for the drawings, see *Leonardo da Vinci, Master Draftsman* exh. cat. 2003, 496–98 cat. 88 and 530–36 cats 98–99. See also *Leonardo e il mito di Leda*, exh. cat. 2001, 112–15 cats 11, 4–5; and recently Nanni and Monaco 2007, 192–208.

131 Ferrari 2001, 35 no. 154 or 158; Ferrari 2003b, 347, no. 7273 or 7277; intriguingly, Ferrari 2003b no. 7273 is a pair of Renaissance marble figures of Leda and Venus.

132 For example, 'Mantegna may have met Leonardo (if the younger artist actually visited Mantua in 1500)'; *Leonardo da Vinci, Master Draftsman* exh. cat. 2003, 513.

IV

LEONARDO'S PORTRAIT DRAWING
OF ISABELLA

1 'seria quasi impossibile, non havendo vui comodità di transferirvi in qua': Villata ed. 1999, 170 no. 191; Ferrari 2003a, 78 doc. 11; and see pages 233–34, Appendix, no. 13.

2 Luzio repr. 1913, 186–87; Campbell L. 1990, 178.

3 'in questa ultima volta che semo state retratte mi è venuto tanto in fastidio la patientia de star ferme et immote che più non vi ritornaressimo'; Luzio repr. 1913, 210–11; translation in Cartwright 1903, I, 383; for this episode, see recently Hickson 2004, 182–87.

4 'spesso lo consideriamo, supplendo cum la informacione de . . . Jacomo et altri che hanno veduto la S. V. al defecto del pictore per modo che niente restano inganno del concepto nostro'; Luzio repr. 1913, 188.

5 'dubito venire in fastidio non solum a la S. V. ma ad tuta Italia cum mandare questi miei retracti in volta'; Luzio repr. 1913, 198; *Splendours* exh. cat. 1981, 159.

6 'anchor non mi sia molto simile, per essere uno poco più grasso che non sono io'; Luzio repr. 1913, 198; Brown D. A. 1990, 53–54; Viatte 1999, 20.

7 Franceschini 1995, 234 doc. 323g and 235 doc.

324d; Syson 1999, 226; Campbell S. J. 2002, 31 and 247.

8 Modena, Biblioteca Estense L.5.16, Ital. 720, fol. 3v; illustrated in Viatte 1999, 16 pl. 9.

9 Luzio repr. 1913, 184–85; and see Hickson 2004, 209–10, for this episode.

10 Hickson 2004, 210.

11 Brown C. M. 1973, 158; Norris 1987, 134 and 141 n. 23.

12 See chapter three, page 74.

13 Syson 1997a, 291.

14 'haverla mostrata, come cosa divina ad tutte queste Regine, quale tutte cum maravegla la reguardava: et che la Regina mugliera, avante andasse in Spagna la vidde: che pareva non se potesse sarciar de guardare dicendo che ultra la singulare bellessa: che leffigia indicava un grande Inzegno: . . . Così tutte le altre che la vide, summamente la laudo insino alle figlie del Grande Capitaneo . . . le quale dopoi reguarda-tole per longo spatio mille volte dice chel basò la bella medaglia: Havendo anche loro per Fama udito rasonare de la condicione et valore vostro'; Venturi 1888b, 151; translation in Cartwright 1903, II, 12–13; see also Norris 1987, 40–41 n. 22; Syson 1997a, 287.

15 'io parlava della mia Signora delle quale con-templavamo qualche volta el piatoso et caro retraction che sia benedetto qual maestro Francesco retractatore che me ha cosi ben servita!'; Hickson 2004, 128 and 330–31, Appendix II, 2.

16 'quando il vederà al parangone de quel primo non mancho natural che quello ma de artificio assai più perfecto. In questa nostra citate tuti queli che conoscono V. Ex. vedendo questo ritratto tutti consentienti insieme affirmano che gli par vedere la viva imagine di quella'; Luzio repr. 1913, 212; Negro and Roio 1998, 118; Cartwright 1903, I, 384–85.

17 'avendovi vui cum l'arte vostra facta assai più bella che non ni ha facto natura': letter of 25 November 1511. See Luzio repr. 1913, 212; Negro and Roio 1998, 118; Cartwright 1903, I, 385–86.

18 Hickson 2004, 193 and text in 335–36, Appendix III, 3; ibid., 181–93 for this whole episode.

19 'all'improvisa il bel retratto de la vostra Ill.ma Madama'; ibid., 193 and 336–37, Appendix III, 5.

20 'la Hypolita portò in qua un suo retrato et come vado a tavola lo fazio ponere suso una cadrega per scontro a me, che vedendolo me pare pure essere a tavola cum V.S.'; Luzio repr. 1913, 186; Fletcher 1981, 57; Hickson 2004, 132 and 160 n. 74.

21 'vole poi mandar là el maestro che retragi V.S. pregando quela se digni esserne contenta perchè il vi vorà tenir in loco di cosa sancta al capo del suo lecto'; Luzio repr. 1913, 186–87; Viatte 1999, 18.

22 'essere priva dela presentia di vostro Signora . . . [m]i aiutaro col caro ritratto al più che mi sera possible'; Hickson 2004, 129 and 332, Appendix II, 4. Another portrait of Isabella d'Este had been commissioned from Francesco Bonsignori in 1494, but this project was incom-plete at the time that Francesco Gonzaga required Bonsignori to paint a battle scene at Fornovo, to celebrate Francesco's victory there in 1495; see Luzio repr. 1913, 191–92.

23 The *Portrait of a Lady* by Lorenzo Costa in the Royal Collection, Hampton Court, is here excluded, although it is sometimes tentatively identified as being a portrait of Isabella d'Este.

24 'sapendo cum quanta difficultà se ritrovano pictori che perfectamente contrafaciano el vulto naturale'; Luzio repr. 1913, 188; Land 1994, 115 and 198 n. 35; Syson 1997a, 281; Hickson 2004, 174.

25 'perche el pictore ne ha tanto malfacta, che non ha alcuna de le nostre simiglie'; Lightbown 1986, 463 no. 81; Land 1994, 114; Hickson 2004, 174–75. It may be noted in this context that Marquess Ludovico Gonzaga had written in 1475, 'It is true that Andrea is a good master in other things, but in portrait painting he could have more grace, and doesn't do so well'; Elam 1981, 19; Signorini 1974, 232.

26 Jacobus 1993, 94.

27 Hickson 2004, 175.

28 For discussion in general of these issues in Renaissance portraiture, see Burke 1987, Woods-Marsden 1987, Simons 1995; *Virtue and*

Beauty exh. cat. 2001, 63–87; in general on Isabella d'Este and portraiture, see further Land 1994, 111–16; Hickson 2004, 167–228.

29 On Cecilia Gallerani, see Shell and Sironi 1992; also Brown D. A. 1990. Born in 1473 (or perhaps 1474), she became Ludovico Sforza's mistress probably in 1489. She gave birth to his son, Cesare Sforza Visconti, on 3 May 1491, and on 18 May was presented by Ludovico with the town and territory of Saronno. On 27 July 1492 she married Count Ludovico Carminati de Brambilla, known as Bergamino.

30 Luzio 1888a, 45; Beltrami 1919, 51; Villata ed. 1999, 112–13 no. 129; Ferrari 2003a, 76 doc. 1; for the original text, see page 221, Appendix, no. 1.

31 Luzio 1888a, 45; Beltrami 1919, 51 n. 89; Villata ed. 1999, 113–14 no. 130; Ferrari 2003a, 76 doc. 2; for the text, see page 222, Appendix, no. 2.

32 Brown C. M. 1969a, part 2, 189–91; Shell and Sironi 1992, 64 n. 14; Villata ed. 1999, 114–15 no. 131; see pages 222–23, Appendix, no. 3.

33 Lauts 1962, 241 and pl. 61.

34 Robertson 1968, 94; see also Goffen 1989, 58–59.

35 On the painting's condition see *Leonardo da Vinci 1452–1519: Lady with an Ermine* exh. cat. 1991; D. Bull, in *Leonardo: La dama con l'er-mellino* exh. cat. 1998, 83–90, who also concludes that there is in fact no evidence that originally there was a window at the right. See now *Leonardo da Vinci: Painter at the Court of Milan*, exh. cat. 2011, 110–13 cat. 10, and 61–62 for its technique and condition.

36 'Cecilia se belissima oggi è quella/Che a suoi begli occhi il sole per ombra oscura'; 'Pensa, quanto sarà più viva e bella,/Più a te sia gloria nell'età futura'. Bellincioni 1876, 72 no. XLV (sonnet CXXVIII); *Leonardo da Vinci 1452–1519: Lady with an Ermine* exh. cat. 1991, 10; Shell and Sironi 1992, 48–49 and 64 n. 12.

37 'quella dolcezza et suavità de aiere che haveti per arte peculiare in excellentia'; Villata ed. 1999, 170 no. 191; Ferrari 2003a, 78 no. 11; pages 233–34, Appendix, no. 13; see also Land 1994, 116. Further on the Gallerani portrait, see Shell and Sironi 1992; Simons 1995, 277–83; Brown

D. A. 1990; Bull 1992; *Leonardo: La dama con l'ermel-lino* exh. cat. 1998; *Leonardo da Vinci: Painter at the Court of Milan*, exh. cat. 2011, 110–13 cat. 10.

38 Codex Atlanticus fol. 669r (formerly fol. 247r-a); Kemp and Walker 1989, 265. The 'Ligny Memorandum' is conventionally dated to 1499, but there is some evidence that it might be better dated to 1494, when Ligny was in Milan with King Charles VIII; see Kemp and Cotte 2010, 37–38.

39 'A di 13 di marzo 1500. Inlustrisima Madona . . . E l'è a Venecia Lionardo Vinci, el quale m'à mostrato uno retrato de la signoria vostra ch'è molto naturale a questa, sta tanto bene fato non è possibile melio'; Luzio repr. 1913, 200; Beltrami 1919, 63 n. 103; Villata ed. 1999, 130–31 no. 144; Ferrari 2003a, 76 doc. 3; and see pages 223–24, Appendix, no. 4.

40 For this correspondence, see Braghirolli 1877; Brown with Lorenzoni 1982; Chambers ed. 1970, 125–33 docs 64–72.

41 Kemp 2006, 206.

42 See pages 233–34, Appendix, no. 13.

43 Beltrami 1919, 65 no. 106; Villata ed. 1999, 133–34 no. 149; Ferrari 2003a, 76–77 doc. 5; and see pages 225–26, Appendix, no. 6.

44 Bambach 1999, 250, gives 'a sketch in a cartoon' and suggests that it 'was very much a work in progress'; see also pages 226–27, Appendix, no. 7.

45 Vasari 1965, 265–66.

46 Beltrami 1919, 65–66 no. 107; Villata ed. 1999, 134–35 no. 150; Ferrari 2003a, 77 doc. 6; and see pages 226–27, Appendix, no. 7.

47 The letter is dated 14 April 1501; Villata ed. 1999, 136–37 no. 151; see pages 227–28, Appendix, no. 8.

48 For the Louvre drawing, see most recently Viatte 1999; Bambach 1999, 111–12; *Léonard de Vinci* exh. cat. 2003, 185–89 cat. 61; *Mantegna 1431–1506* exh. cat. 2008, 326–27 cat. 134; for that in the Ashmolean Museum, see Parker 1972, 13 cat. 19, and the entry in Kemp and Barone 2010, 147–50 cat. 116.

49 'Quando fusti in questa terra, et che ne retrasti de carbono, ne promettesti farni ogni modo

una volta di colore'; Villata ed. 1999, 170 no. 191; Ferrari 2003a, 78 doc. 11; and see pages 233–34, Appendix, no. 13.

50 These are the dimensions given for the Paris drawing in *Léonard de Vinci: Dessins et Manuscrits* exh. cat. 2003, 185; the dimensions of the copy in the Ashmolean (Parker 1972, 13 cat. 19) are those given in Kemp and Barone, 2010, 147–50 cat. 116. I am grateful to Juliana Barone for allowing me to consult the catalogue entries that she and Martin Kemp have written on this drawing, and on the copy of the Isabella d'Este portrait drawing in the British Museum, and for discussing the Ashmolean copy in detail with me.

51 Compare the Carpaccio portrait (pl. 59) in Denver, Colorado: 426 × 311 mm; the portrait by Giovanni Ambrogio de Predis in the Biblioteca Ambrosiana, Milan: 510 × 340 mm; the *Portrait of Cecilia Gallerani* (pl. 58): 550 × 404 mm. The slightly later *Mona Lisa* is larger, at 770 × 530 mm.

52 Viatte 1999, 7; *Léonard de Vinci* exh. cat. 2003, 185; Bambach 1999, 111–14 and 277.

53 Codex Atlanticus fol. 669r: 'Piglia da Gian di Paris il modo di colorire a seccho, e'l modo del sale bianco e del fare le carte impastate, sole e in molti doppi, e la sua cassetta de' colori. Impara la tempera delle cornage. Impara dissolvere la lacca gomma'; Fiorio 1997, 343; Villata ed. 1999, 127–28 no. 141; Kemp and Cotte 2010, 192 n. 11; the translation cited here is in Kemp and Cotte 2010, 36.

54 Kemp and Cotte 2010, 36–38 and 115–19.

55 Ibid., passim; Cotte and Kemp 2011. The portrait is of Bianca Sforza, an illegitimate daughter of Duke Ludovico Sforza, and was cut from a copy of the *Sforziad* that was printed and illuminated on vellum to celebrate Bianca Sforza's marriage to Galeazzo Sanseverino in 1496.

56 For these, see recently *Leonardo da Vinci, Master Draftsman* exh. cat. 2003, 658–59 cat. 128 (Biblioteca Ambrosiana Cod. F 290 inf. 8) and 655–57 cat. 127 (Biblioteca Ambrosiana Cod. F 290 inf. 7) respectively; both are there described as in 'brown, yellow ocher, red, and ivory pastel over charcoal on paper'. That

Boltraffio made his earliest three surviving pastel drawings in 1500–02 may strengthen the view that Leonardo learned this technique from Perréal in 1499, having learned to draw 'à trois crayons' in 1494.

57 Clark 1959, 100.

58 Bambach 1999, 111.

59 Lightbown 1986, 461 no. 72. For portrait drawings by Pisanello, see *Pisanello* exh. cat. 1996, 208–9 cat. 118 (Emperor John VIII Palaeologus), 211–12 cat. 121 (Niccolò Piccinino), 213–14 cat. 125 (Filippo Maria Visconti) and 373–74 cats 251–52 (Guarino da Verona?).

60 *Andrea Mantegna* exh. cat. 1992, 343–45 cat. 105. This is not the place to enter into discussion of the attributional issues presented by the Francesco Gonzaga drawing and others that can be associated with it. Although Giovanni Bellini and Francesco Bonsignori have in the past been proposed, the most obvious candidate is Francesco Gonzaga's principal court artist, Andrea Mantegna.

61 On this, see especially Bambach 1999, 111–12; also *Léonard de Vinci* exh. cat. 2003, 189.

62 *Léonard de Vinci* exh. cat. 2003, 189 and fig. 60.

63 Byam Shaw 1976, I, 38 cat. 19; II pl. 13.

64 Salaì is mentioned by Fra Pietro da Novellara in his second letter from Florence to Isabella, dated 14 April 1501; see pages 227–28, Appendix, no. 8.

65 For the British Museum copy, see Popham and Pouncey 1950, I, 72 cat. 118; Kemp and Barone 2010, 118 cat. 84.

66 Viatte 1999, 6.

67 See Isabella's letter to Fra Pietro da Novellara, pages 225–26, Appendix, no. 6.

68 Viatte 1999, 4.

69 Yriarte 1888; see Viatte 1999, 10.

70 Wethey 1971, II, 102 cat. 37.

71 Martin Clayton, in *Leonardo da Vinci: The Divine and the Grotesque* exh. cat. 2002, 101.

72 A good example from the 1490s, in red chalk, is Florence, Uffizi 423E, recently included in an exhibition at the British Museum; see *Fra Angelico to Leonardo* exh. cat. 2010, 214–15 cat. 55.

73 Windsor, RL 12554 and 12557; see Clark and

Pedretti 1968–69, 1, 103–4; *Leonardo da Vinci: the Divine and the Grotesque* exh. cat. 2002, 56–59 cats 17–18.

74 Windsor, RL 12276v; see Clark and Pedretti 1968–69, 1, 3–4; *Leonardo da Vinci: One Hundred Drawings* exh. cat. 1996, 20–21 cat. 5; *Leonardo da Vinci: The Divine and the Grotesque* exh. cat. 2002, 16–19 cat. 1.

75 Windsor, RL 12505; see Clark and Pedretti 1968–69, I, 88–89; *Leonardo da Vinci: The Divine and the Grotesque* exh. cat. 2002, 104–5 cat. 43.

76 Campbell S. J. 2002, 240–43 cat. 15; Manca 2003, 81–83; the miniature is on fol. 2v of the manuscript.

77 Manca 2003, 82; Gundersheimer 1993, 13 and fig. 15.

78 Radcliffe, Baker and Maek-Gérard eds 1992, 68–73 cat. 5.

79 See recently *Virtue and Beauty* exh. cat. 2001, 106–9 cat. 3.

80 *Pisanello* exh. cat. 1996, 187–90 cat. 105; Syson and Gordon 2001, 102–5.

81 *Pisanello* exh. cat. 1996, 342 cat. 224; Syson and Gordon 2001, 116–17.

82 Gilbert 1998a; see also Wright 1996.

83 Negro and Roio 1998, 141 cat. 12. In general, see also Brown D. A. 1983; Castelfranchi Vegas 1983.

84 See most recently *Virtue and Beauty* exh. cat. 2001, 172–75 cat. 25.

85 See recently David Alan Brown's entry in *Virtue and Beauty* exh. cat. 2001, 142–47 cat. 16; and Brown D. A. 1998, 101–22.

86 Fletcher 1989; Brown, in *Virtue and Beauty* exh. cat. 2001, 142, dates the portrait 1474 or perhaps early 1475, while Kemp 2006, 29–30, prefers 1478–80.

87 Windsor, RL 12558; Clark and Pedretti 1968–69, 1, 104–5; *Leonardo da Vinci: One Hundred Drawings* exh. cat 1996, 14–15 cat. 1. For another view, that this drawing was an early study for the Cecilia Gallerani portrait, see *Leonardo da Vinci: The Divine and the Grotesque* exh. cat. 2002, 108.

88 'Una tavoletta, dipintovi di una testa di dama franzese, cholorita a olio, opera di Pietro Cresci da Bruggia . . . f. 40'; Spallanzani and Gaeta

Bertelà eds 1992, 52; see, recently, Nuttall 2004, 107–8 and 224–27.

89 Brown D. A. 1990; *Leonardo: La dama con l'ermellino* exh. cat. 1998. Bernardo Bellincioni, author of the sonnet in praise of the portrait (see above, pages 112 and 251 n. 36) died in 1492.

90 Windsor, RL 12513; Clark and Pedretti 1968–69, 1, 90; *Leonardo da Vinci: The Divine and the Grotesque* exh. cat. 2002, 106–8.

91 Ludovico 'il Moro' received the Order of the Ermine in 1488; and the Greek name for the animal, 'galèe', forms a pun on the sitter's name.

92 Binaghi Olivari 1983, 640–44.

93 Binaghi Olivari 1979, 92–99; Brown D. A. 1990, 57.

94 Clark and Pedretti 1968–69, 1, 88; *Leonardo da Vinci: The Divine and the Grotesque* exh. cat. 2002, 104–5 cat. 43.

V

ISABELLA AND HER COLLECTION OF ANTIQUITIES

1 The literature on Isabella d'Este as a collector of antiquities is large. The classic study is Brown C. M. 1976; for the documents, see Brown C. M. with Lorenzoni and Hickson 2002; for a recent valuable overview, see Brown C. M. 1996; see also Fletcher 1981; San Juan 1991; Brown C. M. 1995.

2 'Per Capelleto mando a Vostra Signoria certo broncino antiquo de mixtura, quale ritrovai in heredità di uno antiquissimo e valente dottore'; Brown C. M. 1976, 337 (Appendix 18.1, doc. 11). In the Stivini inventory of 1542, seventy-two vases, of which fifty-five were of pietre dure, are recorded; Brown C. M. 1976, 328.

3 For the auction, see Brown C. M. 1972; for letters of 11 May 1506 from Isabella to Lorenzo da Pavia and to Taddeo Albano about bidding for this (and other) objects, see Brown C. M. with Lorenzoni 1982, 91 docs 104 and 173

(Appendix 11); for the whole correspondence, see Brown C. M. with Lorenzoni and Hickson 2002, 218–30.

4 'lo insaciabile desiderio nostro de cose antique'; Brown C. M. 1976, 324.

5 'perché essendo nui de natura appetitose, le cose ne sono più chare quanto più presto le havemo'; Brown C. M. 1995, 83.

6 'sapeti quanto siamo apetitose di queste antiquità'; Brown C. M. with Lorenzoni and Hickson 2002, 135 doc. 12c.

7 'io che ho posto grande cura in recoglire cose antique per honorare el mio studio desideraria grandemente haverli'; this comment refers to a 'Venere antiqua de marmo picola' – a small classical Venus in marble – that she hoped Ippolito would help her to acquire; see further below, pages 165 and 255 n. 29, and Brown C. M. 1976, 324.

8 Ferrari 1995, 2001 and especially 2003b, 339–51; for analysis of what can be learned from the inventory, see Brown C. M. 1976, 325–30.

9 For these letters and acquisitions, see Brown C. M. 1997, 98–100, and Brown C. M. with Lorenzoni and Hickson 2002, 104–9.

10 'usati ogni diligentia per trovarne un ache habia qualche bono intaglio et compratila'; Brown C. M. 1997, 98; Brown C. M. with Lorenzoni and Hickson 2002, 90.

11 'li intaglii in queste zoglie ne delectano ultramodo'; Brown C. M. 1995, 76.

12 For the correspondence in 1492 with Brognolo, see Brown C. M. with Lorenzoni and Hickson 2002, 93–99; for the 16 March 1496 letter, see ibid., 106.

13 'la fantasia sia in sua electione purché la sia cosa che representi antiquità'; Isabella to Giorgio Brognolo, 17 April 1496; Brown C. M. 1997, 99; Brown C. M. with Lorenzoni and Hickson 2002, 107–8. This instruction was noted in chapter two above, page 29.

14 'Primo. Un cameo grande fornito d'oro con due teste di rilievo di Cesare et Livia, legato in oro con una gherlanda incirca, con foglie di lauro smaltate di verde, con una perla de sotto, e da roverso lavorato a niello, et una tavola con il nome della illustrissima Signora Madamma

di buona memoria'; Ferrari 1995, 18; Ferrari 2001, 28; Ferrari 2003b, 339. Formerly identified with either the so-called 'Gonzaga cameo' in St Petersburg or the so-called 'Ptolemy cameo' in Vienna, Isabella's cameo, of which an engraving was made for Fulvio Orsini, seems to have been similar to but distinct from these, and is now presumed lost; see Brown C. M. 1997, 94 fig. 11.

15 'E più, una medaglia d'oro con l'effigie di Madamma bone memorie, quando sua signoria era giovane, con lettere di diamante adorno che dicono "Isabella", con rosette tra l'una e l'altra lettera smaltate di rosso, con un retortio atorno, con rosette smaltate di bianco e azzuro et de roverso una Victoria di rilievo'; Ferrari 1995, 18; Ferrari 2001, 28; Ferrari 2003b, 340.

16 In a literary parallel, Battista Spagnoli Mantuanus drew ancient and modern comparisons between Isabella and both Penelope and Artemisia; G. B. Spagnoli, *Operum*, 1513, 111, fol. 131r; cited by Brown, C. M. 1995, 76.

17 'L'acquisto di gemme, di perle e di pietre preziose d'ogni genere conferisce dunque, a quanto pare, il fascino dello splendore'; but he added, 'quantunque in questo campo non sia possible risplendere se non si è straricchi' (however, in this field it is not possible to shine if one is not super-rich); Pontano ed. Tateo 1999, 276.

18 'voressimo altro cha chamei . . . nui desideramo anchora molto più de havere qualche figurette et teste de bronzo et marmore'; Brown C. M. 1976, 331; Hickson 2000, 94; Brown C. M. with Lorenzoni and Hickson 2002, 128.

19 'so che quella se ne diletta ultra modum'; Lightbown 1986, 245; Brown C. M. with Lorenzoni and Hickson 2002, 112–13.

20 Brown C. M. 1976, 333 and 351 n. 63; Brown C. M. with Lorenzoni and Hickson 2002, 180–81.

21 Allison 1993–94, 274–75.

22 Bourne 2008a, 33–34.

23 'le digne et copiose sue virtù'; Allison 1993–94, 275.

24 'di continua pensa in adornare il camerino di la Signoria vostra, et ch'el ha per le mane certa cosa che è de le belle, non solum di Roma, ma dil mondo'; Brown C. M. with Lorenzoni and Hickson 2002, 113.

25 'uno brazo de una figura de bronzo antiquo . . . ditto brazo è al commando de la signoria vostra'; ibid., 114.

26 'vostro fratello ne ha presentato el brazo de bronzo, qual, per desiderare nui molti copia de antiquità per ornare uno studio principiato, non poteressimo havere hauto cosa più grata'; Brown C. M. 1976, 331; Brown C. M. 1995, 83; Brown C. M. with Lorenzoni and Hickson 2002, 115.

27 'scrivere a Roma alli amici suoi, ricordateli a scrivere de dimandare de le antiquita cossi de marmo come de bronzo'; Brown C. M. 1995, 83; Brown C. M. with Lorenzoni and Hickson 2002, 133.

28 Brown C. M. with Lorenzoni and Hickson 2002, 133.

29 Gaye 1839–40, II, 53–55; Brown C. M. 1976, 324; Brown C. M. with Lorenzoni and Hickson 2002, 147–48.

30 For this episode, see Venturi 1888a; Norton 1957; and Hirst and Dunkerton 1994, 20–28; for the correspondence, see Brown C. M. with Lorenzoni and Hickson 2002, 112 and 156–60.

31 'Quel Cupido è moderno et lo maestro che lo ha facto è qui venuto, tamen è tanto perfecto che ognuno era tenuto antiquo: et dapoi che è chiarito moderno, credo che lo daria per manco pretio, na non la volendo la signoria vostra, non essendo anticho, non ne dico altro'; Hirst and Dunkerton 1994, 22 and 73 n. 27; Brown C. M. with Lorenzoni and Hickson 2002, 112.

32 Gaye 1839–40, II, 54; Brown C. M. with Lorenzoni and Hickson 2002, 158: 'il Cupido, per cosa moderna, non ha paro'.

33 Brown 1995, 86 n. 6; Brown C. M. with Lorenzoni and Hickson 2002, 109–11.

34 'de havere uno Cupido antiquo quale è di le figlioli de quondam Messer Giulio Bonatto, il quali ce lo darianno ogni volta che uno de lor fratelli havessimo uno beneficio de cento

ducati o qui o in Roma'; Brown C. M. 1976, 333; Brown C. M. with Lorenzoni and Hickson 2002, 160–61 (for the whole correspondence, see ibid., 160–72). As it finally turned out, the benefice provided by Pope Julius II was worth 150 ducats; ibid., 333 and 350 n. 58; Brown C. M. 2001, 110.

35 Norton 1957, 255–56; 'La Prima Donna del Mondo' exh. cat. 1994, 310–16 cats 101–2; and see Hirst and Dunkerton 1994, 25–28; and now the extensive discussion in Fusco and Corti 2006, 41–52. On the two Sleeping Cupids and the literary debate that they stimulated, see Campbell S. J. 2004b, 91–102.

36 Rossi 1888, 435–36 n. 3; Brown C. M. 1976, 346 n. 8; Brown C. M. with Lorenzoni and Hickson 2002, 146–47.

37 'molto galante … et è molto nobile de tante misture et varie diverse de serpentino, porfido et simile che non la superia baptizare'; Martindale 1964, 186–88; Brown C. M. 1976, 332 and 349 n. 53; Brown C. M. with Lorenzoni and Hickson 2002, 133–36.

38 Brown C. M. with Lorenzoni and Hickson 2002, 136–43.

39 'prometto mandare a Vostra Illustrissima Signoria doi fauni, quasi de tucto rilievo, li quali fanno una musica sopra un sacrificio, in uno quadro de marmoro, vero è che ad uno mancho tucta la testa et a l'altro la mità, et credo et son certo a quella piaceranno'; Brown C. M. 1976, 332 and nn. 52–53, and 336–37 Appendix 18.1, doc. 1; Brown C. M. with Lorenzoni and Hickson 2002, 142. For these and other related episodes, see Fusco and Corti 2006, 187–89.

40 Brown 1976, 336–37 and 345 n. 7, and Appendix 18.1; Splendours exh. cat. 1981, 166–67 cat. 116.

41 Perry 1975; Brown C. M. 1976, 333 and 351 n. 60.

42 For Fra Sabba's letter of 10 May 2007, see Brown C. M. with Lorenzoni and Hickson 2002, 203–4 (for the whole correspondence, ibid., 193–212). For Michiel's record, see ibid., 195 n. 1.

43 Brown C. M. 1969b, 32 n. 8; Splendours exh.

cat. 1981, 170 cat. 122; Fusco and Corti 2006, 201.

44 Brown C. M. 1976, 334; Brown C. M. with Lorenzoni and Hickson 2002, 214–16.

45 Brown C. M. 1976, 333–34; Brown C. M. with Lorenzoni and Hickson 2002, 236–38.

46 Brown C. M. 1972, 126–28; *Splendours* exh. cat. 1981, 168 cat. 119; Brown C. M. with Lorenzoni 1982, 173–88; Brown C. M. with Lorenzoni and Hickson 2002, 218–30; Welch 2005, 271–73.

47 'Credemo che havereti inteso che habiamo havuto il vaso de agata del quondam Vivianello et la Summersione de Farahone. Haveremo etiam la Faustina del Mantigna, et cossì, a poco poco, andarimo facendo un studio'; Brown C. M. with Lorenzoni and Hickson 2002, 230.

48 Campori 1870, 28–29; Weiss 1969, 167 n. 3; Fusco and Corti 2006, 83.

49 Allison 1993–94, 271–74 doc. 10; Fusco and Corti 2006, 83–84.

50 On Ciampolini, see Fusco and Corti 1991 and 2006, passim; for this exchange of letters, see Brown C. M. with Lorenzoni and Hickson 2002, 212–14.

51 Brown C. M. 1976, 333; Brown C. M. with Lorenzoni and Hickson 2002, 181.

52 Bennett and Wilkins 1984, 55–56.

53 Brown B. L. 1983, 1053–54; the letter is excerpted in Luzio repr. 1913, 199.

54 Bourne 2008a, 406–7 doc. 155; Brown B. L. 1983, 1054 n. 3.

55 Luzio repr. 1913, 199; Bourne 2008a, 406 doc. 154; and see pages 224–25, Appendix, no.5.

56 Luzio repr. 1913, 199; Bourne 2008a, 409 doc. 159: in this way he 'would have both the model and the maestro together'.

57 Pedretti 1978, 137–44. These are Codex Atlanticus fols 220r-c and 220v-b, datable to around 1503–4. They are principally studies of staircases within a building whose ground-plan layout is not closely similar to that of the Villa Tovaglia. Nor is there any good reason to associate with the Villa Tovaglia a problematical drawing at Windsor (RL 12689; Clark and Pedretti 1968–69, I, 173, as 'not by Leonardo'),

which shows half of a two-storey rusticated building set beyond a terraced garden, and to which a Doric colonnade is attached. Although sketchy annotations showing bushes or young trees could possibly have been added by Leonardo, the drawing as a whole is not by him nor apparently from his workshop; moreover, it is coloured, unlike Leonardo's drawing of the Villa Tovaglia according to Malatesta.

58 This is the argument presented by Brown B. L. 1983, 1059–60.

59 Gaye 1839–40, I, 274–75 no. cxvii: letter from Baccio Pontelli to Lorenzo de' Medici, 18 June 1481; Vasic Vatovec 1979, 425.

60 Brown B. L. 1983, 1058–59.

61 Ibid., 1060; Bourne 2008a, 468–69 doc. 257 (letter of 30 March 1508).

62 Brown C. M. 1983, 65.

63 'Quelli dessigni de vasi venali, quali ni hai mandati aciò che madama nostra consorte vedi se gli è cosa per lei, anchor non se gli sono potuti monstrare per essere lei stata incognita a Venetia'; Brown C. M. 1983, 65; Brown C. M. with Lorenzoni and Hickson 2002, 148.

64 'Circha a li vasi de li quali a questi di mandai li disegni, prego la Signoria Vostra che li piacia intender bene perché non sono vasi de arzento sicome par che la Sig. Vostra habia compreso per la sua littera, ma sono di pietre dure zoé: diaspise, christallo, et anintista. Hanno bene el piede et el coperchio d'oro sicome apare scripto sotto li desegni che ho mandati. Sono chose rare et chose da signori le quale el Magnifico quondam Lorenzo de Medici teneva per chose molto chare, et veneno a le man de creditori quando Piero fu chazato'; Brown C. M. 1969a, 197; Heikamp ed. 1974, 175–76; Brown C. M. 1983, 65; Brown C. M. with Lorenzoni and Hickson 2002, 149–50. On the whole episode, with transcriptions of the correspondence, see Heikamp ed. 1974, 174–81.

65 Heikamp ed. 1974, 176–77; Brown C. M. with Lorenzoni and Hickson 2002, 150; for the letter in full, see page 230, Appendix, no. 10.

66 Heikamp ed. 1974, 177–78; Brown C. M. with Lorenzoni and Hickson 2002, 150–52; pages 231–32, Appendix, no. 11. The letter continues

with discussion of unrelated matters. In citing the price of the jasper vase with a gold foot set with pearls and rubies as 150 ducats, Malatesta seems to have confused it with the plain jasper vase which is the one priced at 150 ducats in the attached list.

67 Heikamp ed. 1974, 178–79; Brown C. M. with Lorenzoni and Hickson 2002, 152–53.

68 Heikamp ed. 1974, 179–81; Brown C. M. with Lorenzoni and Hickson 2002, 153–54.

69 On Bishop-Elect Ludovico, see Brown C. M. 1983, 67; on the episodes outlined below, see also Hickson 2000.

70 'venni ad Gazolo . . . sua Signoria Monsignore et tucti li altri ne ferono grade carize, vidi el studio et multe altra cose'; Hickson 2000, 90.

71 Hickson 2000, 90–91.

72 On this episode, see also Brown C. M. and Hickson 1997, 19.

73 Brown C. M. 1983, 64; Hickson 2000, 91.

74 'Adriano barbuto, Tito vecchio senza barba, Geta barbuto e un altro testa senza barba e senza nome'; Hickson 2000, 91.

75 'un vaso di grande e bella forma composto di 49 pezi di cristallo ligati in argento dorato et smaltato e intagliato'; described thus in the letter of 4 July 1505 from Gian Cristoforo Romano to Isabella d'Este; Brown C. M. and Hickson 1997, 22.

76 'un vaso di cristallo che sariano perfetta compagnia'; Brown C. M. and Hickson 1997, 22.

77 'El vaso de Caradosso è bello e molto mi piace, ma, per essere troppo grande da studio, l'havemo lassato in sua libertà'; Brown C. M. and Hickson 1997, 23.

78 'E poi me ano mostrato lil vaxi che sono quidece': three of these were made of agate (although one was badly damaged), and the rest were of jasper and crystal; see Heikamp ed. 1974, 173.

79 'della grandeza simile al nostro grande de diaspes'; Hickson 2000, 92–93.

80 'perche pur g'è qualche altra persona, come per altre mie ho scripto, che desidera de haverli'; Brown C. M. 1969a, 201; Heikamp ed. 1974, 178; Hickson 2000, 94; Brown C. M. with Lorenzoni and Hickson 2002, 152.

81 'perchè dubitamo che, venendo lì lo illustrissimo signore nostro patre, qual se ne delecta, che non levasse le più belle cose che gli fusse, haveremo charo che faciati ogni opera possible perchè le siano aviate nanti la gionta de sua excellentia, che non ce poteresti fare cosa più grata'; Brown C. M. 1976, 350 n. 54; Brown C. M. 1996, 64; Brown C. M. with Lorenzoni and Hickson 2002, 127 doc. 9a.

82 Venturi 1888b, 113–16 and n. 1; Fusco and Corti 2006, 300.

83 'Ho visto el schizo delli vasa [sic] mi ha portato Marco et inteso el pretio loro' Brown C. M. 1983, 64; Hickson 2000, 93.

84 'quelli vasi de'quali Marco mio mii portò li schizi'; ibid.

85 'de gli altri vasi che mi scriveti aspetto mi mandiati disegni et lo pretio di epsi'; ibid.

86 See pages 231–32, Appendix, no. 11.

87 Clark and Pedretti 1968–69, 1, 10–11; *Leonardo da Vinci: One Hundred Drawings* exh. cat. 1996, 91–94 cat. 50. Another early example of Leonardo's coloured topographical drawings is the *Map of the Arno and Mugnone Rivers to the West of Florence*, drawn and coloured in translucent watercolours probably in late summer 1504; see Clark and Pedretti 1968–69, 1, 168; *Leonardo da Vinci: One Hundred Drawings* exh. cat. 1996, 103–5 cat. 57; *Leonardo da Vinci: Master Draftsman* exh. cat. 2003, 475–77 cat. 80.

88 Windsor, RL 19057–59; RL 19059 is dated 2 April 1489; see Clark and Pedretti 1968–69, III, 24.

89 See pages 231–32, Appendix, no. 11.

90 Ventrinelli 1998, 459 n. 10; Pedretti 1973, 132.

91 Kemp and Walker 1989, 222.

92 Janson 1961; *Andrea Mantegna* exh. cat. 1992, 429.

93 Popham and Pouncey 1950, 94–95 cat. 156; Lightbown 1986, 496 cat. 194; *Andrea Mantegna* exh. cat. 1992, 449–50 cat. 146; *Mantegna 1431–1506* exh. cat. 2008, 342–44 cat. 143. Another example of this colouration technique is, of course, the *Allegory of the Fall of Ignorant Humanity* drawing; see chapter three, pages 55–58 and pl. 25.

94 Christiansen, in *Andrea Mantegna* exh. cat. 1992, 67–78.

95 Kemp and Walker 1989, 313.

96 Ibid., 95; McMahon 1956, 769.

97 Kemp and Walker 1989, 96; McMahon 1956, 777 and 780–81 respectively. See also Gombrich 1976, 19.

98 Gombrich 1976, 31.

99 Ibid., 20.

100 Ibid., 33. For Leonardo's portrait of Ginevra de' Benci, see page 152, pl. 84.

101 On *lustro*, see Ventrinelli 1998, 457–58 n. 5; on the 1504 letters, see Brown C. M. 1969d.

102 'Gli è necessario che Vostra Excellentia me dia aviso se l'opera de Messer Andrea è lustro, et che lustro, overamente se l'è invernigata o non'; Brown C. M. 1969d, 542; Campbell S. J. 2004b, 294 (Appendix Two, 70).

103 'non sono già colorite ad olio, ma cossi a guazo, et poi invernigate doppo che tutto sono finite. Le pictore vostro haveva lui a colorire over ad olio o a vernice secundo il [la] consueta, arte et satisfactione sua'; Brown C. M. 1969d, 542.

104 Windsor, RL 12321; Clark and Pedretti 1968–69, I, 23–24.

105 Windsor, RL 12546; Clark and Pedretti 1968–69, I, 101.

106 Windsor, RL 12530; Clark and Pedretti 1968–69, I, 96.

107 This is suggested by Fusco and Corti 2006, 118–19, who translate *lustro* as 'gloss'.

108 'Cum et ad lucem solidam gemmae partem objectares . . . cubica corporalitate intus sublucida et vitrea transparenti umbra mira pulchritudine membra quoque spirantia enitescere conspectantur'; Ashmole 1959, 39–40; Gilbert 1980, 207 (using the phrase 'gleaming in their solid corporeality, in shining glassy transparent shadow with marvelous beauty'); see also Syson and Thornton 2001, 90 and fig. 62; Fusco and Corti 2006, 210. The gem is now in Berlin, Staatliche Museen.

109 'l'abbi questa gentilezza, ch'ella si possi godere così di notte chome el giorno, perché nonn è mancho bella sperarla la lume di chandela che il giorno'; Fusco and Corti 2006, 120 and 297–98 doc. 71.

110 For discussion of the fate of the Medici vases after the expulsion of Piero de' Medici in 1494, see Heikamp ed. 1974, 25; Fusco and Corti 2006, 159–77.

111 Spallanzani and Gaeta Bertelà eds 1992, 34–36; Heikamp ed. 1974, 167–68.

112 Fusco and Corti 2006, 165 and 369–70 doc. 271.

113 A later, but also unidentifiable, example in Isabella d'Este's own case is a drawing of an obelisk recently discovered in Rome, sent to her on 19 October 1511 by Stazio Gadio: 'Facio far il disegno d'uno obelisco grande novamente ritrovato, che è dedicato al sole, come vostra signoria potrà comprender per le littere sue et, fatto, mandarolo, a quella'; Brown C. M. with Lorenzoni and Hickson 2002, 250–51.

VI

LEONARDO'S LAST PROJECT
FOR ISABELLA

1 Villata 1999, 170 no. 191; Ferrari 2003a, 78 no. 11; and see pages 233–34, Appendix, no. 13.

2 See pages 233–34, Appendix, no. 13.

3 On Isabella's interest, from 1500, in images of male infants, see Campbell S. J. 2004b, 102–7.

4 Villata 1999, 169 no. 190; Ferrari 2003a, 78 no. 10; and see pages 232–33, Appendix, no. 12.

5 Villata 1999, 171 no. 192; Ferrari 2003a, 78 no. 12; and see pages 234–35, Appendix, no. 14.

6 Villata 1999, 174–75 no. 200; and see page 236, Appendix, no. 16.

7 For the history and chronology of work on the *Anghiari* mural, see *inter alia* Kemp 2006, 226–31.

8 Villata 1999, 194–95 no. 227; Ferrari 2003a, 79 no. 15; and see pages 236–37, Appendix, no. 17.

9 Villata 1999, 195 no. 228; Ferrari 2003a, 79 no. 16; and see pages 237–38, Appendix, no. 18.

10 Kemp 2006, 271.

11 See pages 233–34, Appendix, no. 13.

12 See page 236, Appendix, no. 16.

13 See pages 236–38, Appendix, nos 17–18.

14 Clark and Pedretti 1968–69, I, 84–85; *Leonardo da Vinci: The Divine and the Grotesque* exh. cat. 2002, 96–99 no. 41.

15 Białostocki 1956.

16 Davies 1961, 317–20; Ottino della Chiesa 1956, no. 84.

17 Kemp and Walker 1989, 149.

18 Windsor, RL 12328r; Clark and Pedretti 1968–69, I, 27–28. It is conceivable that Leonardo was aware of precedents for this sort of image established by Antonello da Messina in his two paintings of the *Virgin Annunciate* in Palermo (*Antonello da Messina* exh. cat. 2006, 232–35 cat. 35) and Munich (*Antonello da Messina* exh. cat. 2006, 254–55 cat. 41); see Ringbom 1965, 65.

19 *Leonardo da Vinci: Painter at the Court of Milan,* exh. cat. 2011, 300–03 cat. 91.

20 'Painted by Leonardo da Vinci. Etched by Wenceslaus Hollar after the Original. In the year 1650'.

21 For the derivatives, see *inter alia*, Heydenreich 1964, and Fiorio 2005.

22 *Leonardo da Vinci: One Hundred Drawings* exh. cat. 1996, 81.

23 For discussion of the scientific and technical evidence, see the forthcoming book, edited by Robert Simon, on the newly discovered Salvator Mundi.

24 Further, see again ibid. It is generally agreed that significant *pentimenti* indicate the master at work, since a pupil or copyist will transcribe the completed image without making changes or revisions.

25 Snow-Smith 1982, 18–25; *Leonardo da Vinci: Painter at the Court of Milan,* exh. cat. 2011, 303.

26 See pages 227–28, Appendix, no. 8.

27 Windsor, RL 12525 and 12524 respectively; Clark and Pedretti 1968–69, I, 94 (as 'probably after 1504'); *Leonardo da Vinci: One Hundred Drawings* exh. cat. 1996, 81 cats 43–44 (as '*ca.* 1504–08'); Marani 2000, 268 and 276–77 (as 'after 1504'); but see now *Leonardo da Vinci:*

Painter at the Court of Milan, exh. cat. 2011, 298–99 cats 89–90 and 303, in which these two drawings are dated unusually early at 'around 1500'.

28 Windsor, RL 12514; Clark and Pedretti 1968–69, I, 90–91; *Leonardo da Vinci: The Mystery of the Madonna of the Yarnwinder* exh. cat. 1992, 48–49 cat. 6; *Leonardo da Vinci: One Hundred Drawings* exh. cat. 1996, 62–64 cat. 32; *Leonardo da Vinci: Painter at the Court of Milan,* exh. cat. 2011, 292–93 cat. 87; Kemp and Wells 2011, 43–44 and fig. 20.

29 Windsor, RL 12538; Clark and Pedretti 1968–69, I, 97–98; *Leonardo da Vinci: One Hundred Drawings* exh. cat. 1996, 132–36 cat. 75.

30 Fiorio 2000, 162–64 cat. C1; Fiorio 2005, 267 fig. 4.

31 Sedini 1989, 42–44 no. 10; the early dating has been accepted by some critics: see Fiorio in *Il Cinquecento Lombardo* exh. cat. 2000, 123–24 cat. III.25.

32 Fiorio 2005, 270 fig. 6.

33 Ibid., 273 fig. 8; for the attribution, see Marani in *Il Cinquecento Lombardo* exh. cat. 2000, 162–63 cat. III.46.

34 Fiorio 2000, 185–86 cat. D.12; *Mantegna a Mantova 1460–1506* exh. cat. 2006, 172–73 cat. 54; and now *Leonardo da Vinci: Painter at the Court of Milan* exh. cat. 2011, 242–43 cat. 66 (as Marco d'Oggiono).

35 Ekserdjian 1997, 29.

36 Hebrews 5:6, 6:20, 7:17, 7:21; also Hebrews 7:1.

37 Venice, Galleria dell'Accademia, 215, 215A and 216; *Leonardo da Vinci: Master Draftsman* exh. cat. 2003, 477–85 cats 81–83; Kemp 2006, 232–34.

38 Kemp and Walker 1989, 225.

39 Ibid., 222.

APPENDIX

LETTERS TO AND FROM ISABELLA

1 Archivio di Stato di Mantova, *Archivio Gonzaga*, serie F, II, 9, busta 2992, copialettere 9, no. 169, fol. 54r; Beltrami 1919, 51 no. 88;

Villata ed. 1999, 112–13 no. 129; Ferrari 2003a, 76 no. 1.

2 Archivio di Stato di Mantova, *Archivio Gonzaga*, serie E, xlix, 2, busta 1615; Beltrami 1919, 51 no. 89; Villata ed. 1999, 113–14 no. 130; Ferrari 2003a, 76 no. 2.

3 Archivio di Stato di Mantova, *Archivio Gonzaga*, serie E, xlix, 2, busta 1615; Villata ed. 1999, 114–15 no. 131.

4 Archivio di Stato di Mantova, *Archivio Gonzaga*, serie E, xlv, busta 1439, fol. 55r; Beltrami 1919, 63 no. 103; Brown with Lorenzoni 1982, 51 doc. 29; Villata ed. 1999, 130–31 no. 144; Ferrari 2003a, 76 no. 3.

5 Archivio di Stato di Mantova, *Archivio Gonzaga*, serie E, xxviii, 3, busta 1103, no. 137, fols 138r–v; Beltrami 1919, 64 no. 105; Villata ed. 1999, 132–33 no. 146; Ferrari 2003a, 76 no. 4.

6 Archivio di Stato di Mantova, *Archivio Gonzaga*, serie F, ii, 9, busta 2993, copialettere 12, no. 80, fol. 28r; Beltrami 1919, 65 no. 106; Villata ed. 1999, 133–34 no. 149; Ferrari 2003a, 76–77 no. 5. Villata gives the date of this letter as 29 March 1501.

7 Archivio di Stato di Mantova, *Archivio Gonzaga*, serie E, xxviii, 3, busta 1103, fol. 272r; Beltrami 1919, 65 no. 107; Villata ed. 1999, 134–35 no. 150; Ferrari 2003a, 77 no. 6.

8 New York, private collection; Beltrami 1919, 66–67 no. 108; Villata ed. 1999, 136–37 no. 151.

9 Archivio di Stato di Mantova, *Archivio Gonzaga*, serie E, xxviii, 3, busta 1103, fol. 290; Beltrami 1919, 67–68 no. 110; Villata ed. 1999, 138–39 no. 154; Ferrari 2003a, 77 no. 7.

10 Archivio di Stato di Mantova, *Archivio Gonzaga*, serie F, ii, 9, busta 2993, copialettere 13, no. 195, fol. 69v; Beltrami 1919, 70 no. 115;

Villata ed. 1999, 142 no. 158; Ferrari 2003a, 77 no. 8.

11 Archivio di Stato di Mantova, *Archivio Gonzaga*, serie E, xxviii, 3, busta 1104; Beltrami 1919, 70–71 no. 116; Villata ed. 1999, 143–44 no. 159; Ferrari 2003a, 77–78 no. 9.

12 Archivio di Stato di Mantova, *Archivio Gonzaga*, serie F, ii, 9, busta 2994 copialettere 17, no. 55, fol. 19v; Beltrami 1919, 89–90 no. 141; Villata ed. 1999, 169 no. 190; Ferrari 2003a, 78 no. 10.

13 Archivio di Stato di Mantova, *Archivio Gonzaga*, serie F, ii, 9, busta 2994 copialettere 17, no. 56, fol. 20r; Beltrami 1919, 90 no. 142; Villata ed. 1999, 170 no. 191; Ferrari 2003a, 78 no. 11.

14 Archivio di Stato di Mantova, *Archivio Gonzaga*, serie E, lxi, 1, busta 1890, fol. 281r; Beltrami 1919, 90–91 no. 143; Villata ed. 1999, 171 no. 192; Ferrari 2003a, 78 no. 12.

15 Archivio di Stato di Mantova, *Archivio Gonzaga*, serie F, ii, 9, busta 2994 copialettere 17, fol. 44r; Beltrami 1919, 94 no. 152; Ferrari 2003a, 78 no. 13.

16 Archivio di Stato di Mantova, *Archivio Gonzaga*, serie F, ii, 9, busta 2994, copialettere 17, no. 128, fol. 44r; Beltrami 1919, 94 no. 152; Villata ed. 1999, 174–75 no. 200.

17 Archivio di Stato di Mantova, *Archivio Gonzaga*, serie E, xxviii, 3, busta 1105, fol. 703r; Beltrami 1919, 109 no. 173; Villata ed. 1999, 194–95 no. 227; Ferrari 2003a, 79 no. 15.

18 Archivio di Stato di Mantova, *Archivio Gonzaga*, serie F, ii, 9, busta 2994, copialettere 160, no. 250, fol. 92r; Beltrami 1919, 109–10 no. 174; Villata ed. 1999, 195 no. 228; Ferrari 2003a, 79 no. 16.

BIBLIOGRAPHY

A casa di Andrea Mantegna: Cultura artistica a Mantova nel Quattrocento, exh. cat. Mantua (Casa di Mantegna) 2006, ed. R. Signorini with D. Sogliani, Cisinello Balsamo, 2006

Agosti, G., 'Autour de La Vierge de la Victoire', in *Mantegna 1431–1506* exh. cat., 2008, 291–319

Allison, Ann Hersey, 'The Bronzes of Pier Jacopo Alari-Bonacolsi, called Antico', *Jahrbuch der Kunsthistorischen Sammlungen in Wien* 89/90, 1993–94, 37–310

—, 'Antico e Isabella d'Este', in Ventura, ed., 1995, 91–111

Ambrogio Bergognone: Un pittore per la Certosa, exh. cat., Pavia (Certosa) 1998, ed. G. C. Sciolla, Milan, 1998

Ames-Lewis, F., *The Intellectual Life of the Early Renaissance Artist*, New Haven and London, 2000

Andrea Mantegna, exh. cat., London (Royal Academy of Arts) 1992, ed. J. Martineau, London, 1992

Angelicoussis, E., 'The Stuart Legacy: Ancient Busts at Hampton Court Palace', *Mitteilungen des Deutschen Archäologischen Instituts. Römische Abteilung* 110, 2003, 57–84

Antonello da Messina: L'opera completa, exh. cat., Rome (Scuderie del Quirinale), ed. M. Lucco, Cisinello Balsamo, 2006

Ashmole, B., 'Cyriac of Ancona', *Proceedings of the British Academy* 45, 1959, 25–41

At Home in the Renaissance, exh. cat., London (Victoria and Albert Museum) 2006, ed. M. Ajmar-Wollheim and F. Dennis, London, 2006

Bambach, C. C., *Drawing and Painting in the Italian Renaissance Workshop: Theory and Practice, 1300–1600*, Cambridge, 1999

—, 'A Leonardo Drawing for the Metropolitan Museum of Art: Studies for a Statue of *Hercules*', *Apollo* 153/469, 2001, 16–23

Baxandall, M., *Giotto and the Orators*, Oxford, 1971

Bellincioni, B., *Le Rime*, ed. P. Fanfani, Bologna, 1876

Beltrami, L., *Documenti e memorie riguardanti la vita e le opere di Leonardo da Vinci*, Milan, 1919

Bennett, B., and D. Wilkins, *Donatello*, Oxford, 1984

Bertolotti, A., *Le arti minori all a corte di Mantova*, Milan, 1889

Białostocki, J., ' "Opus quinque dierum": Dürer's "Christ among the Doctors" and its Sources', *Journal of the Warburg and Courtauld Institutes* 22, 1959, 17–34

Binaghi Olivari, M. T., 'I francesi a Milano (1499–1525): Arti figurative e moda', *Annali dell'istituto storico italo-germanico in Trento* V, 1979, 85–116

—, 'La moda a Milano al tempo di Ludovico il Moro', in G. Bologna, ed., *Milano nell'età di Ludovico il Moro*, 2 vols, Milan, 1983, II, 633–50

Bini, D., ed., 'Isabella d'Este: La primadonna del Rinascimento', Quaderno di *Civiltà Mantovana* (supplement to no. 112, May 2001), Modena, 2001

Biondo, M., *Della nobilissima pittura*, Venice, 1549

Bober, P. P., and R. O. Rubinstein, *Renaissance Artists and Antique Sculpture*, London, 1986

Bourne, M., 'Renaissance Husbands and Wives as Patrons of Art: The Camerini of Isabella d'Este and Francesco II Gonzaga', in Reiss and Wilkins, eds, 2001, 93–123

—, *Francesco II Gonzaga: The Soldier-Prince as Patron*, Rome, 2008 [2008a]

—, 'Mantegna's "Madonna della Vittoria" and the Rewriting of Gonzaga History', in Nelson and Zeckhauser, eds, 2008, 167–83 [2008b]

Braghirolli, W., 'Carteggio di Isabella d'Este Gonzaga intorno ad un quadro di Giambellino', *Archivio Veneto* XIII, 1877, 376–83

Brown A., ed., *Language and Images of Renaissance Italy*, Oxford, 1995

Brown, B. L., 'Leonardo and the Tale of Three Villas: Poggio a Caiano, the Villa Tovaglia in Florence and Poggio Reale in Mantua', in G. Garfagnini, ed., *Firenze e la Toscana dei Medici nell'Europa del '500*, III: *Relazioni artistiche, il linguaggio architettonico*, Florence, 1983, 1053–62

Brown, C. M., 'Little Known and Unpublished Documents concerning Andrea Mantegna, Bernardino Parentino, Pietro Lombardo, Leonardo da Vinci and Filippo Benintendi, 2', *L'Arte*, n.s. II, 6, 1969, 140–64, and 7–8, 1969, 182–214 [1969a]

—, 'Comus Dieu des fêtes, allégorie de Mantegna et de Costa pour le studiolo d'Isabella d'Este Gonzague', *La Revue du Louvre et des Musées de France* XIX, 1969, 31–38 [1969b]

—, ' "Una testa di Platone antico con la punta dil naso di cera": Unpublished Negotiations between Isabella d'Este and Niccolò and Giovanni Bellini ', *Art Bulletin* 51, 1969, 372–77 [1969c]

—, 'New Documents concerning Andrea Mantegna and a Note regarding 'Jeronimus de Conradis pictor', *Burlington Magazine* III, 1969, 538–44 [1969d]

—, 'An Art Auction in Venice in 1506', *L'Arte* 18–20, 1972, 121–36

—, 'Gleanings from the Gonzaga Documents in Mantua: Gian Cristoforo Romano and Andrea Mantegna', *Mitteilungen der Kunsthistorisches Institut in Florenz* 17, 1973, 153–59

—, '"Lo insaciabile desiderio nostro de cose antique": New Documents on Isabella d'Este's Collection of Antiquities', in C. H. Clough, ed., *Cultural Aspects of the Italian Renaissance: Essays in Honour of Paul Oskar Kristeller*, Manchester, 1976, 324–53

—, 'The Grotta of Isabella d'Este', *Gazette des Beaux-Arts*, ser. 6, LXXXIX, 1977, 155–71, and XCI, 1978, 72–82

—, 'Francesco Bonsignori: Painter to the Gonzaga Court, New Documents', *Atti e memorie dell'Accademia Virgiliana di Mantova*, n.s. XLVII, 1979, 81–96

—, 'I vasi di pietra dura de' Medici e Ludovico Gonzaga Vescovo Eletto di Mantova (1501–1502)', *Civiltà Mantovana*, n.s. I, 1983, 63–68

—, *La Grotta di Isabella d'Este: Un simbolo di continuità dinastica per i duchi di Mantova*, Mantua, 1985

—, '"Purché la sia cosa che representi antiquità": Isabella d'Este Gonzaga e il mondo greco-romano', in Ventura, ed., 1995, 71–89

—, 'A Ferrarese Lady and a Mantuan Marchesa: The Art and Antiquities Collections of Isabella d'Este Gonzaga (1474–1539)', in Lawrence, ed., 1996, 53–71

—, 'Isabella d'Este Gonzaga's *Augustus and Livia* Cameo and the "Alexander and Olympias" Gems in Vienna and Saint Petersburg', in C. M. Brown, ed., *Engraved Gems: Survivals and Revivals* (Studies in the History of Art 54), Washington, D.C. (National Gallery of Art), 1997, 85–107

—, 'Isabella d'Este e il mondo Greco-Romano', in Bini, ed., 2001, 109–27

—, *Isabella d'Este in the Ducal Palace in Mantua: An Overview of Her Rooms in the Castello di San Giorgio and the Corte Vecchia*, Rome, 2005

—, L. Fusco and G. Corti, 'Lorenzo de' Medici and the Dispersal of the Antiquarian Collections of Cardinal Francesco Gonzaga', *Arte Lombarda* 90–91, 1989, 86–103

—, and S. Hickson, 'Caradosso Foppa (c.1452–1526/27)', *Arte Lombarda* 119, 1997, 9–39

—, with A. M. Lorenzoni, *Isabella d'Este and Lorenzo da Pavia: Documents for the History and Culture in Renaissance Mantua* (Travaux d'Humanisme et Renaissance CLXXXIX), Geneva, 1982

—, with A. M. Lorenzoni and S. Hickson, *'Per dare qualche splendore a la gloriosa città di Mantova': Documents for the Antiquarian Collection of Isabella d' Este*, Rome, 2002

Brown, D. A., 'Leonardo and the Idealised Portrait in Milan', *Arte Lombarda* 67, 1983, 102–16

—, 'Leonardo and the Ladies with the Ermine and the Book', *Artibus et Historiae* 22, 1990, 47–61

—, *Leonardo da Vinci: Origins of a Genius*, New Haven and London, 1998

Bull, D., 'Two Portraits by Leonardo: *Ginevra de' Benci* and the *Lady with an Ermine*', *Artibus et Historiae* 25, 1992, 67–83

Burke, P., 'The Presentation of Self in the Renaissance Portrait', in *The Historical Anthropology of Early Modern Italy*, Cambridge, 1987, 150–67

Byam Shaw, J., *Drawings by Old Masters at Christ Church, Oxford*, 2 vols, Oxford, 1976

Caldwell, D., *The Sixteenth-Century Impresa in Theory and Practice*, New York, 2004

Campbell. L., *Renaissance Portraits*, New Haven and London, 1990

—, *National Gallery Catalogues: The Fifteenth Century Netherlandish Schools*, London, 1998

Campbell, S. J., *Cosmè Tura of Ferrara: Style, Politics and the Renaissance City, 1450–1495*, New Haven and London, 1997

—, *Cosmè Tura: Painting and Design in Renaissance Ferrara*, Boston, Mass., 2002

—, 'Mantegna's Triumph: The Cultural Politics of Imitation "all'antica" at the Court of Mantua 1490–1530', in *Artists at Court: Image-making and Identity 1300–1550,* exh. cat., Boston (Isabella Stewart Gardner Museum), ed. S. J. Campbell, Boston, 2004, 91–103 [2004a]

—, *The Cabinet of Eros: Renaissance Mythological Painting and the* Studiolo *of Isabella d'Este*, New Haven and London, 2004 [2004b]

Campori, G., *Lettere artistiche inediti*, Modena, 1866

—, *Raccolta di cataloghi ed inventari inediti*, Modena, 1870

Cannata Salamone, N., 'Women and the Making of the Italian Literary Canon', in Panizza, ed., 2000, 498–512

Canova, A., 'Mantegna *invenit*', in *Mantegna 1431–1506* exh. cat., 2008, 237–89

Canuti, F., *Il Perugino*, 2 vols, Siena, 1931

Cartwright, Julia, *Isabella d'Este, Marchioness of Mantua 1474–1539: A Study of the Renaissance*, 2 vols, London, 1903

Castelfranchi Vegas, L., ' "Retracto di naturale": Considerazioni sulla ritrattistica lombarda degli anni fra Quattrocento e Cinquecento', *Paragone* 401–3, 1983, 64–71

Castiglione, B., *The Courtier*, trans. G. Bull, London, 1967

Chambers, D. S., ed., *Patrons and Artists in the Italian Renaissance*, London, 1970

Chiappini, L., *Eleanora d'Aragona, prima Duchessa di Ferrara*, Rovigo, 1956

Christiansen, K., 'Paintings in Grisaille' and 'The Studiolo of Isabella and Late Themes', in *Andrea Mantegna* exh. cat., 1992, 394–400 and 418–26

Circa 1492, exh. cat., Washington, D.C. (National Gallery of Art) 1991, ed. J. Levenson, Washington, D.C., 1991

Clark, K., *Leonardo da Vinci: An Account of his Development as an Artist*, Harmondsworth, 1959

Clark, K., and C. Pedretti, *The Drawings of Leonardo da Vinci in the Collection of Her Majesty the Queen at Windsor Castle*, 3 vols, London, 1968–69

Comboni, A., ed., *Paride da Ceresara, Rime*, Florence, 2004

Cotte, P., and M. Kemp, '*La Bella Principessa* and the Warsaw *Sforziad*', London 2011, at http://www.bbk.ac.uk/hosted/leonardo/#HH

Covi, D., *Andrea del Verrocchio, Life and Work*, Florence, 2005

D'Arco, C., 'Notizie di Isabella Estense moglie a Francesco Gonzaga aggiuntivi molti

documenti inediti che si riferiscono alla stessa signora, all'istoria di Mantova, ed a quella generale d'Italia', *Archivio Storico italiano*, Appendice, II, 1845, 205–326

—, *Delle arti e degli artefici di Mantova*, 2 vols, Mantua, 1857

Davies, M., *National Gallery Catalogues: The Earlier Italian Schools*, 2nd ed., London, 1961

Dionisotti, C., 'Battista Fieri', *Italia medioevo e umanistica* I, 1958, 401–18

Dubois, R., *Giovanni Santi*, Bordeaux, 1971

Ekserdjian, D., *Correggio*, New Haven and London, 1997

Elam, Caroline, 'Mantegna and Mantua', in *Splendours of the Gonzaga* exh. cat., 1981, 15–25

—, 'Les *Triomphes* de Mantegna: La forme et la vie', in *Mantegna 1431–1506* exh. cat., 2008, 363–403

Equicola, Mario, *De mulieribus: Delle donne*, ed. G. Lucchesini and P. Totaro, Pisa and Rome, 2004

Fahy, C., 'Three Early Renaissance Treatises on Women', *Italian Studies* II, 1956, 30–55

—, 'The *De mulieribus admirandis* of Antonio Cornazzano', *La Bibliofilia* 62, 1960, 144–74

Fenlon, I., 'Women and Learning in Isabella d'Este's "Studioli"', in C. Mozzarelli, R. Oresko and L. Ventura, eds, 1997, 353–67

Ferrari, D., 'L'"Inventario delle gioie"', in Ventura, ed., 1995, 11–33

—, 'L'"Inventario delle gioie"', in Bini, ed., 2001, 21–43

—, '"La vita di Leonardo è varia et indeterminata forte": Leonardo da Vinci e i Gonzaga nei documenti dell'Archivio di Stato di Mantova', in *Leonardo, Machiavelli, Cesare Borgia* exh. cat., 2003, 73–79 [2003a]

—, *Le Collezioni Gonzaga: L'inventario dei Beni del 1540–1542*, Cinisello Balsamo, 2003 [2003b]

Fiorio, Maria Teresa, 'Leonardo, Boltraffio e Jean Perréal', *Raccolta Vinciana* XXVII, 1997, 325–55

—, *Giovanni Antonio Boltraffio, un pittore milanese nel lume di Leonardo*, Milan and Rome, 2000

—, 'Un *Salvator Mundi* ritrovato', *Raccolta Vinciana* XXXI, 2005, 257–83

Fletcher, J. M., 'Isabella d'Este and Giovanni Bellini's *Presepio*', *Burlington Magazine* 113, 1971, 703–12

—, 'Isabella d'Este, Patron and Collector', in *Splendours of the Gonzaga* exh. cat., 1981, 51–63

—, 'Bernardo Bembo and Leonardo's Portrait of Ginevra de' Benci', *Burlington Magazine* 131, 1989, 811–16

Fortini Brown, P., *Venetian Narrative Painting in the Age of Carpaccio*, New Haven and London, 1988

Fra Angelico to Leonardo: Italian Renaissance Drawings, exh. cat. London (British Museum) 2010, ed. H. Chapman and M. Faietti, London, 2010

Franceschini, A., *Artisti a Ferrara in età umanistica e rinascimentale: Testimonianze archivistiche,* part II, vol. I: *Dal 1493 al 1516*, Ferrara, 1995

Furlan, I., 'Su Mantegna scultore', in *La scultura al tempo di Andrea Mantegna tra classicismo e naturalismo* exh. cat., Mantua (Castello di San Giorgio), ed. V. Sgarbi, Milan 2006, 34–45

Fusco, L., and G. Corti, 'Giovanni Ciampolini (d. 1505), a Renaissance dealer in Rome and his Collection of Antiquities', *Xenia* 21, 1991, 7–46

—, *Lorenzo de' Medici: Collector and Antiquarian*, New York and Cambridge, 2006

Gaye, G., *Carteggio inedito d'artisti dei secoli XIV, XV e XVI*, 3 vols, Florence, 1839–40

Genovesi, A., 'Due imprese musicali di Isabella d'Este', *Atti e memorie dell'Accademia Virgiliana di Mantova* 61, 1993, 73–102

Gerola, G., 'Trasmigrazioni e vicende dei camerini di Isabella d'Este', *Atti e memorie della R. Accademia Virgiliana di Mantova*, n.s. 21, 1928–29, 253–90

Giannetto, N., ed., *Vittorino da Feltre e la sua scuola: Umanesimo, pedagogia, arti*, Florence, 1981

Gilbert, Creighton E., *Italian Art 1400–1500: Sources and Documents*, Englewood Cliffs, N.J., 1980

—, 'The Two Italian Pupils of Rogier van der Weyden: Angelo Macagnino and Zanetto Bugatto', *Arte Lombarda* 122, 1998, 5–18 [1998a]

—, 'What Did the Renaissance Patron Buy?', *Renaissance Quarterly* 51, 1998, 392–450 [1998b]

Gobio Casali, M. P., 'Ceramic Tiles for the Gonzaga', in *Splendours of the Gonzaga* exh. cat., 1981, 44–45 and 173–74 cats 127–28

—, *La ceramica a Mantova*, Ferrara, 1987

Goffen, R., *Giovanni Bellini*, New Haven and London, 1989

Gombrich, E. H., 'An Interpretation of Mantegna's "Parnassus"', *Journal of the Warburg and Courtauld Institutes* XXVI, 1963, 196–98

—, 'Light, Form and Texture in Fifteenth-Century Painting North and South of the Alps', in *The Heritage of Apelles: Studies in the Art of the Renaissance*, Oxford, 1976, 19–35

Grendler, P., *Schooling in Renaissance Italy: Literacy and Learning 1300–1600*, Baltimore, Md., 1989

Gundersheimer, W. L., 'Women, Learning and Power: Eleanor of Aragon and the Court of Ferrara', in Labalme, ed., 1980, 43–65

—, 'Clarity and Ambiguity in Renaissance Gesture: The Case of Borso d'Este', *Journal of Medieval and Renaissance Studies* XXIII, 1993, 1–17

Halliday, A., 'The Literary Sources of Mantegna's Triumphs of Caesar', *Annali della Scuola Normale Superiore di Pisa*, ser. iii, XXIV, 1, 1994, 337–96

—, 'The Literary Sources of Mantegna's *Triumphs of Caesar*', in Mozzarelli, Oresko and Ventura, eds, 1997, 187–95

Heikamp, D., ed., *Il tesoro di Lorenzo il Magnifico: I vasi*, Florence, 1974

Heydenreich, L., 'Leonardo's "Salvator Mundi"', *Raccolta Vinciana* XX, 1964, 83–109

Hickson, S., 'Bishop-Elect Ludovico Gonzaga, Ercole d'Este and Isabella d'Este and the Pietre Dure Vases of Lorenzo de' Medici', *Civiltà Mantovana* XXXV, III, 2000, 89–97

—, 'Un concorrente per le collezioni antiquarie di Isabella d'Este: Ludovico Gonzaga e i vasi medicei', in Bini, ed., 2001, 155–65

—, 'Female Patronage and the Language of Art in the Circle of Isabella d'Este in Mantua (c. 1470–1560)', PhD thesis, Queen's University, Kingston, Ontario, 2004

Hill, G. F., *A Corpus of Italian Medals of the Renaissance before Cellini*, London, 1930

—, and G. Pollard, *Medals of the Renaissance*, London, 1978

Hirst, M., and J. Dunkerton, *The Young Michelangelo*, London, 1994

Hope, C., 'The Triumphs of Caesar', in *Andrea Mantegna* exh. cat., 1992, 350–56

Il Cinquecento Lombardo: Da Leonardo a Caravaggio, exh. cat., Milan (Palazzo Reale) 2000–1, ed. F. Caroli, Milan, 2000

Iotti, R., and L. Ventura, *Isabella d'Este alla corte di Mantova*, Modena, 1993

Jacobus, L., ' "A lady more radiant than the sun": Isabella d'Este's Creation of a Personal Iconography', in F. Ames-Lewis and A. Bednarek, eds, *Mantegna and 15th-Century Court Culture*, London, 1993, 93–102

James, C., *Giovanni Sabadino degli Arienti: A Literary Career*, Florence, 1996

James, C., and F. W. Kent, 'Margherita Cantelmo and Agostino Strozzi: Friendship's Gifts and a Portrait Medal by Costanzo da Ferrara', *I Tatti Studies* 12, 2009, 85–115

Janson, H. W., 'The Image Made by Chance', in M. Meiss, ed., *De Artis Opuscula XL: Essays in Honor of Erwin Panofsky*, New York 1961, 254–66

Jones, R., 'What Venus Did with Mars: Battista Fieri and Mantegna's Parnassus', *Journal of the Warburg and Courtauld Institutes* 44, 1981, 193–98

—, 'Mantegna and Materials', *I Tatti Studies* 2, 1987, 71–90

Kemp, M., 'Portrait of a Lady with an Ermine (Cecilia Gallerani)', in *Circa 1492* exh. cat., ed. J. Levenson, 1991, 271–72 cat. 170 [1991a]

—, 'Christo fanciullo', *Achademia Leonardi Vinci* iv, 1991, 171–76 [1991b]

—, 'Leonardo verso 1500', in *Leonardo & Venice* exh. cat., 1992, 45–49

—, *Leonardo da Vinci: The Marvellous Works of Nature and Man*, 2nd ed., Oxford, 2006

—, and J. Barone, *I disegni di Leonardo da Vinci in collezioni britaniche*, Florence, 2010

—, and P. Cotte, *Leonardo da Vinci "La Bella Principessa": The Profile Portrait of a Milanese Woman*, London, 2010

—, and A. Smart, 'Leonardo's *Leda* and the Belvedere *River-Gods*: Roman Sources and a New Chronology', *Art History* 3, 1980, 182–93

—, and M. Walker, *Leonardo on Painting*, New Haven and London, 1989

—, and T. Wells, *Leonardo da Vinci's* Madonna of the Yarnwinder: *An Historical & Scientific Detective Story*, London, 2011

Knox, G., 'The Camerino of Francesco Corner', *Arte Veneta* 32, 1978, 79–84

Kolsky, S., 'Images of Isabella d'Este', *Italian Studies* 39, 1984, 47–62

—, 'An Unnoticed Description of Isabella d'Este's Grotta', *Journal of the Warburg and Courtauld Institutes* lii, 1989, 232–35

—, *Mario Equicola: The Real Courtier*, Geneva, 1991

Kristeller, P., *Andrea Mantegna*, Berlin and Leipzig, 1902

Labalme, P. H., ed., *Beyond their Sex: Learned Women of the European Past*, New York, 1980

Land, N., *The Viewer as Poet: The Renaissance Response to Art*, University Park, Pa., 1994

'La Prima Donna del Mondo': Isabella d'Este, Fürstin und Mäzenatin der Renaissance, exh. cat., Vienna (Kunsthistorisches Museum) 1994, ed. S. Ferino-Pagden, Vienna 1994

Lauts, J., *Carpaccio: Paintings and Drawings*, London, 1962

Lawrence, C. M., ed., *Women and Art in Early Modern Europe: Patrons, Collectors and Connoisseurs*, University Park, Pa., 1996

Lehmann, Phyllis Williams, 'The Sources and Meaning of Mantegna's Parnassus', in P. W. Lehmann and K. Lehmann, *Samothracian Reflections*, Princeton, N.J., 1973, 51–178

Léonard de Vinci: Dessins e Manuscrits, exh. cat., Paris (Louvre), ed. F. Viatte and V. Forcione, Paris, 2003

Leonardo & Venice, exh. cat., Venice (Palazzo Grassi) 1992, ed. P. Parlavecchia, Milan, 1992

Leonardo da Vinci: The Divine and the Grotesque, exh. cat., Edinburgh (Queen's Gallery, Holyroodhouse) and London (Queen's Gallery, Buckingham Palace) 2002–3, ed. M. Clayton, London, 2002

Leonardo da Vinci 1452–1519: Lady with an Ermine, from the Czartoryski Collection, National Museum, Cracow, exh. cat., Washington, D.C. (National Galley of Art) ed. J. Grabski and J. Walek, Vienna, 1991

Leonardo da Vinci, Master Draftsman, exh. cat., New York (The Metropolitan Museum of Art) 2003, ed. C. C. Bambach, New Haven and London, 2003

Leonardo da Vinci: The Mystery of the Madonna of the Yarnwinder, exh. cat., Edinburgh (National Gallery of Scotland) 1992, ed. M. Kemp, Edinburgh, 1992

Leonardo da Vinci: One Hundred Drawings from the Collection of Her Majesty the Queen, exh. cat., London (Queen's Gallery, Buckingham Palace) 1996–97, ed. M. Clayton, London, 1996

Leonardo da Vinci: Painter at the Court of Milan, exh. cat., London (National Gallery) 2011–12, ed. L. Syson, London, 2011

Leonardo dopo Milano: La Madonna dei Fusi (1501), exh. cat. Vinci (Castello dei Conti Guidi) 1982, ed. C. Pedretti, Florence, 1982

Leonardo e il mito di Leda: Modelli, memorie e metamorfosi di un'invenzione, exh. cat., Vinci (Palazzina Uzielli del Museo Leonardiano) 2001, ed. G. Dalli Regoli, R. Nanni and A. Natali, Cinisello Balsamo, 2001

Leonardo: La dama con l'ermellino, exh. cat., Rome (Palazzo del Quirinale) 1998, ed. B. Fabjan and P. C. Marani, Cisinello Balsamo, 1998

Leonardo, Machiavelli, Cesare Borgia: Arte, Storia e Scienza in Romagna 1500–1503, exh. cat., Rimini (Castel Sismondo) 2003, ed. A. Ravaioli, M. Barbieri, M. Gottifredi and L. Chicchi, Rome, 2003

Le Studiolo d'Isabelle d'Este, exh. cat., Paris (Louvre) 1975, ed. S. Béguin, Paris, 1975

Liebenwein, W., *Lo Studiolo: Die Entstehung eines Rahmtyps und seine Entwicklung bis um 1600*, Berlin, 1977

—, *Studiolo: Storia e tipologia di uno spazio culturale*, trans. C. Cieri Via, Modena, 1988

Lightbown, Ronald, *Sandro Botticelli*, 2 vols, London, 1978

—, *Mantegna*, Oxford, 1986

Looney, D., and D. Shemek, eds, *Phaeton's Children: The Este Court and Its Culture in Early Modern Ferrara*, Tempe, Ariz., 2005

Lorenzoni, Anna Maria, 'Contributo allo studio delle fonti Isabelliane dell'Archivio dello Stato di Mantova', *Atti e memorie dell'Accademic Virgiliana di Mantova*, n.s. 47, 1979, 97–135

Luzio, A., *I precettori d'Isabella d'Este*, Ancona, 1887

—, 'Nuovi documenti su Leonardo da Vinci', *Archivio storico dell'arte* 1, 1888, 45–46 [1888a]

—, 'Ancora su Leonardo da Vinci e Isabella d'Este', *Archivio storico dell'arte* 1, 1888, 181–84 [1888b]

—, 'I ritratti di Isabella d'Este', *Emporium* 11/65, 1900, 344–59, and 11/66, 1900, 427–42; repr. ibid., *La Galleria dei Gonzaga venduta all'Inghilterra nel 1627–28*, Milan, 1913, Appendix B, 183–238

—, 'Isabella d'Este e il sacco di Roma: L'inventario della Grotta di Isabella d'Este', *Archivio storico lombardo* 10, 1908, 413–25

—, 'Isabella d'Este e Giulio II', *Rivista d'Italia* 12, 1909, 837–76

—, *La Galleria dei Gonzaga venduta all'Inghilterra nel 1627–28*, Milan, 1913

—, and R. Paribeni, *Il trionfo di Cesare di Andrea Mantegna*, Rome, 1940

—, and R. Renier, 'Delle relazioni di Isabella d'Este Gonzaga con Ludovico e Beatrice Sforza', *Archivio storico lombardo*, ser. 2, 7, 1890, 74–119, 346–99 and 619–74

—, and R. Renier, 'Niccolò da Correggio', *Giornale storico della letteratura italiana* 21, 1893, 203–64; 22, 1893, 65–119.

—, and R. Renier, 'Il lusso di Isabella d'Este, Marchesa di Mantova', *Nuova Antologia*, ser. 4, 1896, LXIII, 441–69; LXIV, 1896, 294–324; LXV, 261–86 and 666–88

—, and R. Renier, 'La coltura e le relazioni letterarie di Isabella d'Este Gonzaga', *Giornale storico della letteratura italiana* XXXIII, 1899, 1–62; XXXIV, 1899, 1–97; XXXV, 1900, 193–257; XXXVI, 1900, 324–49; XXXVII, 1901, 201–45; XXXVIII, 1901, 41–70; XXXIX, 1902, 193–251; XL, 1902, 289–334; XLII, 1903, 75–111; complete repr. ed. S. Albonico, Milan, 2005

McMahon, A., ed. and trans., *Treatise on Painting by Leonardo da Vinci*, Princeton, N.J., 1956

Malaguzzi Valeri, F., *La corte di Lodovico il Moro*, Milan, 1913

Mallet, J. V. G., 'Floor Tiles with Gonzaga Devices, as Laid in Isabella's First Studiolo', in *Splendours of the Gonzaga* exh. cat., 1981, 173–74

—, 'Tiled Floors and Court Designers in Mantua and Northern Italy', in Mozzarelli, Oresko and Ventura, eds, 1997, 253–72

Manca, Joseph, 'Isabella's Mother: Aspects of the Art Patronage of Eleonora d'Aragona, Duchess of Ferrara', *Aurora* IV, 2003, 79–94

Mantegna 1431–1506, exh. cat. Paris (Louvre) 2008, ed. G. Agosti and D. Thiébaut. Paris, 2008

Mantegna a Mantova 1460–1506, exh. cat., Mantua (Palazzo Té) 2006, ed. M. Lucco, Geneva and Milan, 2006

Marani, P. C., 'Ritratto di corte', in *Ambrogio Bergognone* exh. cat., 1998, 269–73

—, *Leonardo da Vinci: The Complete Paintings*, New York, 2000

Martindale, Andrew, 'The Patronage of Isabella d'Este at Mantua', *Apollo* LXXIX/25, March 1964, 183–91

—, *The Triumphs of Caesar by Andrea Mantegna in the Collection of Her Majesty the Queen at Hampton Court*, London, 1979

Massing, Jean-Michel, *Du texte à l'image: La Calomnie d'Apelle et son iconographie*, Strasbourg, 1990

Mozzarelli, C., R. Oresko and L. Ventura, eds, *La corte di Mantova nell'età di Andrea Mantegna: 1450–1550*, Rome, 1997

Mumford, Ivy L., 'Some Decorative Aspects of the Imprese of Isabella d'Este (1474–1539)', *Italian Studies* 34, 1979, 60–70

Müntz, E., *Les collections des Médicis au quinzième siècle*, Paris and London, 1888

Nanni, R., and M. C. Monaco, *Leda: Storia di un mito dalle origini a Leonardo*, Florence, 2007

Negro E., and N. Roio, *Francesco Francia e la sua scuola*, Modena, 1998

Nelson, J. K. and R. J. Zeckhauser, eds, *The Patron's Payoff: Conspicuous Commissions in Italian Renaissance Art*, Princeton, NJ, 2008

Norris, A. S., 'The Tomb of Gian Galeazzo Visconti at the Certosa of Pavia', PhD thesis, New York University, 1977

—, 'Gian Cristoforo Romano: The Courtier as Medalist', in J. G. Pollard, ed., *Italian Medals* (Studies in the History of Art 21), Washington, D.C. (National Gallery of Art), 1987, 131–41

Norton, P., 'The Lost Sleeping Cupid of Michelangelo', *Art Bulletin* XXXIX, 1957, 251–57

Nuttall, P., *From Flanders to Florence: The Impact of Netherlandish Painting, 1400–1500*, New Haven and London, 2004

Ochenkowski, H., 'The Lady with the Ermine: A Composition by Leonardo da Vinci', *Burlington Magazine* 34, 1919, 186–94

Ottino della Chiesa, A., *Bernardino Luini*, Novara, 1956

Panizza, L., ed., *Women in Italian Renaissance Culture and Society*, Oxford, 2000

Parker, K. T., *Catalogue of the Collection of Drawings in the Ashmolean Museum*, II: *Italian Schools*, Oxford, 1972

Pedretti, C., *Leonardo: A Study in Chronology and Style*, London, 1973

—, *Leonardo architetto*, Milan, 1978

—, 'La "Dama con l'ermellino" come allegoria politica', in S. Rota Ghibandi and F. Barcia, eds, *Studi politici in onore di Luigi Firpo*, Milan, 1990, I, 161–81

—, 'Il tema del profilo, o quasi', in M. T. Fiorio and P. C. Marani, eds, *I leonardeschi a Milano: fortuna e collezionismo*, Milan, 1991, 14–23

M. Perry, 'A Greek Bronze in Renaissance Venice', *Burlington Magazine* 117, 1975, 204–11

Piepho, L., ed., *Adulescentia: The Eclogues of Mantuan*, New York and London, 1989

Pignatti, T., *Giorgione*, Venice, 1970

Pisanello, exh. cat., Paris (Louvre) 1996, ed. D. Cordellier, Paris, 1996

Pontano, G., *I libri delle virtù sociali*, ed. F. Tateo, Rome, 1999

Pope-Hennessy, J., *Italian High Renaissance and Baroque Sculpture*, 3 vols, London, 1963

—, *Italian Renaissance Sculpture*, London, 1971

Popham, A. E., and P. Pouncey, *Italian Drawings in the Department of Prints and Drawings in the British Museum: The Fourteenth and Fifteenth Centuries*, 2 vols, London, 1950

Praz, M., 'The Gonzaga Devices', in *Splendours of the Gonzaga* exh. cat., 1981, 65–72

Prizer, W. F., 'Isabella d'Este and Lorenzo da Pavia, "master instrument maker"', *Early Music History* 11, 1982, 87–127

—, 'Isabella d'Este and Lucrezia Borgia as Patrons of Music: The Frottola at Mantua and Ferrara', *Journal of the American Musicological Society* 38, 1985, 1–33

—, '"Una virtù molto conveniente a madonne": Isabella d'Este as a Musician', *Journal of Musicology* 17, 1999, 10–49

Radcliffe, A., 'Antico and the Mantuan Bronze', in *Splendours of the Gonzaga* exh. cat., 1981, 46–49

—, '"Una figura nuda legata a un tronco": A Gilt Bronze Statuette Here Attributed to Andrea Mantegna, II', *Atti dell'Accademia Virgiliana di Mantova* LXV, 1997, 94–104

Radcliffe, A., M. Baker and M. Maek-Gérard, eds, *Renaissance and Later Sculpture, with Works of Art in Bronze: The Thyssen Bornemisza Collection*, London, 1992

Rama, E., 'Un tentativo di rilettura della ritrattistica di Boltraffio fra Quattrocento e Cinquecento', *Arte Lombarda* 64/1, 1983, 79–92

Rausa, F., 'Mantova, Mantegna e l'antichità classica', in *A casa di Andrea Mantegna* exh. cat., 2006, 178–91

Rebecchini, G., *Private Collectors in Mantua, 1500–1630*, Rome, 2002

Reiss, S., and D. Wilkins, eds, *Beyond Isabella: Secular Women Patrons of Art in Renaissance Italy*, Kirksville, Mo., 2001

Ricci, L., ed., *La redazione manoscritta del* Libro de natura de amore *di Mario Equicola*, Rome, 1999

Richter, J. P., *The Literary Works of Leonardo da Vinci Compiled and Edited from the Original Manuscripts*, 3rd ed., 2 vols, London, 1970

Ringbom, S., *Icon to Narrative: The Rise of the Dramatic Close-up in Fifteenth-century Devotional Painting*, Abo, 1965

Robertson, G., *Giovanni Bellini*, Oxford, 1968

Romano, G., 'Verso la maniera moderna: da Mantegna a Raffaello', in F. Zeri, ed.,

Storia dell'Arte italiana VI, parte seconda, vol. secondo, 1: *Cinquecento e Seicento*, Turin, 1981, 5–88

—, 'I *Ricordi* sulle arti di Fra Sabba: note per una cronologia relativa', in Anna Maria Gentilini, ed., *Sabba da Castiglione 1480–1554: Dalle corti rinascimentali alla Commenda di Faenza*, Florence, 2004, 273–80

—, 'Mantegna dans le studiolo d'Isabelle d'Este Gonzague', in *Mantegna 1431–1506* exh. cat., 2008, 321–61

Rossi, U., 'I medaglisti del Rinascimento alla corte di Mantova, II: Pier Jacopo Alari-Bonacolsi detto l'Antico', *Rivista italiana di numismatica* 1, 1888, 161–94 and 433–38

Sabba da Castiglione, *Ricordi ovvero Ammaestramenti* (1549), ed. S. Cortesi, Faenza, 1999

San Juan, R., 'The Court Lady's Dilemma: Isabella d'Este and Art Collecting in the Renaissance', *Oxford Art Journal* 14/1, 1991, 67–78

Santoro, D., *Della vita e delle opere di Mario Equicola*, Chieti, 1906

Sedini, D., *Marco d'Oggiono: Tradizione e rinnovamento in Lombardia tra Quattrocento e Cinquecento*, Milan, 1989

Shell, J., and G. Sironi, 'Cecilia Gallerani: Leonardo's Lady with an Ermine', *Artibus et Historiae* 25, 1992, 47–66

Shemek, D., '"In Continuous Expectation": Isabella d'Este's Epistolary Desire', in Looney and Shemek, eds, 2005, 269–300

Shephard, T., 'Constructing Isabella d'Este's Musical Decorum in the Visual Sphere,' *Renaissance Studies* 25, 2011, 684–706

Signorini, R., 'Federico III e Cristiano I nella Camera degli Sposi di Mantegna', *Mitteilungen des Kunsthistorischen Institutes in Florenz* 18, 1974, 227–50

—, '"Una porta gemmea": Il portale della Grotta di Isabella d'Este in Corte Vecchia', in A. M. Lorenzoni and R. Navarini, eds, *Per Mantova una vita: Studi in memoria di Rita Castagna*, Mantua, 1991, 25–51

—, '"Una figura nuda legata a un tronco": Una statuetta in bronzo dorato qui attribuita ad Andrea Mantegna, I', *Atti dell'Accademia Virgiliana di Mantova* LXV, 1997, 49–93

Simons, P., 'Women in Frames: The Gaze, the Eye, the Profile in Renaissance Portraiture', *History Workshop: A Journal of Socialist and Feminist Historians* 25, 1988, 4–30; repr. in N. Broude and M. D. Garrard, eds, *The Expanding Discourse: Feminism and Art History*, New York, 1992, 39–58

—, 'Portraiture, Portrayal, and Idealization: Ambiguous Individualism in Representations of Renaissance Women', in A. Brown, ed., 1995, 263–311

Snow-Smith, J., 'The Salvator Mundi of Leonardo da Vinci', *Arte lombarda* 50, 1978, 69–81

—, *The Salvator Mundi of Leonardo da Vinci*, Seattle, Wash., 1982

Spallanzani, M., and G. Gaeta Bertelà, eds, *Libro d'inventario dei beni di Lorenzo il Magnifico*, Florence, 1992

Splendours of the Gonzaga, exh. cat., London (Victoria and Albert Museum) 1981, ed. D. S. Chambers and J. Martineau, London, 1981

Sricchia Santoro, Fiorella, *Antonello e l'Europa*, Milan, 1986

Stone, Richard, 'Antico and the Development of Bronzecasting in Italy at the End of the Quattrocento', *Metropolitan Museum Journal* 16, 1982, 87–116

Syson, L., 'Reading Faces: Gian Cristoforo Romano's Medal of Isabella d'Este', in Mozzarelli, Oresko and Ventura, eds, 1997, 281–94 [1997a]

—, 'Consorts, Mistresses and Exemplary Women: The Female Medallic Portrait in Fifteenth-century Italy', in S. Currie and P. Motture, eds, *The Sculpted Object, 1400–1700*, Aldershot, 1997, 43–64 [1997b]

—, 'Medals and Other Portraits Attributed to Cosmè Tura', *Burlington Magazine* 141, 1999, 226–29

—, and D. Gordon, *Pisanello: Painter to the Renaissance Court*, London, 2001

—, and D. Thornton, *Objects of Virtue: Art in Renaissance Italy*, London, 2001

Tatrai, V., 'Osservazioni circa due allegorie del Mantegna', *Acta Historiae Artium* XVIII, 1972, 233–50

Thornton, D., *The Scholar in his Study: Ownership and Experience in Renaissance Italy*, New Haven and London, 1997

Tietze-Conrat, E., 'Mantegna's Parnassus: A Discussion of a Recent Interpretation', *Art Bulletin* XXXI, 1949, 130

Tuohy, T., *Herculean Ferrara: Ercole d'Este, 1471–1505, and the Invention of a Ducal Capital*, Cambridge, 1996

Uzielli, G., *Ricerche intorno a Leonardo da Vinci*, 2nd ed., Turin, 1896

Vasari, G., *Le vite de' più eccellenti pittori, scultori ed architettori scritte da Giorgio Vasari, pittore aretino, con nuove annotazioni e commenti di Gaetano Milanesi*, 9 vols, Florence, 1878–85

—, *The Lives of the Artists*, trans. G. Bull, 2 vols, London, 1965–79

Vasic Vatovec, C., *Luca Fancelli*, Florence, 1979

Ventrinelli, P., ' "Diaspise, christallo et anitista": Pietre dure e vetri di Leonardo', in F. Frosini, ed., *"Tutte le opere non son per instancarmi": Raccolti di scritti per i settant'anni di Carlo Pedretti*, Rome, 1998, 457–69

Ventura, L., ed., *Isabella d'Este: I luoghi del collezionismo*, Quaderno di *Civiltà Mantovana*, 3rd ser., XXX, Modena, 1995 (catalogue of an exhibition held in Mantua (Palazzo Ducale), 1995)

—, 'Isabella d'Este: Committenza e collezionismo', in Ventura, ed., 1995, 47–69

Venturi, A., 'Il "Cupido" di Michelangelo', *Archivio storico dell'arte* I/I, 1888, 1–13 [1888a]

—, 'Gian Cristoforo Romano', *Archivio storico dell'arte* I/2, 1888, 49–59, 107–18 and 148–58 [1888b]

Verheyen, E., *The Paintings in the Studiolo of Isabella d'Este at Mantua*, New York, 1971

Viatte, F., *Léonard de Vinci: Isabelle d'Este*, Paris, 1999

Villa, A., *Istruire e rappresentare Isabella d'Este: Il* Libro de natura de amore *di Mario Equicola*, Lucca, 2006

Villata, E., ed., *Leonardo da Vinci: I documenti e le testimonianze contemporanee*, Milan, 1999

Virtue and Beauty, exh. cat., Washington, D.C. (National Gallery of Art) 2001–2, ed. D. A. Brown, Washington, D.C., 2001

Walek, J., *Female Portraits by Leonardo da Vinci*, Kraków, 1994

Ward Swain, E., ' "My excellent and most singular lord": Marriage in a Noble Family of Fifteenth-Century Italy', *Journal of Medieval and Renaissance Studies* 16, 1986, 171–95

Weiss, R., *The Renaissance Discovery of Classical Antiquity*, Oxford, 1969

Welch, E., 'Sforza Portraiture and SS Annunziata in Florence', in P. Denley and C. Elam, eds, *Florence and Italy: Renaissance Studies in Honour of Nicolai Rubinstein*, London 1988, 235–40

—, 'Between Milan and Naples: Ippolita Sforza, Duchess of Calabria', in D. Abulafia, ed., *The French Descent into Italy, 1494–1495*, Aldershot, 1995, 113–36

—, *Shopping in the Renaissance*, New Haven and London, 2005

Wethey, H., *The Paintings of Titian*, 3 vols, London, 1971

Wind, E., *Bellini's Feast of the Gods: A Study in Venetian Humanism*, Cambridge, Mass., 1948

—, 'Mantegna's *Parnassus*: A Reply to some Recent Reflections', *Art Bulletin* XXXI, 1949, 224–33

Woods-Marsden, J., ' "Ritratto al Naturale": Questions of Realism and Idealism in Early Renaissance Portraits', *Art Journal* 46, 1987, 209–16

Wright, A., 'A Portrait for the Visit of Galeazzo Maria Sforza to Florence in 1471', in M. Mallett and N. Mann, eds, *Lorenzo the Magnificent: Culture and Politics*, London, 1996, 65–92

—, *The Pollaiuolo Brothers: The Arts of Florence and Rome*, New Haven and London, 2005

Yriarte, C., 'Les relations d'Isabelle d'Este avec Léonard de Vinci, d'après des documents réunis par Armand Baschet', *Gazette des Beaux-Arts* I, 1888, 116–31

—, 'Isabelle d'Este et les artistes de son temps', *Gazette des Beaux-Arts*, ser. 3, XIII, 1895, 13–32, 189–206 and 382–98; XIV, 1895, 123–38; and XV, 1896, 215–28 and 330–46

Zaffanella, Chiara, 'Isabella d'Este e la moda del suo tempo', *Civiltà Mantovana* XXXV/3, 2000, 66–81

Zorzi, N., 'Demetrio Mosco e Mario Equicola: Un volgarizzamento delle "Imagines" di Filostrato per Isabella d'Este', *Giornale storico della letteratura italiana* 174, 1997, 522–72

INDEX

PHOTOGRAPH CREDITS